THE
BUSINESS OF
PORTRAIT
PHOTOGRAPHY

THE
BUSINESS
OF
PORTRAIT
PHOTOGRAPHY

Revised Edition

TOM McDONALD

AMPHOTO BOOKS

An imprint of Watson-Guptill Publications/New York

Senior Acquisitions Editor: Victoria Craven
Edited by Sarah Fass
Cover and interior designed by Leah Lococo and Jennifer Moore
Graphic production by Hector Campbell

First published in 2002 by Amphoto Books, an imprint of Watson-Guptill Publications,
a division of VNU Business Media, Inc., 770 Broadway, New York, NY 10003 www.watsonguptill.com

Library of Congress Cataloging-in-Publication Data
McDonald, Tom, 1933-
 The business of portrait photography / Tom McDonald.— Rev. ed.
 p. cm.
Includes bibliographical references and index.
 ISBN 0-8174-3615-4
 1. Portrait photography. I. Title.
 TR575 .M37 2002
 778.9'2'068--dc21

 2002002176

Typefaces: Belucian, Granjon, Liberty, Minion Ornaments, Shelley Allegro, Woodtype Ornaments, Zapf Dingbats

Manufactured in Hong Kong

First printing, 2002

1 2 3 4 5 6 7 8 9 / 09 08 07 06 05 04 03 02

DEDICATED TO

WILLIAM S. MILLER

PITTSBURG, KANSAS

IN APPRECIATION
OF YOUR GUIDANCE AND INSPIRATION

CONTENTS

PREFACE

A FTER A RECENT PORTRAIT SESSION my subjects, a four-year-old boy and his six-year-old sister, ran back into the camera room to hug me. Their gesture and the appreciation of all of our clients are the greatest rewards that I will ever seek from my profession. Difficult times such as those we all experienced in 2001 provide a valuable opportunity to think about what's really important in our lives. For me, it certainly isn't financial rewards or material possessions. We saw on September 11, 2001, how quickly they can vanish. To me, the most important areas of my life are relationships with our Lord and His children—of all races, religions, ethnic groups, and countries.

My thirty-seven-year career in photography has granted me the opportunity to travel worldwide and meet some wonderful people in Asia, Europe, Canada, Mexico, and throughout the U.S. In our teaching assignments, my wife, Jo Alice, and I have had a chance to work hand-in-hand with some interesting people—a Hindu photographer from India, a Buddhist from Vietnam, a Shinto believer from Japan, a Roman Catholic professional from Spain, a Mormon from Norway, a Jewish speaker from Israel, and a Muslim artist from Indonesia. We discovered that we all had a common bond in our love for people, especially as expressed in portraiture.

One of the prerequisites for opening a portrait business is a love of people. You must also be able to communicate with them in order to bring out their personalities. The word "portrait" comes form the Latin word "protrahere," which means "to draw forth." To be successful, portrait photographers must have the ability to involve a subject so completely that they capture the essence of the person's spirit in a dramatic way.

During a two-year tour in the United States Army (1955–56), I learned to value "mission" almost to the exclusion of everything else in life. In fact, my Army leaders ingrained mission so thoroughly in me that it has become an integral part of my personality. My commander didn't waste our time with spit-and-polish inspections of the barracks, mess halls, or uniforms, but he put the fear of death in us when it came to mission. This training has helped me achieve my goals in both my private life and my business.

For example, my professional mission is to create portraits, so the first thing I must do each day is to prepare to make portraits. This involves such mundane chores as cleaning up the camera room, loading cameras, testing lights,

checking shutter synchronization, setting up backgrounds, preparing props, learning background information about my subjects, and—most important of all—preparing myself mentally for a shooting session.

Sounds simple, doesn't it? But constant pressures, as well as distractions, can keep me from my mission. Because I am as prone to procrastination as the next person, I would rather start the day by drinking coffee and talking with my friends, reading the newspaper and the mail, and checking the computer for e-mail. I have so many demands on my time—from my family, church, and civic organizations—that I have trouble concentrating on my mission. But the discipline of mission tells me, like it or not, that I must get the camera room and myself ready first.

Long hours and hard work, plus God-given talent, are the first ingredients of a successful photographer. These are followed by the perseverance needed to overcome failure and frustration. Next, you must develop the ability to seek the advice of others who have been successful in such areas as human resources, sales, finance, computer technology, engineering, psychology, and print competition. Through the Professional Photographers of America (PPA) affiliate groups, civic club contacts, and church friends, I've found many experts willing to help. Most important, I've had guidance from a Higher Power throughout my career, leading me to Jo Alice and my dedicated business colleagues, who make up for my many weaknesses with their talents and dedication to serving others.

The objective of this book is to help those who want to fulfill the dream of owning their own business in a profession that will allow creative expression while pleasing clients with a product whose chief benefit is *love*. Newcomers, as well as those who have been in business for many years, can learn not only how to create portraits but also to make a profit, without which no one stays in business for long.

Asked to contribute to the book or to provide expert advice in areas beyond my expertise, my friends have rallied to support a cause that all of us feel is worthwhile. I believe this book provides a unique guide to a profitable career in portrait photography, thanks to the combined efforts of a lot of dedicated people. In addition to the photographers whose work appears on these pages, I would like to express my deep appreciation to my wife, Jo Alice, and to Victoria Craven, Jeff Crump, Marybeth Wydock, Arnie Burton,

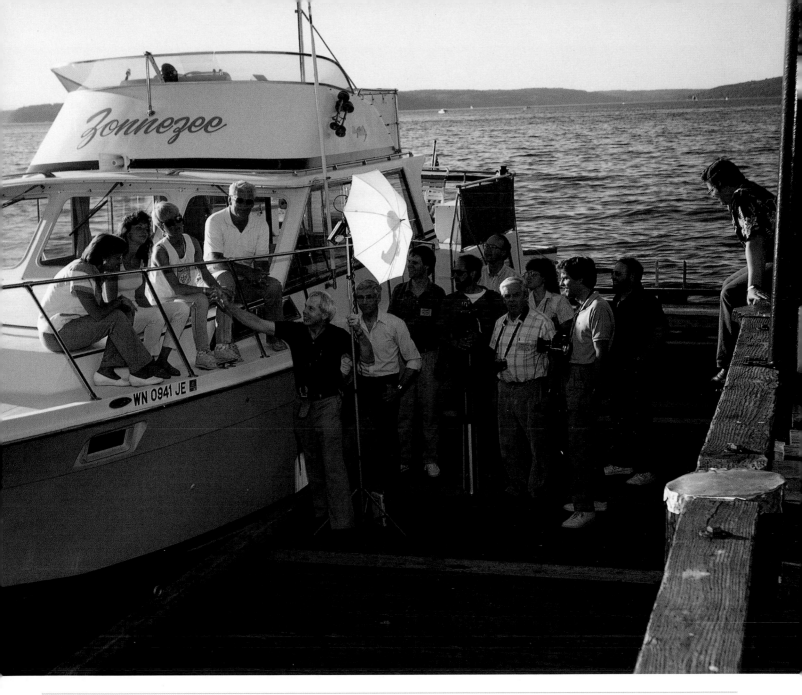

While teaching in Seattle, I showed a group of professionals my style of lifestyle photography, making a portrait of a family on its 52-foot boat.
Hasselblad 150mm lens, f/8 at 1/125 sec., Fujicolor Portrait NPH 400 Professional

Nema Velia, Linda Clements, Belinda Gambill, Alison McDonald, Curtis McKinney, Richard Miller, Dick Coleman, John Hurst, Kinji Yokoo (Fuji-New York), Barbara Palmer (Kodak-Australia), and my loyal clients, whose support has made my career possible.

As American lawyer Louis Nizer (1902–94) said: "A man who works with his hands is a laborer; a man who works with his hands and his brain is a craftsman; but a man who works with his hands and his brain and his heart is an artist."

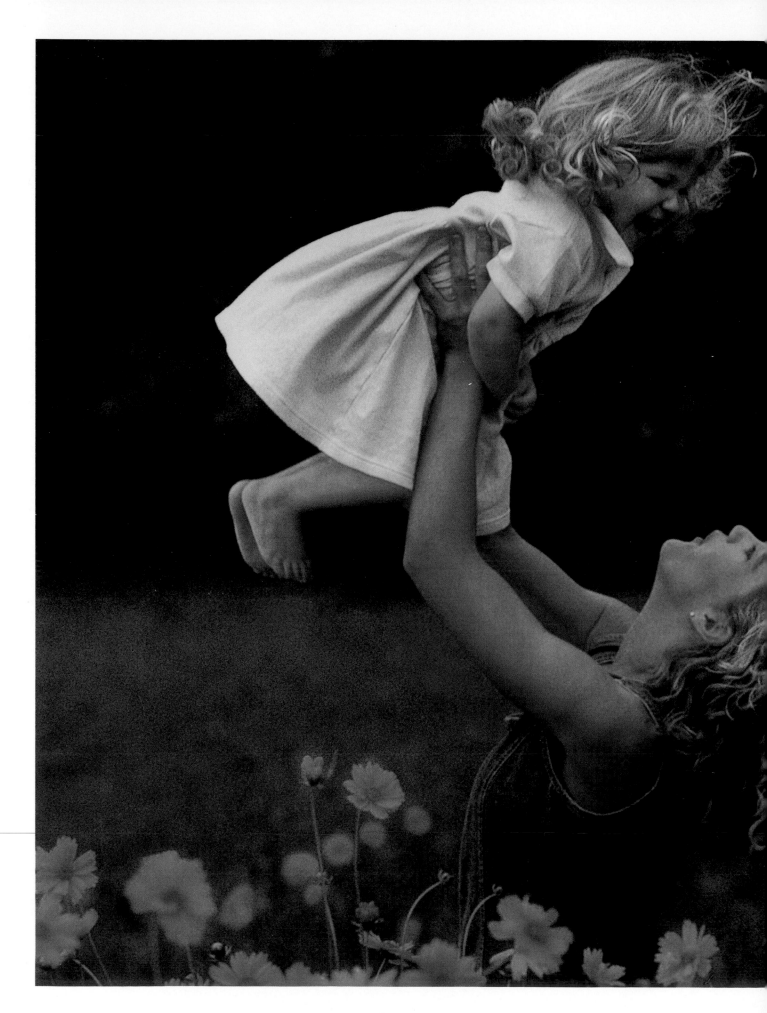

PHOTOGRAPHY BASICS

SELECTING ESSENTIAL EQUIPMENT

AS A PROFESSIONAL PORTRAIT PHOTOGRAPHER, you should choose your camera equipment with a careful plan based on needs, not wants. Many photographers are gadget-oriented by nature, buying equipment because it fascinates them. The litmus test for any equipment purchase should be: How long will it take the piece of equipment to pay for itself?

It is very possible to build your new photography business in stages, thereby reducing your immediate expenses. One big expense is a camera room. To get started, I recommend working outdoors and in clients' homes during the first stage of your career so you don't have to purchase furniture, carpet, backgrounds, and other essential camera-room props right away. Some highly successful portrait photographers do all of their sessions on location because they prefer the look and feel of clients' homes to the contrived atmosphere of a camera room.

The second stage would be renting space to show images, deliver orders, and book sessions. This space should have an elegant gallery showcasing large wall portraits, correctly framed and illuminated.

Acquiring a fully equipped studio would be the last stage, providing all of the elements from stage two plus a camera room, assembly areas, and storage space.

CAMERAS, LENSES, AND ACCESSORIES

Much of my equipment gets such heavy use that I have two of certain essential items so I will have something to use while repairs are being made. I have two camera bodies, two 150mm lenses, one 120mm lens, two 80mm lenses, one 50mm lens, and one 40mm lens.

I like the 6 x 6cm (2 ¼ x 2 ¼-inch) format because it allows me to enlarge images to 40 x 60 inches. In addition, square-format film makes it possible to wait until after the film has been processed to decide whether to show the client a vertical, horizontal, or square image. Finally, the 6 x 6 camera's light weight permits handholding, which can be necessary on wedding, commercial, and some portrait assignments. I sometimes handhold my Hasselblad while standing on a ladder; this allows me to shoot from a height that is impossible with most tripods.

To control lens flare, a bellows shade made out of fabric is essential. Flare is a haze over the image that reduces contrast. Fabric is less reflective than metal, so it makes a superior lens shade.

Lindahl's double-bellows lens shade not only blocks stray light, but also provides an excellent platform for adding filters, diffusers, and vignettes. The slot next to the lens is wide enough to hold glass filters such as those made by Tallyn and Harrison & Harrison. The center slot accommodates both high-key and low-key vignettes, and the front has a ferrous metal plate to hold vignettes with magnetic strips. Vignettes (see Chapter 6) soften, lighten or darken part of the image, while diffusers (see Chapter 5) affect the entire photograph.

DURABLE EQUIPMENT

Some equipment is so durable that I do not need backup items. These include a camera stand, tripod, flash meter, eye-level viewing prism, and electronic portrait lights.

Regal/Arkay manufactures a monostand (the Arkay Mono-Stand Junior) that allows you to move the camera from floor level to its full height of 6 feet with the smooth move of one handle. The side arm holding the camera has a tray, which is a perfect place to put an extra film magazine, filters, and a dark slide. For outdoor and location work, I use a model 3221 lightweight Bogen tripod with a model 3265 "joystick" head (a grip action ball head with a quick-release plate and safety lock). Both the tripod and camera stand have bubble levels, which are essential to keep the camera straight so that walls, doors, and windows don't appear to lean to one side.

When putting any camera on a stand, I put the camera strap around my neck. This way, if the camera slips during the mounting process the strap will prevent it from hitting the floor. After I think the camera is secure on the stand, I pick it up to see if the tripod comes with it. This assures me that the camera is securely mounted. My friends in the camera-repair business tell me that quick-release devices result in more camera breakage than anything else.

Another piece of durable camera equipment that does not require redundancy is an eye-level prism viewfinder. Hasselblad makes several viewing prisms, but I prefer the eye-level PM 90 because it permits me to raise the camera to a 90-degree angle from the ground—higher than the 45-degree or waist-level viewers. (Taller photographers will probably be satisfied with the 45-degree or waist-level viewers.) One important accessory that is available for the PM 90 viewer is the 2X focusing magnifier, which contains an adjustable diopter, making focus accurate for each individual's eye correction. This increases sharpness considerably. Some representatives at color labs tell me that focus is one of the critical problems plaguing photographers; the focus magnifier will help.

Another helpful focus aid is the Hasselblad Acute-Matte screen, which increases the brightness of the image in the viewer by about 100 percent. This is especially helpful when focusing outdoors or in a dark room. The Acute-Matte and similar ground-glass screens are made with special materials that collect more light from the lens and make the camera easier to focus. This effectively doubles the brightness of the focusing screen.

A flash meter is an essential piece of equipment. I don't like a lot of complicated "whistles and bells" so I use a simple meter, the Sekonic L-328 Digilite F, that reads both flash and existing light.

Equally important in setting up a location shoot is a Polaroid back. I prefer the NPC brand because it fits my Hasselblad 503CW camera with the PM 90 prism in place of the film magazine. NPC also manufactures Polaroid backs for almost every type of medium-format camera on the market.

--------- ❈ ---------

LIGHTS

For location and outdoor assignments, I use a Quantum Qflash T2 with Turbo battery. Combined with an umbrella reflector, this gives me sufficient power for fill flash, with fast recycle time and computer-controlled output. I also like the Quantum Radio Slave 4i to trigger flash units from the camera without the need for a connecting wire. I have used the Quantum slave for many years in the studio, on location, and on teaching assignments as far away as Europe and Asia.

Photogenic manufactures the heavy duty lights I use in the studio and on location. I have used some of my Photogenic lights for more than thirty years, and they have required very little maintenance. I use both Flashmasters and PowerLights. The Flashmasters have the power supply in the base, so they aren't likely to topple over if the head is raised 10 feet or so. PowerLights have an infinitely adjustable power switch, making them easy to set when moved various distances from the subject.

Most of the lights in my camera room are mounted on a Photogenic Master-Rail system, which increases efficiency dramatically. The lights can be moved easily from side to side as well as from front to back within the room. They are mounted on light lifts, which move easily from the ceiling to the floor. Also, the system keeps wires off the floor, an important safety factor that also makes the room look much neater.

Some of the lights are used with Photogenic Eclipse umbrellas of varying sizes, but I use a Larson 27-inch Super Silver Reflectasol for my main light. I also use a 42-inch black Larson Reflectasol to block overhead light while working outdoors, and I use a 27-inch white Reflectasol as a fill-in reflector both for window light and outdoors. Any of the Reflectasols also can be used to block stray light from striking the lens.

--------- ❈ ---------

WILL EQUIPMENT MAKE YOU MONEY?

Because most photographers love equipment, they constantly want more and more. The manufacturers introduce new equipment every year, tempting us to buy something that will do the job better than what we have. However, we must carefully ask ourselves, "Will it pay for itself in a reasonable period of time?" We must decide if our present equipment will do the job adequately. Our clients judge us not by the equipment, but by the service and product we provide for them. When our children were young, I frequently had to ask myself if a particular piece of equipment was needed more than dancing lessons for my daughter or a new bicycle for our sons.

This aspiring film director posed with his video camera, illuminated by north window light. Hasselblad 150mm lens, f/8 at 1/15 sec., Fujicolor Portrait NPZ 800 Professional

CONSTRUCTING A CAMERA ROOM

SOME PHOTOGRAPHERS NEVER BUILD A camera room because they feel that they can work more effectively in their clients' homes. Sooner or later, however, most portrait photographers dream of having a camera room so they don't have to lug lights in and out of clients' homes all day. How do they know when it is time to build a camera room? When they have enough money to buy the equipment and furniture they need, plus sufficient net profit to cover the increased cost of space. Photographers who want to do six or more sessions a day need a camera room, but those with marketing plans that call for only two sessions a day may prefer location sessions. Certainly, location portraits provide greater variety than can be achieved working within the same four walls every day.

Given a choice, most photographers would build a huge camera room, about 50 x 50 feet. This space would be large enough to do a big family group or a bride with a long train. However, the high cost of real estate—either to rent or to own—leads most photographers to find a compromise between what they would like and what they can afford.

Some photographers build camera rooms that are only about 10 x 15 feet long, but this limits the size of the groups they can photograph with a normal lens. One solution to the problem of a small camera room is to build it adjoining an atrium or greenhouse. This makes it possible to move from indoors to an "outdoor" studio with heat and air conditioning. These enclosed garden studios have the advantage of being available year round, regardless of wind, cold, heat, snow, or rain. A friend in Texas who has such a camera room keeps it heated to 50 degrees Fahrenheit in winter to preserve the plants he keeps there.

Because they are creative people, many photographers

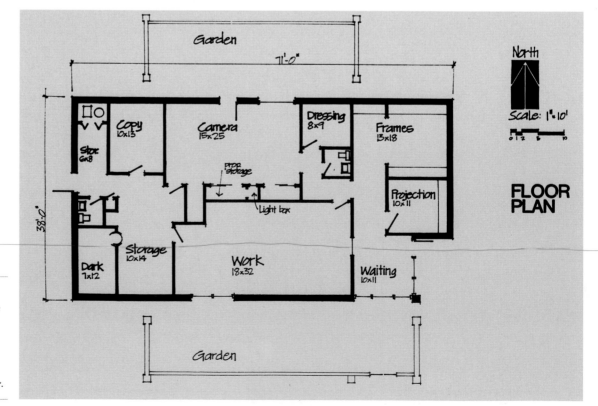

The floor plan of our studio shows the location of our camera room. The window provides north light, which is important for portraiture.

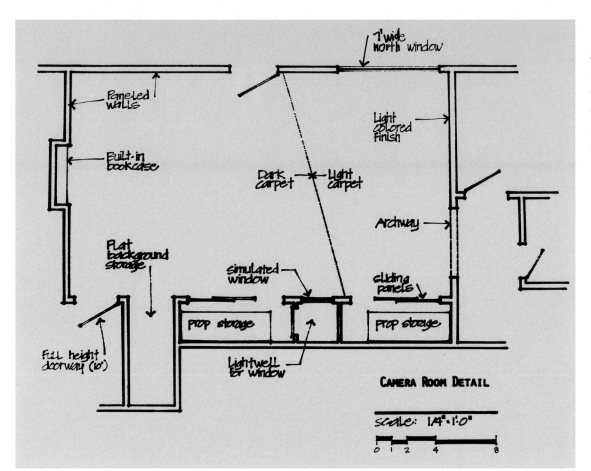

Labels in figure:
7' wide north window
Paneled walls
Built-in bookcase
Light colored finish
Dark carpet — Light carpet
Flat background storage
Archway
Simulated window
Sliding panels
Prop storage
Prop storage
Full height doorway (6')
Lightwell or window

CAMERA ROOM DETAIL

scale: 1/4" = 1'-0"

0 1 2 4 8

come up with clever ways to stretch their money and obtain the maximum results. A photographer in Utah converted a two-car garage into an efficient camera room. He glued thin, neutral gray carpet on the floor and extended it up the wall on three sides at one end of the garage. The carpet curves gracefully at the horizon line, creating a diffused look at the line where the floor meets the wall. The wide expanse of dark carpet allows him to photograph large groups, as well as brides with long trains.

CAMERA ROOM ESSENTIALS

Outline your goals and requirements before drawing plans for your camera room. Here are some issues to consider:

✦ *Locating the camera room.* Try to position the camera room so that no one has to walk through it to get to another room (such as a dressing room).

✦ *Room width.* I suggest a minimum width of 18 feet at one end of the camera room so that you can accommodate large family groups or a bride with a long train. With that width, you should be able to put a bride's face in the center of the frame, even if her train is 9 feet long.

A minimum length of 23 feet (26 feet would be even better) will facilitate the use of a lens that reduces the foreshortening problem associated with short-focal-length lenses. I prefer a 150mm lens for groups so the people in the front row don't appear larger than those in the back. With a larger group, I switch to a 120mm lens, then to an 80mm lens for a group of thirty or more. I avoid using a 50mm lens with the 6 x 6cm format because of the foreshortening problem.

If the background has vertical and horizontal lines, as in as a paneled wall, the camera must be kept level so the walls don't appear to lean. However, if lines aren't a problem, consider raising the short-focal-length lens so that people in the back row are approximately the same distance from the lens as those in the front. I often stand on a ladder to get this kind of height.

✦ *Ceiling height.* Adequate ceiling height is important for several reasons. One is the ability to raise the camera mentioned earlier. Another is to hide backgrounds and lights that are in the ceiling above and behind the subjects. Since we were able to design our camera room before the studio was built, our builder was able to space the roof trusses to allow for a recessed area for mounting roll-down backgrounds above and behind the subject's heads.

A third reason to consider your camera room's ceiling height carefully is that you should be able to raise your main light high enough to create a shadow from the

subject's nose to the corner of the mouth. When a normal-sized client is standing, this requires a ceiling height of at least 10 feet, although 12 feet would be even better.

Keep in mind, too, that a white, smooth ceiling allows for efficient use of bounce light. Textured and colored ceilings soak up a great deal of light, so the bounce effect isn't as effective.

✦ *Floors and walls.* Next, consider floor and wall surfaces that are not distracting. These eliminate such problems as reflections and horizon lines. Dark brown and dark gray floors work well in a camera room, especially for groups, brides, and executives. Dark carpet eliminates the distractions and problems found in most location assignments.

A light, shiny flooring material such as white vinyl or light-colored wood will cause reflection problems in your subjects' eyeglasses. Carpeting will reduce these reflections, but avoid mixing light carpet with dark walls and vice versa. This creates a contrast situation that draws the viewer's eyes away from the subjects.

I recommend thin carpet (about ⅛ inch thick) to make it easy to move a wheeled camera stand. In our camera room, we pull out a white, seamless paper background over the carpet. The hard, thin carpet reduces the problem of the subject's shoe heels punching holes in the paper.

✦ *Dressing rooms.* When planning a camera room, keep in mind that it should adjoin a restroom and one or two dressing rooms. Having two dressing rooms makes it possible for one client to pack up while another is preparing for a session.

✦ *Storage.* The camera room should be an efficient, well-organized room with all equipment, props, and furniture readily accessible, thereby maximizing time usage for both the photographer and the clients. Closets and cabinets can keep props, furniture, and equipment out of sight. Heavy furniture such as sofas or desks should have casters or skids so it can easily be moved around the room.

CUSTOMIZING THE ROOM

When architects Dwain Beisner and Howard Shannon drew up plans for our studio building, they arranged the space to include a north-facing window and a door leading from the camera room to our north-facing garden. All four walls of the camera room were designed to be used as backgrounds; they resemble areas in a client's home.

One side of the camera room simulates a fine library, with a built-in floor-to-ceiling bookcase at the end and a fake fireplace on one of the side walls. To avoid reflections from the paneled walls, we used unfinished grade-A plywood and stained it a medium-tone birch color. (The gloss on pre-finished paneling often creates a glare problem.) The molding designed by the architects to bridge seams in the paneling also serves to enhance the décor. The carpeting in this part of the camera room is dark brown, so the horizon line isn't noticeable. Above the bookcase are six roll-down backgrounds nestled in a ceiling cove. They are out of sight when not in use.

Opposite the bookcase end of the room is an archway that serves both as an entry from the studio to the camera room and a background area for full-length, high-key portraits. Painted ivory, this end of the room has matching ivory carpet. The result is the look of a fine home, especially when ivory furniture, such as a sofa and French Provincial armchair, is added. I use this area both for groups and for bridal portraits.

One of the ivory walls contains the north-facing window, which I can use for close-ups as well as full-length portraits. Behind the arched entryway is the exterior wall of the restroom. Because this small hallway doesn't receive as much electronic light as the subject, I bounce a small electronic light off the ceiling above the subject's head. (It's out of sight, hidden by the camera-room wall.) The valance creating the archway casts a shadow, so an additional light is needed behind the subject.

Closets holding furniture, props, and equipment line the south wall on the high-key end and allow us to keep the camera room neat and orderly. The closets reduce the width of this end of the camera room to 15 feet, 3 feet narrower than the library end of the room.

Careful study and expert advice can help you make the maximum use of space and money in the construction of a camera room. Even if you're working with an experienced architect, it's a good idea to show the plans to an experienced photographer; this may prevent costly mistakes. If possible, build a model based on the architect's plans to help you envision how the camera room will look. Try to avoid installing anything that will cause an obstruction between the camera and the subject, or that will interfere with smooth movement of portrait light units. Also, try to maintain as much clear space in the camera room as possible, putting props, furniture, and cabinets on wheels so they can be moved as needed.

DETERMINING EXPOSURE

EXPOSURE CAN BE DETERMINED BY metering, by making film tests, or by relying on your experience. Since most people reading this book will not have the experience to see light well enough to judge exposure, we will deal with the first two methods. Although meters are a good indicator of probable exposure, I prefer to test film and send it to the laboratory for density readings, which indicate the best exposure for each situation. Professional labs have density meters that read each frame of film. They have established a range of ideal readings for each type of film. If your exposure falls between those parameters, your negative is rated "normal." For instance, if the range for Fujicolor NPS 160 Professional film is between 62 and 72, your negative would be normal if its density falls between those numbers. The density number is listed on the glassine and back of the proof, along with color balance information and the frame number.

MAKING TEST EXPOSURES

Select a subject wearing both light and dark articles of clothing and pose him or her against a dark background. If possible, choose a subject with dark hair. With proper exposure, you should be able to see separation between dark hair and a dark background, even without using a background light or hair light.

Suppose the ISO rating of your film is 160. Set your light meter or flash meter accordingly and then aim it at the light source. If the meter indicates a flash reading of $f/11$, make a series of exposures at half-stop increments on either side of $f/11$. These would be $f/5.6$, $f/6.3$, $f/8$, $f/9.5$, $f/11$, $f/13.5$, $f/16$, $f/19$, and $f/22$. Of course, you don't have to use a 4-stop exposure range for each test, but that's the way I do it.

Next, send the film to the lab and ask the specialists to tell you which exposure they like best. For instance, if they tell you the negative exposed at $f/8$ works best for them, even though your meter called for $f/11$, you would need to adjust your meter. That means the effective ISO for this particular film would be 80 instead of 160.

USING A METER

There are two ways to calculate exposure with a light meter. I prefer the "incident" method, which means pointing the meter at the light source. Others prefer the "reflected" method, which means pointing the meter at the subject. In my opinion, the reflected method works best with a spot meter because it's difficult to point the meter at exactly the correct spot on the subject. When the meter is set to the reflected mode, you must be extremely careful, because it can

DETERMINING FILM SPEED

Film Speed Rating	Meter Reading	Your Lab's Preferred Exposure	Set Your Meter On
ISO 160	$f/11$	$f/5.6$ (+2 STOPS)	ISO 40
ISO 160	$f/11$	$f/8$ (+1 STOP)	ISO 80
ISO 160	$f/11$	$f/11$ (NO DEVIATION)	ISO 160
ISO 160	$f/11$	$f/16$ (-1 STOP)	ISO 320

be confused by backlighting or spectral highlights. That's why I prefer the incident mode for reading a meter—it tends to be more accurate.

Light meters are made to produce a reading for an 18-percent-gray card. This standard assumes your subject is similar to a gray card, which is seldom the case for a portrait photographer. So what should you do to expose your subjects properly?

Set the film speed, or ISO, on your meter to the right setting for the film you're using, as stated by the manufacturer on the box. Put the meter in incident mode, then point it at the light source. For more than 30 years, I have based my exposure on the main light (ignoring readings from reflectors or fill lights), so when I'm working with a continuous light source such as window light or quartz tungsten light, I set the meter for daylight or ambient light. If I'm working with flash, I set the meter in the electronic flash mode.

Either way, I'll have a starting point for determining exposure. I use the phrase "starting point" because the true tests for a portrait photographer are the film tests discussed earlier.

EXPOSURE TOLERANCE

Most negative films have a tolerance range in terms of exposure, which is called exposure latitude. This means you can usually slightly over- or underexpose film and still get printable negatives. Because of this latitude, few portrait photographers bracket their exposures. (Bracketing exposures means using three sequential f-stops for each exposure, for instance taking one photograph at f/8, one at f/11, and one at f/16.) Successful portraiture requires the split-second capture of an expression that may never be repeated, so it isn't practical to bracket exposures.

While negative films can be printed successfully when they are one stop overexposed or one stop underexposed, that kind of tolerance isn't possible with digital cameras or transparency film. These cameras and films require almost perfect exposure.

Proper exposure should produce detail in both white and dark clothing, as well as hair. Overexposed white backgrounds or clothing sometimes look pink, while underexposed images may lack contrast. Some photographers intentionally overexpose low-contrast scenes to increase contrast.

Contrast can be increased by using saturated films such as Fujicolor NPC 160 or Kodak Professional Portra 160 VC. Some photographers rely on these films to increase contrast when they use soft lighting produced by huge soft boxes or umbrellas. A similar effect can be produced with digital retouching.

CONSISTENT LIGHTING

Exposure in the camera room should be consistent if you use quality equipment and use care when setting up your lights. By "care," I mean that you maintain the same distance between the lights and the subject for every exposure, even if you have to measure the distance with a string. I have a string tied to the mounting screw on my main light that measures 39 inches, which is my preferred distance between the light and the subject's nose.

Fortunately, most labs provide exposure information on the negative glassines or on the back of the proofs, indicating over- or underexposure. If you're not sure what these numbers mean, call your lab and ask them what density range they prefer for the film you're using. For instance, our lab likes a range of 62 to 72 for Fuji NPS film.

EFFECTIVE DEPTH-OF-FIELD LIMITS

	Camera-to-Subject Distance (in feet)			
	5	10	15	30
f-stop*	Depth of Field (in feet)			
f/4	5	10	$14^3/_4$–$15^1/_4$	$28^3/_4$–$31^1/_3$
f/5.6	5	10	$14^1/_3$–$15^1/_3$	$28^1/_4$–32
f/8	5	$9^1/_2$–$10^1/_2$	14–16	$25^1/_2$–34
f/11	5	$9^1/_2$–$10^3/_4$	$13^1/_2$–$16^3/_4$	24–$39^1/_2$
f/16	$4^1/_4$–$5^1/_4$	9–11	$12^3/_4$–18	22–47
f/22	$4^3/_4$–$5^1/_3$	$8^3/_4$–$11^3/_4$	12–$19^3/_4$	20–60

*on a Hasselblad 150mm lens

By studying this information on each session, you can fine-tune the exposure for various situations. For instance, you may see that you need a little more exposure with black backgrounds and a little less with white backgrounds. I open up a half-stop for black backgrounds and close down a half-stop for white backgrounds.

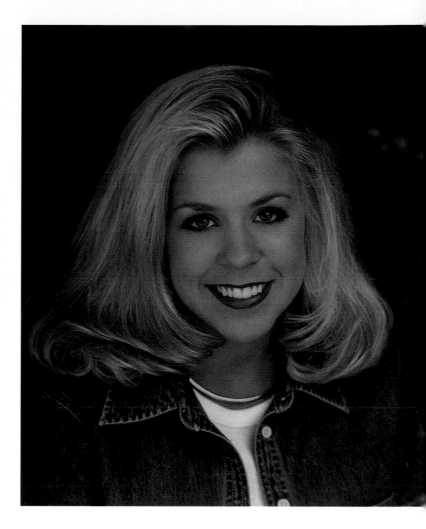

EXPOSING FOR FLASH

Electronic lights in the camera room stop action via the short duration of the flash, so shutter speed isn't critical. It simply must be fast enough to prevent room light from adversely affecting the image. I usually opt for a shutter speed of 1/60 sec.

The duration of an electronic flash pulse varies from 1/400 sec. to 1/10,000 sec. or faster, depending on the equipment being used. Front-leaf shutter cameras, such as the Mamiya RZ67 and Hasselblad "C" series cameras, can synchronize with flash at shutter speeds of up to 1/500 sec. However, focal-plane shutter cameras such as Nikons and Canons usually require 1/60 sec. or slower.

A properly exposed negative yields detail in all areas of the print—light as well as dark—with brilliant luminosity in the eyes. Hasselblad 150mm lens, f/5.6 at 1/60 sec., Fujicolor Portrait NHG II 800 Professional

In the camera room, I usually use an aperture of f/11 to get sufficient depth of field for groups. However, I avoid a smaller aperture such as f/16 because it brings my vignettes into focus. Also, I like the background to be slightly out of focus to give the subject's face prominence in the portrait. Our study of art tells us that a viewer's eye accepts what's in focus while rejecting what's out of focus.

BALANCING APERTURES AND SHUTTER SPEEDS

Outdoor portraits always present a compromise between aperture and shutter speed. When working without a tripod, I prefer a shutter speed of 1/250 sec. with my 150mm lens to produce sharp handheld exposures. Even with ISO 800 film, that results in an f-stop of f/4 or f/5.6 in the shady locations where I normally work. Those f-stops have almost no depth of field.

Sufficient depth of field is needed for groups to bring subjects into focus when they are on different planes. Small f-stops, which are needed for wide depth of field, call for slow shutter speeds. This can lead to fuzzy portraits if the subjects move even slightly.

With a sturdy tripod, I prefer a shutter speed of 1/60 sec., although I sometimes work as slow as 1/15 sec. Skillful posing can alleviate the depth-of-field problem by placing the

subjects on approximately the same focus plane. Also, full-length poses produce greater depth of field than close-ups. As you can see on the accompanying chart, the depth of field is 3 $^1/_4$ feet at f/11 with a Hasselblad 150mm lens when focusing at 15 feet. However, it's only 1 $^1/_4$ foot when focusing at 10 feet.

EFFECTIVE FOCUS

In his excellent book, *The Hasselblad Manual* (page 148, Focal Press, 1986), Ernst Wildi explains, "At normal distances, the unsharpness increases more rapidly in front of the subject and more gradually behind it. As a result, about 33% of the total depth of field is in front, 67% behind." Working at f/11 while focused at 29 feet, the focus range would extend from 24 to 39 $^1/_2$ feet. It would be 5 feet in front of the focus point and 10 feet behind it. When I focus, I check the depth-of-field preview button on the camera to see if all subjects are in focus.

Most lenses indicate the depth of field for various f-stops. You can measure the distance to the nearest object and to the farthest object, then set the focus so both extremes are covered. Sometimes for an assignment where focus is critical, I measure the distance from the film plane to the subject using a steel tape ruler.

LIGHTING

THE PROPER PLACEMENT AND RATIO of lights can make a subject's face seem to jump off the paper. In effect, they transform a one-dimensional piece of paper into three-dimensional roundness. The light that creates shadow patterns producing roundness is called the *main light*. (Some photographers call it the *key light* or *contrast light*.)

Although you can create beautiful portraits with only the main light and a reflector, it is much easier to use another light to soften the shadows. This is called the *fill light* because it fills in the shadows. Reflectors can't duplicate the effectiveness of a fill light, especially for full-length and group portraits.

A photographer can begin just with two lights, then add others later as skill and finances allow. Accent lights include *background lights, hair lights,* and *rim lights.* These lights tend to be overused and often ruin what could have been pleasing portraits. Inexperienced photographers tend to make them too bright, so they call attention to the light rather than the subject.

Most color papers will reproduce a 1 1/2-stop difference between highlights and shadows, so contrast must be kept within this exposure range. Usually, I try for a 1-stop difference between the main light and the fill light, with accent lights 2 stops down from the main light. For me, that means an incident flash meter reading of *f*/11 for the main light, *f*/8 for the fill light, and *f*/5.6 for the hair light and rim light.

THE MAIN LIGHT

Different kinds of reflectors produce different results. Photographers who want a softer look with relatively low contrast use a large light source such as a huge soft box or umbrella for their main light. Those who want more snap and higher contrast use a pan reflector in a parabolic shape, something like a stainless steel mixing bowl.

Others, including myself, use something in between, such as a medium-size umbrella or soft box. The reflector I prefer is a Larson Super Silver 27-inch-square Reflectasol with barn doors, positioned 39 inches from my subject. This produces a contrast pattern almost identical to a 27-inch soft box, with a couple of advantages.

With the barn doors on the sides, the top and bottom of the Reflectasol are open. When I have the subject stand on a white paper background, light streams out of the bottom of the reflector, brightening the floor portion of the paper. With most lighting setups, the floor turns out gray when using a

sweep of white paper for a full-length background. My main light puts light on the floor as it strikes the client's face.

Another advantage of the Reflectasol is its adaptability. When I want to take the light on location, it's much easier to move than a soft box. I use the 27-inch Reflectasol for individuals and groups of up to four people. For larger groups, I switch to a 45-inch white umbrella (a Photogenic Eclipse).

Silver and white umbrellas work well for me because they avoid color crossover problems found with gold umbrellas and reflectors. The silver cloth in the 27-inch Reflectasol provides some spectral highlights on the subject, although it is a medium-soft light. The medium-size Reflectasol or a soft box is a compromise between high-contrast pan reflectors and huge white umbrellas or soft boxes.

Many photographers "feather" the pan reflector used as a main light by turning the light slightly away from the subject, toward the background. The illumination then comes off the side of the pan reflector rather than from the center. However, this effect does not work with umbrellas and Reflectasols. Feathered light is much softer than direct light coming out of the center of a pan reflector, but it still is not as soft as umbrella or soft box light.

My main light yields a flash meter reading of f/11 when placed 39 inches from the subject's nose, using Fujicolor Portrait NPS 160 Professional.

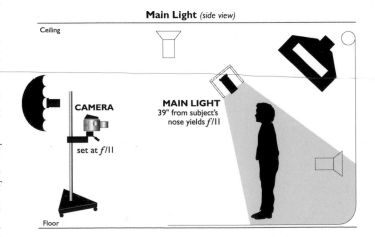

Main Light (side view)

Ceiling

CAMERA
set at *f*/11

MAIN LIGHT
39" from subject's
nose yields *f*/11

Floor

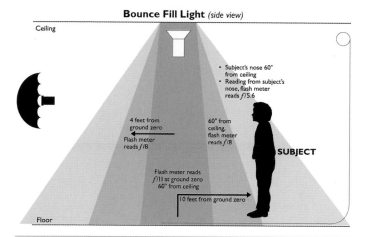

Bounce Fill Light *(side view)*

Ceiling

Floor

- Subject's nose 60" from ceiling
- Reading from subject's nose, flash meter reads *f*/5.6

4 feet from ground zero
Flash meter reads *f*/8

60" from ceiling, flash meter reads *f*/8

Flash meter reads *f*/11 at ground zero 60" from ceiling

10 feet from ground zero

SUBJECT

My bounce fill light yields a flash meter reading of f/5.6 approximately 60 inches away, using Fujicolor Portrait NPS 160 Professional.

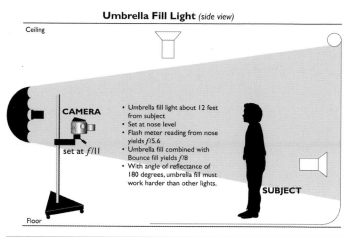

Umbrella Fill Light *(side view)*

Ceiling

Floor

CAMERA

set at *f*/11

- Umbrella fill light about 12 feet from subject
- Set at nose level
- Flash meter reading from nose yields *f*/5.6
- Umbrella fill combined with Bounce fill yields *f*/8
- With angle of reflectance of 180 degrees, umbrella fill must work harder than other lights.

SUBJECT

My umbrella fill light yields a flash meter reading of f/5.6 approximately 12 feet away, using Fujicolor Portrait NPS 160 Professional.

The pan reflector is more difficult to use with children because it requires the subject to stay within a couple of inches of the aim point. Larger light sources, including the 27-inch Reflectasol, are more forgiving, allowing considerable subject movement while still getting good exposures.

Large umbrellas are easier to use than the small or medium reflectors, allowing even more subject movement away from the aim point. They are more forgiving of wrinkled faces and are kinder to subjects wearing eyeglasses because they cast virtually no shadow from the eyeglass frame onto the face. Smaller light sources can cause a sharp shadow from the frames of eyeglasses. Another advantage of large light sources such as umbrellas or soft boxes is that in group portraits subjects don't cast shadows on each other.

Keep in mind, however, that large soft boxes and umbrellas take up more space in the camera room and are more difficult to keep out of camera range. Also, they don't provide any spectral highlights on the face, which are important to many superb portrait photographers such as Yousef Karsh.

Ideally, the main light should be positioned to produce five highlight points on the subject's face: the forehead, nose, chin, left cheek, and right cheek. Try to avoid unwanted highlights on the ear, neck, jaw, and chest.

The main light should create a shadow from the nose to the corner of the mouth, but this angle sometimes must be sacrificed to get "catchlights" (reflections on the eyes). The main light must penetrate both eyes in order to bring out the color and luminosity of the eyes.

❖

FILL LIGHTS

The bigger the light source, the softer the shadows, so large reflectors make superior fill lights. Light bounced off the ceiling (called *bounce light*) is an excellent fill light because the ceiling itself becomes the reflector. It virtually fills a room with light, with the brightest area directly under the lamp head, gradually diminishing in a circular fashion toward the edges of the room. Usually, my subjects are about 12 feet away from the light source.

Bounce light is the best way to avoid glare in eyeglasses and other shiny objects such as mirrors and plate glass. When I work on location, I bounce the fill light as often as possible because it solves so many reflection problems. Of course, some ceilings don't permit bounce light—they are too dark, too high, or too absorbent. In these cases, I sometimes use a 42-inch white Reflectasol to simulate a ceiling and bounce the light off of it.

The big disadvantage to using bounce light is that it causes a shadow under the subject's nose and chin. When the main-light shadow crosses the bounce-light shadow, an unflattering double shadow is created.

My solution is to add a second fill light, a 45-inch white umbrella at nose level next to the camera or about 12 feet from the subject. Ideally, this light should be on the same side as the main light to avoid cross-shadows, but it is so soft that it usually doesn't matter. This light washes out the nose shadow caused by the bounce light.

To maintain a contrast range that looks pleasing on photographic paper, I always try to make the total output of the fill lights 1 stop less than the main light. In my system, that usually means the main light is *f*/11 and the combined reading of all fill lights is *f*/8. The bounce light yields a flash meter reading of *f*/5.6 when pointed at the light from the subject position. The umbrella light also yields *f*/5.6. The combined reading of both lights is *f*/8—1 stop less than the main light.

If the subject is wearing eyeglasses, I remove the umbrella and bounce both fill lights off the ceiling, yielding a combined flash meter reading of *f*/8. Two lights bounced off the ceiling produce a heavy nose shadow but I tolerate this in order to get rid of eyeglass glare, which I feel is a bigger problem.

In my camera room, umbrella or soft box fill lights can't be raised high enough to avoid eyeglass glare, so the bounce light is a good solution. Some photographers use large fabric panels as fill lights, but I don't like them because they are too hard to move and cause large reflections in eyeglasses.

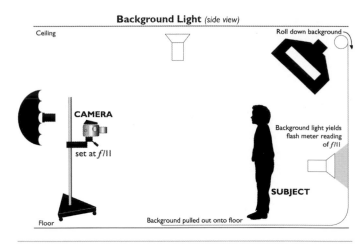

SETTING UP THE CAMERA ROOM

When setting up my camera room, I like to place the subject about 7 feet from the background so the lights don't create shadows on the background. I turn off all room lights so it's easier to see patterns from the electronic lights.

For consistency, I always base my exposure on the main light. When the only light comes from a flash on the camera (as used by some wedding photographers), it is the basis for exposure. If the main light yields a flash meter reading of *f*/11, I set *f*/11 on the lens as my shooting exposure. Combining the main and fill lights will yield an exposure of *f*/13.5, so *f*/11 is means I'm slightly overexposed. However, it gives me the shadow detail I'm seeking.

When you are working outdoors, the sun is the main light, so exposure is based on the sun, whether it's direct, filtered through a shade tree, or softly peeking over the horizon. When working with window light, expose for the light coming from the window.

My background light yields a flash meter reading of f/11 approximately 18 inches from the flash tube, using Fujicolor Portrait NPS 160 Professional.

When exposure is based on the main light, it's more consistent than using a formula based on the fill light because sometimes there is no fill light. As noted earlier, I use electronic lights for my fill lights in the camera room, but outdoors I may use a reflector. It's hard to measure light off a reflector. Some photographers base their exposure on the fill light, but I abandoned that method years ago because, as mentioned earlier, there may not be a fill light in the case of a flash on the camera or direct sunlight outdoors.

Some photographers try to create more dramatic portraits

The background in this portrait was intentionally underexposed to be darker than the priest so the brightly lit altar would not distract from his face. The silver umbrella main light produced f/11 and the white umbrella fill light produced f/8. Illumination from tungsten spotlights on the altar measured 1/30 sec. at f/11, so my camera setting left the background underexposed by 2 stops. Hasselblad 50mm lens, f/11 at 1/125 sec., Fujicolor Portrait NPS 160 Professional

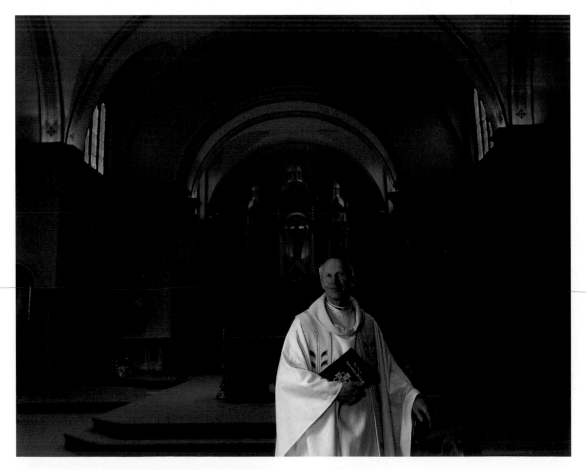

by increasing the ratio between the main and fill lights, but that produces shadows without detail or washed-out highlights because the photographic paper won't reproduce the increased contrast.

BACKGROUND LIGHTS

Sometimes I use one background light directly behind the subject; sometimes I use two lights on either side of the background out of camera range for full-length portraits. Sometimes I don't use any background lights. If the exposure is correct, I don't need a background light for separation.

For the background to record correctly, it needs to receive the same amount of light as the subject, which in my system means *f*/11. Therefore, the two lights on either side of a white paper background should yield *f*/11 when the meter is pointed straight ahead (not directly at either light). With some films, if too much light is put on white it turns pink . My twin background lights are 16-inch pan reflectors that are 36 inches high and are placed 54 inches from the edge of the paper. Both of them are aimed at the center of the background.

If the background is red, blue, or any other color, it will record correctly if the background light illuminates it with the same reading that is set on the camera. If I want the background to be darker, I put less light on it than the camera setting.

For a dramatic effect in head-and-shoulders portraits, I position a single background light so it creates a soft halo on a gray background at shoulder height. The background light is about 18 inches away from the background, yielding a flash meter reading of *f*/16—a slight overexposure to create a brilliant, radiant center.

HAIR LIGHTS

Photographers should use hair lights for accent only—not for exposure. I place the hair light about 7 feet behind the subject, angled so it skims across the hair like moonlight shining on water. I set the light so it does not shine into the camera lens, using barn doors for greater control.

The hair light should come from the same side as the main light, creating the illusion of one light source, just as there is one sun in the sky. With the camera set at *f*/11, I like the hair light to yield *f*/5.6, so it's 2 stops less than the camera setting.

The proper ratio of lights produces a dramatic effect, with brilliant spectral highlights in the face, while retaining detail in the shadow areas. Here, the main light was set at f/11, the fill light at f/8 and the rim light at f/5.6. The rim light added another layer of highlight on top of the main light, so it required less power than the other lights. Hasselblad 150mm lens, f/11 at 1/60 sec., Fujicolor Portrait NPS 160 Professional

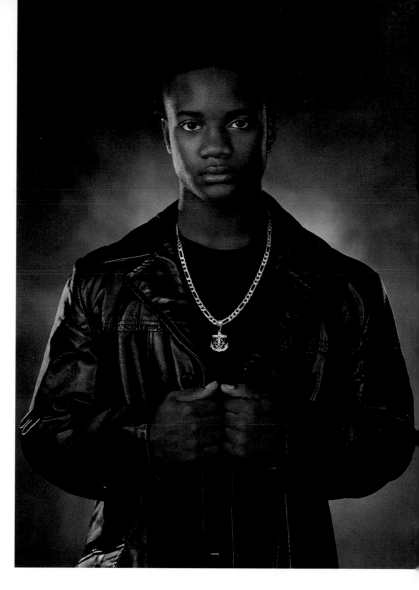

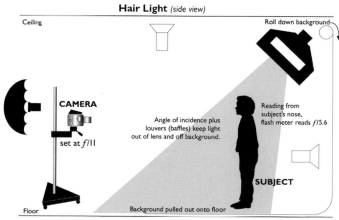

My hair light yields a flash meter reading of f/5.6 at subject's nose, using Fujicolor Portrait NPS 160 Professional.

Because of its angle, the hair light doesn't have to work as hard as the other lights, so it doesn't require as much power. I normally aim it at approximately a 10-degree angle to the lens, compared with the main light at 45 degrees and the fill light at 180 degrees. So the fill light has to work the hardest to do its job.

DIFFUSION

ANUFACTURERS MAKE MOST CAMERA LENSES as sharp as possible, but unfortunately, they are often much too sharp for portraiture. If a lens is sharp enough to show every brick in a building, it also will capture every wrinkle, every blemish, and every scar in a person's face. Therefore, most photographers use some kind of diffusion so their portraits are kinder to their clients.

Just as surgeons must choose which instrument to use and when to use it, photographers have to learn which diffusers to use and when to use them. Before you can make this decision, you must do some research and conduct tests. These steps will help you attain the skills and knowledge needed to master this style of portraiture.

The amount of diffusion necessary is relative to head size. A close-up calls for more diffusion than a full-length portrait. A close-up of two people requires more diffusion than a portrait of a group of four.

Communication with the client is absolutely essential when you make decisions about diffusion. It is a good idea to let your clients see portrait samples of the same subject with varying degrees of diffusion. If they want a group portrait, show them sample prints of a group.

Diffusion (Tallyn Softfuser No. 4) adds to the storybook message of this portrait of child, but notice the flare, which results in a loss of highlight detail in the book and buttons. Hasselblad 150mm lens, f/11 at 1/60 sec., Fujicolor Portrait NPS 160 Professional

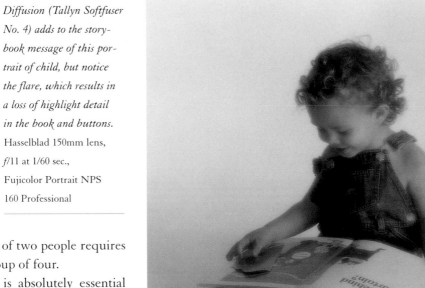

CHOOSING A DIFFUSION SYSTEM

Obviously, a portrait photographer must select a diffusion system that is sufficiently flexible for many types of assignments. I need a system that will enable me to vary diffusion in small increments with no changes in exposure. I also want to be able to change diffusers quickly without having to remove the lens shade each time. And I want a system that will provide a minimum of flare without significant loss of contrast or color. I look for eight qualities in a diffusion system:

1 *Variable diffusion.* Harrison & Harrison, Tallyn, and other manufacturers offer as many as five diffusers in their systems. Their effects range from very slight to heavy. Among the strong diffusion filters, some decrease contrast more than others. For example, Nikon diffusers

lose about 25 percent of their contrast, while the Harrison & Harrison "D" series filters lose even more. The Harrison & Harrison "Black Dot" filters and the Tallyn filters retain contrast better than most of their competitors. Some strong diffusion filters, however, get "mushy."

Many photographers create diffusion by using net fabric or hosiery stretched across the lens. Each layer of material requires additional exposure, which means that you have to open up 1 stop for one layer, 2 stops for two layers, etc. This limits the amount of diffusion possible with hosiery or netting because you won't want to give up 2 or 3 stops of exposure for increased diffusion.

2 *Minimum flare.* Diffusers and soft-focus lenses modify the subject's appearance by forming a second image that is slightly out of register. This produces a white veil, which is called *flare* or *ghosting,* in certain situations at the point of

MY DIFFUSION CHOICES FOR VARIOUS SITUATIONS

Type of Portrait	Recommended Filtration*
Man, full-length pose	No diffusion
Man, 3/4 pose	No. 1
Man, close-up	No. 2
Young woman, full-length pose	No diffusion
Young woman, 3/4 pose	No. 2
Young woman, close-up	No. 3
Older woman, full-length pose	No. 1
Older woman, 3/4 pose	No. 3
Older woman, close-up	No. 4 or 5
Child	Only for special effects
Small group, close-up	No. 2
Large group	No diffusion
Bride, full-length pose	No diffusion
Wedding group	No diffusion
Wedding, close-up of bride	No. 3
Wedding, close-up of mother	No. 4
Newspaper reproduction	No diffusion

Diffusers range from No. 1 (weakest) to No. 5 (strongest).

contrast where blacks and whites converge. Metal jewelry, such as a gold necklace, also results in flare. Harrison & Harrison won an Academy Award for technical excellence with its black-dot diffusers because of their ability to minimize flare. These filters look like glass splattered with black spray paint. The black offsets the characteristic flare that the diffusers produce.

3 *No exposure increase.* Black dot diffusers and most forms of net diffusers require a wider lens opening, which can reduce depth of field. Some filters demand one additional stop of exposure, so, for example, *f*/11 becomes *f*/8. This can make it difficult to bring a group into focus from front to back. And remembering to change *f*-stops every time you change diffusers can be a bit problematic, too.

Most soft-focus lenses alter the degree of diffusion via disks that necessitate exposure changes. For example, Mamiya's 150mm soft-focus lens is sharp at *f*/8 and quite soft at *f*/4. The holes in the disks have an effective aperture of *f*/5.6. So if you set up your lights for a working aperture of *f*/11, you would have to change them in order

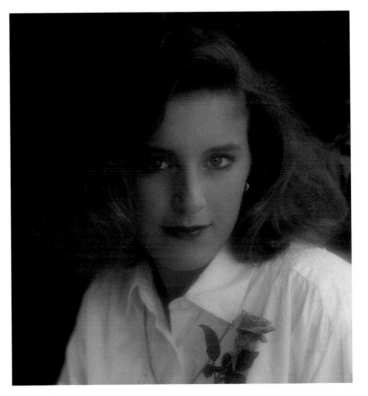

Moderate diffusion with a No. 3 Tallyn Softfuser adds a touch of glamour to this portrait of a young woman, but the white shirt against the dark background creates slight flare. Hasselblad 150mm lens, *f*/5.6 at 1/60 sec., Fujicolor Portrait NPZ 800

to correlate with an aperture of *f*/5.6.

4 *Durability.* Some diffusers that are made of glass, such as those manufactured by Harrison & Harrison, break easily under the duress of a wedding or portrait session. Others, such as the Cokin AE83, are made of hard plastic that is

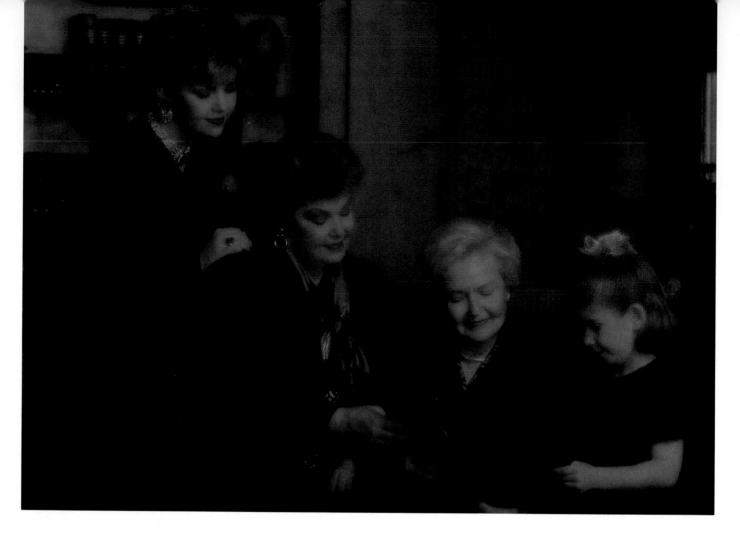

almost indestructible. These diffusers do, however, sometimes get scratched. When this happens, the plastic diffusers bend light differently from the way they were intended to. The Tallyn Softfusers are made of glass but are mounted in plastic filter holders that protect them when they're dropped. Obviously, though, all glass breaks when it is abused.

5 *Predictability and consistency.* High-quality diffusers with similar manufacturing tolerances produce predictable results. Some leaders in the field are Harrison & Harrison, Tallyn, Nikon, B + W, and Tiffen.

6 *Ease of use.* Portrait photographers need to be able to vary the amount of diffusion quickly as they move from a close-up to a full-length pose. So it is much easier to adopt a system that lets you change diffusers without removing the professional lens shade, or *compendium*. Some filters have threads that screw onto the lens while others, such as the Hasselblad Softar, have a female bayonet mount that fits onto the lens's male bayonet threads. These require you to remove the shade each time you switch diffusers, which is time-consuming and wears out the fabric lens shade. I use a Lindahl double-bellows lens shade made out of fabric on my Hasselblad 150mm lens because it has a filter slot next to the lens. This feature enables me to change diffusers in a matter of seconds without removing the lens shade. The Tallyn and Sailwind diffusers are fixed in mounts that drop easily into the Lindahl and Sailwind lens shades.

7 *No herringbone effect.* Some filters produce diffusion by a series of lines etched into glass or plastic in a pattern similar to an open fish net. In some portraits these diffusers cause an unfortunate swirling, or crosshatch, effect, especially with certain types of clothing patterns, such as herringbone, or with net vignettes.

8 *Moderate price.* Soft-focus lenses made for or adapted to medium-format cameras are much more expensive than a set of diffusers. Having tested and experimented with many soft-focus systems for more than 30 years, I use Tallyn diffusers because they have five degrees of diffusion, are relative inexpensive, and offer manufacturing quality and consistency. And when you mount them in a filter holder, you can change them quickly and easily with the Lindahl lens shade. Almost unbreakable, these diffusers produce minimal flare, don't require an exposure increase, and don't cause a herringbone effect.

A Cokin Sunsoft diffuser provided warmth and softness to four generations of women. Hasselblad 150mm lens, f/9.5 at 1/60 sec., Fujicolor Portrait NPS 160 Professional

VIGNETTES

SUBTLE TOUCHES SEPARATE PORTRAITS THAT qualify as wall décor from plain pictures made by photographers who either didn't have the skill or didn't take the time to make them better. One of these subtle differences involves the use of vignettes. *Webster's II New College Dictionary* (1995, Houghton Mifflin) defines a vignette as "an unbordered portrait that shades off into the surrounding color at the edges."

For hundreds of years, portrait painters used vignettes to soften the edges of art, thereby drawing the viewer's eye to the center of interest. Photographers can achieve the same effect today, creating subtle changes that make the difference between a mere picture and a portrait.

DARKENING VIGNETTES

Vignettes that darken the edges of a photograph direct the viewer's attention to the subject because it is brighter than the edges. To achieve this darkening, I use a vignette made of dark net material because it allows some detail to show through without obliterating the edges.

Famed outdoor-portrait photographer Leon Kennamer developed a set of darkening vignettes (sold by Camera World of North Carolina under the trade name Sailwind— see the Resources list on page 189) called Leon Pro II. These vignettes have magnetic tape on the side facing the camera that enables them to bond to the ferrous metal plate on the front of the Lindahl lens shade. As such, you can easily attach them to or remove them from the lens shade. To keep them at my fingertips, I tie an elastic string between the vignettes and the posts under the lens shade.

I manipulate Sailwind's Leon Pro II darkening vignettes to achieve different effects. I cut an oval in one vignette for outdoor portraits of individuals and couples; this shape darkens all four corners of the image. When I work indoors, I use a vignette that I cut in half. This darkens the bottom part of portraits, which is especially helpful in concealing hands.

To achieve gradual darkening, I cut the vignette so that a single layer of net is closest to the subject, with two layers ¹/₂ inch from the

Dark net vignettes
The Leon Pro II vignettes made from net help me darken selected areas. The manufacturer makes vignettes with a small hole in the center (top right). I create a large oval in order to darken all four corners on outdoor portraits (top left). Then I cut another vignette in half to darken only the bottom half of indoor portraits (bottom).

opening and three layers 1 inch from the opening. This effect darkens the image ¹/₂ stop, 1 stop, and 1 ¹/₂ stops in the three-layer stage.

Be aware that you always face the danger of the vignettes coming into focus, in which case the vignettes become a problem rather than an aid to fine portraiture. If there is a problem I can see it in the ground glass when I press my camera's depth-of-field preview button. To prevent the vignettes from coming into focus, I suggest using long-focal-length lenses, about twice the diagonal of the negative. For example, you would want to use a 150mm lens with a 6 x 6cm camera. Vignettes aren't recommended for wide-angle lenses because the lenses' extended depth of field allows the vignettes to come into focus too easily. If you choose to use a vignette with an 80mm lens on a 6 x 6cm camera anyway, the vignetting device must be close to the lens. The distance from the lens to the vignette is proportional to the focal length and *f*-stop. For instance, a lens with a focal length of from 75mm to 90mm would require the vignette to be closer to the lens to prevent it from coming into focus.

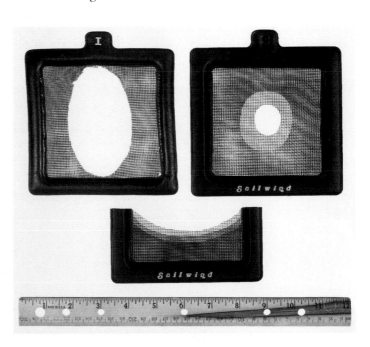

I tested the vignetting device at various distances to see how the scene looked on film with each change. I concluded that the darkening vignette needed to be about 5 inches from my 150mm lens and about 2 inches from my Hasselbald 80mm lens, working at *f*/11. Because wide-open *f*-stops are less likely to come into focus, I recommend using a range of from *f*/2.8 to *f*/11 for your tests. As you stop down, the vignette moves closer to the center, so *f*/2.8 would touch only the outside edges of the image, while *f*/16 would cover most of the negative.

The focusing distance also affects vignetting. The vignette is less likely to come into focus in close-ups than in full-length portraits when the angle of view is increased. Test your vignettes at different *f*-stops, different focusing distances, and different distances from the lens. Also, make sure that you don't use a dark vignette with a subject wearing light-colored clothing or a white opaque vignette with a subject in dark-colored clothing. And if you see direct light (available or artificial) striking your vignette, either remove the vignette or shade the light from it. You can use almost any blocking device to prevent light from striking the vignette, but I use either a Photogenic head screen (product number 7506) or a Larson 27-inch black Reflectasol.

Keep in mind that darkening vignettes made of net can cause a confusing crosshatch effect when used with net or hosiery diffusers and some types of clothing, such as those with herringbone or seersucker patterns. Dark vinyl or plastic vignettes can cause color shift toward blue or gray tones,

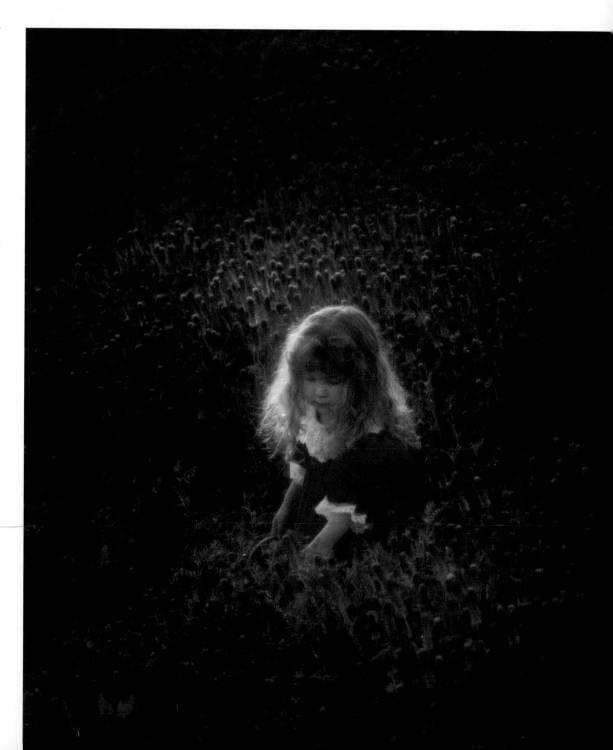

The foliage around this child was darkened with a Leon Pro II vignette that was cut to create a large oval in the center. This makes the subject brighter than the background. Hasselblad 150mm lens, *f*/5.6 at 1/60 sec., Fujicolor Portrait NPZ 800 Professional

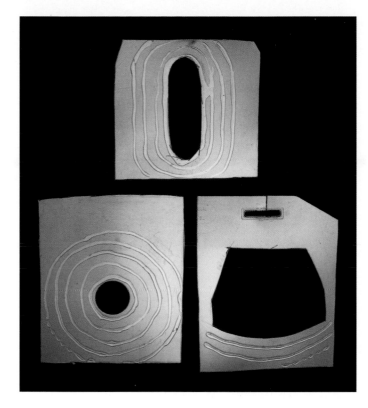

which don't occur with dark net. Vignettes made out of charcoal-colored plastic affect anything they cover. For example, green grass could look blue-green and tan clothing could look dark gray.

CLEAR VIGNETTES

When you look at a photograph, your eye almost always accepts areas of sharp focus and rejects images that are out of focus. It is fairly easy to use selective focus with close-ups, particularly with a wide-open aperture because the resulting depth of field is so shallow. But full-length and pictorial portraits have such an extensive depth of field that it is virtually impossible to throw the background out of focus.

I've solved this problem with homemade vignettes constructed of clear, untinted vinyl that is ordinarily used for motorcycle face shields. I can usually cut three 4 x 5-inch vignettes out of one face shield. I make the outside cut with a paper cutter and the inside trims with a sharp knife, an electric drill, or a small saw used for miniature hobby work. The 4 x 5-inch vignette fits nicely in the center slot of a Lindahl double-bellows lens shade, giving me about 2 inches of bellows in front of it for protection from stray light. This light can cause unwanted flare if it strikes a clear vignette, so I make sure to block it with the front part of the bellows lens shade, as well as other devices if needed. These include the Photogenic head screen or light blocks such as the Larson Reflectasol attached to a light-stand. Some photographers call these "gobos," which is a shortened version of "go-betweens."

This is the clear vignette that I use most often. After

cutting a scoop-type oval, I create lines on the vinyl about 1/4 inch apart, giving a slight diffused effect. I make the tiny lines with model cement. Another popular design, with a cutout shaped like a long oval (about 3 inches long and 1 inch wide) is used for full-length portraits. It leaves the subject in sharp focus while the edges, which contain things like doorways or curtains, are rendered soft. Clear vignettes are difficult to see in the viewfinder, so I stop down the diaphragm to the shooting aperture, usually $f/11$. Then, I move my finger around the edges of the vignette opening to see where it appears in the image.

You can use flat black spray paint to make different vignettes from the motorcycle face-shield material, including a blocking device for double exposures. I cut the design I want from the clear face shield and then spray both sides with the black paint. The double-exposure-blocking device has a vertical opening exactly in the center, so half of a vertical image is blocked while the other half remains clear. I make one exposure with the left side blocked, flip the device over, and make a second exposure with the right side blocked.

For those situations when you need to "white out" an object, for example a child wearing dark shoes against a white background, consider the use of an opaque white vignette. One of the best on the market is the Leon LVK, sold exclusively by Camera World of North Carolina (see the Resources List on page 189). This vignette is opaque gray, which allows some slight detail to show through but turns everything white or gray.

The Leon LVK vignette comes in both all-around and half-vignette versions. The half-vignette is used more often than the all-around because of the occasional need to lighten a child's dark shoes. When a young subject is wearing white clothing, I prefer to use a white background so that everything blends. However, a child wearing dark shoes would create a distracting point of contrast, so I use an opaque white half-vignette to lighten the shoes. The all-around opaque white vignette comes in handy on those rare occasions when you must eliminate an electrical outlet or a ceiling light fixture.

Most opaque vignettes work best on the front of the Lindahl lens shade with light striking them, thereby creating

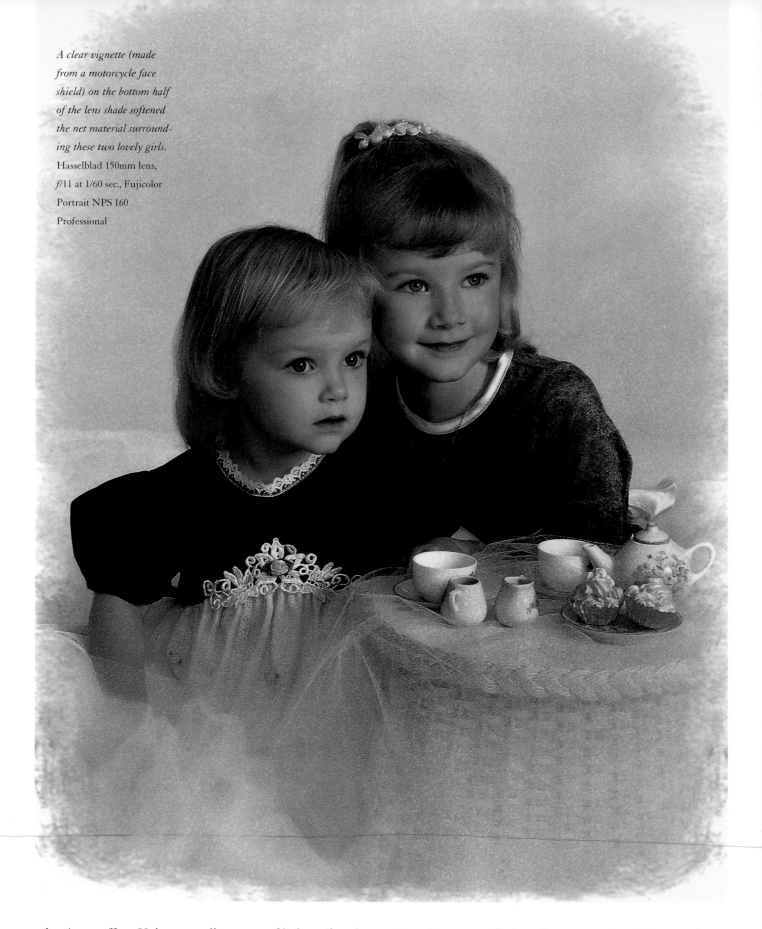

A clear vignette (made from a motorcycle face shield) on the bottom half of the lens shade softened the net material surrounding these two lovely girls. Hasselblad 150mm lens, f/11 at 1/60 sec., Fujicolor Portrait NPS 160 Professional

a luminous effect. Unless a small amount of light strikes the opaque vignette, the image will become gray instead of white. Usually, the light reflected off the white background is sufficient to keep the vignette radiant, but some photographers aim a low-power flash at the vignette from below so that it doesn't hit the lens. I don't like this method because it involves another lengthy step that takes time away from having a conversation with my subject.

PRODUCING THE PRINT

ONE OF THE AGONIZING DECISIONS facing portrait photographers is whether to process their own photographs or hire the services of a professional laboratory. This issue is even more important in these days of digital imaging, especially since convention speakers and magazine articles constantly tell us how easy it is to process our own prints.

Since color photography became dominant in the 1960s, most professionals have relied on outside labs to process their film and prints. With the advent of digital imaging, most continue to let outside experts do what they do best: process, retouch, print, and finish photographs. Some photographers who have taken on the processing of digital imaging have made the shocking discovery that they have taken on work they formerly paid a lab to do. This means the manager must work increasingly longer hours or hire additional staff members.

So the key question remains: Do you want to manage a large staff to do your processing, with considerable capital expense for equipment, or do you want to send the work to a professional lab? I prefer to let a professional lab process all of our images, allowing me time to create portraits and to manage our business, including marketing and public relations. Also, this gives me free time to spend with my family and friends.

The money I would have spent on expensive processing equipment can be used for advertising, studio décor, and *profit*. Computers and printers become obsolete quickly, requiring constant capital expense to keep pace with the latest technology. I prefer to shift this expense to the professional processing laboratory, where they have sufficient sales volume to update equipment frequently.

Ted Sirlin of Sacramento, California, who was one of my early instructors in the business of photography, taught a basic principle of management: *Any investment must pay for itself in a reasonable amount of time.* Any businessperson must judge every investment based on this criterion. When purchasing a camera, a computer, a printer, or lights, we must "put the pencil to it" to determine the life of the equipment. When I consider the purchase of processing equipment, plus the necessary accompanying staff, there is no way I can justify the capital expense when compared to the cost of hiring these services from a professional laboratory.

Some photographers enjoy doing processing themselves, with no value given to the cost of their own time, so they neglect marketing, management, public relations, artistic development, and family life. They compare the cost of a piece of photographic paper with the price of a finished print

from the lab, telling themselves: "I can do that a lot cheaper than they can." However, they fail to count the cost of how many pieces of paper they wasted to get one print acceptable for delivery. Usually their acceptability level for their own work is considerably more lax than the standard they require from an outside lab.

In making the decision about processing, a businessperson should accurately determine the cost of production. Our goal is to spend no more than 20 percent of sales on production. If the cost exceeds that figure, we know we need to reduce the number of proofs we are shooting or raise our prices. Cutting down on the number of exposures in a session can be the difference between profit and loss for a studio.

There are three vital elements for a photography business:

1 Photographic skills
2 Business management
3 Processing

Choosing the right lab can make or break a business, especially in the early stages. Color labs share with portrait photographers the common problem of seasonal production pressures. Neither photographers nor labs can breeze through November and December without an occasional late order. Just as photographers team with clients and colleagues to produce beautiful portraits, they also must make the lab a part of their team.

Communication is absolutely the most critical part of working with, rather than against, a color lab. Since most photographers have never worked in a production darkroom, they don't have the experience to deal with the problems that come up in a lab. Much of the information they receive from other photographers is poor and misleading. It's important to visit the lab at least on an annual basis to see how they process your images and to meet the people who do the work.

Early in my career, I took a course in color printing, even though I had no intention of printing my own work. This gave me an idea of what goes on inside a color lab, and I constantly update that perception with frequent visits to the lab. With digital imaging, I think it's important to study the

technology, perhaps enroll in a course in Photoshop, so you can see what can—and cannot—be done.

The biggest sources of controversy between photographers and their labs are color, density, and artwork. Clients would accept most prints rejected by photographers if given the opportunity. Time is precious for a photographer, and it requires considerable time to write a remake order, ship the print back to the lab, then reinspect it when it returns a second or third time.

Believe it or not, some photographers cannot see color accurately, especially when the prints are viewed in questionable light, such as fluorescent. Prints can look green under fluorescent light, blue in daylight, and red under tungsten light. If the prints satisfy lab specialists who have passed rigid color eyesight testing, I show them to my clients without imposing on them my personal color prejudices.

When clients view a print at home, it is probably illuminated with a combination of tungsten and fluorescent light. So I make sure that they see their prints in the studio's viewing area under similar lighting conditions. When I saw the viewing lights used by our lab, I purchased one of them (a Dayton 2V-351) so I could see the prints in our work area under the same conditions. This light has a tungsten bulb surrounded by a circular fluorescent bulb.

When sending an order to the lab, I view the proof selected by the client under the Dayton light so I can give instructions in four generic terms: "warmer," "cooler," "lighter," or "darker," adding easy-to-understand adverbs and adjectives such as "slightly," "moderately," and "heavy" to direct color/density corrections. Also, I mark the negative glassine for the cropping requested, using an adjustable cropping guide provided by the lab that corresponds to their mask sizes. If the client requests specific cropping that is different from the lab's standard masking, I place the proof in a 4 x 5 acetate sleeve so I can mark on it with a Sharpie pen.

With 6 x 6cm negatives, I ask the order-entry clerk to crop images so that there is about ¼ inch (5mm) of space between the top of the subject's head and the top of the mask. Then when the negative is enlarged 4.44 times to produce an 8 x 10-inch print, the headspace takes up about an inch, which I consider the proper spacing. When the negative is enlarged 8.88 times to produce a 16 x 20-inch print, the headspace becomes about 2½ inches, which I consider about right.

At the same time, I send instructions about retouching: whether it's to be done with traditional methods, with digital methods, or if there is to be no retouching at all. If I request digital, I type detailed instructions about what I want done: remove stray hair, darken specific areas, lighten others, remove double chins, open eyes slightly, etc. The instructions are typed on brightly colored paper and placed inside the glassine.

If the lab's order form is filled out by hand, it's much quicker to send some standard instructions by using a rubber stamp, such as "match proof" or "print warmer than proof." Of course, the advent of the Internet has made it possible for instructions to be given via e-mail.

My lab asks each of its customers to submit a "Personal Order Profile," which allows specialists to follow standing orders. These include:

♦ *Negative retouching.* In our sales consultations, we ask our clients if they wish certain corrections to be made. These might include removing broken blood vessels in eyes, scars, age spots, moles, and facial lines, especially on the neck, forehead, and temples. The retoucher should soften all visible veins. With digital retouching, we also can remove wrinkles in clothing, facial shine, eyeglass glare, stray hair, Adam's apples, and secondary catchlights. In addition, we can firm up chin lines, correct eyeglass refraction problems, cinch waistlines, and equalize eye sizes. *Refraction* is the optical problem caused by some eyeglasses that makes the edge of the face appear to contract or extend to the edge of the eyeglass lens.

♦ *Printing instructions.* On enlarger prints, I may ask the printer to lighten some shadow areas or darken light areas such as white clothing. Also, cropping can be customized if it does not fall within machine print masks. Of course, these same corrections can be done with digital retouching, which then can be printed by machine with identical results from print to print.

♦ *Mounting.* I have all prints that are 11 x 14 or larger mounted by the lab. We also mount our top-of-the-line 5 x 7s and 8 x 10s, but not our less expensive finishes. Mounting keeps prints from getting cinch marks in handling and prevents them from curling after being framed.

♦ *Finishes.* With the exception of wallet-sized prints, I have a protective coating applied to all portraits. Wallet-sized prints are not coated because the treatment melts when placed in a wallet, creating all kinds of problems. The coating prevents a print from sticking to glass and protects it from fingerprints. A lab process also textures our middle-of-the-line finish with a surface modification that looks like linen, while the cheapest finish is coated but smooth. Our top-of-the-line finish is bonded to canvas, giving the look and feel of a fine painting. The print and canvas are bonded in a massive press that exerts several tons of pressure, pushing the canvas texture through the print.

PRINT PRESENTATION

MANY LOW-PRICE, LOW-QUALITY PHOTOGRAPHY STUDIOS produce what some of us laughingly call "un-prints": photographs that are un-retouched, un-sprayed, and un-mounted.

At my studio, we take great pride in our print presentation, offering various finishes for varying prices, but all of them of high quality. Even if an image benefits from the finest lighting, posing, and retouching, it will suffer if it is not presented like a valuable work of art. A photographer friend in California presents his work in a polished enamel box. Working with gloves, he carefully unwraps the tissue from the print and presents it with considerable flair under a brilliant spotlight. Obviously, such print presentation makes the perceived value of his work increase dramatically.

Except for billfold-sized prints (2 ½ x 3 ½ inches), all of our portraits are coated for ultraviolet protection and mounted on art board. Our sales staff always refers to the mounts as "art board" because it has a better connotation than such terms as "cardboard" or "mount-board." For many years, our prints were sprayed with lacquer, but that process was discontinued because of safety hazards. Prints now are coated with a water-based protective coating.

THREE FINISHES

Just as everyone doesn't drive the same kind of car, all of our clients won't choose the same kind of finish for their portraits. Some want the best we offer and some want the least expensive, but most of them select something in the middle. That's why we offer three finishes.

- *Standard.* With the Standard finish, limited negative retouching is done in the traditional method with lead and dyes. The prints are finished with a protective coating and textured by a machine. This finish is primarily recommended for children who require little retouching. Our copyright logo is applied with a gold stamping machine.
- *Classic.* With the Classic finish, extensive negative retouching is possible by digital methods. This includes softening lines, removing age spots, cleaning up stray hair, strengthening jaw lines, trimming waists, and ironing out clothing wrinkles. The Classic prints get a protective coating and then a linen texture that looks like finely textured canvas. Our copyright logo is applied with a gold stamping machine.
- *Signature.* The Signature finish gets the same digital

retouching as the Classic prints, and prints 8 x 10 and larger are mounted on canvas. Canvas prints can be mounted on a stretcher frame, mount-board, or Masonite board, but we prefer mount-board. Smaller prints are put on art board with beveled edges finished in gold. All Signature prints are signed by the artist using a gel pen in a color that harmonizes with colors in the print.

The largest print in each order is shown in a frame that compliments the portrait and, at the same time, seems appropriate for the home or office where it will be shown. During the session or while in the order process, we inquire about the client's décor and personal taste in frames. This helps us decide what kind of frame to offer for the first showing of the portrait.

Smaller prints are placed in tasteful charcoal folders, wrapped in tissue and boxed for delivery. Also included in the box are a copy of the client's invoice, a guarantee from the manufacturer, and a copy of the copyright caveat that was signed by the client when he or she arrived for the session. Through professional color labs, both Kodak and Fuji offer guarantees for their photographic papers against the possibility of fading or other defects.

Portrait by Indra Leonardi, Jakarta, Indonesia.

CHAPTER 9

RETOUCHING

IN THE OCTOBER 1979 ISSUE of *Kodak Studio Light* magazine, California's Robb Carr, a world-renowned retoucher, described the problems with capturing people's spirits: "Still photography, unlike motion pictures, is a static, two-dimensional representation of a person's character. If you were to see these people live or in a film, you would look into their eyes and deal with their personality, not with their pores! A still photograph should be a proclamation of the person's spirit, but more often than not, it absolutely crucifies them. Imperfections become bigger than life, primarily because the essence of that person, the personality, isn't there to refocus our attention—to shroud the unimportant flaws that might otherwise catch our interest. Retouching, if you will, refocuses our attention."

With the advent of digital retouching, usually done with Adobe Photoshop, changes in photographs now can be done with a mouse or stylus movement that once took hours with dyes, airbrush, or pencil. The problem is that inexperienced digital artists can go too far, removing all traces of character in a face. It takes years and lots of experience for an artist to gain the judgement needed to know how much, or how little, retouching needs to be done.

Most of the decisions will be based on client preference. Some clients, particularly in the United States, want extensive retouching done, while clients in some European countries prefer little or no changes in their faces. Communication between the client and the retoucher are essential; the photographer's staff is usually the conduit for that information. It requires photographers and their assistants to show samples to clients, then interview them carefully to learn the extent of the retouching they would like: Do they want lines completely removed or merely softened? Do they want moles and birthmarks removed? Do they want their waistlines trimmed?

Clearly, digital retouching is superior to traditional pencil and dye retouching because it can do so many more things so much better with repeatable results. Once the retouching has been done on the computer, it can be saved to a disk, then used as many times as needed with identical results that are impossible with traditional retouching. As a result, additional prints can be made cheaply by machine, doing away with the need for enlarger printing.

Another advantage is that prints made from digital files do not show fade problems when compared with retouching done on the print. When prints retouched by pencil or airbrush fade, the dye in the print fades at a different rate than the artwork, making the fading quite evident. With digital retouching, the dyes in the print already have all corrections included, so fading is uniform, thus less evident.

Working with traditional retouching materials is messy, labor-intensive, and time-consuming compared with digital. Before starting a job, a traditional artist must coat the print with "retouch matte spray" so it will have a tooth to accept pencil and dyes. A finish coating must be applied on top of the retouch matte, but sometimes a viewer can see the first spray under the finish coating, so it must be returned to the lab for another coating.

Consider the many areas which can be corrected with digital retouching:

+ *Glasses glare.* Reflections in the lenses of glasses are removed.
+ *Eyeglass refraction.* With some eyeglasses, the flesh behind the lens appears indented or set out beyond the normal profile line of the face. This can be corrected easily using digital techniques.
+ *Eyeglass shadows.* Sometimes the rims of eyeglasses cast a shadow over the eyes. This can be softened or removed with digital retouching.
+ *Unwanted catchlights.* Usually, I want only one catchlight in each eye, giving the impression that the sun is illuminating the portrait. This should come from the main light. However, the fill light sometimes creates a secondary catchlight in the center of the eyes, which we ask our retoucher to remove. The exceptions would be outdoor portraits, those entirely illuminated by existing light, and glamour portraits where a mirror is placed under the chin to create more sparkle in the eyes.
+ *Bloodshot eyes.* Occasionally, clients will have broken capillaries in their eyes, giving a tired or weary appearance. These can be removed with digital retouching.
+ *Uncrossing eyes.* Some clients have an eye that will wander so that the iris does not line up with the other eye. A skilled artist can correct this so that it looks natural.
+ *Opening eyes.* If one or both eyes are half open, giving a

sleepy look to the portrait, a talented artist can open them. When eyes are fully closed, the artist can do a much better job if he or she is given guidance about what the client's eyes look like when they are open. In the case of completely closed eyes, we usually send an additional negative to the artist so he or she can move the open eyes to the negative where the eyes are closed. It's extremely difficult to open eyes without knowing what the client's eyes look like when they are open.

◆ *Double chins.* Removing or subduing double chins is another area requiring great skill. It needs to look natural, without the appearance of a collar that's been pasted on the subject. Our retoucher also firms up sagging jaw lines and softens or removes the Adam's apple, as well as lines on the neck.

◆ *Whitening teeth.* Only when requested, we have teeth whitened. Most people have some degree of yellow in their teeth, and it looks unnatural when they are made stark white. However, some clients ask to have stains removed from their teeth, in which case our artist clones the lightest of their teeth and makes all of them that shade.

◆ *Teeth braces.* If a client wants orthodontic braces removed, it can be done with digital retouching far better than with pencil retouching or airbrushing. The artist clones the white enamel and moves it to cover the metal braces. Missing teeth or crooked teeth can be corrected with similar retouching.

◆ *Clothing wrinkles.* This is another area that requires considerable skill by the artist, so that wrinkles are removed but the shape and form of the garment are retained.

◆ *Trimming waistlines.* When requested, our artist cinches the waist slightly to remove overhang created either by the clothing or by too much weight.

◆ *Close up necktie.* If part of the shirt collar appears above the necktie, we ask our artist to fill in the space so the tie touches the neck. Also, if a tie is off-center or too short, it can be corrected.

◆ *Sleeves lengthened.* When a man wears a suit, we like to show about ¼ inch (25mm) of shirtsleeve beyond the coat. Occasionally, we ask our artist to lengthen or shorten the shirtsleeve so it appears well tailored.

◆ *Background changes.* Sometimes if a client doesn't like the background behind the subject(s), we ask our artist to change it. Once again, it requires considerable skill to avoid making the subjects look like cutouts. We send negatives of several of our painted backgrounds to our artist so she can choose a replacement background for the one that has been rejected.

◆ *Moving heads.* This probably requires the greatest skill of all corrections we request from the artist. Sometimes she moves the entire body of a subject from one negative to another so that everyone in a group portrait will have his or her eyes open and a pleasing expression.

◆ *Removing objects.* If a photographic light or reflector appears in a portrait, it can be removed, sometimes without a lot of difficulty. Reflections created by photo lights in a window or mirror can also be removed, but this may require greater skill.

◆ *Dodging and burning.* This has been done in the darkroom for years, but now it can be accomplished just as easily with digital retouching. To *dodge* is to lighten a specific area and to *burn* is to darken an area. Sometimes part of a face has too much shadow, so it can be lightened. At other times, some clothing—especially white clothing—may need to be darkened.

◆ *Stray hair.* A single strand of hair falling across the forehead or sticking out from an ear can be quite distracting. A single hair or an entire clump of hair can be removed, and it can be filled in where light shines through thinning hair.

◆ *Facial shine.* Sometimes highlights on the face can be distracting, especially on a woman's nose or a man's receding hairline. These shiny areas are easily removed or toned down.

Another advantage of digital retouching is that the artist can enlarge a specific area of the face for retouching, allowing for precise work to be done in a certain area. Imagine the difficulty of retouching each face in a group of thirty people using conventional pencil and airbrush methods.

Computer-generated prints, up to 30 by 40 inches, now look as good as traditional prints produced by an enlarger. However, a computer print is only as good as its weakest link, meaning that the original negative must be scanned correctly, retouched by an expert, and printed with considerable skill. Direct digital printing—meaning the prints come directly from the digital file without the benefit of an optical negative—has advanced this process greatly.

COPIES AND RESTORATIONS

BILLIONS OF SNAPSHOTS AND OLD photographs provide an infinite market for professional photographers with the ability to create demand for copy and restoration work. The key to marketing these services is reliability, because discerning clients won't leave their cherished originals with someone they don't trust.

How do you establish trust? In addition to longevity in business, you can attract clients through your demeanor, as well as a tasteful display of your credentials. Every time you receive a certificate or diploma, exhibit it in a frame and mat that demand respect. Hang the certificates in a well-illuminated area where your clients can discreetly take a look at them.

Your studio and personal appearance also send important messages to potential customers. You should appear well groomed, with neat clothing, hair, hands, face, and shoes. Your clothing doesn't have to be expensive, but it should be newly laundered and as wrinkle-free as possible.

The public areas in your studio should indicate to your clients that your business is clean, neat, and well organized. This means that every detail of the public area must be inspected continually to be certain it is clean and orderly. You don't want chipped paint, worn carpeting, stained upholstery, or faded drapes to give a bad impression. Finally, the contacts you make in civic clubs, in your church or synagogue, and at the social events you attend can also help build public confidence in you and your studio. If prospective clients see you as warm and friendly, they'll be more likely to come to you for their photographic needs, especially if you present a professional appearance. I make it a point to sit with someone different each week at my civic club, so that I can broaden my contacts and expand my networking possibilities.

HANDLING THE INITIAL INQUIRY

Ted Sirlin of Sacramento, California, my first photographic-business instructor, trained me in the art of restoration sales as well as a thousand other marketing and management skills. I am indebted to him for many of the business principles that have proven successful for me for more than thirty-five years. One of the many strategies Sirlin shared with me revealed how to successfully deal with an initial inquiry about copying and restoration from a potential customer.

You'll probably receive the first inquiry over the telephone, so you and your staff members should be able to ask the right questions and provide the key information the caller needs. Otherwise, the inquiry will turn into a breakdown in communication, not a jumping-off place. Consider the following dead-end conversation:

Caller: Do you copy old pictures?
Studio staff member: Yes, we do . . . (pause).
Caller: How much do you charge for an 8 x 10 copy?
Staff member: $10 for making the copy and $15 for the print.
Caller: I'll let you know later (click).

As you might guess, this caller will never be heard from again. What did the staff member do wrong? He or she showed no enthusiasm or interest in the caller's needs, and volunteered no information.

When people call you with a price inquiry, they're actually calling for help. Because they don't know anything else to ask, they request information about prices. If you answer the price question before telling the callers what they really want to know, you've lost the battle before it begins. Take a look at a different scenario with a well-trained salesperson answering the telephone:

Studio staff member: McDonald Photography. Elizabeth speaking.
Caller: Do you copy pictures?
Staff member: Yes, we specialize in copy and restoration work, Mrs. excuse me, I didn't hear your name.
Caller: I'm Mrs. Jones.
Staff member: Tell me about your photograph.
Caller: My aunt died last month, and I found this old photograph of my parents—one I'd never seen before.

Before-and-after samples give clients an idea of how a restored photograph will look. The original in these samples has water stains and other blemishes. I copied the client's original and sent the copy film to our lab, where artists made the corrections and a finished copy print. The work was preserved on a compact disk from which additional copies can be made. We retain the CD in the client's negative file.

It's really the only one I have of them as newlyweds.
Staff member: Wow! I bet it means a lot to you.
Caller: Well, it's bent in the middle, and one corner is torn. But it's the only one I have and I don't want to risk losing it.
Staff member: I don't blame you for wanting to be careful with a priceless keepsake. We place your photograph on a copy-board and take a picture of it, so it isn't harmed in the least. It never leaves our studio; in fact, we can copy it while you are here so you don't even have to leave it. No work is done on your original, which is returned to you unharmed. Let me suggest we make an appointment for you to come by the studio so I can see your photograph. Then I can show you types of restorations and finishes. After seeing your original, I can give you a price estimate, as well as some suggestions about displaying your prints. There won't be any charge for this estimate, of course. Would mornings or afternoons be best for you, Mrs. Jones?
Caller: Afternoons. Thursday would be best for me.

In this conversation, the staff member dealt with the caller on a personal level by asking her name, conveyed interest in her photograph, understood her concerns, explained the next step, and expressed a willingness to help her. Because of the attention she received, this caller undoubtedly showed up for her first appointment.

HANDLING THE NEGOTIATION

When a client brings a photograph to your studio to be copied, your skill, knowledge, and ethics are challenged. If the photograph bears a copyright symbol or the name of an existing studio, you must advise the client to return to the original studio for additional copies. Some high-volume photographers don't keep old negatives, and they will give you written permission to copy the picture. Occasionally, clients send an original photograph through the mail, but we don't recommend this because of the danger of loss or damage. If we must handle a job by mail, we send the original in a separate package from the copy print. We send both via a courier that requires the recipient to sign for the package.

You can gain your client's confidence if you can identify which kind of old photograph they have, such as a tintype or a daguerreotype. If you and your associates need to learn about the various types, you can find examples of early photographs in many museums and libraries. In addition, many books describe early photographic processes in great detail.

When it comes to copy and restoration work, you can offer your clients a range of choices:

✦ A simple copy with no retouching or correction
✦ Cracks and spots retouched
✦ Missing parts restored
✦ Faded prints restored
✦ Subjects or objects removed
✦ Regrouping: photographs of two or more individuals put together to make a group
✦ Various print finishes: glossy, matte, sepia, hand-colored, digitally colored, and traditionally colored

Samples that you can show customers are essential. Find a badly cracked and torn original that you can use as a "before" sample. Then make up restoration samples in different finishes,

such as a simple copy without any corrections, a copy with cracks retouched, a digital restoration with everything corrected, and a brush oil print with everything corrected plus color added. (A brush oil portrait is created by a highly skilled artist who uses oil paint over a sepia-toned print.)

Restorations require careful sales techniques. Many clients ask us to create beautiful wall portraits from small, fuzzy snapshots; sometimes we're asked to lift just one person out of the snapshot. "Because there is no detail in your snapshot, it will be difficult for our artist to create a portrait like the image you have in your memory," I typically say to my clients. My policy is to *undersell* and *over-deliver* restorations. I promise little and work tirelessly to produce a better result than my customer expects.

If you aren't sure how to price a difficult job, send a copy of it to your digital or oil artist for an estimate. Once you have the cost, the selling price will depend on many factors, such as your overhead cost, return on investment, and risk of rejection. You continually face the possibility that your customers will occasionally refuse a job. This results in a total loss that the selling price of all jobs must cover. Although some photographers double the cost and others make it as much as seven times higher because of the chance of rejection, the majority price their work somewhere in between. A high markup on a difficult restoration might cause the client to turn down the job, but a high-risk assignment requires compensation. If a client rejects a print, the photographer has to swallow the cost.

WORKING WITH AN ORIGINAL PRINT

To gain customer confidence, studios should copy originals on the premises, thereby eliminating the chance that the clients' property will get lost in transit. I never attempt any alteration on a client's original because of the danger of damaging it. All restoration work is done on the copy print.

Client originals are copied with two photoflood bulbs rated at 3200K (General Electric ECA bulbs), covered by polarizing filters. Another polarizing filter is placed over the camera lens to control reflections. The originals are held on a metal copy-board with magnetic strips. The metal copy-board has a non-reflective, matte surface.

Almost any camera can be used for copy work, including the Hasselblad that I also use for portraits and weddings. To avoid camera vibration, I focus on the original, and then put the camera mirror in the lockup position. The copy camera has a Lindahl lens shade that blocks out stray light while permitting the use of filters next to the lens. Without special control, contrast increases in copy work. Harrison & Harrison makes a series of low-contrast filters that provide the easiest way to solve this problem. I prefer the LC-1 filter for most jobs; the 3-inch-square version fits in the Lindahl filter slot next to the lens.

Another way to control contrast is via a technique called *flashing*. Here, you expose the original normally and then double-expose the film by placing a white card over the original for 5 percent of the first exposure time. For example, if the first exposure time is 100 seconds, the exposure time for the white card will be 5 seconds. This step actually fogs the film slightly, thereby reducing contrast. Flashing is consistent, but lab tests are recommended to determine the exact flash time with various films.

For copy and restoration work, I use Kodak Tri-X film for black-and-white jobs and Fujicolor NPL 160 Professional for color jobs. The NPL film is balanced for the 3200K bulbs I use. Copied alongside the original is a 7-inch Kodak gray scale that helps the printer determine density and color. A gray scale shows all densities from pure black to pure white in gradual steps. When the lab analyzes the negative to show detail in all parts of the gray scale, the original will be reproduced correctly both in density and color.

Over the years, I made an important discovery: Maintaining a notebook proves valuable as a guide to exposure. For each copying job, write down the exposure time, the *f*-stop, and the filtration. Keep separate pages for jobs done with filters and flash. Note the size of the original because close-ups (which are made with a long bellows draw) require more exposure. Also note the density of the original. Is it light, medium, or dark? After a few years, your notebook will be a more accurate exposure guide than a light meter will. Each time you get a processed negative back from the lab, indicate in your notebook whether it was correctly exposed, overexposed, or underexposed.

New technology is sweeping the copy business along with the rest of the photography industry. Some photographers are purchasing the Fuji Pictrostat or Kodak Copyprint Station to make copies of photographs instead of relying on traditional copy negatives. Digital imaging will get better and better, and the price of technology will get lower and lower every year.

PRINT COMPETITION

ONE OF THE BEST WAYS to build a reputation in photography is through print competition. Photographers can improve their skills and gain valuable publicity by entering and eventually succeeding in print shows. During your struggle to earn degrees or accolades from photographic organizations, your skills and reputation will grow. In turn, you'll enjoy increased sales as your clients recognize your progress.

From a personal standpoint, you'll feel more confident in your skills, as well as in your ability to take command of a session. A runner's high didn't compare with the exhilaration I felt when I received my first 80 score at a Professional Photographers of America (PPA) print judging. I thought that my heart was going to explode when judges at the 1968 convention gave me an 80 (out of 100), because that score gave me my first print merit. But some tough years followed. I didn't earn any print merits in 1970 and 1971. I kept studying, however; I went to photography classes and continued to enter print competitions until I learned more about how to win.

To be successful in print competition, a portrait needs to have light, line (pleasing composition), and mood (emotion). This portrait also had the added dimension of mystery—the judges wondered how it was done. Actually, I made the girl's portrait in the studio, then my digital artist combined it with a photograph of concrete culvert pipe. Hasselblad 150mm lens, *f*/11 at 1/60 sec., Fujicolor Portrait NPS 160 Professional

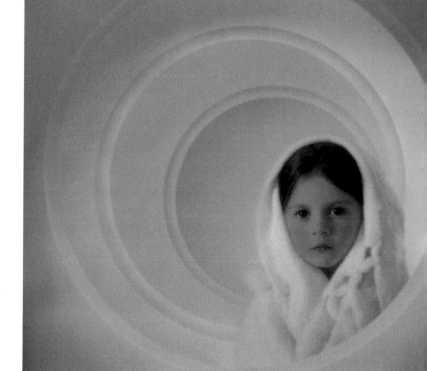

LEARNING THE RULES

Working on the print committee for the five-state Southwestern Photographers Association probably helped me more than anything else. I not only learned the rules, but also had the opportunity to hear judges comment on prints. I was able to observe new trends and styles that scored well. During breaks, I had the opportunity to ask questions of print winners, including how they came up with new techniques and who did the enhancement on their prints. Enhancement usually includes retouching, but it also involves the brightening of eyes and sometimes unusual mounting or presentation.

The print judging at PPA affiliates has strict standards that are maintained from coast to coast. Competitors can enter only four prints with an outside dimension of 16 x 20

inches. The photographer's name can't appear on the front of the print; it must be listed on the back, along with the print's title and category. To obtain print rules, call the Professional Photographers of America (see Resource list on page 189).

The Southwestern photographers also taught me that at every session I should work toward producing a trophy-winning print. I benefited from this approach, my clients loved it, and my sales increased. As a result, I've made about half of my more than sixty award-winning prints during regular portrait sessions.

I do, however, use invitational sessions to experiment with new techniques, styles, and locations. I enjoy this part of the growing experience. Usually, I devote an afternoon or

evening to concentrating on the creative process. Most of my experimental shoots don't yield award winners, but they lay the groundwork for success in the future.

Get the Best Print Possible

Regardless of whether you do your own printing or use an outside laboratory, get the best print possible from your negative. If you use an outside lab, either give its staff a print guide or trace the composition on a piece of paper, ideally the same size as the print. You should also provide these professionals with detailed instructions about dodging, burning, color, and density. If possible, you should supervise the printing either at the lab or by requesting test prints.

If you don't do your own artwork, get the best artist available. Then give the person time to do the job right. Producing a winning print often requires months and sometimes even years, so start early!

Judging Lights

You should view prints that you intend to enter in a competition under the same lighting conditions that the judges will use. PPA and other accrediting groups provide the rules governing the competition, include lighting requirements, to their members.

When I look at my prints under judging lights, I find that a Harrison & Harrison Color Viewing Screen helps me evaluate them for competition because it isolates highlights and shadows. The filter clearly shows the areas that need to be darkened with printing or artwork and those that need to be lightened.

Develop a Thick Skin

Most photographers need to have their prints critiqued in order to grow and improve as artists. When your prints are displayed at conventions, ask the judges to give you their professional opinions. As you listen, you should keep an open mind, take notes, and refrain from arguing with the judges. Although it is difficult to bite your lip and listen to someone criticize the "work of art" you've tried so hard to create, your photography will improve if you learn to separate your work from your feelings.

Seek out the toughest critics you can find, not judges or other photographers who tell you how good you are. Sometimes you might have to travel to another city to get help from a judge or a photographer you respect.

QUALITIES OF A WINNING PRINT

Prints entered in professional judgings get better every year. Most experienced judges say that some of their own prints that received awards ten years ago wouldn't win today because the competition has increased significantly. Merely good portraits don't stand out when judged with hundreds of other good prints; if you want to win, your portraits must be great! The prints must have something to make them special, such as an artistic touch or an unusual subject. Award-winning photographers must work not only to develop techniques, but also to discover the inner self that provides the spark that separates their work from that of others.

In this portrait of a young woman, my wife utilized her gift for spatial relationships to place the subject in the left half of the composition. Leading lines add interest to a print entered in competition; here, the fence becomes a leading line, running diagonally through the portrait. The picture was taken in the last few minutes before sunset with no reflector. Hasselblad 150mm lens, *f*/8 at 1/60 sec., Fujicolor Portrait NHG II 800 Professional

+ *Impact.* Is the print an attention-grabber or a showstopper? Impact is an important element in winning pictures, providing the quality that stops viewers in their tracks and demands attention. Ask yourself, "Is this a new and fresh approach to an assignment?" If your answer is no, the image probably looks unreal or contrived. Try again.

+ *Composition.* The effective use of space, diagonals, pyramids, leading lines, and other compositional elements is essential for artistic photographs. In *The Power of Composition,* the late Canadian photographer Frank Kristian wrote, "When we stand in front of a truly well-composed photograph, the only feeling we can have is humility, for we know that we are freed from the many details of our daily lives."

 Some people have a natural gift for composition. They instinctively place their subject in a position that is pleasing to the eye. Most people, however, have to learn composition by studying art principles. There are five basic types of composition: from left to right, from right to left, the triangle, the "S" composition, and the "L" composition. If you need help, ask for cropping or composition suggestions from talented artists whose work you respect. You can also study books or take classes on composition.

+ *Subject matter.* Extraordinary faces and places attract more attention than ordinary ones do. Beautiful women, handsome men, adorable children, and expressive faces make superior subjects for portraits.

+ *Center of interest.* Does your eye zoom to the photograph's center of interest? If it doesn't, you may have two or more centers of interest that vie for the viewer's attention. Anything that detracts from the center of interest lowers a print's score. For example, I made a portrait of a North

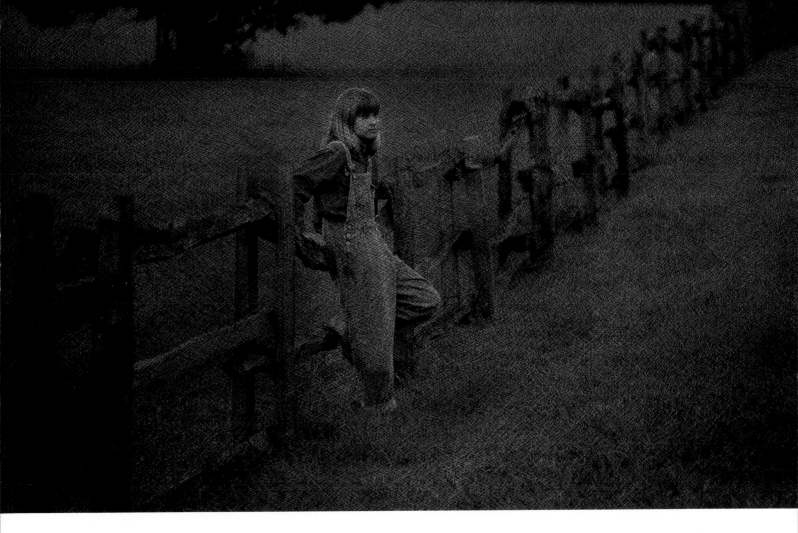

Carolina state official in the capitol rotunda in Raleigh. In addition to the man, the portrait also showed the rotunda skylight, a round rail leading up to him, a statue in the foreground, and two doors illuminated by big light fixtures in the background. The portrait contained so many elements that the subject almost got lost. This was only a good—not great—portrait.

✦ *Style.* Does the photograph tell a story? In some images, the story is confused by conflicting elements. Fortunately, you can soften or darken these with a vignette or artwork. Another problem in some photographs is the use of contrived props or locations, such as a hay bale combined with a painted background. These, too, can adversely affect the story.

✦ *Lighting.* Does the use of light improve or detract from the photograph? The ability to truly see light is one of the most precious gifts a photographer can cultivate. Learning how to observe and utilize various types of

illumination often requires years of practice or study under skilled instructors.

Light must illuminate the areas of interest in an image while placing subordinate areas in shadow. The power of a stunning outdoor portrait can be damaged by raw sunlight striking a secondary area, such as a fence or a tree. Judges don't spend time discussing whether or not the illumination comes from a short light, a broad light, or a split light. They analyze how well the photographer used the light.

✦ *Color balance.* Do the strongest colors add to the center of interest or do they lead the viewer's eye elsewhere? Warm colors, such as red and orange, dominate photographs, while cool colors, such as green or blue, recede into the background.

✦ *Print quality.* Does the print contain detail in the high lights as well as the shadows? An award-winning print must have both. Also, is the print sharp? Did enlargement,

*This dean of a Texas
university collected art,
so I used the painting to
provide a leading line.
I set the main light at
f/11. The fill light was
set at f/8 and bounced
off the ceiling.*
Hasselblad 50mm lens,
f/11 at 1/60 sec.,
Fujicolor Portrait NPS
160 Professional

focus, or subject movement create a fuzzy image?

✦ *Presentation.* Do the mounting and/or mat help the print or do they detract from the overall effect? Any mounting or matting that calls attention to itself will hurt the print's score. Once when I judged another photographer's sensitive portrait of a baby's christening, I found that the presentation was ruined by the distracting mat surrounding the print. The skillful use of underlay and other mounting techniques can enhance a print.

Sometimes, there isn't enough room in front of the subject. To solve this problem, simply make a smaller print, such as an 11 x 17, and mount it on one side of the 16 x 20 mountboard. Be sure to leave a blank area in front of the subject. This creates the illusion of space in the foreground, which wasn't on the original negative. Some photographers mount prints as small as 4 x 5 inches on the 16 x 20 board, so it's difficult to tell how much space was on the original negative. PPA is constantly changing rules about minimum size, so be sure to read the current print rules.

✦ *Finish.* A luster or glossy coating intensifies color brilliance and saturation. Matte spray dulls colors and lowers print scores. When you consider the finish, you should also keep in mind that textured prints are difficult to see under bright judging lights.

The final judge of a photograph is the buying public. Nevertheless, in my experience clients are attracted to the same high-scoring prints that pleased the judges.

CREATIVITY

For me, creativity always requires concentration and sometimes exercises that help light an inner spark. From my doctor, I learned to wash my mind clear of all thoughts except my client. I ask my associates to aid my concentration by deferring telephone calls and other interruptions for a short length of time.

From talented California portrait photographers Alessandro Baccari, David Peters, and Michael Taylor, I learned to prepare for a session with warm-up exercises to free the creative spirit that comes to me from a higher power. Often I'll skim books by great photographers or artists before a session. I also keep notebooks filled with magazine clippings and photographs organized by subject, such as men, women, children, groups, and brides.

Composer Johannes Brahms said he tried to put his mind in neutral so the music would flow through him. Some of my best creative ideas have formed on extended, predawn walks when I have time to listen without interference from telephones, radio, television, or other people. Discipline and creativity might seem to be in conflict, but for me they go hand-in-hand: I must force myself to take time for long walks in order to have quiet time alone for prayer and contemplation.

Dr. Eugene Lowry of St. Paul's Seminary in Kansas City, Missouri, says: "Like a river, creativity has two elements, flow and banks. Without flow, it is a dry gulch. Without banks, it has no direction and flattens out, just as there would be no river if there were no banks." For me, the flow is the spark that comes from the inner spirit, or the unconscious. The banks represent the discipline: learning the rules, mastering the mechanics of the camera, and seeing the light. It took me quite a while to develop my photographic skill so that I didn't have to spend a lot of time thinking about camera operations. My camera became an extension of me.

Years of working eight to ten hours a day behind the camera finally paid off when I learned to see light, composition, and emotion in a session. Some days I don't feel like doing the scheduled sessions in my appointment book, but my sense of professionalism requires me to work anyway. And by the end of the day, I usually feel exhilarated. An added bonus: sometimes on these jam-packed days I create award-winning prints.

PART II

PORTRAITS

ELEMENTS OF A SUCCESSFUL PORTRAIT

EVERY PORTRAIT MUST HAVE THREE essential elements in order to be successful in the eyes of its audience, whether the viewers are print jurors or, even more important, members of the buying public. These three components are *light, line,* and *mood.* My friend Alessandro Baccari, a gifted photographer who lives in San Francisco, says, "I look at each assignment as if it were my last. With commitment, I gather my energy, thoughts and creativity to produce what I think to be the last image. Pride drives me to say it must be worthy of my signature. If work completed does not reflect one's best effort, then it was not worth doing." (*The Professional Photographer,* March 1994)

Paul Strand, one of the pioneers of American camera art, said "deciding when to photograph, the actual click of the shutter, is purely controlled from the outside by the flow of life, but it also comes from the mind and the heart of the artist."

CREATING A MOOD

Even if a portrait is brilliantly illuminated and well composed, it won't be successful if it doesn't capture a mood or feeling. For that reason, it is important to consider the following five steps of portraiture:

1 *Don't over-pose your subjects.* If they are sitting or standing in a manner that will result in an appealing portrait, ask them to remain that way. The portrait will be more natural-looking and will better capture the subjects' personalities.

 If your subject isn't in a stance that enhances the portrait, suggest another body position. A good way to learn about proper posing is to study art, beginning with ancient Greek and Roman statues. You'll notice that a man's pose looks stronger when his head and shoulders are aligned, not tilted toward the higher shoulder. A woman's pose looks more feminine when she tilts her head toward the high shoulder. For instance, if the woman has her weight on her left foot, which lowers her left shoulder, then her head should tilt toward her right shoulder, which is the higher shoulder.

 Venus de Milo, a Greek statue dating from 100 BC and housed in Paris's famed Louvre museum, serves as a wonderful guide to the ideal female pose. Pictures of the statue are readily available in art books and encyclopedias.

Notice how the subject is posed with every joint in her body bent in a graceful manner—from the ankle to the knee to the hip to the shoulder to the head, including the elbow, wrist, and fingers.

 When a woman is seated, her weight should be on her back hip. This can be achieved in two ways, either by having her stand with her weight on her back foot and then sit or by asking her to lean on her back arm, using a table or chair with arm rests. Her knees and ankles will now be together, with the ankles gracefully bent so that the front foot is facing the camera.

2 *Fine-tune the lighting setup.* Then focus and frame the subjects in the camera viewfinder.

3 *Refine the pose.* Place the subjects' hands and head in the exact position you're seeking. Next, ask them to sit or stand erect. If needed, press on the subject's spine at the small of the back to aid the posture.

4 *Show the subject where to look while you make the exposure.* This should not be done until the first three steps have been taken. Clients should glance at one spot for only 5 to 10 seconds to prevent the stare fixation that destroys so many portraits. For a profile or three-quarter view of the face, ask them to look at an object that will keep the eyes centered. This will prevent you from showing excessive white in the eyes.

5 *Make the exposure.* Finally comes that brief shining moment, the 1/100 sec. when the exposure is made. This is the most important moment for a photographer. It is the essence, the very life, of a portrait. If you elicit wonderful expressions from your subjects, you will sell portraits even if other qualities, such as posing and lighting, aren't as strong.

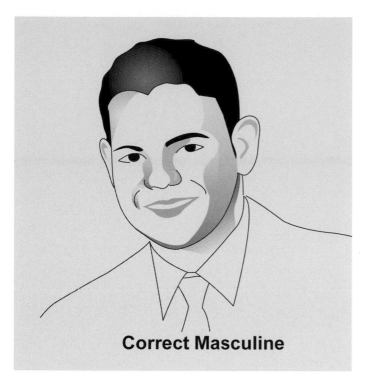

Correct Masculine

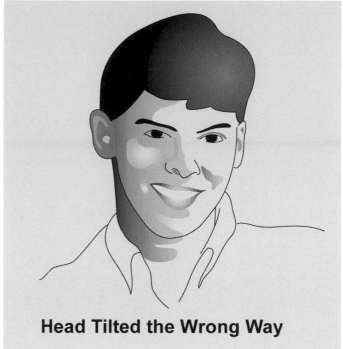

Head Tilted the Wrong Way

Masculine Posing

A proper masculine pose denotes strength, with the head erect and tilted
in the same direction as the shoulders.

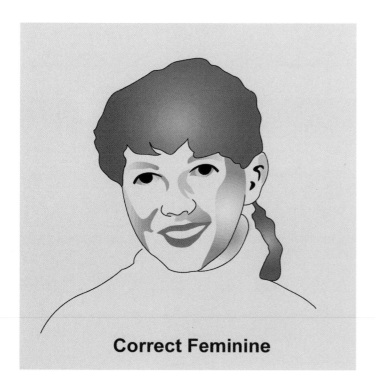

Correct Feminine

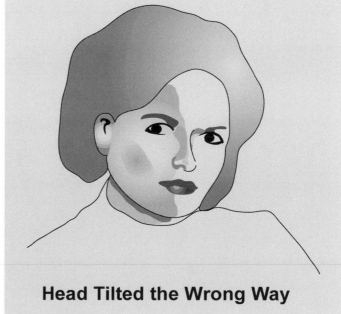

Head Tilted the Wrong Way

Feminine Posing

A correct feminine pose captures gracefulness, with the head tilted toward
the higher shoulder.

ESTABLISHING RAPPORT

In order to build rapport with clients, I make them my friends before the session. Sometimes, I do this in the pre-portrait consultation; sometimes I wait until shortly before the shoot. To explore my clients' personalities, I might ask them to tell me about themselves, their families, their jobs (or schools), or their last vacation. I might ask if they like music, movies, or books, and if so, to tell me about their favorite singer, actor, or author.

Armed with this information, I usually can say something that will trigger a response during that fraction of a second when I make the exposure. Usually, I ask the subject to think about something, because the thought will prompt a smile or pleasant expression. This is exactly what I'm seeking, an insight into their personality. On the contrary, if I ask my subjects to say a word, their lips might be pursed in an unfortunate position during the moment of exposure.

I use a number of prompts to get an expressive response from my subjects, including the following:

+ "Think about the day you graduated."
+ "Think about the day you got married."
+ "Think about your favorite food."
+ "Think about lying on the beach in Hawaii."
+ "Think about skiing in Colorado."
+ (For a student): "Think about getting a perfect score on a test."
+ "Think about that new car you've been wanting."

Sometimes, I find that simply saying "Cheer up!" works well, especially with a group. And if you smile, your clients are more likely to smile, too. Sometimes, just for fun, sit in the subject's chair and see what the scene looks like from that viewpoint.

In the September/October 2001 issue of *Lens* magazine, Emmet Robinson noted that he makes a game out of seeing

Top left: Incorrect standing pose: weight equally distributed on both feet.
Top center: Correct standing pose: weight on back foot and ankle of front foot gracefully bent with toe pointed toward camera.
Top right: Another graceful standing pose: rear foot crossed behind front foot.
Bottom left: Incorrect seated pose: both feet pointed in the same direction.
Bottom center: Correct seated pose: front foot pointed toward the viewer and ankle slightly bent.
Bottom right: Another pleasing seated pose with the back foot locked behind the ankle of the front foot and both ankles bent gracefully.

just how long he can keep clients talking about themselves. He asks the kinds of questions a caring friend might ask, helping them relax and pose more naturally.

CAPTURING A SUBJECT'S SPIRIT

A few years ago, a young college graduate with a degree in photography asked me for career guidance. He had sound technical knowledge but no experience in working with people. At my suggestion, he went to work for a high-volume, chain-store studio where he had to learn to get saleable expressions with every exposure. After doing thirty to seventy sessions a day for two years, he launched a successful business, starting with one location and later expanding to several studios.

Clients tend to see their loved ones through rose-colored glasses, tinted by emotion. They see a motion picture. They see spirit. They see character. They see someone who is continually moving, speaking, and expressing him- or herself in body language. Contrast that with the image clients sometimes get in a portrait: a face frozen by two harsh lights illuminating every defect and every wrinkle, but with no expression in the eyes. Sometimes the subjects are poorly posed and uncomfortable-looking. On occasion, they also are victims of ill-fitting clothes and a poorly chosen camera angle.

My goal is to capture the spirit of each person in front of my camera. I try to portray all clients at their absolute best so that viewers of the portrait will think that the subjects look as if they could speak. If I've accomplished this, then many years from now I will be able to look back at my career with pride.

PREPARATION

Preparing yourself and your clients involves planning. Ask them to bring photographs of themselves—either snapshots or professional portraits—for you to study. Which side of the face looks best? Is a smiling or serious expression more appropriate? Which clothing enhances your clients' appearance?

Prepare the clients by sending them an appointment letter, video, or e-mail that offers suggestions about clothing, hair, makeup, and the best time of day for a portrait. For example, instruct your adult male clients to come with a fresh shave and week-old haircut (not freshly skinned). Ask female clients to wear their usual hairstyle rather than one created specifically for the shooting session.

Next, prepare yourself for the shoot by studying successful portraits of similar subjects. You can't copy a pose or lighting, but this method can reawaken your creativity. I keep several looseleaf binders filled with photographs and clippings from newspapers and magazines. They are broken down by subject (men, women, children, brides, pets, groups, etc.).

When I attend a convention, I carry a point-and-shoot camera to capture images that contain something that interests me—a pose, a prop, a location, or even furniture.

Finally, prepare your studio by creating a warm atmosphere, with sights, sounds, and smells that send pleasant messages deep into your client's subconscious. Test various air fresheners to see which evoke the most positive response from your clients. You certainly don't want the smell of photo chemicals, cigarette smoke, or even stale air to permeate your camera room and sales areas.

Music sets the mood for almost any business, and portraiture is especially sensitive to aural influences. Your choice of music will depend on the audience you wish to attract. If you're marketing to a younger audience, your choice probably will be rock, pop, rap, or even country music. If you're seeking a more mature clientele, you might want classical music or show tunes. Be sensitive to the fact that the wrong music can irritate rather than soothe the client.

For thirty-five years, we have played Muzak in our studio's lobby and sales areas, with a separate stereo system in the camera room so that our clients can choose from nine radio stations. Photographers want their work protected through copyright, and the musicians should be paid, too. We pay ASCAP and BMI royalties through our monthly Muzak fee.

Displaying well-illuminated portraits in the studio plants a desire in the minds of your clients to have similar wall art in their homes. Large areas in your studio call for mural-sized portraits, perhaps illuminated by projection spotlights that can be set to hit only the prints, not the entire wall, via built-in barn doors. In a hallway with a viewing distance of only 4 feet, we display 16 x 20 and 20 x 24-inch images with picture lights mounted on the frames.

When a client calls to inquire about price, one of the first questions we ask is "Where do you plan to hang the portrait and how to you plan to light it?" The client probably hasn't considered either question, and introducing the topic provides a reason to visit the studio in person—not just to see sizes but also to learn how best to light the portrait.

Prepare the dressing room and other public areas by making them clean and attractive, yet warm and homey. Remove any hazards that might injure children or snag the clients' clothing, such as hot lightbulbs and furniture with sharp edges. Offer dressing aids that your clients might need. For example, you might want to stock the dressing room with unscented hairspray, sterilized combs and brushes, hairpins, a hair dryer, a curling iron, scissors, static-removal spray, makeup, a clothes steamer, an iron and ironing board, and an electric razor.

The consultation and appointment letter that we send to clients covers clothing, hair, makeup, glasses, and beards, but sometimes we get surprises when they arrive. When men need a shave, we ask them if they would like to use our battery-

powered electric razor. We also have disposable razors, shaving cream, and aftershave lotion available. Some men come in thinking they want the look of stubble or a dark beard, but they may not realize exactly what that will look like in a photograph. It's a sensitive situation, and I don't want to force my opinion on them, so I show them portraits of men with facial hair to see if this is the look they are trying to achieve.

Makeup is a delicate legal problem, which you should investigate thoroughly. In most areas, only licensed cosmetologists can apply makeup. Some laws allow clients to use your makeup. With the ease of corrections available by digital retouching, makeup to remove blemishes isn't as important as it once was. It just makes the proofs look better.

Clients are asked to bring several changes of clothing and

jewelry even if the session calls for only one outfit. I go through the clothing with them, carefully selecting one outfit over another depending on which I think will flatter them the most. I prefer solid colors, simple lines, and nonreflective jewelry. Dark clothing diminishes, while light-colored clothing expands the way people look in portraits. Also cool colors, such as black, gray, and green, recede or diminish, while warm colors, such as red, orange, and yellow, come forward. Stripes, plaids, and bold prints usually dominate portraits, overpowering the subject's face. As accessories, pearls are a good choice, but large coin necklaces and earrings cause reflection problems.

We ask clients who wear eyeglasses to borrow a pair of empty frames that look like their glasses from their eye

Children blossom in outdoor settings that give them space and freedom. For this photo, existing overhead light was softened with a 52-inch soft gold/white circular reflector. Hasselblad 150mm lens, f/8 at 1/250 sec., Fujicolor Portrait NHG II 800 Professional

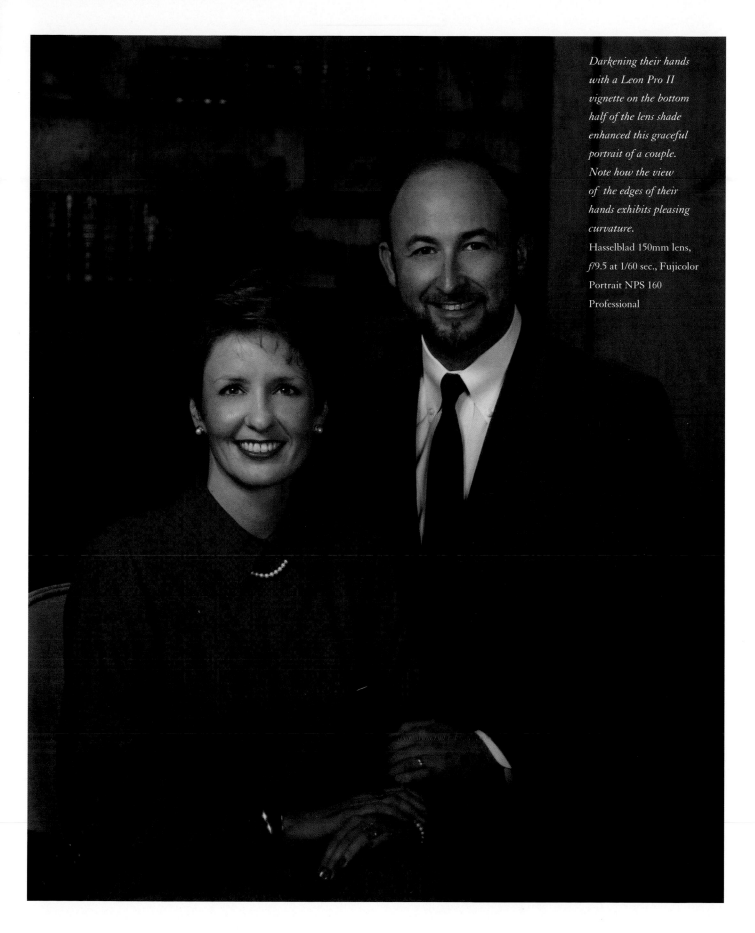

Darkening their hands with a Leon Pro II vignette on the bottom half of the lens shade enhanced this graceful portrait of a couple. Note how the view of the edges of their hands exhibits pleasing curvature. Hasselblad 150mm lens, f/9.5 at 1/60 sec., Fujicolor Portrait NPS 160 Professional

specialist. This eliminates the problem of glasses glare. Sometimes clients offer to remove the lenses from their glasses; in this case we offer them a jeweler's screwdriver to do the work. (We never remove eyeglass lenses ourselves because of the liability in ruining someone's glasses.) If all else fails, I handle the eyeglass problem with corrective lighting.

OUTDOOR AND AVAILABLE-LIGHT PORTRAITS

O UTDOOR AND AVAILABLE-LIGHT PORTRAITURE CAN be stunning when all the elements come together to produce photographic art. Clients love soft light because it is so flattering, and close-ups of people with blue or green eyes are especially beautiful when light penetrates the eyes to bring out their brilliant color. Photographers like outdoor and window light because they involve less work and less expense than setting up studio lights. Print jurors like these types of illumination because film exposed by them produces a more natural look with a greater tonal range when compared with electronic light.

Any kind of clothing, formal or informal, is suitable for outdoor portraits. This versatility comes in handy when you or your clients have a hard time deciding on a setting for a portrait. I've done outdoor and window-light portraits with clothing ranging from evening gowns to swimsuits.

Available-light portraits of subjects wearing eyeglasses are possible if you are careful. To reduce eyeglass glare when shooting outdoors, I use a high camera angle, place black or green fabric on the ground underneath the subject, and position the face to avoid bright reflections from sidewalks, streets, and buildings.

Outdoor and available light add another dimension to my portraiture, offering more lighting variety and additional ways to please clients. Another convenient advantage of outdoor portraits is that they can be shot at any time of the day if I work in total shade, especially on the north side of a building. Of course, you can work almost anywhere in the first hour after sunrise or the last hour before sunset. Many professionals even work several minutes after sunset to take advantage of what they refer to as "sweet light." In this brief 15-minute time span, light has a softness that isn't seen at any other time of day.

For outdoor and available-light portraits, I prefer Fujicolor Portrait NPZ 800 Professional film. The fast film speed allows me to employ a faster shutter speed. As mentioned in Chapter 3, I always perform film tests, exposing a test roll at various f-stops and taking notes on meter settings, f-stops, and shutter speeds. I then ask my color lab to tell me which exposure it likes best. This procedure lets me set my light meter to correlate with actual lab results.

WHAT TO LOOK FOR

As the human eye scans a scene from its brightest to its darkest area, the pupil dilates to compensate for the difference between the two. This allows the eye to see detail in shadows. Unfortunately, film can't do this, so it is helpful to view window-light or outdoor scenes through a viewing glass. This instrument, made by Harrison & Harrison, converts what your eye can see into what film can record, thereby revealing shadow areas that need more light. It is used by movie directors to determine when they need fill-in lights or reflectors for sunlit outdoor scenes, and can serve the same purpose for portrait photographers.

When I use either outdoor or window light, I look for a quality of light that is suitable for portraiture. To me, this means soft illumination with sufficient contrast to act as a main light. I also look for backgrounds that enhance and support, not detract from or compete with, the subject. An ideal outdoor background would be foliage in soft shade without sunlit hotspots. I try to find an area where green grass blends into green foliage so the horizon line won't be distracting.

In addition, I keep an eye out for interesting features of the location that will add to the composition, such as rocks, trees, gates, fences, and decorative windows. At the same time, I check carefully for elements that might spoil the portrait. These include reflections, hot

With wind blowing her hair, this little girl is lost in her thoughts during an early spring day. Hasselblad 150mm lens, f/8 at 1/250 sec. with reflector fill, Fujicolor Portrait NHG II 800 Professional

USING ELECTRONIC FILL FLASH OUTDOORS

Flash-to-Subject Distance	Flash f-stop	Available Light	Camera Setting
32 feet	f/4	f/5.6	f/5.6
22 feet	f/5.6	f/8	f/8
16 feet	f/8	f/11	f/11
11 feet	f/11	f/16	f/16
8 feet	f/16	f/22	f/22
5.6 feet	f/22	f/32	f/32

spots, light streaks, strong horizontal lines such as streets and sidewalks, and bright vertical lines such as telephone poles and street signs.

HANDLING CONTRAST

Finally, I evaluate the contrast in the scene. Does the contrast need to be raised or lowered? The highlight side of the subject's face should be a half to a full stop brighter than the shadow side. Selecting an area void of harsh light such as north window light or total shade outdoors can soften contrast, aided by reflectors or fill flash.

In fine portraiture, flat light is just as much of a problem as too much contrast. When the highlight and shadow sides of the face look almost the same, I create more contrast. To achieve this goal, I either intensify the highlights or deepen the shadows. With either outdoor or available light, I can increase contrast by using a black cloth subtractive reflector on the shadow side of the face. My favorite tool for this is a Larson 42-inch-square black Reflectasol mounted on a stand. The late Leon Kennamer taught me this technique, which he called "subtractive light," since it takes away light from an area.

Electronic flash is another way to increase contrast, but it must be softened to match the existing light. Harsh electronic light in a soft-light situation would seem out of context and might disturb the viewer. I soften the electronic flash by bouncing the light off a white umbrella. Other photographers use large soft boxes or translucent panels between the flash and the subject. Since wind can topple an umbrella, I put a weight on the base of the stand, using sand- or water-bags sold by photo dealers.

I use either a Quantum Qflash or a Lumedyne outdoors. They are battery powered and the power can be adjusted as needed. I set the main light to yield a 2:1 ratio, so with an existing light of f/5.6, I try to get an electronic flash reading of f/8. The camera is set at f/8. Usually, I measure the flash while indoors using an electronic flash meter. I find the reading for 10 feet, and then I can adjust the light when I get outdoors.

*To bring out the color
of this young woman's
eyes, as well as delicate
detail in the poinsettias,
I chose window light
for my main light.*
Hasselblad 150mm lens,
f/8 at 1/15 sec., Fujicolor
Portrait NPH 400
Professional

*These boys had a chance
to enjoy themselves as
I captured them with
a fast shutter speed.
My umbrella fill flash
was set at f/5.6.*
Hasselblad 150mm lens,
f/8 at 1/250 sec., Fujicolor
Portrait NPZ 800
Professional

*I photographed this fami-
ly, all dressed in white,
by a lake, with the father's
head at the top of the
composition. Soft evening
sun provided the main
light, with umbrella fill
flash set at f/5.6 (1 stop
less than existing light).*
Hasselblad 150mm lens,
f/8 at 1/60 sec., Fujicolor
Portrait NHG II 800
Professional

ADULT PORTRAITS

PORTRAITURE IS A DELICATE BALANCE between art and technology, between left-brain and right-brain tendencies. Unfortunately, one aspect can't survive without its counterpart. Although you need to be disciplined to achieve technically consistent portraits, emotion is vital to making them enduring keepsakes. It is necessary to learn the mechanics of camera operation, lighting, and posing so thoroughly that they require little conscious thought on your part. You'll then be free to concentrate on the emotion you want to depict in the portrait, to communicate with your client, and to draw forth your subject's personality.

Fortunately, I began my portrait photography career by working with dozens of college and high school students every day. Operating the camera, setting up lighting equipment, and posing my subjects became as routine as breathing. This volume portraiture gave me the opportunity to study thousands of faces over a four-year span. Unfortunately, it left no time to capture emotions and feelings, so I changed my business in order to do fewer portraits that are more artistic—portraits from the heart.

As part of the discipline of my craft, each day I check the equipment before starting my portrait sessions. I run the same tests before every wedding because equipment failure on such an occasion can be catastrophic! First, I make sure that the electronic lights synchronize with the camera shutter. Using my customary exposure settings of f/11 at 1/60 sec., I remove the camera back from my Hasselblad and aim the lens at the main light. While looking through the lens with only one eye, I release the shutter. If everything is working correctly, I should see a flash through the lens. The opening should have a hexagonal shape, which is consistent with an f/11 aperture. If everything looks black, I know that the shutter and flash are not synchronized. Some possible causes for the problem could be a broken shutter or an improper setting on the lens. Some older lenses still have an "M" setting, which stands for "Manual," in addition to "X" for "Electronic." I have asked the Hasselblad service department to disable the "M" setting on all of my older lenses.

Next, I test my lights by turning them on individually, watching the white recycle light to see if it fired. If the electronic flash does not have a recycle button, I hold my hand over the flash tube to see the flash and feel the heat generated when it fires. The recycle lamps remain illuminated as long as the capacitors are charging. When they go off, the power supply is ready to fire again.

Since I use a Quantum Radio Slave 4i to send a signal from my camera to the lights, I test it every day, also.

Occasionally, I need to change the 9-volt battery in the transmitter, which is secured to the top of the camera's prism with Velcro. The receiver is mounted next to the power supplies of the electronic lights, so it is powered with electricity, not by a battery, although it can be powered by four AA cells, if needed.

CORRECTIVE PORTRAITURE

Not everyone who appears before your lens is perfect-looking. In fact, few people have perfect features. As a professional photographer, I am expected to have the skills to make my subjects look their best, diminishing physical problems and emphasizing strengths. Most corrective portraiture involves judgement, experience, and training. Just as you would expect a surgeon to have the judgement and skill needed to solve a problem, portrait photographers should be able to do the same.

Knowledge of a few rules of physics and art should be the first step in learning corrective portraiture. Study of physics tells us that whatever is closer to the lens appears larger and whatever is farther away appears smaller. Short-focal-length lenses emphasize this principle.

As a portrait photographer, I want my subject's face to be paramount in a photograph, not the furniture, clothing, or background. Art principles teach us that our eyes are drawn to the point of greatest contrast, such as a white object against a black background. Therefore, if I wish to make clients look smaller, I ask them to wear dark clothing and place them against a dark background, perhaps using a background light for a little separation. Their faces are the lightest areas in the portrait, so a viewer sees them first, which is what I want. Most famous portrait painters, including Rembrandt, van Dyck, and Gainsborough, used this same effect.

If small subjects, such as children, are wearing white clothing, I use a light background so their faces come forward.

Being dark against a light background, their faces form the point of greatest contrast, so the eye is drawn to their faces, not clothing, background, furniture, or props.

Lighting Eyeglasses

Other than overweight subjects, the lighting of eyeglasses probably poses the biggest challenge in corrective portraiture. As noted in Chapter 12, the easiest way to handle the problem is to ask clients to come to the studio with no lenses in their glasses. However, things are seldom that easy. Sometimes they didn't take time to pick up empty frames; even if they did, their eyes may look worse without the corrective lenses in their glasses. Some peoples' eyes cross without glasses and others can barely keep them open.

The laws of physics tell us about reflections in glasses, specifically that *the angle of incidence (direct light) equals the angle of reflectance.* Most reflections in glasses come from the fill light because it is traveling in a direct line from the camera to the glasses, then reflected back into the camera lens. There are four solutions to this problem:

1 *Raise the light.* This increases the angle of incidence (direct light) traveling from the fill light, so when it strikes the eyeglasses it is reflected back below the camera lens. The angle is changed from 180 degrees to 45 degrees.
2 *Raise the camera.* This raises the camera lens above the reflected light coming from the eyeglasses. With corrective portraiture, there is never a perfect solution to any problem. Raising the camera may increase the perceived length of the subject's nose and chin. If the subject has a bald head, the camera is looking down at an area you want to avoid.
3 *Lower the subject.* This is almost the same as raising the camera, but it's sometimes easier to do. When I'm posing a family group, I usually ask those persons wearing glasses to be seated because of the problem with reflections when they're standing.
4 *Change the tilt of the eyeglasses.* Asking a client to tilt his or her head down slightly can reduce reflections considerably. Of course, this also can increase a double chin on a heavy subject—another case where solving one problem creates another one. Occasionally I raise the earpieces of the eyeglasses slightly to change the tilt of the lens. I try to avoid moving them so much that this correction can be seen in a portrait.

Most of the time, I make each of these corrections in a small way so that it isn't evident.

Short lighting helps slenderize a broad face by putting the cheek closest to the camera in shadow. Broad lighting can make a narrow face appear wider.

Lighting Corrections

Placement of the main light can change the way a face looks in a portrait. With a heavy subject, I try to put the part of the face nearest the lens in shadow, making it appear smaller. This is called a *short light.* Some photographers call it a "Rembrandt light," but I avoid that term because a study of the Dutch painter reveals that he used many different lighting patterns on the face. The short lighting pattern is especially good for subjects whose ears are not hidden by hair (such as men), because the ear is placed in shadow. To create a short light, I move the main light from behind the subject until it creates a highlight triangle on the shadow-side cheek.

A *split light* also is good for heavy faces because it eliminates the triangle of highlight on the shadow side of the face. So one side of the face is completely in shadow. To position this light properly, move the main light slowly until the triangle of highlight has just disappeared. This leaves a glow from the main light without the normal triangle of highlight.

With a thin face, I try to place the light so the cheek nearest the lens is in highlight, making the face appear larger. This is called a *broad light.* To create a broad light, I move the main light from the front of the subject until it creates a triangle of highlight on the shadow-side cheek.

When a subject is wearing eyeglasses, I sometimes use a *loop light* to minimize the shadow coming from the frames of the eyeglasses. This is achieved by moving the main light until a shadow has formed beside the nose but does not extend all the way to the corner of the mouth (as it normally would).

The *butterfly light* is used by a lot of glamour photographers for a dramatic look. The late George Hurrell used this lighting pattern on many of the Hollywood film stars of the

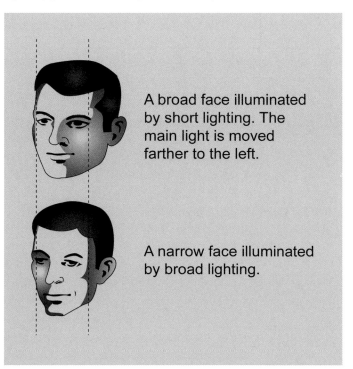

A broad face illuminated by short lighting. The main light is moved farther to the left.

A narrow face illuminated by broad lighting.

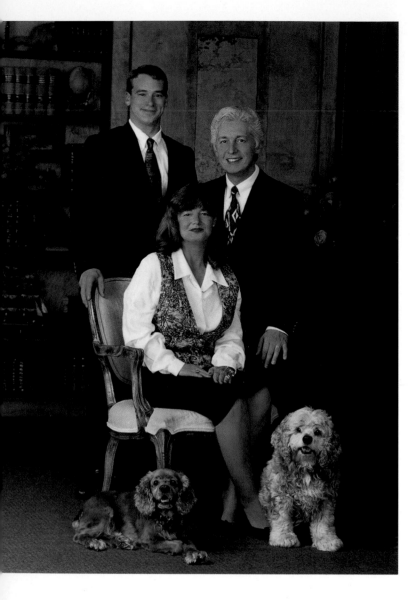

Mom, dad, and son pose formally with the other two members of their family, illuminated by a 45-inch white umbrella flash main light set at f/11 and a 60-inch white umbrella fill light set at f/8. Hasselblad 150mm lens, f/11 at 1/60 sec., Fujicolor Portrait NPS 160 Professional

is to focus the lens, then put the camera in a mirror-up position before making the exposure. I usually wait a couple of seconds after flipping the mirror up so the subject can get past the blink, then I release the shutter to expose the film. I also ask subjects to concentrate on looking at a certain spot, which they can usually do for a few seconds.

Stares give photographers just the opposite problem. When I see a fixed stare, I ask the subject to look at the ground to break the stare. Then I ask the subject to look up quickly and I make the exposure instantly. Stares are a common problem in the work of inexperienced photographers because they usually leave the subject staring at a certain spot while they focus, move lights, etc.

Occasionally, a client will have white showing under the irises (the colored parts) of their eyes. I ask these subjects to look lower than normal. (I normally ask a client to look slightly above the lens in order to get catchlights from the main light.)

With subjects with crossed eyes, I always try a profile pose, putting the problem eye out of camera range. Sometimes it helps to have them look at an object away from the lens. Usually, they can't concentrate on an object for more than a few seconds, so I make an exposure quickly. Digital retouching is a wonderful solution to the problem of crossed eyes.

1940s. It's flattering to a subject with blue or green eyes, high cheekbones, a thin nose, and a normally shaped chin. However, it can be harmful to a face with flat, flaring nostrils because it makes them appear even wider. I create a butterfly light by placing the main light above the face so the shadow is directly under the nose, slightly above the upper lip. There should be space between the shadow and the upper lip. It's important to have the fill light low so the shadow appears gray instead of a deep black with no detail.

The *flat light* is similar to the butterfly light, except there is no shadow under the nose. Some fashion photographers use the flat light extensively because they're interested in calling attention to the clothing, not the face.

Blinks and Stares

Some people blink more than others, and this can cause a problem in portraiture. Usually, people blink when they hear the mirror move in the single-lens-reflex camera, which is a split-second before the exposure. One solution to this problem

Other Corrections

Profiles and three-quarter views of the face are excellent poses for clients who have big ears. Also, a three-quarter view of the face doesn't let the nose break the cheek line. When the nose breaks the cheek line it's called a "split profile." Most professionals consider this bad portraiture.

With my kind of lighting, the best solution for people with bald heads is to make the skin blend with the background. A light background usually works best; especially the maple-colored paneling in the library set in our camera room. I also use white or ivory backgrounds with bald heads. Photographers who use a high-contrast main light, such as a pan reflector, can use a blocking device to hold back light from the bald head, but this doesn't work with umbrella lighting because it's too soft.

To shorten a long neck, raise the camera. To lengthen a short neck, lower the camera. Remember that whatever is closest to the lens appears larger and whatever is farther away appears smaller.

USING SHORT-FOCAL-LENGTH LENSES

I usually use a lens with a moderately long focal length to avoid the problem of foreshortening (objects closer to the lens appearing abnormally large). Experienced portrait photographers choose a lens that's twice the diagonal of the negative, so a 6 x 6cm negative would call for a 150mm lens. (The diagonal measurement of a 6 x 6cm negative is 75mm.) The 6 x 7cm negative calls for a 180mm lens for normal portraiture.

Occasionally, I use a short-focal-length lens for corrective portraiture. Sometimes I switch to an 80mm lens, stand on a ladder, and make a portrait from high above a heavy subject. This diminishes the subject's size because the short lens emphasizes the principle of foreshortening. In this case, the subject's face is closest to the lens and the body is farther away, and this is made even more dramatic by the short lens paradoxically making him or her look smaller.

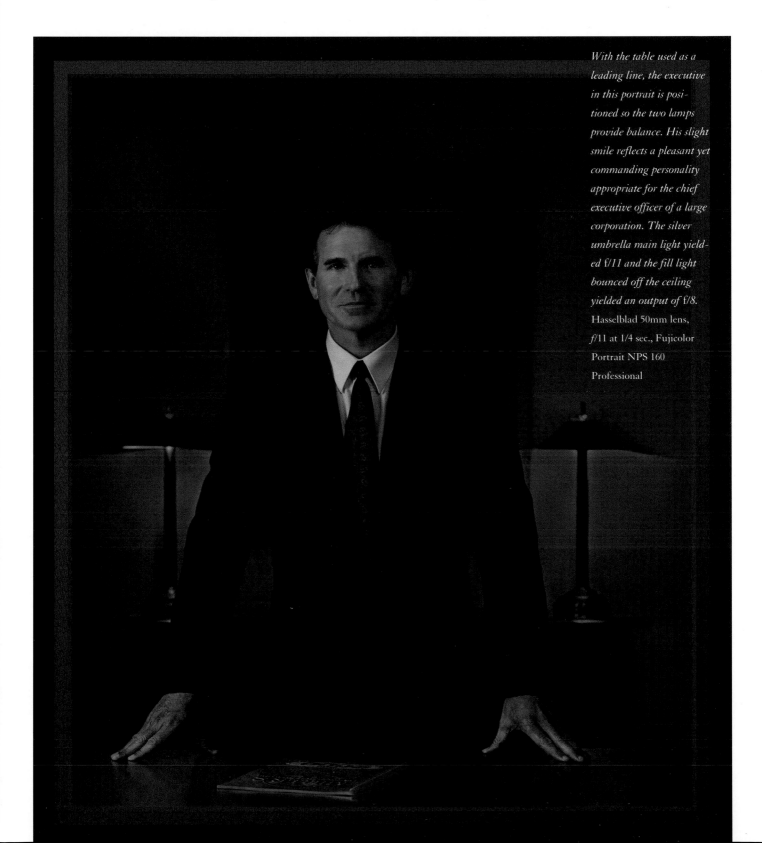

With the table used as a leading line, the executive in this portrait is positioned so the two lamps provide balance. His slight smile reflects a pleasant yet commanding personality appropriate for the chief executive officer of a large corporation. The silver umbrella main light yielded f/11 and the fill light bounced off the ceiling yielded an output of f/8. Hasselblad 50mm lens, f/11 at 1/4 sec., Fujicolor Portrait NPS 160 Professional

CHILDREN'S PORTRAITS

JO ALICE MCDONALD

THE PSYCHOLOGY OF MARKETING CHILDREN'S PORTRAITS runs much deeper than most photographers can comprehend because it is so multifaceted. Children can tug at your heartstrings like no one else, especially if they are your children or grandchildren.

Never underestimate the love of a parent, grandparent, or caregiver for a child. If you cultivate these adult clients, they'll return year after year for more portraits. In time this can lead to graduation and wedding photographs. Clearly, the cycle can be never-ending as long as you please your customers. From a marketing standpoint, children provide a renewable resource for portrait photographers because new ones keep coming every year.

At this stage of our careers, Tom and I are photographing second-generation children whose parents we worked with twenty or twenty-five years ago. In Tokyo, the Photo. Kunst-Atelier Ariga studio has been doing portraits successfully for more than eighty-five years (see page 116). Yumiko Ariga photographs children whose grandparents or great-grandparents were photographed by her grandfather.

WHAT A SMALL STUDIO CAN OFFER

As the owners and operators of a small business, Tom and I need to analyze the competition we get from large corporations operating in department stores, discount stores, and chain-owned studios. What can we do better? Obviously, Tom and I can offer better service, better packaging, and, we trust, better portraiture.

Variety is essential to our success with children's portraiture, as well as to our ability to capture the many aspects of this cherished, soon-to-be-gone stage of life. Tom and I seek variety in children's clothing, asking parents or caregivers to bring light-colored, dark-colored, dressy, and casual clothing to the session. We then coordinate the garments with different backgrounds that range from light to dark and from formal to informal. Our knowledge and skill enable us to utilize many forms of illumination: high-key, low-key, profile, window, and outdoor light. We like to capture many expressions, including somber, pleasant, happy, and inquisitive looks. And of course, we try to preserve lots of smiles.

Because Tom and I work by appointment, we don't keep children waiting, so parents and caregivers avoid the long lines they must endure elsewhere. In fact, our schedule is so flexible that we can wait if a baby is sleeping at the designated time for the session. On one occasion, we let a baby sleep in the dressing room while the parents went to lunch. The baby awakened while they were gone and we finished the session by the time they returned.

Tom and I have a convenient dressing room in the studio and schedule a minimum of one hour for the session time, so we can often photograph children in three to five changes of clothing, if their patience

When photographing children, it is necessary to be ready to capture the unexpected things they do, so Tom sets his focus on the chair where the child will be seated, with the shutter setting already made. This exposure was made outdoors, illuminated by north light.
Hasselblad 150mm lens, *f*/5.6 at 1/125 sec., Fujicolor Portrait NHG II 800 Professional

This three-month-old baby, not old enough to sit alone, was photographed on a christening bench. When a subject is lying down, everything must be elevated. The electronic main light (set at f/11) was high and positioned behind the baby, and the white umbrella fill light (set at f/8) was raised to the ceiling and pointed at the baby. Tom stood on a ladder with the camera at the top of a 6-foot-tall Regal/Arkay monostand so the camera could look down on the baby. Hasselblad 80mm lens, f/11 at 1/60 sec., Fujicolor Portrait NPS 160 Professional

will allow for it. Parents like to bring favorite clothing for their children to wear during the portrait session. We continually tell parents, "Take your time. We're in no hurry."

We switch backgrounds and furniture with every clothing change. For example, if a child is dressed in classic, dressy clothing, we'll select a formal, classic prop, such as a Queen Anne chair. If, on the other hand, the child is wearing jeans and a T-shirt, we may photograph the child in our outdoor garden area where we have live plants and large stones that a child may sit or lean on. The color and style of the child's clothing determine the background and prop selection. Our goal is to achieve a harmonious effect.

We want the child—rather than the clothing, props, or background—to be the star of the portrait. We usually include exposures made outdoors or by window light as part of the session. Volume operators can't offer these options, relying as they do on painted backgrounds and stage-type sets.

In terms of marketing, you can learn a great deal from McDonald's, the fast-food giant. This incredibly successful company attracts customers through repetitive advertising; a consistent, good-quality product; the development of new products; seasonal promotions; a friendly atmosphere; playgrounds; and special packaging for children.

In terms of artistry, you can learn from painters like Anthony van Dyck, Thomas Gainsborough, and John Singer Sargent. These artists followed a carefully detailed formula

for commercial success, portraying patrons in fine clothing in their expensive homes complete with columns, elegant furniture, and manicured gardens. Tom and I have a similar artistic approach, photographing children in their best clothing with an environment to match.

PREPARING FOR THE SESSION

Preparing parents and children for the portrait session is important. Tom and I do this through both a consultation and an appointment letter, advising the parents to schedule a time when the children will be at their best. The parents must be assured of our sincere concern for the children's security and wellbeing during the session.

Before the session, Tom and I work with our staff members to remove all objects that could harm children from the reception room, dressing room, and camera room. We also ask the parents or caregivers to prepare the children by talking about the good time they will have playing with bubbles and toys at our studio.

Tom and I also tell parents to avoid the word "doctor" during this discussion because the children may associate it with painful memories. We do everything possible to keep our studio environment from looking like a hospital or doctor's office, and we never wear clothing that suggests a medical environment on days when we're scheduled to work with children. Tom and I hang portraits of babies and children in the dressing room to create a friendly atmosphere. If children seem apprehensive, we start the session outdoors so that they quickly see that our studio is a fun place.

We use our standard lighting equipment and setups for children's portraiture. Once again, white seamless paper plays a prominent role on the set. All of our seamless backgrounds are 9 feet wide, so we can quickly move them up and down with electric background rollers. The bottom edge of the paper is held flat with two pieces of aluminum bar stock or flat bar $1/8$ inch thick, $3/4$ inch wide, and 8 feet long. The two pieces are attached to either side of the paper with four No. 3 Bulldog clips (Hunt-Boston No. 2003). Because children move so rapidly, Tom usually focuses on the seams or texture of their clothing rather than on their eyes.

Try to select chairs and other props that your most discriminating clients would welcome in a portrait hanging on their wall. Until your budget enables you to purchase expensive furniture as props, use simple pieces, such as cubes and benches, that won't attract attention. Avoid cheap-looking furniture.

Two of the greatest joys of children's portraiture are the delight that comes from earning your subjects' friendship and the fulfillment that comes from capturing an expression that warms the hearts of viewers everywhere.

WORKING WITH CHILDREN

Photographing children always requires teamwork. First, a good working relationship must develop between the photographer and the assistant. Because this camaraderie is so important to a smooth session, I recommend practice sessions before beginning revenue-producing assignments.

Tom and I involve the parents or caregivers as partners. We ask them to handle clothes changes and keep the children's faces wiped clean and their hair in place. Coaxing cooperation and wonderful expressions from children is my responsibility during the session. I genuinely like and enjoy children. They usually sense and respond to the way I care for them.

Because of this natural ease on my part and the children's positive responses to me, Tom and I ask the caregivers and anyone else in the camera room to provide silent assistance. Too many voices and too much noise confuse children and prove to be counterproductive.

Children are very sensitive to adult comments and criticism. They often misinterpret what people say to them. Adult talk may cause children to react inappropriately. These responses can manifest themselves as fretfulness, tics, uncooperative behavior, or temper tantrums.

Children view the world from their perspective, which is based on limited experience. An interesting example of this occurred when a father bought his young daughter a videotape of Disney's *Beauty and the Beast*. The scene in the movie in which the beast tells Belle to go anywhere in the castle except the west wing made a special impression on the child. The beast roars, "It is forbidden!" After viewing the movie a number of times, the little girl went to her father and said there was something she couldn't understand. "Who is this Bidden guy?" she asked. "Why can he go into the west wing and Belle can't?"

Often children don't have the language skills needed to communicate what is on their minds. They are aware of adult facial expressions and body language, sensing different moods and feelings. Children respond positively when adults are pleasant, relaxed, and confident. Adults who are tense, insecure, and irritable evoke negative responses from children. They react to the adults' tone of voice, as well as to the words that are spoken to them.

Since I have an easy time directing our young subjects, Tom is free to stay behind the camera once the lights have been

When children are involved with each other, they forget about the camera, and the result is a totally believable portrait without any pretense. This portrait was made with soft overhead light just one hour before sunset. Tom used a white reflector at ground level to soften the shadows around the subjects' eyes. Hasselblad 150mm lens, f/8 at 1/125 sec., Fujicolor Portrait NPZ 800 Professional

This boy gave Tom a coy look as I held up a coin for him to insert in the coin bank shaped like a train. The electronic flash main light was set at f/11, a white umbrella fill light was set at f/8, and a hair light was set at f/5.6. Hasselblad 150mm lens, f/11 at 1/60 sec., Fujicolor Portrait NPS 160 Professional

set up and the scene established. I know the operating range of the main light, so I keep the child in place. This method enables Tom to focus, frame the subject, and make the exposures.

Some photographers, such as Sarah Smith (see page 168), involve the parents more actively than we do, getting the caregivers to draw out expressions while she operates the camera. Smith spends a great deal of time preparing caregivers for the session. They have an advantage in that they know their child better than anyone else.

Although Tom and I don't hurry the parents during their child's session, we work fast once the child is ready. Most toddlers, for example, have short attention spans. We work together to prepare the set, and then I position the feet while Tom operates the camera because children don't stay in one place for long. Most children perform better for women, but occasionally Tom and I switch roles when a toddler seems to interact better with men. On rare occasions, one of us has to leave the camera room because a child has had a bad experience with a man or a woman.

<div align="center">❈</div>

DIRECTING CHILDREN

The following suggestions are based on thirty-five years of working with little ones. Children, like adults, enjoy people who are interesting and who genuinely like and appreciate them. A successful session depends on:

◆ Gaining children's confidence
◆ Getting them to cooperate
◆ Creating a sense of security
◆ Eliminating their fears
◆ Ridding children of suspicions

When you work with children, you also have to establish authority in the camera room. Explain to the parents or caregivers that everyone's attention must be directed and focused. Someone speaking at the wrong time breaks a child's concentration.

Ask everyone in the camera room to remain quiet during the session. Tom and I need children to look toward the main light in order to get catchlights in their eyes, as well as to achieve the proper highlights on their faces. For these reasons, I work between the main light and the camera, so that the lighting pattern will be correct as the children look at me. When young subjects hear other voices, they'll look in the wrong direction.

Never ask stubborn or cantankerous children if they "want" to perform a certain activity. This kind of question plants the idea in the children's minds that they have the power to refuse. This, in turn, gives them the advantage over you. It is better to tell the children in a positive tone of voice that they'll be busy with a specific activity. This approach eliminates the opportunity for the children to say no and to refuse to cooperate.

You should never make promises to children that you don't intend to keep. Bribing children to make them cooperate can be risky. They'll test the limits of the bribe by seeing how much misbehavior you'll tolerate and still give them the promised reward.

When you make a promise, be sure to carry out the commitment according to the guidelines you explained. I find it best to reward the child after the session has been completed. I might say something like, "Congratulations on being such a good model," and then offer a token gift, such as a coloring book and crayons or a small toy. These expressions of appreciation give the children a sense of accomplishment and pleasant memories of the occasion. Positive affirmation results in a loyal friend, which will help during any future sessions.

Throughout the session, it is important to involve the children in some appealing pastime. This strategy lets you gain their confidence and alleviate their fear at the same time you divert their attention from the photographer and the camera. For the most part, emotionally secure children quickly enter into interesting pursuits, such as watching and/or catching bubbles or listening to stories. Younger children are often intrigued by books with pictures that are animated or have part of the story concealed under a flap that lifts up. An assistant or a caregiver can hold these books, out of camera range, while reading or showing them to a child.

Allowing active children to put coins in a bank is an effective way to keep your subjects in position while you photograph them. Concealing squeakers in your hand that cause mysterious sounds to come from unexpected places can pique a child's interest. Curious toddlers usually try so hard to reproduce the sounds by mimicking your motions that they stay in the desired spot for the portrait.

Keeping children located within the boundaries of the light and camera angle can sometimes be difficult with youngsters who are hyperactive or have a short attention span. I've discovered that a challenge or dare often helps me accomplish this goal. Such statements as "I can stand still longer than you!" or "I can be quiet longer than you!" are amazingly successful in achieving the desired results. This technique is especially helpful when you allow the children to win. You can then say, "You won that time, but I'm going to win next time!" You can continue to play the game until your subjects become bored.

Finally, you should always treat children with the same courtesy and consideration you would extend to adults. Give genuine compliments. Children aren't deceived by insincerity. When you are dishonest with children, they become suspicious, cautious, and uncooperative.

THE AGE FACTOR

The photographic techniques and tools you use vary according to the age of the child. You can coax expressions from very young babies by communicating through the senses of sight, sound, and touch. Newborns and infants have limited visual ability, so I use a small bell or a squeaker to capture their attention instead of trying to establish eye contact. In response, babies with normal hearing turn their heads toward the sound.

If the child's sight is developed enough to react to moving objects and/or bright colors, I'll wave a colorful toy to direct the eyes. Young babies see black and white better than color, so a black-and-white object may serve to focus your subject's attention.

When a baby isn't old enough to sit alone, I often prop the subject in the corner of a wingback chair covered with velvet. (Any chair with a closed back works well.) Sometimes I arrange a "nest" of pillows on the floor or use a christening bench from Wicker by Design (see Resources section, page 191). The look is soft: The baby is lying on a white lace blanket, and white tulle is woven under and around the bench or pillows to create a "cloud" effect. Tom softens the edges with a vignette and raises the camera higher than usual to get the proper angle on the subject's face. Ordinarily, he keeps the camera at the nose level of the person being photographed. In these situations, he raises the camera about 5 feet and angles the lens downward in order to photograph the complete face.

A fearful or fretful baby may need the touch of a trusted caregiver, usually the mother, for comfort and reassurance. You can accomplish this during an actual exposure by covering the caregiver with a piece of black velvet. The adult is completely concealed but provides support for the child by holding the baby on the lap or shoulder, which is covered with the dark velvet. You should always use a dark background behind the baby when using this approach. This technique can save the day when a crying child can't be separated from the caregiver.

To make the velvet drape, which should be 8 feet wide by 9 feet long, simply buy 6 yards of 48-inch-wide velvet. Next, cut the fabric into two 3-yard pieces and sew them together. Velvet has a grain or nap creating a definable direction in the texture of the fabric. Be sure that the texture of these two pieces of fabric is turned in the same direction so no discernable seam can be detected when the two pieces of fabric are sewn together. One of the advantages of using velvet is that it absorbs light, so wrinkles in the fabric don't show. Velvet also comes in handy during location sessions in clients' homes when their furniture's upholstery isn't suited for portraiture. Tom and I also use black velvet as a backdrop at weddings, as well as to block unwanted light from coming in a window. For commercial jobs, we use the velvet drape to hide unwanted objects and to control reflections.

With young children who can sit alone, I play such games as patty-cake and peek-a-boo. But even if a six- or seven-month-old child can sit without any assistance, I place a large pillow on the floor in front of the baby. This way, if the baby tumbles out of a child-sized chair, the landing will be soft.

When I work with a one-year-old child, I sometimes use a feline puppet and make a noise like a cat, often stroking the child's leg with the puppet. Tom photographs all children on the floor; he never uses a table because it poses the danger of falling.

Tom usually works with older children by himself. Some of his techniques include engaging the subject in conversation by asking questions within the realm of the child's experience or entertaining them with riddles. Magazines such as *Highlights for Children* can be a valuable resource for material to improve communication with older children. This magazine has a section devoted to riddles that children enjoy. In fact, you can find entire books of riddles in the children's section of bookstores. Depending on the age of the child, Tom may ask such questions as:

✦ "If you had three apples in one hand and three in the other, what would you have?" (The answer: Big hands.)
✦ "How any seconds are in a year?" (The answer: twelve—January 2nd, February 2nd, etc.)

The laughs usually will come when you give your subjects the answers. Sometimes, the response is just a pleasant expression, which may be preferred in a portrait.

GRADUATION PORTRAITS

G RADUATION PORTRAITS OF HIGH SCHOOL seniors provide the biggest product line and highest average sales for many photography studios in the United States, sometimes accounting for more than half of their annual sales. Graduating seniors not only have a need for portraits, but are a renewable resource. Another class comes along every year.

Some high school officials sign a contract with one studio for exclusive rights to photograph the senior class, while others permit the graduates to go wherever they wish for their portraits. Even though some seniors are required to go to a contract photographer, they can go elsewhere for additional, more creative portraits.

HOW TO COMPETE SUCCESSFULLY

Contract photographers typically operate under time and financial constraints because they're required to provide a school with money, goods, or services in order to get a contract. Many schools ask photographers to submit bids in order to win a contract to schedule all of the graduating seniors. The bids usually include not only what prices the seniors will pay, but also what the photographer will give the school in return for the contract. These "favors" may include film for the yearbook staff; an advertisement in the yearbook; free processing for yearbook photographs; free photographs of school clubs, ball games, and homecoming activities; and/or a cash payment. In effect, graduating seniors are underwriting the school's yearbook or other extracurricular activities. To overcome the drain on profits that results from granting favors, photographers must reduce the amount of camera time allotted to each senior and/or product quality.

To compete in this market, noncontract photographers must offer seniors longer sessions to accommodate a higher number of clothing changes, locations, and props. These professionals must also pay more attention to each graduate's individual personality. Because seniors are a close-knit group

in daily contact with each other, they spread the word quickly about the good or bad treatment they receive at the hands of a photographer, as well as trendsetting portraits that appeal to them.

Photographers wanting to enter the graduate market must do extensive research in order to understand the teenage mind. This means spending a great deal of time with them and listening to them, so that you can speak their language. Noted California photographer Ted Sirlin has a sign in his window: "Teen spoken here." It is a good idea to find out what music they like, what cars they drive, what magazines they read, and what they eat, drink, and wear. Graduating seniors select the photographer who they think will make them look best and who will bring out their best qualities. They want a photographer who can make them relax and capture their personality on film.

This high school senior was photographed with wind blowing her hair in a natural way. The roof overhang of our studio blocks the overhead light so that no reflector is needed. The sun is setting behind her with north light to her left.

Hasselblad 150mm lens, *f*/5.6 at 1/125 sec., Fujicolor Portrait NHG II 800 Professional

REACHING POTENTIAL CLIENTS

Direct-mail advertising is my favorite medium for reaching graduating seniors and their parents. I schedule five mailing pieces. The first is a large—either 4 x 9 or 6 x 9—color postcard that I mail to eleventh graders in May, before the end of the school year. This postcard contains pictures of nine or ten members of the current graduating class, selected from different schools, featuring some of my best portrait styles. (These portraits would have been taken the preceding summer or fall.)

In June, I send out the second mailing, which consists of a 4 x 9 ½ (No. 10) window envelope with a billfold-sized photograph showing through the window. This is a portrait of a popular student from the recipient's school. I send a direct-mail piece to upcoming seniors in about fifteen high schools, so I select a representative from each school to appear in the advertisement.

The third piece of direct mail is a 3 ½ x 5 ½ color postcard with a "call-to-action" line urging upcoming graduates to have their sessions completed during the summer before they get busy with school activities. I mail this card in late July.

Next, I send out a 3 ½ x 5 ½ monochrome postcard in September, after school starts. This advises graduating seniors about the need to book their sessions as soon as possible in order to have portraits ready for the yearbook deadlines.

Finally, I mail another 4 x 9 ½ window envelope in March, offering additional portraits at a special savings. This mailing encourages the students' parents to order photographs to be sent with graduation announcements.

KEEPING THE PEACE

Graduates usually decide which portrait studio they want to go to, but their parents decide how large the print order will be, sometimes after heated negotiations with their teenagers. Seniors want lots of billfold-sized portraits to exchange with their friends, while their parents want larger prints for the home and relatives. It isn't unusual for an order to exceed $500 for wallet pictures alone, with the total sale exceeding $1,000.

Sometimes my staff members and I act as referees between graduating seniors and their parents when they arrive at the studio fighting over how the teenagers want to look in the portrait. The real debate, of course, centers around the coming-of-age issue. Most parents want to maintain control as long as possible. The problem manifests itself in conflicts over personal choices regarding clothing, jewelry, hairstyles, makeup, music, cars, and romance.

Addressing the parents, I usually say something like, "You remember how goofy we looked in high school; if it weren't for

This double exposure of a high school musician was created by making two exposures on one negative. After making the first exposure, I removed the film back before advancing the film. Then, with the back removed, I advanced the camera crank, re-cocking the shutter. The film back was put back on the camera to make the second exposure. The first exposure was made with the subject completely on the right side of the viewing screen; the second exposure was composed completely on the left side of the viewing screen. Hasselblad 150mm lens, *f*/11 at 1/60 sec., Fujicolor Portrait NPS 160 Professional

pictures, we may have forgotten some of the best times of our lives. Let me suggest we do some outfits the way your son wants, and we'll do some formal poses for you and the graduation announcements." Then I negotiate with the senior to select some outfits that will satisfy him and others that will please his parents. I always hope that this attempt at a compromise will produce a session that is photographically pleasing for all concerned, including me.

If the family members are getting along, I'll invite the parents to stay in the camera room to help me look for stray hair and clothing wrinkles. If the family is arguing, I'll tactfully suggest that the parents go shopping for an hour or so. I don't want parents in the room when they're waging a war with their child.

THE SHOOTING SESSION

When seniors arrive for a session, I have them look at a gallery of graduation portraits so they can tell me what they like and don't like. Typically, they'll say something along the lines of, "I like the couch, the shutters, the library, and the doorway, but I don't like projected lights and colored backgrounds."

This double exposure of a high school baseball player was made against a black background. The first exposure was made with the profile framed completely on the right side of the viewing screen so it did not overlap the second exposure. The second exposure was made with the camera moved back for a full-length portrait, this time composed completely on the left side of the viewing screen.

Hasselblad 150mm lens, *f*/8 at 1/60 sec., Fujicolor Portrait NPS 160 Professional

The "water look" is popular with graduating seniors. I set it up by placing a roll of mirror-like Tallyn polyester on the floor, then bouncing a spotlight off it onto the background, creating brilliant reflections. The girl is lying on the material and leaning on a clear acrylic block.

Hasselblad 150mm lens, *f*/11 at 1/60 sec., Fujicolor Portrait NPS 160 Professional

Music is an important part of the session, so I ask my teenage clients which radio station they like. My stereo system has about nine radio stations programmed in memory that play hard rock, classic rock, oldies, rap, blues, jazz, gospel music, country music, and classical music.

My associates and I treat seniors with the respect that a seventeen-year-old who has completed eleven years of school deserves. Even when we discuss them during staff meetings, we refer to them as "this young woman," "this young man," or "this student"—not as "this kid" or "this little girl." Our attitude toward clients in private carries over to our face-to-face relationships with them. Everyone—even a toddler—is capable of sensing when an adult loves or respects him or her. At the beginning of the sessions, I use the following questions as icebreakers:

✦ "Why don't you tell me a little bit about yourself?"
✦ "What kind of music do you like?" (I then tune in the radio station the senior prefers.)
✦ "What television shows do you like?"
✦ "What movies have you seen lately?"
✦ "Are you into any special activities?"
✦ "What kind of car would you like to have?"

During the session, the dialogue continues nonstop, aided by the beat of the music. Often, a graduate will bring along a classmate, who is welcome in the camera room to break the ice. Sometimes I ask the friend to help move props, look through the viewfinder, or hold reflectors, thereby giving the student a sense of participation in a session that should be fun for everyone involved.

I devote at least half of every session to classic portraiture. These photographs call for live plants, real bricks, genuine books, and authentic doors and windows. I find that my teenage clients want absolute realism and natural settings. They reject imitation props, cheap plastic and Styrofoam, and projected high-tech backgrounds.

When I decide to use paper backgrounds, usually they are solid white or solid black and accompanied by simple cubes, ladders, or chairs. Both teenagers and their parents agree on outdoor settings as natural backgrounds for portraits. I enjoy outdoor portraiture because the available light enhances the subjects' faces, especially when broad catchlights in the eyes seem to penetrate their souls.

I enjoy working with graduating seniors for two reasons: they are full of energy and optimism, and their tastes are continually changing. But, regardless of the latest teenage trends, parents want well-illuminated, well-posed graduation portraits with traditional backgrounds that they can give to their relatives with pride. Because of the challenges, as well as the opportunities, I find that seniors are my favorite subjects. They certainly keep me thinking young!

BRIDAL PORTRAITS

WHEN SOMEONE CALLS ASKING ME to photograph a wedding, if I'm not available on the requested day, I respond: "I'm sorry. I'm booked for another event on that date, but I can do an exquisite, unforgettable wedding portrait before the wedding. Many brides display a large, framed portrait on an easel at their reception, so the wedding guest can see you and your dress elegantly presented in soft, alluring light."

The ability to create stunning wedding portraits gives photographers another strong product line, one that results in high sales averages. In some parts of the world, including the United States, bridal portraits are considered more important than wedding candids and, therefore, worthy of a bigger investment. Styles and traditions vary widely throughout the world. Probably the best-selling wedding photographs all over the globe are full-length poses of the bride and groom together and of the bride alone.

STUDIO PORTRAITS

Wedding portraits made several weeks before the ceremony actually require a great deal of studio space and considerable skill. A studio sitting typically lasts 1 1/2 hours. For a full-length, standing-pose portrait, photographers usually place the bride in the center of the negative frame, with her bridal train extending to one side. Trains may be up to 9 feet long, so with the bride centered and standing, they often require a background that is 18 feet wide. It is a good idea to provide for this kind of width when you build a camera room.

What do you do with all the space on the side opposite the bride's train? In the Deep South, photographers traditionally offset the train by placing an elegant chair in front of the bride. Sometimes they direct her to put her hand on the back of the chair. One bride told a photographer in North Carolina, "I don't care what your backgrounds look like, just show me what chair you're going to use."

LOCATION PORTRAITS

Although I designed my camera room so that it has sufficient width to accommodate bridal portraits, I prefer to do wedding portraits on location. Location sessions offer many challenges, but the absolute realism of the environment makes all of your efforts worthwhile. Location portraits usually are done in the bride's home, but occasionally brides prefer the larger space offered by a friend's home or a public building, such as a church,

Stairs provide the ideal posing aid for bridal portraiture because they solve the problem of what to do with the train. Since it flows below the bride naturally, the composition lends itself to a vertical format. The electronic flash main light, bounced into a Larson 27-inch Super Silver Reflectasol set to f/11, was placed so that it provided cross-lighting on the front of the bride's dress, which gives the appearance of texture. In these circumstances, the main light should be positioned so that the bride's shadow falls up the staircase, thus no shadow falls on the wall next to the bride. The fill light, yielding f/8, was bounced off the ceiling on the second floor at the top of the staircase. Hasselblad 50mm lens, f/11 at 1/60 sec., Fujicolor Portrait NPS 160 Professional

museum, or hotel. The problem of negative space in front of the bride is more easily solved on location. I can take advantage of windows, columns, tapestries, arches, paintings, and sculpture. Location bridal sessions typically require three hours from setup to breakdown.

On any location portrait, my first goal is to capture the bride's personality as expressed in her environment. Next, I look for problems that require special care, such as windows, mirrors, and distracting colors or patterns. The last step is to decide how to illuminate the portrait.

Staircases are excellent for posing bridal portraits because they allow the train to flow below the bride at a 45-degree angle. This eliminates one problem for the photographer: figuring out what to do with all the space in front of the bride. Because any scene that includes doors, windows, and walls must be kept vertical, I use a spirit level on both my tripod and

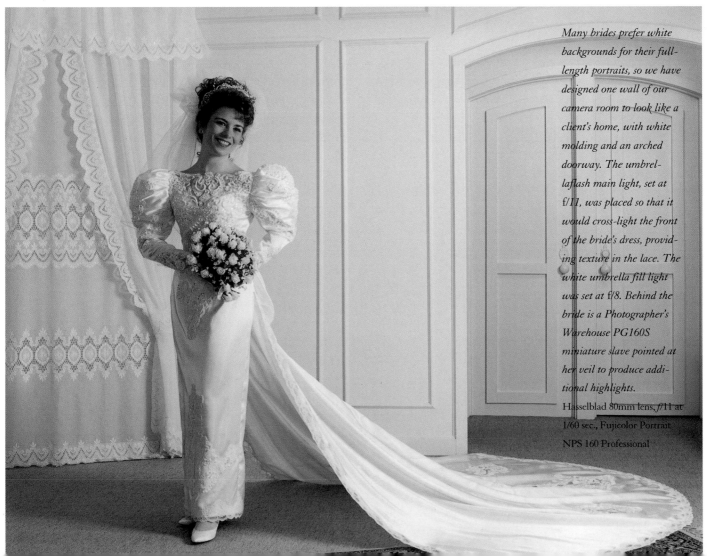

camera. For most portraits, the walls should be level, not leaning one way or another.

For full-length portraits, I usually adjust the camera height so that it is level with the bride's waist. This relatively low camera angle keeps the architectural elements straight and makes the bride appear taller than she really is. Full-length seated poses of the bride are popular, too. Here, the train is elegantly draped in front of her. I prefer to have the bride sit on a beautiful backless bench. This makes it easy to pull the train around in front of her.

For the most part, I use my Hasselblad 80mm lens for full-length bridal portraits. However, sometimes on location I use my 50mm lens so that I can show all of the train. I learned to do this the hard way: after being severely criticized by mothers of brides for failing to show all of the veil and train. If a bride or her mother wants a closer view, I always can crop part of the image. But if not all of the train and veil are on the negative, they can't appear in the image—you can't print what you didn't shoot in the first place!

Sometimes it's possible to pin the bride's train and veil to the floor in order to stretch them out and to show their full beauty. If I'm working on a hard floor, I often pin small lead weights to the underside of the train and veil to keep them in position. These weights also work well for outdoor portraits when wind proves troublesome. The weights are enclosed in white silk bags to make them less obvious if they appear in the image.

Bouffant-type veils tend to sag due to the weight of the net pulling them flat on top. Sometimes I run a long hatpin through the bride's veil and hair to take the weight off the veil, thereby enhancing the bouffant effect on top of the bride's head.

POSING THE BRIDE

Getting the bride to stand erect is important; not only to compose the image, but also to keep wrinkles out of the waistline. I strive for the "S" curve by asking the bride to put her weight on her back foot and extend her other foot towards the camera. Her hip should pivot toward her back foot.

The bride should be posed with her body at an angle to the camera, with both arms away from the waist so they don't make her waistline appear larger than it is. If she is posing with a bouquet, she should hold it with her back hand low at the waist, showing only the edge of her front hand, which doesn't actually hold the bouquet. The bride's head should be at an angle to her shoulders and tilted slightly toward the front shoulder. For standing poses, I ask the bride to keep her knees and feet moving continuously; I don't want her to faint because of improper blood flow.

Correct posture is vital for seated poses, too. Ask the bride to sit erect and then lean her upper body toward the back hip and slightly forward. This produces a diagonal composition. Toward the end of the session, I make some portraits from the waist up for newspaper announcements. I do these exposures exactly as I do the other seated poses, using the same posture and lighting.

LIGHTING BRIDAL PORTRAITS

I use my standard main and fill lights to shoot bridal portraits—whether I'm working in the studio or on location—but I add a background light that shines through the veil at shoulder level. I must position this light carefully so that the illumination from it doesn't destroy the detail in the veil via overexposure. For example, if the camera is set at $f/11$, the veil light should register an incident reading of $f/5.6$ on the flash meter when read from the bride's back.

I often use a miniature, battery-powered electronic flash unit for the background light so that no wires show. My choice is a Photographer's Warehouse PG160S with a built-in photocell, powered by two AA batteries. I mount the flash unit on a $^3/_8$-inch threaded rod that is 4 feet high. I insert the rod into a plumber's lead weight with a hole drilled in it. The miniature light is hidden by the bride's dress.

I conclude most sessions with some candlelight portraits, placing candelabra on the same side as the main light. I am very careful to light the candle several feet away from the subject, so that the spark from the match won't ignite the hair spray on the bride's hair. Of course, I keep the candle flame away from her hair and veil, as well. The exposure is made with the 150-watt quartz modeling light of the electronic flash, which usually requires a reading of about $^1/_2$ sec. at $f/4$ on ISO 160 film.

Since the fill light's modeling bulb usually doesn't produce enough illumination to soften the main light, I place a white reflector next to the shadow side of the bride's face. Accented by an eight-point star filter over the lens, the warmth of the quartz light on daylight-balanced film produces a beautiful effect.

Sometimes brides select this pose for their large portraits, and they almost always buy an extra print of it for the groom because the golden glow of the candlelight is so romantic. (This technique works equally well for first communion portraits of girls with Bibles and rosary beads.)

A bridal portrait may be the most important photograph in a woman's life, and it is worthy of the finest effort a portrait photographer can muster. When you're entrusted with this important responsibility, you should expend every ounce of energy on the portrait's preparation and execution.

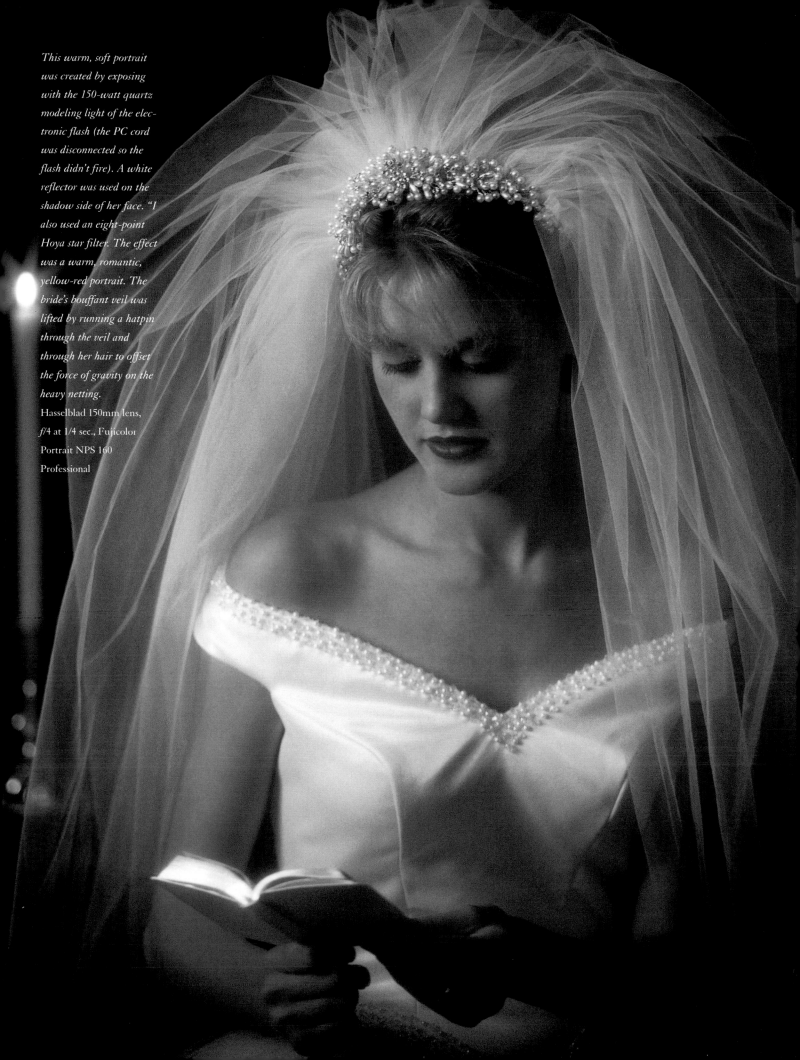

This warm, soft portrait was created by exposing with the 150-watt quartz modeling light of the electronic flash (the PC cord was disconnected so the flash didn't fire). A white reflector was used on the shadow side of her face. "I also used an eight-point Hoya star filter. The effect was a warm, romantic, yellow-red portrait. The bride's bouffant veil was lifted by running a hatpin through the veil and through her hair to offset the force of gravity on the heavy netting. Hasselblad 150mm lens, f/4 at 1/4 sec., Fujicolor Portrait NPS 160 Professional

FAMILY PORTRAITS

O F ALL THE OPPORTUNITIES IN the portrait business, photographing family groups is the most challenging, the most fun, and the most lucrative. Family portraits are difficult because they involve posing men, women, and children both individually and as a unit. The goal is to use the group to create a pleasing design, but getting children to stay in one place and look happy, preventing adults from watching the children, and keeping everyone's eyes open present the photographer with a multifaceted problem.

Despite all this, if you like people and enjoy working with them, the challenges of making family portraits can be highly rewarding. You'll find that photographing family groups enables you to understand them better, and you'll probably have fun at the sessions. In addition, family groups provide the biggest average sales of all the types of portraits I make, yet these sessions only require about the same camera time as a session with a bride or a graduating senior.

SELECTING EQUIPMENT

When I photograph families, I use my longest lens (150mm) whenever possible because of the foreshortening problem. For groups of fifteen or more, I have to use an 80mm lens because the 150mm lens's angle of view isn't wide enough for my camera room. I avoid using a wide-angle lens because of the distortion that results when one person in the group gets too close to the camera. Be aware that even an 80mm lens can make subjects in the front row look bigger than those in the back if you get too close. Sometimes I stand on a ladder when using the 80mm lens so that the distance from the film plane to the subjects is about the same regardless of whether they are on the front row or back row. However, if the background contains vertical lines—such as the sides of a bookcase—the camera must be level to avoid a "keystone effect," in which the walls appear closer together at the floor than at the ceiling. As mentioned earlier, I use a spirit level on the tripod and on the camera to keep it straight.

To achieve proper depth of field, I usually expose at f/11 for studio portraits and at f/8 for outdoor scenes. An aperture of f/11 would be better for both indoor and outdoor portraits, because the resulting depth of field would render both the front and back rows of a group in sharp focus. Occasionally however, the outdoor lighting isn't bright enough for that aperture to produce a reasonably fast shutter speed (at least 1/30 sec.). I must then use f/8. Shooting at a shutter speed slower than 1/30 sec. would probably record even the slightest subject movement as a blur. If I'm shooting at a distance of 30 feet with my 150mm lens set at f/5.6, the depth of field will range between 28 and 32 feet. Clearly, two rows of people can stay in focus when the camera is far enough away. But remember depth of field shrinks as the camera gets closer to your subjects.

A camera stand, such as a tripod or monostand, is a must for groups. It not only minimizes the problem of subject movement, but also keeps architectural lines straight. A spirit level on the camera or camera stand helps, or you can level your camera by lining up a doorway or wall molding with the center line on your viewing screen.

LIGHTING FAMILY GROUPS

For groups of four or less, a small light source, such as a 27-inch soft box or umbrella, works well as the main light. Larger groups require larger light sources. When the group comprises more than four people, I use a 45-inch umbrella as the main light. For groups of all sizes, the fill light is a combination of bounce lighting and a 60-inch umbrella.

When I set up the lighting equipment, I aim the main light at the farthest subject, so that the illumination is feathered away from the person closest to the main light. This arrangement helps spread the light more evenly, thereby preventing hotspots. As the size of the group increases, I move the main light closer to the camera, so that the illumination becomes flatter and less directional. For very large groups (ten or more people) I simply try to spread the light evenly with two, three, or four umbrellas on either side of the camera.

Large light sources, such as umbrellas, bounced lights, and panels provide even illumination; this eliminates the problem of one person throwing a shadow on another. However, you must elevate these light sources when you photograph people with eyeglasses to avoid reflections. As mentioned earlier, one of the corrective procedures for eyeglass glare is to raise the lights as high as possible. I also ask subjects wearing glasses to tilt heir heads down to help control glare.

You should also be careful to avoid double shadows on people and backgrounds. This isn't a problem when you position large umbrellas behind the camera. The resulting illumination is so soft that the umbrellas don't create shadows on the background or from one row to another.

Sometimes portrait photographers use background lights and snooted hair lights on small groups, but they become sources of error in large-group portraits because they produce hotspots and uneven illumination. (A snoot attachment on the front of a light looks like a piece of stove pipe measuring about 6 inches long and 3 to 6 inches in diameter.) Instead of using a small snoot hair light, I prefer to shine a broad light, such as a wide strip (10 x 36-inch) soft box, over groups so that the top of each person's head is lighted evenly. Sometimes bouncing a single light off the ceiling above the group produces the same effect. With a group extending 15 feet across the camera room, it is difficult to get a background light to spread even illumination over the entire space, so I leave it off.

Keep in mind that the hair light should be 2 or 3 stops less than the main light. You want it to provide only accent lighting, not shadows or hotspots. If one of your subjects is bald or has a receding hairline, turn off the hair light so that it doesn't call attention to this physical feature.

PLANNING THE PORTRAIT

Group portraits probably require more planning and preparation than any other type of portraiture. Proper clothing selection can make or break a group portrait. It is essential, then, for you to communicate clearly with your clients about this. Show them an example of a group portrait in which the subjects are wearing suitable clothing, and another photograph with inappropriately dressed subjects, so they can see the difference.

Printed materials showing family groups wearing both good and bad clothing selections are available from such

Using arms and legs to form the base, this portrait achieves a pyramid design where no one's head is directly behind someone else's. It was exposed in total shade with umbrella fill flash yielding f/8.

Hasselblad 150mm lens, *f*/11 at 1/60 sec., Fujicolor Portrait NHG 400 Professional

Years from now, when the family members look at the portrait, they'll remember their time together, as well as a special moment of love and togetherness like no other. The magic of photography can capture and preserve this memory.

POSING FAMILY GROUPS

Posing groups is the most difficult of all portrait assignments. As a photographer, you must be able to direct men, women, and children so they look natural, comfortable, and graceful. Next, you must position your subjects so that the family group presents a pleasing design. Remember the ultimate goal here is a portrait suitable for wall décor.

While artists paint or draw design elements into their creations, portrait photographers must use the arms, legs, and torsos of their subjects to create an effective design. Architectural components, furniture, or natural elements, such as hills, trees, shrubs, and flowers, can enhance group compositions. An experienced photographer avoids placing lamps or trees directly behind a subject's head.

Although photographing family groups is complicated and difficult, with practice you can learn how. When I began my career, I practiced group posing and lighting with my

sources as Marathon Press (see the Resources section, page 190). These guides make it easy for clients to see why they should plan their clothing carefully. Schedule a pre-portrait consultation with the family group, and ask them to bring along the clothing they're planning to wear during the actual session.

Solid colors harmonize better than plaids, stripes, and bold prints. Cool colors, such as blue, green, gray, and black, recede into the background, thereby letting the subjects' faces dominate. Warm colors, such as red and orange, come forward and compete with the faces. Light-colored clothing, along with bright colors and plaids, makes people look bigger. Dark clothing, including subtle vertical stripes, makes them appear smaller. Sleeveless clothing draws attention to the upper arms, which might appear larger than the face, plus there is a danger of bra straps showing in the portrait.

Your subjects' garments should blend. For example, all of the group members should wear either informal or formal outfits. It is difficult to pose a group when some people are wearing suits and ties and others are wearing jeans and T-shirts. Shoe styles and colors should blend with the rest of a person's attire: dark outfits call for dark shoes and socks.

Talk with your clients to learn what they want in the portrait. If their goal is a wall portrait for the living room, they'll probably want to wear formal clothing and pose against formal backdrops. If, on the other hand, they want to hang the portrait in the den or family room, the clothing and the backgrounds can be casual. You should also inquire whether they want the portrait to be done in their home, in your studio, or outdoors. If they want the portrait session to be held in their home, you should try to capture the environment. Include such props as a fireplace, a staircase, or a favorite chair.

Close-up portraits of couples have more impact when one face is slightly higher than the other (rather than when the eyes are at the same height). This exposure was made outdoors with north light and no reflector.

Hasselblad 150mm lens, *f*/8 at 1/60 sec., Fujicolor Portrait NPZ 800 Professional

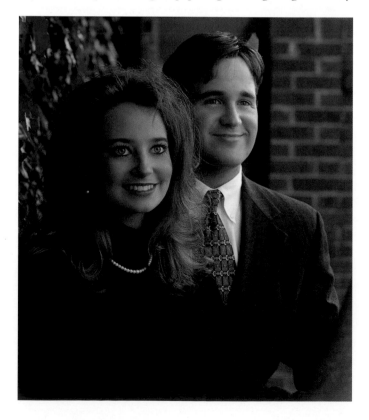

This family with college-aged children wanted to capture the warmth of their home, so I used the stairway railing as a leading line pointing to the father. Notice the son next to his father is placed so that his head is in the corner of the window, a technique I learned from studying compositions by the seventeenth-century Dutch painter Jan Vermeer. If a diagonal line was drawn from the top right corner of the window to the bottom left corner, it would intersect with his face. My main light was a 45-inch white umbrella yielding f/11, while my fill light, placed at the top of the stairs, bounced off the ceiling and yielded f/8. Outside light was measured at 1/15 sec. at f/11, an adequate aperture to capture light from the chandelier and the table lamp as well. I used a Quantum Radio Slave 4i to trigger the fill light, with a photoelectric cell triggering the main light on the floor near the camera.

Hasselblad 50mm lens, f/11 at 1/15 sec., Fujicolor Portrait NPZ 800 Professional

extended family, usually in their homes. It's far better to practice with nonpaying subjects than with clients who are paying "big bucks" for the expertise they expect you to have.

Study drawings, paintings, photographs, and design books to see how great artists posed groups. Almost every public library has books with reproductions of paintings by such masters as Peter Paul Rubens, Anthony van Dyck, Thomas Gainsborough, Joshua Reynolds, Jacques-Louis David, and John Singer Sargent. It's even better to study original works of art rather than print reproductions, so if you have an opportunity to visit a museum or gallery, take it. Concentrate on aesthetics, composition, design, perspective, rhythm, style, and lighting to see what constitutes a work of art. Before the session begins, some outstanding photographers sketch the composition they would like to use for the finished portrait. Others bring a painting or photograph into the camera room as a guide for posing family groups.

Learn to pose individuals first. Practice posing men, women, and children separately; then you can move on to posing groups. Start with small groups of two, three, and four. Place your subjects in various arrangements, such as pyramids, "V" formations, and diagonals. Try to avoid putting heads on the same plane. Be sure to position subjects so that they form a harmonious family unit, reflecting love and warmth.

I usually begin posing traditional family groups with the mother in the center of the design. I have the father stand behind her, in order to accentuate his slightly taller build. An ideal design relationship is to have the mother's eyes approximately even with the father's mouth. I then add the other relatives so that they complete a pyramid, "V," or diagonal design. If an infant is part of the group, I'll have the adults form a "protective nest" around the baby. The resulting portrait tells a story of a family bonded by generations of love.

ESTABLISHING A MOOD

Successful family portraits depict emotion. A good photographer will capture a family's love for each other forever in a photograph that will be handed down from generation to generation. Place the figures close together and link them. Direct your subjects to touch hands, rest an elbow in the mother's lap, or place a child's head on the father's shoulder.

Family portraits can be activity-centered. Instruct the relatives to read a book; you can also have the adults gaze at a child in the group. You might want to try camera-centered portraits. Here, family members look at the lens, so all faces are readily visible. Ordinarily I shoot both ways because some clients prefer one style over the other.

When you study the work of portrait painters, you'll notice that Gainsborough usually depicted his subjects looking at the viewer, while Mary Cassatt and Joseph Wright of Derby both typically showed their subjects involved in activities. All were popular painters in their day, so your approach is just a matter of taste, then as now. Some highly regarded photographers don't even always show the subjects' faces in portraits. They work from the back or in deep shadows. It is absolutely essential for you to communicate with your clients beforehand, so that you know their preferences. Some customers like dark backgrounds, while some like white backdrops; some like smiles, while some don't; and some like sharp photographs, while some like soft-focus images.

When I work with subjects to achieve compelling expressions, I try to get my clients to look cheerful. To do this, I ask them to think of something pleasant, such as a favorite family meal or vacation. If I'm composing an activity-centered portrait, I'll direct the family members to play with an infant or a pet. The result: a portrait of family that appears to be genuinely happy.

LIFESTYLE PORTRAITS

IN THIS TWENTY-FIRST CENTURY, THE typical family's lifestyle is vastly different from what it was a generation ago, with the last ten years bringing especially drastic changes. There was a time when families went on picnics or went boating together, but today each member of the family is more likely to pursue his or her own individual interests than to participate in family activities. Sometimes, the only time an extended family gathers under one roof is when it celebrates special holidays such as Christmas, Kwanzaa, Ramadan (Iftar), Passover, Easter, Thanksgiving, Mother's Day, or Father's Day.

Naturally, an ambitious portrait photographer will take advantage of making group portraits whenever families gather, usually in their homes or wherever the reunion is taking place. Because these family gatherings are so rare, the participants realize that the event needs to be recorded for posterity, so the potential for sales is enormous, especially when the photographer breaks the large group down into sub-groups of individual family units.

Most lifestyle portraiture involves an individual's activities and/or paraphernalia, such as computers, golf, hunting, fishing, photography, boating, cars, motorcycles, board games, or collections of any kind. We have made portraits of clients with such collections as movie posters, dolls, action figures, model airplanes, stuffed animals, trophies, clocks, model trains, guns, stamps, knives, books, quilts, Indian artifacts, and pottery.

Portraits involving small collections can be made in the studio. In fact, about half of the graduating seniors who come to the studio bring lifestyle collections with them, usually sports equipment or cheerleading souvenirs. Sometimes we arrange the items on a seamless white paper background that is 9 feet wide and 20 feet long. We illuminate them with a 16-inch background light on either side, about 54 inches from the background, aimed at a 45-degree angle to the background. I frequently take the portraits while standing on a 6-foot ladder to get a better view of the objects, using either the 80mm or 150mm lens on the Hasselblad.

Shirts and jackets are displayed on pedestals made of Formica-clad plywood with one side covered with plastic canvas (available at craft stores). The shirts can be pinned to the plastic canvas with large safety pins. The pedestals are 2 feet wide, 2 feet deep, and 5 feet tall.

Some lifestyle portraiture is done on location. We have photographed couples at the seashore; families on their boats; and individuals in their gardens, on the golf course, at a horse stable, at a fishing lake, and in their airplanes. People who collect classic cars usually have a special garage where they are lovingly restored. Wild game hunters display their stuffed trophies in their homes or offices.

Location work requires great skill on the part of a photographer because it requires both the communication skills of a portrait specialist and the technical know-how of a commercial photographer. Sometimes these assignments require

When working with horses, I try to find a solid green background that will permit me to back-light the horse. For this portrait, I used a white umbrella fill flash set to 1 stop less than the existing light.
Hasselblad 150mm lens, f/5.6 at 1/60 sec., Fujicolor Portrait NHG II 800 Professional

This high school golfer asked to have her club, bag, and a lot of golf balls surround her for a lifestyle portrait. After placing the balls in a design that would leave room for her, I hand-held my camera while standing on a ladder. The exposure was made with hazy sunlight and a white reflector.
Hasselblad 50mm lens, *f*/8 at 1/125 sec., Fujicolor Portrait NPZ 800 Professional

A young girl who loved to play the banjo wanted her portrait made with the instrument. This photograph was exposed outdoors with north light, next to the north wall of our studio. No fill reflectors were needed because the long roof overhang blocked overhead light, eliminating shadows around the eyes.
Hasselblad 150mm lens, *f*/5.6 at 1/125 sec., Fujicolor Portrait NHG II 800 Professional

lighting a large room while controlling distortion and reflections, and, at the same time, creating an artistic composition and making the client look good.

Obviously, outdoor scenes need to be done at the best time of day for photography, which usually is within an hour of sunrise or within the last hour of daylight. Some horse-lovers are fond of early-morning rides, so they sometimes can be coaxed into a 6:00 A.M. session. Gardeners also usually rise early, so that time may work well for them, too.

Young people usually do better in that last hour of daylight, so we do beach portraits, golfing photos, and boating scenes at that time of day. I like to aim the camera into the setting sun, with reflectors or a fill flash illuminating the subject. The shutter speed is set for the sky and the *f*-stop for the subject. Usually, I want to have the sky underexposed about one stop with the subjects properly exposed so the sky will be darker than the subjects. For instance, if the incident meter reading for the sunset were 1/125 sec. at *f*/8, I would set the camera on 1/250 sec. at *f*/8. Then I would arrange the fill flash on the subjects so the amount of light striking them from the flash would be *f*/8 when measured by a flash meter.

Four children enjoying "tea time" at their country home. I used an umbrella fill flash set at f/5.6. Hasselblad 150mm lens, f/8 at 1/250 sec., Fujicolor Portrait NHG II 800 Professional

It's a good idea to look at your local newspaper to find out the times for sunrise and sunset, or you can find the information on the Web at http://aa.usno.navy.mil/data/docs/RS_OneYear.html. On this site, the U.S. Naval Observatory provides sun- and moonrise tables for locations worldwide. Once, before the advent of the Internet, I was teaching a class in Seattle in June, thinking the sun would set at about 8:00 P.M. as it did at home. I didn't realize that sunset in a city close to the Canadian border would be at 10:30 P.M. So we waited and waited and waited, as our class and the models became more and more exhausted. Finally, the sun set on Puget Sound and the portrait was spectacular, but we learned a valuable lesson about geography.

ANIMAL PORTRAITS

SOME PORTRAIT PHOTOGRAPHERS SPECIALIZE IN pet pictures, while others work with pets only occasionally. But enterprising—hungry—photographers don't like to turn down any job, so it is helpful to know something about the subject. Quite often, family groups insist on including pets in their portraits, so photographers must be willing either to learn this specialty or to face the possibility of losing some assignments.

A veterinarian once told me that human medicine is simple compared to animal care because with people you have only one species to deal with, but with animals, you have hundreds. Animal portraiture is similarly difficult because photographers must deal with a wide variety of creatures and many breeds within each species. And like each human being, each animal has its own personality, which requires special attention.

PHOTOGRAPHING DOGS AND CATS

The dog is probably the animal that appears before the camera most frequently, either alone or with family groups. As a professional portrait photographer, you might find yourself photographing big dogs, little dogs, friendly dogs, vicious dogs, dark-furred dogs, and light-furred dogs. Cats, which comprise the second-largest group, are more difficult to photograph. They are easily frightened by their new environment (the studio), strangers, and flashing lights.

If a dog or cat needs to be moved or brushed, I let the owner handle this task. Pets respond best to the people with whom they are most familiar. Although I've never been seriously injured, I've been nipped four or five times during my long career, always as a result of being careless and moving too quickly.

Posing Dogs and Cats

For studio sessions, all animals need time to adjust to the strange surroundings, so I let them sniff around for a while before attempting to pose them. If you don't know how to pose animals, study pictures in magazines aimed at pet owners (such as *Cat Fancy* or *Dog Fancy*). These images will also give you ideas about backgrounds and lighting setups.

The backgrounds I use for animal portraits are similar to the ones I use for people pictures. These are canvas, muslin, seamless paper, room settings, and outdoor locations. When I use a muslin background, I pull a piece of canvas over a table or bench so that it blends into the background. With other backgrounds, I prefer to cover the table with velvet because it absorbs, rather than reflects, light. My goal is to show the animals without calling attention to the props and background.

For both dog and cat portraits, I ask the animals' owners to remove their collars, which are distracting. Animals are more likely to stay in one place if they're posed on an elevated perch. I try to pose the animals on a table, bench, or couch for another reason, as well: to get a background light behind them. I like to take advantage of the drama and subject/backdrop separation produced by this type of illumination.

I shoot outdoor portraits of animals in a fenced garden at my studio, so I can let dogs run free without fear of them escaping. When I photograph dogs and cats in the camera room, I close all the doors. I don't want them to wander into an area where they can get hurt.

Long-haired cats look best in a comfortable setting such as this sofa with pillows. Hasselblad 150mm lens, f/11 at 1/60 sec., Fujicolor Portrait NPS 160 Professional

Once I've completed the lighting setup and posed the animal, I use a squeak toy at the moment of exposure to get its ears erect. Like children, animals have short attention spans and become bored quickly. When the squeak toy loses its effectiveness, I switch to a small bell, then a whistle, and then coins in a metal can. I use these noisemakers with cats, dogs, and horses.

There's only so much you can do when dealing with animals. For example, I try to do most of the session with a dog's mouth closed, but it is acceptable to make one or two exposures with its tongue out. Because dogs are more likely to keep their mouths closed in a cool camera room, I keep the air conditioner going full force, even in winter. Sometimes I put lemon juice in an atomizer and ask the dog's owner to spray some into its mouth. Then when the animal closes his mouth to taste the juice, I ring the bell to get his ears to stand up and quickly make the exposure.

Lighting Dogs and Cats

The various lighting setups used for furry animals are similar to those used for just about any other kind of portraiture. Be aware, however, that dark-colored animals might require more exposure because their fur or hair soaks up an incredible amount of light. A dog or cat with black fur or hair can require either 2 additional stops of light or the use of a fast film. For example, when I photograph a black dog or cat alone, I usually switch from my standard indoor ISO 160 film to ISO 400 film, keeping the same *f*-stop.

If you don't have any experience in this specialty, you might want to run exposure and lighting tests with a friend's dog or cat. Practice with animals that have dark, light, and medium-colored fur. Conduct these trials just like other bracketed tests: make one exposure exactly as the flash meter indicates, another exposure 1 stop over that reading, and a third exposure 1 stop under the suggested reading. I recommend making extra test shots 2 and 3 stops over the meter reading, too.

When a dark-furred animal is included in a family group, I place the dog or cat closest to the main light. Obviously, the animal receives more illumination than the human subjects do. With some extremely black dogs, I aim an extra spotlight, such as the Bowens Monospot, at the animals. They get 2 more stops of exposure than the people in the picture.

A small animal can be overwhelmed by the size of its owner, so I placed this puppy on his owner's shoulder, then used a squeak toy to get his ears up. The main light was pa white umbrella flash yielding f/11, and the white umbrella fill light yielded f/8. Hasselblad 150mm lens, f/11 at 1/60 sec., Fujicolor Portrait NPS 160 Professional

Accent lights, such as hair lights and rim lights, add texture and depth to animal portraits. They can create luminous highlights around the edges of the animals' fur. I never use diffusion with animals; I prefer their fur and eyes to be tack sharp.

PHOTOGRAPHING HORSES

Because of the subject size, equestrian portraits are easier to do when the horse is in a valley and I am on a hill. This eliminates the problem of the horizon line cutting the horse into two parts. As always, available light is best in the first hour after sunrise and the last hour before sunset when shadows are soft, reducing contrast. A background blends best with a horse if it is solid green, doesn't produce hotspots, and doesn't contain such distractions as fences, barns, or telephone poles.

If people are included in a picture of a horse, I do most of the session with the rider dismounted. This way, their faces appear large. When a rider is astride a horse, his or her face looks small because the camera must be so far from the subjects in order to capture the full height of the horse and rider.

In addition to poses showing all of the horse, I move in for a full-length shot of the rider, showing the front half of the horse in profile. Sometimes I put honey or peanut butter behind the horse's front leg, and when it bends its head back to

lick the leg, I press the shutter-release button. In the resulting image, the rider will be standing between the horse's front and back legs with the horse's head pointing toward him or her.

I prefer to use a 150mm lens with horses to minimize the problem of foreshortening. I use an 80mm or 50mm lens only in extreme circumstances. Close-ups showing the faces of the horse and rider are popular poses, and it is possible to use a reflector or fill flash in these situations to soften shadows. Profiles also work well, with both the horse and rider looking either in the same direction or at each other. Just as in profiles of people, the light should be behind the subjects, outlining the profiles of the rider and the horse.

For these profiles, I ask an assistant to stand in front of the horse with a noisemaker to get the animal's ears erect at the exact moment of exposure. For the other poses, I usually handle the noisemakers myself. When I have a difficult time getting a horse's ears up with noisemakers, I use a lightweight acrylic mirror about 24 x 30 inches in size. When the horse sees its reflection, its ears come up immediately. This strategy works almost every time, but be aware that a spirited horse might run toward the mirror, thinking it sees another horse.

PHOTOGRAPHING SNAKES

Although many people are afraid of snakes, the nonpoisonous varieties are among the easiest pets to photograph. For the most part, these snakes stay in one place and move slowly. In addition, they don't require any special lighting techniques because their skin reflects light just as human skin does. The most common snakes I'm asked to work with are pythons and boa constrictors, and I almost always include their owners. Best of all, snakes don't require you to resort to noisemakers to get their ears up!

To get a snake to "pose" where I want it, I have the owner hold it behind its jaws and position the head correctly. This sometimes means unwinding the snake from the owner's arm, leg, or neck. If I photograph a snake alone, without its owner present, I get it to move by gently tapping its tail.

I wouldn't accept an assignment to photograph a poisonous snake, although I once caught and photographed a live rattlesnake early in my career. I say "once" because I never did it again, especially after seeing the rattler strike at the wire door after I put it in a cage. Venom flowed from its fangs. At the age of twenty, I

Nine brown puppies offered a unique posing challenge—mostly just keeping them in one place! Our client brought an empty box that had held shotgun shells, a camp stool, and a hunter's cap, all of which we used in the composition. The 45-inch white umbrella main light was set at f/11 and the 60-inch white umbrella fill light was set at f/8. Hasselblad 150mm lens, f/11 at 1/60 sec., Fujicolor Portrait NPS 160 Professional

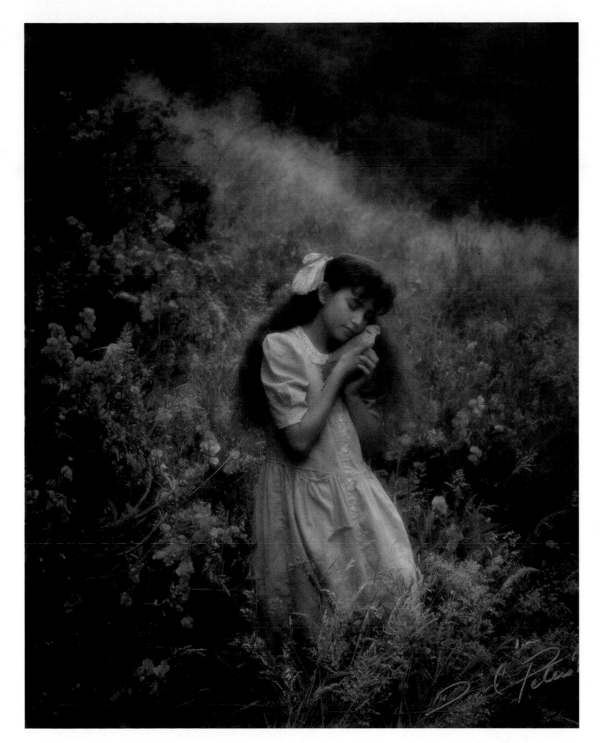

Portrait by David Peters,
San Rafael, California.

was young and foolish; now I confine my photography to non-poisonous snakes.

---※---

PHOTOGRAPHING BIRDS

Frequently owners want to be photographed with their birds. These are usually parakeets or parrots, although I've photographed hawks, eagles, and a mynah bird, too. The eagle had been hurt, and the caretaker was preparing to return it to the wild. The mynah bird was able to imitate any noise, including the telephone and the doorbell. The bird's owner said that he was continually getting up in the middle of the night to answer the telephone, only to find out that it was the bird.

The easiest way to make bird portraits is to have the bird perch on its owner's finger. This pose brings the bird close to the human face. A black velvet background works well with birds, bringing out their brilliant plumage. I usually use a hair light above them and perhaps a rim light coming in from the side to make the lighting more dramatic.

Pets keep life from getting dull in the camera room, as well as provide another source of portrait revenue. Once pet owners find that you have the ability to work with animals, they'll become regular customers and tell their friends about you. The only animals I refuse to photograph are skunks!

PART III

BUSINESS

GETTING STARTED

LAUNCHING A CAREER IN PORTRAIT photography requires artistic talent, organizational skills, business acumen, sales skills, and some capital. Obviously all photographers don't start out on equal footing in every one of those areas, but they build on what they have and acquire the rest over a period of years.

People can develop all the skills needed to run a business—even an art business—but it may take them years to see light or compose as well as the masters do. Some people have natural artistic ability while others have inherent business acumen. The latter can quickly recognize the best value, the best sales strategy, and the best business location without spending too much time studying the situation.

Both the business and art worlds have their share of geniuses, but most successful portrait photographers are average people who have worked hard to get their businesses off the ground and keep them moving steadily upward. Thomas Edison said that genius is 10 percent inspiration and 90 percent perspiration; this formula applies to most portrait photographers. And although a person needs a moderate amount of money to launch a photographic career, it isn't the most important factor.

THE RIGHT ATTITUDE

Through the influence of others, I've learned that we have a choice every day regarding the attitude we'll embrace for that day. We can't change the past, and we can't change the fact that people will act a certain way. All we can do is play on the one string we have, and that is our attitude. Consider the following quotation from Charles R. Swindoll's *Strengthening Your Grip* (Word Publishing, 1982):

"Words can never adequately convey the incredible impact of our attitude toward life. The longer I live the more convinced I become that life is 10 percent what happens to us and 90 percent how we respond to it. I believe the single most significant decision I can make on a day-to-day basis is my choice of attitude. It is more important than my past, my education, my bankroll, my successes or failures, fame or pain, what other people think of me or say about me, my circumstances, or my position.

"Attitude keeps me going or cripples my progress. It alone fuels my fire or assaults my hope. When my attitudes are right, there's no barrier too high, no valley too deep, no dream too extreme, no challenge too great for me."

FORMS OF OWNERSHIP

Before starting a business, the founder must decide on the form of ownership. Three basic kinds of ownership exist: a sole proprietorship, a partnership, and a corporation. The founder should seek the advice of an accountant or attorney about the advantages and disadvantages of each type of entity.

A *sole proprietorship* is probably the most popular form of ownership in portrait photography. Even some businesses with sales in the millions are sole proprietorships. In the United States, a sole proprietorship's income and expenses are reported to the Internal Revenue Service on Form 1040, Schedule C. The income tax on the net income is paid with the individual's personal income-tax return. A proprietorship usually requires less paperwork than the other forms of business ownership.

Probably the greatest advantage of the sole proprietorship is that the owner is free to make decisions without having to consult stockholders or a partner. Early in life when I worked for newspapers and a television station, I set a goal of owning my own business just so I could control the thermostat. Looking back thirty years later, that seems like a silly reason for wanting to be a sole proprietor. But it was just the manifestation of the control I wanted to exercise over my own business, and, in the long run, over my own life.

Partnerships are less common than sole proprietorships because they require two or more people to agree on business and artistic decisions throughout the life of a business. Even if the individuals agree at the start, they frequently grow apart after a few years and dissolve the partnership. Another problem can arise when one partner wants to pursue specialty areas of photography. While the partnership passes on its income and deductions to the individual partners, it is required to file an information tax return allocating the distribution of income and tax benefits.

A third form of ownership, the *corporation,* is a separate legal entity that may offer some protection from lawsuits. Most lending agencies require personal as well as corporate guarantees from new businesses. Corporations must keep a stockholders' minutes book and, in some states, pay a franchise tax.

Writing a business plan may require help from a professional adviser, such as an insurance broker, a lawyer, or an accountant. A college business instructor can help you for a smaller fee than you would incur with a combination of experts.

How much money do you need? Some experienced experts recommend that your start-up capital be sufficient to cover a company's overhead for six months without any income. Overhead includes such necessities as salaries, rent, utilities, taxes, insurance, advertising, and automobile expenses. In addition, photographers who are just starting out need enough money for basic equipment.

POTENTIAL PROBLEMS

Three significant problems face a new business:

+ *Insufficient sales due to lack of public awareness.* Some portrait photographers say that four years are needed to establish an adequate customer base in order to turn a profit.
+ *Lack of experience and/or education.* Few portrait photographers are fortunate enough to grow up in their parents' business, so they must gain experience while building their business. They'll make mistakes, which will result in a loss of customer confidence. Education at a top photography school will help minimize errors.
+ *Equipment expenditures.* These cripple cash flow because they usually must be paid for quickly. In most cases, emerging photographers acquire most of their equipment in the early years of the business when they have little or no income. Photographers who are fortunate enough to earn income during the first few years of operations can take advantage of special tax deductions available to businesses.

Despite all of the problems, many photographers start successful careers every year because of well-thought-out business plans, hard work, courage, sacrifice, determination, and a willingness to take risks. Most well-established photographers say it was worth the price to gain the freedom and fulfillment they enjoy in this profession.

Corporations usually report their income and pay income tax on separate federal and state income-tax returns. A photography studio operating in a corporate structure could be subject to "personal service corporation" rules. These rules impose limits on deductions and tax income at the highest individual rate. Income that is distributed as dividends is taxed a second time on an individual return.

The shareholders of a corporation may file a "small business corporation" election with the Internal Revenue Service to have the corporation's income taxed to the shareholders rather than to the corporation itself. Some exceptions to the taxation rules exist, but shareholder limitation rules must be followed. Distribution of earnings usually isn't considered "dividends," so individuals avoid the double-taxation problem.

HOW MUCH MONEY DO YOU NEED?

Owners who don't have sufficient personal funds to open a business will need a personal net-worth statement and a business plan to secure loans from a bank, a finance company, venture-capital investors, or such government agencies as the Small Business Administration. When other forms of credit aren't available, some people have even started businesses with credit-card loans, despite their high interest rates.

DETERMINING A PRICE LIST

WHEN YOU ARE READY TO establish prices, your first step will be to consult a business manager, who will help you determine how to position yourself in the marketplace. The business manager will ask you if you plan to charge high, midrange, or low prices. Before you answer this question, however, you need to think about the following fact: If you attempt to attract clients via low prices, you'll be competing with the world's largest photographic corporations, which can cut their prices to the bone because of their size and buying power. These companies also have highly effective marketing techniques, a result of their many years in business.

As you determine your price list, consider the pricing strategy many manufacturers use. They are aware that people will pay high prices for products that suggest a sense of style and/or bear certain designer labels. Shirts, for example, cost practically the same amount of money to produce regardless of the brand name, but adults and teenagers are willing to pay two to three times as much for garments adorned with a coveted logo. You'll discover that consumers will do the same for portraits if a businessperson can create a mystique similar to that of Abercrombie & Fitch, Polo by Ralph Lauren, the Gap, Donna Karan, or Tommy Hilfiger.

WHAT TO INCLUDE

A price list isn't just a reflection of costs; it should also be a selling tool. When you establish prices, you can help your sales personnel by making it easy for them to move a client from your least expensive finish to the next best finish, or by moving from a small-size portrait to a larger one.

Items that should appear in a price list include:

+ Name of studio
+ Address (city, state, zip code)
+ Telephone and fax numbers (with area codes)
+ Web site address
+ Credentials of studio or photographer
+ Copyright statement
+ Explanation of finishes
+ Explanation of session fees
+ Terms (list of credit cards accepted, check policies, etc.)
+ Revision date
+ Prices

SETTING PRICES

Putting together a pricing system involves an analysis of several factors—not just costs, but also the big variable of overhead and the use of a price list as a selling tool. Take a look at the different profit margins in the two examples in the chart below.

When determining selling prices, portrait photographers need to consider the total cost of each product, including retouching and packaging. Next, they need to think about the markup. In practice, most photographers multiply the final cost using a formula that yields a two- to seven-times markup. The formula depends on each studio's overhead costs plus a return on the photographer's investment. A businessperson with $10,000 invested in a studio should expect a return on that investment just as he or she would if that amount of money had been put in a savings account or a government bond.

To calculate the total cost of a print, start with the approximate lab cost for an unfinished print ($5), and add the amounts of the various other costs involved. These include print retouching ($4), finish coating ($1), mounting ($2), folder

HIGH VS. LOW PRICES		
	High Price *(in dollars)*	*Low Price* *(in dollars)*
Selling Price	90	18
Cost of Print	14	14
Gross Profit	76	4
Sessions Needed to Break Even	2	35

($1), and box ($1). When you add these figures together, the approximate final cost of the print is $14.

If the overhead expenses, or operating costs, are $140 per day, a high-price portrait-photography business will need to do only two prints a day to make a profit (2 x $76 = $152). In contrast, a low-price studio will have to sell 35 prints a day just to break even (35 x $4 = $140).

In practice, most beginning photographers start with low prices and gradually increase their rates as their skills and reputation grow. Making a profit during the early years of running a studio is quite difficult when selling prices are low; for that reason, many newcomers to the field hold another job until their photographic career gets off the ground. Many successful photographers discover that they need to earn a 60-percent gross profit margin and hold overhead costs to 50 percent of sales in order to make a profit of 10 percent (see chart below). This 10-percent profit, which does not include the owners' salaries, constitutes a return on investment.

Pricing Terminology

Since I'm not an accountant, I rely heavily on local experts in this field to guide me. However, they're primarily interested in tax accounting, and I'm concerned with management accounting. I need to be able to see where I'm doing well and where I have to cut expenses. You don't have to be an expert to read an operating statement, especially if you have it written in both percentages and dollars so that you can track trends. For example, is a particular expense going up? If so, why? First, you need to understand pricing terminology:

+ *Cost of goods sold.* These costs are sometimes called "direct expenses." You wouldn't incur these expenses if you didn't do the job, and you can directly assign them to a specific job or customer. These costs include lab expenses, retouching, frames, albums, glass, mounting materials, folders, and outside contractors hired for a specific job.
+ *Operating expenses.* These general and administrative costs, which are sometimes referred to as "overhead" or

SAMPLE OPERATING STATEMENT

	Percentages
Total Sales	100
Less Cost of Goods Sold	40
Gross Profit	60
Operating Expenses	50
Net Profit	10

THE BOTTOM LINE

	Typical Month (in dollars)	Month with Increased Sales (in dollars)
Sales	100	110
Cost of Goods Sold	40	44
Gross Profit	60	66
Operating Expenses	50	50
Net Profit	10	16

"fixed expenses," are critical to opening your studio doors every morning. Operating expenses include such items as salaries, rent, taxes, utilities, repairs, depreciation, and advertising. You should pay yourself a salary based on what it would cost you to hire someone to do your duties. Make sure that you calculate your salary into the overhead numbers.

+ *Net profit.* This bottom-line figure varies from year to year, but during my thirty-five-year career my net profit has averaged about 10 percent. When I hear of photographers claiming a net profit of 30 to 40 percent, I know that they're usually including their own salary as part of the net gain. This practice isn't recommended. You'll need to invest studio profits in education and new equipment. So pay yourself a salary, and live within its limits.

Naturally, both sales and expenses affect the net profit. To understand how this works, take a look at the following example (see chart above). Here you see the effects of a 10-percent increase in sales, with all other costs remaining the same, on the bottom line. When photographers increase sales by just 10 percent, they can increase their net profit by 60 percent if the operating expenses remain the same. (The cost of goods sold rises proportionately with the increase in sales, from 40 to 44.)

You can increase your sales and profits in various ways. One option is to run a promotion that doesn't call for you to reduce prices. You can offer additional (profitable) services. Yet another approach is to work closer to deadlines for major holidays. For example, if you're taking in $1,500 a day during the Christmas season, you can increase your year's sales by $3,000 simply by extending your deadline two days. How do you do that? Ship film to the lab by overnight freight and ask for rush processing. The cost will be minimal compared with the profit potential.

Be aware that cutting your prices to increase sales is dangerous. If you lower your prices by 10 percent, sales must go up 67 percent in order for you to keep the same profit. And if

you cut prices by 20 percent, your sales will have to go up 400 percent for the profit margin to stay constant. But if you raise prices 10 percent, your sales could fall as much as 29 percent. With this knowledge in mind, consider the fact that you can raise prices 10 percent and lose almost one third of your sales without affecting your profit.

When I learned this formula back in 1968, I decided to increase prices about 10 percent every year until my business reached a profitable level. By doing this, I actually increased my prices by 259 percent in 10 years due to compounding! My experience has indicated that the best time to raise prices is when demand is the highest. Ordinarily, I raise portrait prices in October, wedding prices in November, copy prices in December, and graduation prices in June.

Session Fees

Many photography studios charge a session fee, which is also called a sitting fee or creation fee. This covers the cost of the session, so photographers don't have to build it into the print costs. Among the items that should be included in the session fee are the cost of film, processing, and proofing; overhead; and time charges incurred by the photographer, the hairstylist, the makeup artist, and anyone else involved. To calculate the overhead, divide the number of sessions you did last year into the number of days you worked. For example, if you averaged four sessions a day and you worked 300 days, you would need to include $75 per session in the overhead column.

When figuring out time costs for yourself (the photographer) and others, start with the annual salary and then determine how many workdays the person is available in a year. Suppose you earn $25,000 annually and can work 240 days each year. Simply divide the number of days by the annual salary. In this example, your time is worth $104 per day. And, once again, if you average four sessions a day, the charge for your time would be $26 per session (see chart below).

As you can see, the biggest cost is for your time. This is typical in the industry because portrait photography is a labor-intensive business. I think that it is important to have different session fees for various services because some portraits take longer and/or require more film than others. A bride's session takes more time than a child's session, and a pet session calls for more film than an adult session, etc.

Price List Psychology

When you lay out your price schedule, consider listing your most expensive finish and largest print at the top, and your least expensive and smallest print at the bottom. With this arrangement, your clients will see the biggest and most expensive finish first. If you do it the other way, they may *never* read through your price list to see the 40 x 60 print with the best finish you offer.

Since most customers have a difficult time relating sizes to needs, you should give each portrait size a name. On my price list, the 40 x 60-inch print is called "life size"; the 30 x 40-inch print, "wall-décor size"; the 24 x 30-inch print, "mantel size"; the 20 x 24-inch print, "wall size"; the 16 x 20-inch print, "small wall size"; the 11 x 14-inch print, "large easel size"; the 8 x 10-inch print, "standard size"; the 5 x 7-inch print, "easel size"; the 4 x 5-inch print, "miniature size"; and the 2 ½ x 3 ½-inch print, "billfold size."

I think that it is important to have three finishes because clients typically will choose the middle range when given a choice. Sears, for example, sells three types of merchandise: good, better, and best. You must have an expensive finish in order to get your clients to buy the middle finish. For years, I offered only two finishes to high school seniors, and 90 percent of them selected the less expensive finish. Now that I provide my customers with three finishes from which to choose, half of them opt for the middle finish, which increases profits considerably.

High school seniors love their cars. This portrait of a seventeen-year-old girl was taken in front of her home with an umbrella fill flash set at f/5.6. Hasselblad 80mm lens, f/8 at 1/125 sec., Fujicolor Portrait NPH 400 Professional

TIME COST	
Expense	*Charge (in dollars)*
Film	2.70
Processing/Proofing	7.20
Photographer	26.00
Overhead	25.00
Session Total	60.90

MANAGING FOR PROFIT

REGARDLESS OF HOW MANY PORTRAITS you make, regardless of how much money you take in, your survival in photography depends on how well you manage your business. With machines that can copy your portraits becoming better and more available, you must make policy decisions to protect the time and money you've invested in photographs that are going out the door of your studio. These policy decisions involve such questions as: Will you let the proofs leave the studio? Will you charge a substantial session fee rather than cover most of your expenses in print fees?

PAYMENT POLICIES

Because of the potential problem of copying (see Chapter 29), many professional photographers seek a substantial amount of money in the form of either a session fee or an advance payment before any photographs leave their premises. For example, with a minimum order of $300, some photographers collect $100 at the time of the session, $100 when they send out the proofs, and $100 when the customer places the order. Other professionals, however, prefer to collect the entire sum at the time of the session as a professional fee or minimum order.

I also believe in making financial policies a team effort, so that my clients and I create an appealing portrait. I maintain that since I've invested time and money in the sessions, my clients should, too. I've found that when customers don't have money invested, they are quite critical, and the proofs are unimportant to them.

The amount of the payment depends on the value you place on your time and your proofs. (The word "payment" is more appropriate than "deposit" because the money isn't refundable.) Because most clients want value received for their money, they want their payment to be for a product, not just the photographer's time. In addition, they sometimes regard the session fee as a roadblock because it, too, represents time, not product, so my staff and I try to tie every fee to the delivery of photographs. For example, a promotion might include the session fee and an 11 x 14-inch portrait for a fixed price of $99.

Requiring Payment in Full

I adhere to a non-negotiable policy: No orders leave the studio without payment in full! I don't allow clients to pick up and pay for part of the order while leaving the rest. This is called a "split delivery." The reason, of course, is that many clients never pick up the balance of the order, leaving it unpaid forever.

Sometimes a client asks me to do an involved session, usually on a rush basis, for a small publicity print (and small fee), promising to "buy a big one later." My response is, "Yes, I'll be happy to help you, with payment for the wall-size portrait at the time of the session."

Charge Cards

In today's business climate, it is essential for retailers to accept credit cards, thereby making it easy for clients to pay for goods and services. This option eliminates another roadblock that might get in the way of additional sales. You can set up set up a system for accepting charge cards by getting a merchant account with a bank or factoring company, such as Concord EFS National Bank(see the Resources list on page 189). Charge cards are simple for merchants to handle. You just deposit the credit-card slips as you do checks, and the bank deducts its fee monthly. This figure is usually between 2 and 5 percent of the amount charged. You can negotiate the monthly fee, which depends on the amount of sales. Professional Photographers of America members can take advantage of a low percentage-based fee arranged for by the PPA if they wish to set up an account with the organization.

CHOOSING AN ACCOUNTING SYSTEM

One of the early decisions a businessperson needs to make involves accounting methods. The nature of photography businesses and their small size mean most portrait photographers use the cash method of accounting rather than the accrual method. The cash method is simpler because of the way it handles inventory and income-reporting statements. Accrual accounting is a much more complicated system for a small business, especially for those with limited accounting experience.

With the cash method, a sale isn't considered a sale until money changes hands. If, for example, a client signs a wedding-contract invoice for $1,500 and makes a payment of $500, the sale is recorded as $500. The balance of the invoice isn't recorded as a sale until the remaining $500 is paid. Expenses are recognized when paid. There are no expenses when the client pays the first payment, but these will accrue as the photographer buys film, processing, and albums.

---❖---

SETTING UP A SYSTEM

Keeping track of your clients' payments requires a careful paper trail. Hard copies of paperwork can be generated either using a computer or by hand. The business side of portrait photography can be as much fun as the actual shooting when you treat it as an art, but if systems aren't your forte, hire an associate who has management skills.

◆ *Invoice.* This form, which is the starting point for all paperwork, lists the client's name, address, telephone number(s), fax number, date of the order, date due, pose number, quantity, size, finish, and price per item. All items are added up, discounts deducted, and tax added on the invoice. It also contains two signature lines: one for approving the purchase and the other serving as a model release. I use a four-part invoice. The original white copy goes into the nega-tive envelope, the yellow copy is given to the client as a receipt, the pink copy is attached to the ledger card, and the gold copy is delivered with the order.

◆ *Daily report.* Also called a daily journal, the daily report acts like a cash register in a small business. All customer transactions are recorded on the daily report, including payments, deliveries of prepaid orders, and refunds. The daily report also has columns for various pieces of information: product-line code, such as portrait, wedding, or frame; client name; subject name; invoice number; amount of tax; amount of order; total paid, which is the order plus tax; form of payment (cash, check, charge card); coded category (men, women, children, promotion, etc.); and client account number.

At the close of each business day, the payments recorded on the daily report are totaled, and a deposit is prepared. The daily-report payments and the deposit total should balance after you subtract whatever you started with in the cash drawer. For example, if you begin the day with $100 in the cash drawer, you should deduct $100 from the deposit so that you also end the day with $100 in the drawer.

The daily report is used to record every transaction, including delivery of proofs, orders, payments on orders, and refunds to clients.

An invoice is written for each transaction, whether a sale or a credit given to the client.

McDonald
portraiture

Box 1385 • Jonesboro, Arkansas 72403-1385 • (870) 935-4522 • FAX (870) 935-4550

Account No. _____

STATEMENT

Jim Shorts
123 East Main
Jonesboro AR 68113

TERMS: 50% deposit when order placed, net on delivery.
_____ VISA, MASTERCARD ACCEPTED _____

DATE	ITEM	CHARGES	CREDITS	BAL. DUE
5-18-01	Invoice #25205 (session fee)	58.92		58.92
5-18-01	Paid by check		141.92	CR83.00
6-1-01	Paid by check		331.57	CR414.57
6-22-01	Invoice #47547	414.57		.00

PAY LAST AMOUNT IN THIS COLUMN

Master Printing Co., Inc. (870) 932-4491

Date of Sitting	5-18-01
Name	Family of Jim Shorts
UPS and Postal Address	123 East Main
City, State & Zip	Jonesboro AR 68113
Home Phone 933-0000	Business Phone 933-0001
Who Do We Ask For?	Jim
Charge To:	Jim and Linda Shorts
UPS & Postal Address	123 East Main
City & Zip	Jonesboro AR 68113

Name of Persons in Group | Type of Sitting 411-family group

No. of Clothing Changes 2

Jim-Dad (1.) _____
Linda-Mom (2.) _____
Kevin-14 yrs. (3.) _____
Chad-9 yrs. (4.) _____
 (5.) _____

Likes garden Dislikes painted backgrounds
 library

Ages of Children to Be Photographed 9 and 14

Birthdates Chad 9-9-1992 Kevin 10-2-1987

Why Did You Choose Us? Direct Main advertisement

Surprise () Mail () Notify (x) Will Call ()

Surprise for grandparents

Order needed by 7-2-2001 ___ Finish Comparison Shown ☒ Price List Explained ☒

Who Do We Contact When Previews Arrive? Jim

Apparent Need Anniversary gift

Special Orders (Frames) Thanhardt Burger #9497-244PD-16x20

Originals Ready	5-25	Order Completed Customer Notified	6-22
Customer Notified	5-25	Display Ready Customer Notified	

Sitting Fee/Deposit 138.00 Notifications Sent _____
Sales Tax 3.92
Sub Total 141.92
Mailing/Handling _____
Total _____

The ledger or statement is used to consolidate all charges, payments, and refunds so clients know the status of their accounts.

The sitting card provides information for all records, including family history, the ledger card, and the invoice.

We keep a copy of each client's invoice attached to the daily report when it is filed in case we are audited. Then if the auditors want to balance the funds received that day they can check them quickly.

✦ *Statement.* This summary of payments and charges enables me to give clients immediate answers about what they owe for all the services I've provided up to that point. For example, I can tell a client who has a bridal portrait, a wedding, and a family portrait in progress how much money she owes by looking at the statement. I keep the statements in alphabetical order, so that my staff and I can locate them quickly. Keeping customer statements up to date requires diligence. Every morning one staff member breaks down the daily report, posting payments to the clients' statements. Another staff member posts invoice charges to the statement when orders are completed. The invoices themselves are posted to the ledger only when they are final. If payments run ahead of invoice charges, the client has a credit balance until the final invoices are posted to the ledger. If I need to mail a notice to a client, the statement can be copied and the copy stuffed into a window envelope. Notices are mailed on the first day of each month to clients who have work in progress, such as proofs out or orders ready for pickup.

✦ *Sitting card.* The back side of the statement card does double duty as a sitting card, thereby streamlining paperwork. Customer sitting cards contain the names of family members, addresses, telephone numbers, and birthdays of children up to ten years old. (My staffers and I use this age as the dividing line between children and adult session designations because that is about the time blemishes develop and the client requires retouching,

which usually isn't necessary with children.) These dates are recorded later in a special birthday file so that I can send the child a greeting card.

The sitting card also indicates whether the session is to be a surprise and how the previews are to be delivered. In addition, it contains a reminder to my staff about showing finishes and ways to decorate with portraiture. And the card has room for me to write down a description of the clients' clothing, which helps to identify them later.

◆ *Negative envelope.* To store negatives, proofs, and invoices, I use 5 x 7-inch manila Kraft paper envelopes that are open at the end. I put two labels on each envelope, one on the outside and one on the inside (the inside label is protection in case the outside label falls off). The negative envelopes are moved to different files according to the status of the order: upcoming, film being developed, proofs out, acknowledgements out (a file for held orders awaiting payments), being retouched, being printed, ready for delivery, being displayed, and order done.

After I complete an order, the negative envelope is stored in a current negative file for three years; after that time period, it is transferred to an air-conditioned warehouse. Negative envelopes are stored side by side in 8 ½ x 11-inch Fellowes Staxonsteel transfer files, which can be stacked 10 feet high. I store negatives alphabetically by year, with all names stored in the computer alphabetically and by the year of their session. If I ever lost the computer file, I would still be able to find a particular client by searching through each year's negatives alphabetically.

◆ *Status of order.* When clients call to ask about their orders, I can either find the status in the computer or look for the corresponding negative envelope in the various stages of progress. Finished orders and boxed previews are kept in a cabinet ready for delivery. I store framed wall-sized portraits in larger cabinets with numbered slots. A note on the order box and on the ledger card indicates the numbered slot where the wall portrait can be found.

◆ *Monthly reports.* Gleaning information from the daily reports, one of my staff members prepares a monthly report, totaling the sales, number of sessions, and averages for each product line, each category, and each promotion. Year-to-date totals are also reported, thereby providing a comparison to those of the previous month and the previous year.

ACCOUNTS PAYABLE

Bills from suppliers are paid only when accompanied by an invoice. If a vendor sends me a statement showing an unpaid invoice, one of my staff members checks the statement against the studio journal. If the vendor lists an invoice I don't have, my assistant requests—and must receive—the invoice before the vendor is paid. I take advantage of all cash discounts. A 2-percent discount paid in 10 days on a monthly billing equals a 24-percent discount on an annual basis, so you might even find it worthwhile to borrow money from the bank, if necessary, to take advantage of cash discounts.

My staff members keep a journal for each vendor, even for newspapers and magazines, showing a list of charges by invoice number, and of payments by check number. One copy of each paid invoice is placed in the vendor's file, and the other is attached to a check-reconciliation ledger in case we are audited.

The check reconciliation is temporarily turned over to an outside accountant, who provides a monthly operating statement, which some businesses call a *profit-and-loss statement.* This statement indicates sales by product line, gross profit, operating expenses by category, and net profit. Monthly and year-to-date totals are indicated. I also receive a general ledger that shows the detailed transactions: all assets, liabilities, capital revenues, and expenses.

Only studio owners should know and have access to information about employee salaries. If a staff member handles accounts payable, it is advisable to keep salary figures in a separate account, and to have the studio owner or an outside accounting firm pay the employees' salaries.

All of our checks are written using QuickBooks, a software program that balances the checkbook and breaks out expenses by vendor and category.

Two management ideas have helped my studio run smoothly. My staff marks the final box of all supplies "Last Box—Reorder." This is especially important for printed forms. This step prevents shortages of essential supplies at critical times. Another useful practice is to number all letter files even though they are in alphabetical order. Decimal points or letters can be used when new files are added. For example, if you already have a 56, you can label the new file 56.1 or 56-A.

The business side of owning a portrait studio will determine whether you stay operational. If you don't make a profit, you will be out of business as soon as the capital investment is exhausted. If you make consistent profits, you will be able to derive a comfortable lifestyle from a portrait-photography business.

USING COMPUTERS TO INCREASE PROFITS

COMPUTERS CAN BE WONDERFUL AIDS for any size business, but the use of these marvelous machines can create problems. Most photographers love gadgets, and the computer—the supreme gadget of them all—demands a great deal of time. Some photographers become so enthralled with their computers that the machines actually interfere with the smooth operation of the business; photographers may let their computers become toys that take precedence over more important tasks—such as improving their photography or creating a marketing plan.

One of the early management decisions you must make is with whether to use a computer at the point of sale. After consulting with Mickey Dunlap and Ted Sirlin, two of California's most perceptive photographers, I opted not to use point-of-sale computers in my studio; my goal was, and still is, to operate a small business that offers a high degree of personal service. In the salesroom, my associates and I like to sit at a round table next to customers, not behind a counter, desk, or computer. This decision meant that point-of-sale invoices couldn't be generated on a computer, so my staff members continue to write them out by hand. Some professionals leave the salesroom and go to the office to enter an invoice on the computer, but my associates and I write out the invoice by hand in the salesroom.

Experts help us with both software and hardware because we are photographers, not computer technicians. We use one outside contractor to set up our computers and a different person to keep the software running, training the entire staff on how to use the programs. I still call on the experts to help with problems or changes that need to be made.

SELECTING SOFTWARE AND HARDWARE

When choosing software, you should ask some basic questions. First, will the program handle all of your accounting and status-of-order needs? Will it process all of your advertising needs, such as mailing lists and labels? Can mailing lists be merged or customized? Is the program fast, easy to use, and simple to learn? Is it flexible? Will the programmer or designer make small changes to make it fit your individual requirements?

With computers, it is essential to select the software first, so you'll know what kind of processor (chip) is required to run it. Even when a computer has sufficient

memory, speed is important when a client is waiting; therefore, it is a good idea to buy the fastest processor and the most memory you can afford.

COMPUTER CAPABILITIES

The computers in my studio facilitate the processing of the following administrative needs:

- *Mailing lists.* My associates put all of my clients' names on a master mailing list for future promotions. Staff members update the list every time they send out an advertising piece so that it is always current. I also have two separate mailing lists: one for high school seniors, which changes every year, and one for children, which indicates their birthdays.
- *Account file.* This file is activated on the day before the session, picking up information from the appointment book. From this, my staff produces six mailing labels.
- *Address labels.* Associates run six labels for every customer: two for the negative envelope, one for the statement/sitting card, and three for mail-outs (proofs-ready postcard, order-ready postcard, and thank-you mailer). When clients arrive for their sessions, the staffers check to see if any corrections are required.
- *Appointment schedule.* Members of my staff print out my next day's shooting schedule after they've confirmed the appointments with my clients over the telephone. Once my staffers give me the printout, I familiarize myself with the subjects' names, ages, addresses, and session times.
- *Birthday file.* My associates ask parents for the birthdays of all children under the age of ten; the staff then adds

these dates to the birthday mailing list. Once a month, staff members call all the parents of children whose birthdays fall during that month, and the computer prints out a label addressed to each child in care of the parents. I send an attractive child-oriented card plus a special package price list that expires thirty days after the child's birthday. This emphasizes the call-for-action feature of my advertising.

✦ *Order Tracking.* Once staff members set up an account file, they post status-of-order information. This tracking system lists the following:

- The date of the session
- The date the previews were ready
- When and how the client was notified
- The date the previews went out to the client
- The date the client placed the order
- The date the invoices were sent to the client for signature and first payment
- The date the negatives were sent to the lab
- The date special frames or albums were ordered
- The date the order was ready
- When and how the client was notified
- The date the order was delivered ·

My associates also indicate whether or not one print in the order is being retained for out-of-studio display purposes.

✦ *Sitting total.* Our computer keeps track of the number of shooting sessions held in each category and during each promotion. The software also indicates dollar totals and averages for each category and each promotion.

✦ *Frame inventory.* When my associates receive a shipment

Portrait by Don Emmerich, Denver, Colorado.

of frames that aren't already in the inventory file, they enter the frame manufacturer, quantity, size, cost, selling price, and finish number. If that particular type of frame is in the inventory listing already, they merely add the quantity and size received. The software will then show the frame's cost and selling price, as well as the number in stock. If, for example, I receive five frames, the program will ask if I want five price labels printed. The labels indicate the manufacturer, frame number, size, selling price, and finish. If I wish, I can also enter the cost on the label via a code known only to my staff and me. The computer also displays a running total of frames by manufacturer, size, and finish.

✦ *Mailing inventory totals.* My software also displays the total value of the inventory by cost and selling price. The inventory includes everything I have for resale: frames, albums, folios, and glass.

✦ *Mailing accounts payable.* Our QuickBooks software writes all checks, including payroll checks, and makes up federal and state payroll reports. It keeps a vendor file, showing debits and credits for each manufacturer. QuickBooks also maintains a running balance after each check, providing a monthly printout of expenditures.

✦ *Mailing graphics.* My associates and I call upon Microsoft Word and PowerPoint software for most of the studio's correspondence and graphics needs. Some of the uses include the creation of bookplates for preview albums, signs for display portraits, package price lists, and sales letters

✦ *Mailing lab links.* By using a modem and Procomm Plus software, my staff members and I can call up my business's file at our lab, Miller's Professional Imaging. This tells us not only the status of any order in the lab, but also the studio's account balance and purchases by category with monthly, one-year, and four-year totals. This software system also has bulletin board, "swap-shop," and electronic mail features. The swap shop enables lab customers to list used equipment for sale or trade on the computer.

Technology changes quickly, so I suggest that you buy a demonstration disk before launching into a management system. Each new software program requires more memory than the one it replaced, so computer users constantly must upgrade their hardware to meet the demand. Rather than buy a nationally known computer, we purchase hardware from a local dealer who can increase the memory from time to time as needed. Even then, we must upgrade every three or four years because of new technology.

MARKETING

LIKE A TRIPOD, THE PROFESSION of photography stands on three legs. These are art, business, and production. Remove one of these legs, and the photographic profession falls—and fails! Naturally, many photographers don't want to believe a word of this. They want to view their chosen field as one in which success is inevitable if they are good at capturing images on film. Their motto is "My work sells itself."

The stark truth, however, is that some great photographers operate at near-poverty levels because they are poor at marketing, advertising, accounting, managing for profit, and, most important of all, planning. Fortunately, you can achieve success in sales and marketing via a four-step process: finding your market, establishing value, appealing to emotions, and providing incentive.

FINDING YOUR MARKET

Fledgling photographers, as well as established studios, must define their markets. The reason many experienced photographers fail at business is that they never take the time to analyze their markets. They need to ask themselves the following questions:

- What do I have to offer that is new, different, or currently unavailable from those individuals already in the field?
- Who will buy these unique products or services?
- How can I get my products or services to the market in a manner that I will profit from?

Most successful businesses, even those with billions of dollars of sales, are continually striving to find a niche that no one else has filled. This process requires both marketing and research. And while these tasks may seem far beyond most photographers' budgets, they actually aren't. If you spend some time studying your situation and then brainstorming with someone who is knowledgeable in sales, you will probably come up with many good ideas.

Your research might lead to a realization that you need to develop a new product or put a new twist on an old idea. Suppose, for example, you discover that you want to introduce digital imaging as an improved method for copy and restoration

work in your area. This goal involves learning how digital imaging is done, and then deciding whether you want to do all or part of the work yourself or send it to a laboratory that specializes in the services. If you choose the third option, you'll do the sales and marketing while an outside specialist will handle production. (This is common in the photographic industry.)

Marketing, then, would mean finding out if a need for this particular product and service exists. Do potential clients in your area own old photographs that have to be copied and restored? Also, does the lab use traditional methods of copying with film, producing work-prints, and making corrections with airbrush techniques and oil artwork? Can you do the restoration work better, faster, and perhaps less expensively with digital imaging?

One of the most basic marketing steps is to determine your place in the market. Do you want to appeal to those people with the highest incomes? If so, do enough families with this kind of wealth live in your geographic area? Are there enough of them to support your enterprise? Which photographers currently appeal to these people? How well? Do you have the technical skill, finesse, image, appearance, and language skills to work successfully with clients on this level?

A beautiful little girl whispers to her sister in this storytelling portrait by Jo Alice McDonald. Hasselblad 150mm lens, f/11 at 1/60 sec., Fujicolor Portrait NPS 160 Professional

Would you rather appeal to the middle-income families in your area, those in the middle 60 percent? Alternately, do your plan to market to families whose incomes fall in the lowest 20 percent? Keep in mind that for both middle- and lower-income families, you'll be competing with mass marketers in the photographic industry—the people with studios in malls and discount stores. What can you do that the mass marketers can't? What are their problems? Certainly you can spend more time with your clients, create a warm atmosphere for photographic sessions, and offer to go on location to photograph your customers in a strikingly beautiful park or in their own homes. You can also portray them with their pets, their car, or perhaps even their boat.

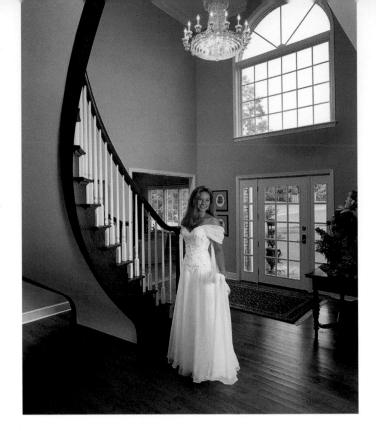

The staircase, chandelier, and doorway frame this elegant young woman in her home.

Hasselblad Super-Wide 38mm lens, f/8 at 1/60 sec., Fujicolor Portrait NPH 400 Professional

ESTABLISHING VALUE FOR YOUR PHOTOGRAPHY

We must realize that mass marketers roll up millions of dollars in sales each year, which makes our sales look miniscule. As an individual photographer or the owner of a small studio enterprise, you have to charge more for your work than mass marketers do. So prospective clients must be convinced that your products and services are worth the price you're charging. You can create a demand for your portrait photography and establish its value in several ways.

Display Your Work

One option is to show your photographs in as many high-traffic locations as possible. Nothing sells your work like exhibiting it to the public. Some places where you might display your portraits are maternity shops, children's stores, hair salons, movie theaters, video stores, frame shops, doctors' offices, hospitals, restaurants, cafeterias, banks, shopping malls, bridal shops, and tuxedo-rental stores.

During discussions with potential hosts about the display, you should emphasize how it will benefit their location via increased traffic, goodwill toward them, and ready conversation topics for those having to wait. A display also ensures recognition for the subjects, and, of course, it provides advertising for you as a photographer. Any public display must be a win-win situation for all concerned.

In more than twenty years of displaying portraits and wedding candids at various locations, I've received thousands of positive comments from potential clients. For example, after the owners of a busy cafeteria displayed my work for fifteen years, they decided to remodel; this meant removing my portraits for about a month while the walls were resurfaced.

As soon as this task was completed, the cafeteria manager called me and wanted to know how quickly I could restore the gallery because customers "wanted the pictures back!"

Print Competition

Entering a competition is another way to attract attention and establish value for your work (see Chapter 11). Most large cities and all states have professional photographic organizations that hold print judging on a regular basis, either monthly or annually. For information about these associations, contact Professional Photographers of America, which runs its own international print competition (see Resources section, page 191).

Audiovisual Shows

These presentations leave a longer-lasting impression than any photograph that you've ever made because of the synergistic effects of the music and slides. Audiovisual (AV) shows evoke emotional responses from audiences and bring you recognition. These, in turn, increase your chances of being the person the audience members will call for their photographic needs. Slide shows are much more effective and easier to stage by using Microsoft PowerPoint software on a laptop computer or by using a disk on a DVD player. These systems are more compact and less error-prone than the old system of 35mm slides and a dissolve unit. After September 11, 2001, I put together a patriotic program with the help of an audio-visual specialist who put the images and music on a DVD. To show the program, all I need are a DVD player, a digital projector, and a sound system. With that setup, I merely push the "play" button and the shows rolls by itself without the previous headache of 35mm slides

sticking in the projector, fouling up the dissolve system.

Themes for shows vary widely. Each of the following ideas can have a strong impact:

- *Memories.* Consider putting together a show by copying old photographs that trace the history of your area. You can provide the pictures with a chronological context by copying old newspapers. I created a popular show in this manner, starting with photographs dating from about 1900 and then progressing through World War I, the Great Depression, World War II, the Korean War, the assassination of President John F. Kennedy, the Vietnam War, the Gulf War, and finally the terrorist attacks of September 11, 2001. I included some memorable local events, such as a flood and a tornado. These dramatic images, combined with stirring music, left hardly a dry eye in the audience when the show was over.

- *Humor.* Images of children always are popular, especially when you show the humor of some sessions. Surprise follows surprise in a merry kaleidoscope of faces as they laugh, cry, yawn, grimace, kiss, blink, and mug. Viewers react with glee as they watch the subjects' natural, uncontrived expressions, which show the full range of childhood emotions.

- *Patriotism.* Scenes of America, especially those that show flags and parades, can constitute a stirring slide show when set to patriotic music. Civic groups clamor for this kind of presentation before national holidays, such as Memorial Day, Independence Day, and Thanksgiving.

- *Spirituality.* Some religious groups and organizations want AV programs with a spiritual flavor. You can fill this need by combining nature scenes with narration of scriptural passages. Views of sunsets and rainbows are particularly effective in shows with spiritual themes.

- *Romance.* When the sponsor of a local bridal fair solicited me to buy booth space, I made a counteroffer to put on a slide presentation just before the fashion show. "It's February, and the snow is flying," I explained to the sponsor. "Let me suggest a way to put the audience in the mood for a summer wedding. I'll put on a short slide show, about eight minutes long, with scenes from one of last summer's weddings, set to romantic music." She agreed to my plan. The audience response was so overwhelming that the sponsor asked me to prepare another show for the following year's bridal fair.

This experience taught me that a slide show is the best way—by far—to sell my wedding services to a prospective bride. In the past, brides and their mothers looked through my sample albums, but they didn't see my photography. They spent their time criticizing the dresses, tuxedos, flowers, cakes, etc. When they finally finished, their typical response was "I'll let you know later." These encounters wasted my time. Now brides and their mothers view my eight-minute slide show and are ready to book immediately because their emotional response is so strong.

Appealing to Emotions

When you study the marketing techniques of large advertisers, you immediately notice that they appeal to your emotions. Consider the impact of well-known advertising slogans: "The power of dreams" (Honda); "Always low prices. Always." (Wal-Mart); "Because you're worth it!" (L'Oréal); "Get the feeling!" (Toyota).

Honda could advertise the features of its vehicles, but it wisely translates the potential buyer's dreams into a desire to buy a new car or truck. Our advertising emphasizes the *benefits* of a portrait, not the *features*. Since love is the greatest motivating force in portrait advertising, almost all of our studio advertisements contain the headline "Because You Love Them." Instead of mentioning details about portraits, the ad copy stresses the lifelong emotional benefits derived from buying photographs.

Which Advertisement Sells?

Notice that the Studio A advertisement calls attention to the features of a portrait while the Studio B ad focuses on its

> **STUDIO A**
> **8 x 10 FOR ONLY $59**
> Mounted on Canvas
> Textured Like a Painting
> Mounted on Art board
> In Folder and Box
> ## COLD, PRICKLY STUDIO

Which of these two advertisements would you respond to?

> **STUDIO B**
> ## BECAUSE YOU LOVE THEM
> Life is a panorama filled with many
> entrances and exits . . . separations and reunions.
> So there are Tom McDonald portraits to
> remember yesterday and the many faces of love.

long-lasting value. People give friends and family portraits out of love and affection. Some of the most successful portraits I've ever displayed tugged at people's heartstrings and brought in new clients. An award-winning portrait of a mother and her son elicited positive responses from a wide range of prospective clients after I showcased it in a number of out-of-studio galleries.

Photographs with emotional value will attract more business for you than anything else you do. Simply shoot some stunning emotional images and then present them to the public through displays, audiovisual shows, and advertising pieces (such as direct mail). Displaying a sunset photograph of a little boy and his horse in a restaurant gallery brought a call from a man two hundred miles away who wanted a similar portrait of his son and their horse. This resulted in an order that was impressive for me at the time, as well as one of the largest of that year. Hundreds of other photographers were probably geographically closer to this client than I was, but their work and approach didn't touch him emotionally the way my display portrait did.

Family portraits are my best-selling product line, so I always have several group photographs on the wall, including one of my own family. This photograph is actually a composite of family-group portraits, one each year for twenty-five years. Seeing a family evolve over the course of so many years is an emotional experience for some prospective clients.

You can reap marketing benefits by having your own family portrait done regularly and displaying the results. A few years ago, I used about ten portraits of my family—showing the changes over the years—in a direct-mail piece, and this led to wonderful results.

In addition to suggesting family-group pictures, you should stress the importance of having a child's portrait taken regularly—at least once a year. Without a portrait, parents will miss an essential stage of their child's development. Many studios have birthday clubs and album plans that offer savings if the client brings in the child at specific intervals, at least annually.

Because previous clients are so valuable, I contact them a minimum of five times a year. Some people like cars, others like boats, others enjoy horses, and still others desire jewelry, but I seek out people who love portraits. And once I find them, I don't intend to lose them. As Peter Orthmann, the owner of Synergetic Selling, says, "It costs six times more to develop a new customer than it does to sell an existing one."

PROVIDING INCENTIVE

Once you establish the perception in the public's mind that your photography has great emotional value you can advance to the next step: giving people an incentive to buy now. Plan your promotions during school vacations and times of the year when prospective clients already have a need to buy, such as Christmas, Mother's Day, Father's Day and Valentine's Day. Many photographers try to promote their services only when their sales are slow rather than seizing the day when the public is ready to buy.

Working long hours during peak buying seasons is offset by vacations during slow times. The more you can stretch the buying season at gift-giving times, the more profitable your business will be. This means not only longer studio hours but also moving your deadlines closer to the holiday by using rush processing and overnight express services if you're working with an out-of-town lab.

"Low-Commitment Specials" have proven successful for me because they offer my clients a fixed price for both the session and the product. These promotions eliminate a major roadblock in the path of prospective clients; people realize that they're getting something for their money. For some reason, clients resent paying a session fee with no value received for the expenditure. During my many years in the portrait-photography business, I've discovered that all people, including the wealthy, want the most value for their money. As John B. Neff, a mutual-fund advisor at Wellington Management, says, "Price is the great equalizer and allocator of spending in a capitalistic society."

"Eight Ways to Say Merry Christmas" and "Happy Father's Day" rank among my studio's most successful low-commitment specials. The eight-way Christmas special is composed of eight 4 x 5-inch color proofs (I call them "originals") delivered in an inexpensive album or folio. The eight-way picture offer is popular with customers because they can have their child photographed in three different outfits with three different backgrounds for a fixed price. This promotion doesn't call for a minimum order or a session fee, and it has almost no restrictions.

Photographers profit from this eight-picture promotion because they can schedule it close to a gift-oriented holiday. The offer also results in lots of sessions and opportunities to reach more potential repeat customers. This increase in volume compares favorably with average package deals and wall portraits sold during a similar time frame. Another advantage is that because the promotion consists of only proofs, the deadline for taking the photos can be less than a week from the occasion.

Sessions are the fuel that keeps a studio running. Someone asked baseball legend Babe Ruth, "How do you hit sixty home runs in a season?" Ruth's answer: "It takes a lot of at-bats!" The portrait-photography business works this way, too. To make sales, you must have shooting sessions, and low-commitment specials attract many customers.

Some possibilities for low-commitment specials include:

- ✦ "Four Ways to Say Happy Mother's Day" (four proofs in a frame with a mat)
- ✦ "Six Ways to Celebrate Spring" (six proofs in a frame with a mat)
- ✦ "Two for One Special" (two 8 x 10 prints for the price of one)
- ✦ "Christmas Cards for Half-Price" (a slim-line greeting-card promotion offered in October to attract early Christmas sessions)

Because small-studio portraiture is such a personal service, it is horribly inefficient in comparison to manufacturing or even chain-store photography. Low-commitment specials increase efficiency since portrait photographers can concentrate on children or groups for an intense period of time. Having to think about only one type of photography for three or four weeks makes photographers not only more productive, but also more creative, because they can try seemingly limitless variations.

Consider a typical telephone conversation between one of my staff members and a prospective customer:

"McDonald Portraiture, Linda speaking."
"What kind of specials do you offer for Christmas?"
"Would this be for yourself or your child?"
"My child."
"May I ask her name?"
"Ann Margaret."
"And your name is?"
"Barbara Coleman."
"Thank you for your inquiry. May I call you Barbara?"
"Yes, that will be fine."
"Barbara, we have an outstanding value to offer you: eight 4 x 5 portrait originals of an individual for just $59."
"But I wanted it of both my daughters, Ann and Margaret."
"Oh, I didn't know you wanted a group portrait. The eight-way feature is for individuals only, but we have an unadvertised 11 x 14 group special for just $99. May I book an appointment for you?"

Never say "no" to potential clients if at all possible. Get them to make an appointment first, then work out the best use of your time. By offering an unadvertised group promotion at the same time as the eight-way promotion, Linda was able to give a positive response to almost all of Barbara's inquiries. Advertising for the eight-way special results in a high number of group as well as individual sessions.

As the end of a promotion nears, appointment times get scarce, particularly after school and on Saturdays. To accommodate this, I schedule sessions during lunch hours and after the studio's closing time. I normally allow an hour for each session, but rather than turn down clients, I often shorten the time to thirty minutes when the demand is heavy. My staff members call each customer the day before the session to confirm the appointment time. If anyone cancels for any reason—a sick child, a minor accident, or an unexpected out-of-town trip—I can readjust the appointment book to increase the length of the day's sessions, thereby giving each client a little more time.

Some appointment slots are so valuable that we require an advance deposit to hold them for clients. These include all day Saturday and after school (usually 4:00–6:00 P.M.). When a client calls for one of these times, we require either a credit card number or a check before we will make the appointment. Clients who don't show up for their appointments and don't call to reschedule are charged the session fee.

Design low-commitment specials that don't reduce your total order. We seek to maintain a certain dollar-amount average on each session. (For instance, a $400 average on children's sessions.) These averages are calculated by dividing the number of sessions for a particular promotion into the total sales. Since package sales are instrumental to increasing averages, a low-commitment special must not eliminate items offered in the packages. For example, the promotion should not consist of two 8 x 10s and four 5 x 7s because that will reduce the need for the client to purchase a package of similar sizes. This is why the six- or eight-way promotion works so well: it doesn't adversely affect package sales.

After the session, some clients will place large orders while others won't order anything beyond the low-commitment special. As a result, I've learned to play the averages and forget the exceptions. During a recent year, my sales on the eight-way special equaled my typical dollar average for portrait orders, and the group special doubled it. Because these promotions are so profitable, it makes good business sense to expend adequate time, effort, and film on each session. As Timothy M. Walden, co-owner of the highly successful Walden's House of Photography in Lexington, Kentucky, says, "We build our business on the majority, not the minority. We're not going to let the minority run our business!"

DEVISING A PROMOTION CALENDAR

ACCORDING TO VICTORIA MAL, WHO has had a distinctive career in marketing with Sirlin Photographers, Art Leather, and Professional Photographers of America (PPA), "People spend more time planning their vacations than they do planning their businesses." Why is this true? I think the answer to this question is twofold. First, most people don't know how to set up a successful business. Second, people would rather spend their time doing something else. For some artists, business matters aren't fun.

"One of the well-known axioms of business is that nothing sells itself," says Marcus Samuel, one of the founders of the Shell Oil Company, in *The Prize* by Daniel Yergin. Unfortunately, some photographers think that they don't require a plan for marketing, advertising, and promotions. But photographers wishing to devise an effective marketing plan need to consider such basic issues as:

+ Who are my potential clients? As mentioned in the chapter on marketing, we must decide if we are aiming at high-income, middle-income or low-income clients.

+ Where do they live? Are there enough prospective clients in our market area to support my business? Perhaps I need to move to an area with a higher population density.

+ Who buys portraits? From my experience, I've learned that women are the primary buyers of portraits. Therefore, I aim my advertising and display galleries so they will appeal to women.

In all likelihood, newcomers to marketing won't know what will work with their prospective customers, so they'll have to experiment with different approaches or adapt other photographers' marketing ideas. Early in my career, I was fortunate enough to study at the Winona School of Professional Photography under Charles H. "Bud" Haynes and Ted Sirlin. Haynes hammered home the need for a carefully structured marketing calendar, and Sirlin described strong promotions that had worked for him. In 1968, I drew up a calendar based on these promotional campaigns, which have worked well for me for more than thirty-three years. Other photographers have achieved the same success in both large and small cities.

THE IMPORTANCE OF TIMING

"You've got to pick the cotton when it's in the fields," advised my father-in-law, Gene McGuire, a successful farmer for more than forty years, when he returned from the mall one December day. "There are people moving around out there spending money." His suggestion led me to develop a plan to attract December sittings that vastly improved my January cash flow. Before that, I had concentrated on processing orders in December, missing the opportunity to photograph family groups when they gathered for the Christmas/ Hanukkah season. Today, the family-group special offered in December is my strongest promotion, providing cash flow in two of the weakest months of the year, January and February.

Seasonal emotions are critical to the success of a targeted-time marketing plan. Sometimes it is simple to attract clients,

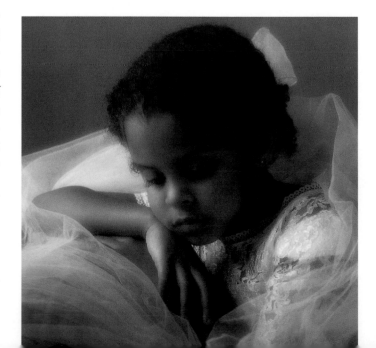

Portrait by Lizbeth Guerrina and Pauline Taricco, Poughkeepsie, New York.

THE PROMOTION CALENDAR

January	Copy and Restoration Promotion	*May*	Mother's Day Gift Certificates
	Frame Sale		Graduation Promotion
	Valentine Promotion		Father's Day Promotion
February	Valentine Promotion continues		First High School Senior Mail-out
	White Sale (sell proofs more than three	*June*	Father's Day Gift Certificates
	years old)		Second High School Senior Mail-out
	Bridal Fairs	*July*	Third High School Senior Mail-out
	Wall-Portrait Promotion	*August*	Fourth High School Senior Mail-out
March	Spring Special (keyed to Passover and		Back-to-School Family-Group Promotion
	Easter)	*September*	Fifth High School Senior Mail-out
	Graduation Reorder Promotion		Early Fall Promotion
	First-Communion Promotion	*October*	Fall Promotion continues
April	Spring Special Continues	*November*	Hanukkah/Christmas Promotion
	Book Proms and Dance Recitals	*December*	Last-Minute Pre-Holiday Promotion
	High School Senior Ambassador		Family-Group Special
	Sessions		Gift-Certificate Promotion

and other times it is almost impossible to entice them. The easiest times to motivate portrait clients are during the spring, with its Easter, Passover, Mother's Day, and Father's Day observances, and during the November/December holiday shopping period. Promotions usually are successful when tied to these seasons.

Another factor that affects special offers is the school calendar. Promotional campaigns are always most successful during school holidays. Parents have more time to prepare their children's hair and clothing, and teachers have time to bring their own children in for sessions.

Contrary to popular opinion, it is difficult to motivate clients when the weather is overcast, gloomy, rainy, stormy, or oppressively hot. Also, news of unsettling changes in geographic and economic conditions can kill sales. For example, in December 1990, a geologist forecast an earthquake for my area, and the United States was preparing to enter the Gulf War when Iraq invaded Kuwait. My studio's sales went flat when local people actually left the area. The Gulf War had little or no effect on my immediate area, and, fortunately, the earthquake never materialized. Nevertheless, fear is a terrible obstacle to overcome when you devise a marketing plan.

DEVELOPING A PROMOTION CALENDAR STEP BY STEP

You should set up a promotion calendar months in advance to allow for the preparation of advertising materials. About four months before the projected starting date, my associates and I decide what we're going to promote. Next, we select a photograph for the advertising piece and secure the client's signature on a special model release for that promotion. About three months before the campaign kickoff, we send the client's negative to the color lab for a glossy print that the printer can reproduce. We order the best retouching and color possible from this negative. The next step is to start copy preparation. Two months prior to the campaign, we send the 5 x 7-inch print and copy to the postcard printer. One month before the kickoff, we make up mailing labels and buy colorful, attention-getting postage stamps for the direct-mail piece. Then when the advertising piece arrives from the printer, we devote our spare time in the weeks before the promotion preparing it for mailing. The promotion calendar should incorporate national holidays, when it is relatively easy to motivate clients. Some promotions have worked particularly well for my studio.

SELECTING MEDIA

After you organize your promotion calendar, your next step is to decide which form(s) of advertising you want to use. A few years ago, I made a list of all the towns in which we had clients and then set up a spreadsheet to see which media would reach them. Direct mail and the Internet were the only media that would reach all of them, with newspaper advertising coming in third.

- *Radio.* Advertising time on radio stations is difficult for an inexperienced businessperson to buy because it is so complicated. If you were to survey your clients, you would probably find that they listen to as many as ten different radio stations, primarily while traveling. So you would have to buy time on several stations, probably during rush hour, in order to reach them.

- *Television.* Advertising on television is expensive if you buy primetime spots on major network stations. *Guerrilla Marketing* by Jay Levinson suggests a strategy for the effective use of cable networks and local nonaffiliated stations.

- *Mini-media.* In his book, Levinson recommends taking advantage of various bargain advertising outlets including bulletin boards, business cards, low-cost brochures, banners, signs, newsletters, circular, door-hangers, trade shows, home shows, contests, and sweepstakes.

- *Yellow Pages.* Once upon a time, each city had only one telephone book that offered Yellow Pages advertising. Now there are many in each city, which makes the decision difficult for an advertising buyer who doesn't know whether to buy ads in one or all of them. Many photographers spend too much of their budget on the Yellow Pages because the directories' salespeople are quite aggressive. These individuals continually knock at the door of my studio, so it takes a great deal of effort to resist their sales pitch.

- *Web site.* In my opinion, Web sites will soon surpass telephone Yellow Pages advertising in popularity because they are viewed in color, can be changed frequently, can offer multiple pages of information, and usually include a contact page allowing prospective clients to get in touch with the studio 24 hours a day, 7 days a week. Marathon Press (see Resources section, page 190) hosts our Web site, which provides excellent coordination with our seasonal promotions. Whenever we send copy to Marathon for a direct mail postcard, it also is posted to our Web site. Marathon has produced several Web pages which its customers can include on their Web sites at no additional cost. Subjects include copies and restoration advertising, decorating with portraits, and how to dress for portraits. Our Web site also includes a map showing how to reach our studio from the major highways and landmarks in our area.

- *School programs and yearbooks.* These mini-media outlets usually amount to goodwill donations. Some, however, can produce results, especially in large cities where regional advertising is necessary.

- *Magazines.* Well-known photographers seeking an upscale clientele advertise in magazines. For example, Yousuf Karsh has advertised for years in the *New Yorker,* and Sam Gray buys space in *Veranda* magazine.

- *Newspapers.* Advertising display space is affordable in small markets, but businesses in large cities may have to use classified advertising, free shopping newspapers, free community newspapers, or regional publications. When my late son operated a hair salon in New York City, he advertised in the *Village Voice* to attract potential clients in the East Village area where his shop was located.

 My father, a newspaper-advertising manager for more than thirty years, taught me some of this medium's principles of advertising:
 - Repetition is absolutely essential. It is far better to publish a small advertisement ten times than a large advertisement only once.
 - Readership is higher on Sundays and Wednesdays (or the weekday when food advertisements are published).
 - Target your market. Since women are the primary purchasers of portraits, request the section of the newspaper that most appeals to them.
 - The page placement of your advertisement is important. Try your best to get above the fold on a right-hand page. Since big, wide advertisements are usually placed at the bottom of a page, design tall, thin ads in the hope that they'll be displayed at the top.
 - Use reverse type, which consists of white letters on a black background. This attracts attention because a reader's eye is drawn to the point of greatest contrast on a page.

- *Direct mail.* You can compare newspaper and broadcast advertising to firing a shotgun and hoping you hit something, while direct-mail advertising is like aiming a rifle right at a target.

In 1965, my studio started with no customers and no business. To build a mailing list, I wrote down the addresses of the most prosperous-looking homes in town and then used the public library's city directory to find out who lived in those houses. I also bought telephone books of neighboring towns and added the names of the doctors and lawyers to my list. In a few years, as my photography business grew, I listed all the towns in which my clients were located and which media could reach them. Because direct mail was the only one that could communicate with all of them, I decided to spend the bulk of my advertising budget on mailings.

Today, my best prospects are previous customers because they know where my studio is and that they like my style of portraiture. As mentioned earlier, it costs far more to develop a new client than to retain an existing one, so I send out at least five mailing pieces each year.

When my staff members deliver an order, they include a stamped evaluation postcard so the clients can rate my photography, facilities, service, and advertising. A few days later,

Portrait by Charles Green, London, England.

Press that permitted the wallet portrait to show through. The window envelope is available in quantities of 100.

When I need a small-quantity advertising piece, I borrow DiCaprio's idea, having my lab print 2 ½ x 3 ½-inch color billfold portraits with die-cut rounded corners that I attach to a 4 x 9-inch card using double-sided tape. Sometimes I have the card done in two colors by a local printer; other times, my staff does it on a copy machine, with hand lettering or using a desktop publishing program.

---❖---

STRESS BENEFITS

In all forms of advertising—newspapers, magazines, or direct-mail pieces—headlines should emphasize benefits, not features. The primary outcome of a portrait is the expression of love, so the headline in most of my studio's advertisements is "Because you love them." Too many photographers focus on features, such as size and finish, rather than benefits. I use the following checklist for all of my advertising:

- ✦ What is the customer benefit?
- ✦ What is the date of the approaching holiday?
- ✦ Is the deadline for sessions and/or orders mentioned?
- ✦ Is the special price or size indicated?
- ✦ Is the amount of savings clear?
- ✦ Are the studio's name and address included?
- ✦ Are both the toll-free telephone number and the regular telephone number listed? (Providing a toll-free telephone number removes a roadblock that might prevent a prospective client from calling the studio.)
- ✦ Are the studio hours specified?
- ✦ On direct-mail pieces, is an address-correction line printed? (With the transitory nature of my clients, it is essential that I continually update my mailing list. The United States Postal Service provides me with address corrections at no additional charge on first-class mailings. The "Return Service requested" line must be printed 1/4 inch below the return address in the upper left corner of a direct-mail piece.)
- ✦ On direct-mail pieces, is there sufficient space for a postage stamp? (I prefer using colorful stamps on my direct-mail pieces because they're distributed faster, handled more carefully, attract more attention, and cost less in the long run via free address corrections than ads with plain stamps.)

I mail a thank-you card to them, enclose a business card, and ask them to refer me to their friends.

All previous clients are placed on my mailing list, which is kept on my computer's hard drive and backed up daily on disk and weekly on tape. Copies of the disk and tape are stored off-premises in case a disaster strikes.

Staff members post address corrections to the hard drive every time they send out a mailing piece. Even though I live in an area with little turnover, address corrections amount to about 1 percent each time I do a mailing, which translates to about 5 percent each year. In other parts of the United States, people move more often, thereby necessitating more frequent mailing-list updates.

My most effective direct-mail pieces have been 4 ¼ x 6-inch color postcards; they attract attention and their size makes it convenient for clients to place them on bulletin boards or refrigerators as a reminder to call for an appointment. My staff buys the cards from Marathon Press. I pay for the materials in advance, which results in a discount.

The minimum order for postcards is ordinarily 1,500, a figure that is too large for beginning studios. Bob DiCaprio of Woonsocket, Rhode Island, who had a short mailing list during the early days of his studio, solved this problem by ordering wallet-sized color prints from an outside laboratory, then sticking them on 4 x 9-inch cards that he printed on his own photocopier. He bought window envelopes from Marathon

BUILDING TEAM SPIRIT

J UST AS I BELIEVE IN working together with my clients to create beautiful portraits, I also want my staff members to work as a team. Building team spirit is one of the most challenging tasks facing a manager. Special expertise is required to communicate with, supervise, and motivate associates. Acquiring those skills takes a lot of hard work, training, and experience, just as it does to achieve camera competence.

At social events, I continually seek out executives who work in the human resources departments at large corporations to see how they're building team spirit. Three corporations in my area—FedEx, Kraft General Foods, and Nucor Steel—form small teams and reward them for superior production. These teams are also self-governing, setting work hours and holidays. Kenneth Blanchard and Spencer Johnson, the authors of *The One-Minute Manager* (see Selected Bibliography on page 191), emphasize that the reward doesn't have to be big. For example, they mention a restaurant manager who handed out $5 bills on the spot to employees who excelled in particular jobs like sweeping floors or cleaning restrooms. People want to feel appreciated by their colleagues and supervisors. A word of praise or, better yet, a tangible reward, goes a long way in building team spirit.

When a photography studio's sales and workload grow, the manager either must hire new employees or reduce the number of portrait sessions scheduled. Some photographers restrict new business by raising prices sufficiently to discourage some potential clients. Most professionals, however, add employees as sales increase.

DETERMINING WHEN TO INCREASE THE NUMBER OF EMPLOYEES

When hiring new employees becomes a necessity, you might want to keep in mind the following rule of thumb. This guideline links the number of people a studio can afford to annual sales in increments of about $110,000. For example, a business with $110,000 in sales can afford only one person, the photographer/manager; a $220,000 business can afford two people; a $330,000 business, three; and so on. The problem is that beginning studios with annual sales of less than 110,000 dollars have the same workload as businesses with 220,000 dollars in annual sales. This translates into longer hours—for less pay—and probably no profit until sales increase.

Another way to estimate when a studio can afford an additional worker is to look at the business's annual profit. Obviously, the profit must be large enough to cover the new worker's salary. It must also be able to accommodate taxes, insurance, and benefits.

Four years passed before my photography business turned a profit because it took time to acquire the necessary client base, skills, equipment, and confidence. For a while, I had three jobs, then two, and finally—after four years—just my studio. I felt like a free man!

HIRING NEW EMPLOYEES

The day arrives when you need to advertise for and hire one or more associates to work in your studio. When that day comes, studio owners and managers need to discuss the qualities they're seeking and what they're willing to offer candidates for employment. If we find highly desirable workers, we can be flexible, if needed, in order to add them to our staff. We might, for example, offer special work schedules to accommodate family problems. As you interview candidates, ask the following questions:

+ Would you like the opportunity to work with interesting people?
+ Do you communicate well with others?
+ Would people who know you describe you as a good listener?
+ Do you naturally respond to the needs and feelings of your clients?
+ Are you a caring, empathetic person?
+ Are you an individual who smiles a lot?
+ Do you smile when you make someone happy?
+ Do you work at getting people to like you?
+ Do you feel good when people you work with compliment you?
+ Do you understand the talents of the people you work with?

- Do you have a talent for establishing a good rapport with others?
- Can you sell aesthetically appealing photographs to an upscale, discriminating clientele?
- Do beautiful photographs stir your emotions?
- Can you discuss qualities of art and artistic expression with others?
- Are you professional in work, style, and appearance?
- Are you a hardworking, success-oriented individual?
- Are you a high-energy person?
- Is it important to you to have work done right and on time?
- Do tasks left undone bother you?
- How do you plan to achieve your personal goals?
- Would you like a chance to join a company you can stay and grow with?

Some photographers advertise for prospective employees, others go through employment offices, and still others rely on networking to find the right person for a position they want to fill. You'll find the following guidelines helpful when you are ready to start interviewing.

The first step is to write down the job description and the necessary qualifications. This will enable you to clarify exactly what kind of person you're looking for, as well as the responsibilities the position entails. Later on during the interviewing process, check to see that candidates turn in completed application forms. Omissions indicate a lack of thoroughness or even an attempt to hide unflattering information. You should have applicants sign and date a statement that all the information provided is correct and complete, with all previous job experience listed. You should also ask for permission to investigate past employment, with former employers authorized to provide all information requested. This statement will help you obtain references in an era when employers are reluctant to disclose information out of concern over potential legal problems.

Be sure to document information obtained during an interview, especially reasons for hiring or not hiring applicants. This will be useful in the event of a discrimination charge. Check the candidates' past records. Have the applicants made steady progress? Have they continued their education and growth? Are they job-hoppers? Look for unexplained gaps in employment. Study the applicants' references and acquaintances carefully. What do you know about the applicants' mental capacity and honesty? If the applicants agree, clinical psychologists can test them for intelligence, motor skills, and truthfulness.

Interview candidates more than once. Have your business partner interview them, too, so you can get more than one opinion. List their strong points and weaknesses. Visualize the candidates in the position, and then give some thought to what they would be good at and where they might fall down.

Selecting the right person the first time will prevent a lot of headaches in the future. I try to find people with three essential abilities: to think, to train, and to get along with others. When I hire new associates, I make it clear that their employment begins with a six-month "introductory" period, during which time they can be dismissed without notice. After this interval, they become "regular" associates and are evaluated every six months. I think that it is also important to have all team members periodically evaluate themselves and then discuss their analyses with their supervisor.

ESTABLISHING EMPLOYEE GUIDELINES

Each business must make choices about a wide range of policies regarding staff members, and it is much better to set up employee guidelines before a problem occurs. In fact, this is a necessity in today's employment climate. For example, when a personnel question arises, I don't want to make a spur-of-the-moment decision that I might regret later. Associates might want time off to attend a friend's funeral or to stay home with a sick child. Staff members might also want to use the company telephone for extended personal calls, entertain frequent visitors at the studio during business hours, or take home company equipment for private use. You must decide where you stand on these matters before the issues arise. For my business, I wrote a simple ten-page policy manual. If you follow suit, your manual must contain a statement saying that policies are subject to change at any time without prior notice. When policies are changed, employees must sign and date an amended statement. The topics I cover in my policy manual include:

- Work hours and schedules
- Work-performance plans, goal-setting, and job evaluations
- Procedures and conduct when dealing with clients
- Paper flow and order procedures
- Staff meetings
- Overtime work
- Secondary employment/moonlighting
- Time and frequency of salary distribution
- Bonuses and incentive pay
- Dress code and grooming for safety, business, and image
- Breaks and mealtimes
- Vacations
- Holidays
- Sick-leave policies

- ✦ Excused and unexcused absences
- ✦ Extended-leave policies
- ✦ Hospitalization and life insurance programs
- ✦ Accident/injury procedures
- ✦ Housekeeping requirements
- ✦ Personal use of studio equipment and facilities
- ✦ Employee purchases and discounts
- ✦ Advancement opportunities
- ✦ Training and educational opportunities
- ✦ Retirement/profit programs
- ✦ Employee rights and grievance procedures
- ✦ Firing policies and documentation
- ✦ Employee resignation and notification

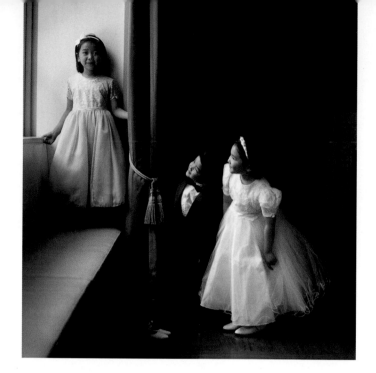

Finally, during the new associates' orientation, show them a checklist that includes the statement that they've read and they understand the policies, and that they agree to adhere to them as a condition of employment. Then have the new staffers sign and date the checklist.

Portrait by Yumiko Ariga, Tokyo, Japan.

EMPLOYEE RESPONSIBILITIES

Most portrait studios start with one person, the founder/owner. This individual has to do all the tasks that might otherwise be done by forty people in a large studio. As the business grows, the workers still must be able to handle a multitude of tasks, from cleaning the windows to decorating a gallery. To succeed, associates must have not only the ability to learn new tasks, but also the willingness to do such dirty jobs as basic janitorial services. The four members of my staff help one another whenever necessary, but each associate has specific responsibilities.

Belinda handles reception-room sales, telephone sales, order deliveries, final order checks, overdue originals, overdue deliveries, posting accounts receivable, posting daily reports, setting up new accounts, monthly promotion reports, monthly sales-tax reports, preparing advertising, promotions, price lists, brochures, model releases, frame inventory, frame pricing, and office-supply inventory.

Linda is in charge of production. This includes organizing proofs and orders for delivery, preparing session cards, confirming sessions the day before they're scheduled, setting up computer records, securing family histories, printing out daily session schedules and labels, posting birthday lists, mailing out birthday cards, maintaining mailing lists, backing up the computer daily, totaling daily reports, making up deposits, addressing advertising mail-outs, and maintaining point-of-sale card racks. Linda also opens and closes the studio each day, greets clients when they arrive for sessions, shows finishes, explains prices, and collects session fees.

Jo Alice is in charge of accounts payable, payroll, set design, children's photography, making signs, and cropping originals.

I am the primary photographer. I also inspect originals, write lab orders, and supervise quality control.

REWARDING EMPLOYEES

Through the years, I've learned one of the greatest principles of management is that *what gets rewarded gets done*. So I try to build team spirit by rewarding the entire staff when the studio is particularly successful. I offer a "carrot" for each month that the studio exceeds sales for the same month in the previous year. For example, if sales for May this year are higher than last May's sales, each member of the team (including the manager) receives a cash bonus. It comes as part of their paycheck with taxes withheld.

The advantage of this plan is that every team member benefits from a job well done, thereby avoiding unhealthy competition between sales personnel that can result from individual sales commissions. For example, if my salespeople worked on individual commissions, they would compete to be the first to wait on a good customer who places a big order every year. But under the team system, my sales staff cooperates with each other to help a client placing a large order. One sales associate might put the portraits in frames while the other writes out the invoice.

I also give out bonuses in mid-December if sales for the year surpass those of the preceding year. All members of the staff get the same bonus, with taxes withheld. Finally, associates receive a longevity bonus on the anniversary of their employment with the studio.

SERVING CLIENTS

MY PORTRAIT STUDIO WILL CONTINUE to be successful only to the extent that my staff and I find new ways to improve our service. Individual selling is an avenue of providing service. It is also a way to determine what clients really want and help them find it.

My sales philosophy insists on no negotiation, no intimidation, no manipulation, no intrigue, no tricks, and no pressure. I've been in business for more than thirty years, and clients return year after year because I treat them fairly and respectfully.

The telephone is the most important tool in a salesroom, so you shouldn't leave it in the hands of an untrained person. It is vital to spend time training yourself and your colleagues in the proper use of the telephone. The person answering the telephone should speak slowly and clearly in a well-modulated voice. The conversation should reflect the kind of warmth you would hear between two good friends. Finally, the telephone salesperson needs to learn to really listen to what the potential client is saying. This will enable the salesperson to show understanding and empathy regarding the customer's inquiries.

HANDLING TELEPHONE INQUIRIES

My staff members are well trained in the art of dealing with telephone inquiries. They know how to find out exactly what potential customers want, as well as how to explain the corresponding information in a clear, concise manner. Here is a typical exchange between a prospective client and a staff member:

"McDonald Photography. This is Maria. How may I help you?"

"How much is an 8 x 10?"

"Is this to be a portrait of yourself or someone in your family?"

"I want a picture of my daughter, Elizabeth."

"Can you tell me a little bit about Elizabeth?"

"She won't sit still, she's into everything, she's as curious as a cat, and she has a mind of her own, but she's beautiful!"

"How old is Elizabeth, Mrs. . . . ? I don't believe I heard your name."

"She's two, and my name is Laura Dumas."

(On a notepad by her telephone, Maria writes down both names and Elizabeth's age. She looks into a mirror on her desk and remembers to smile.)

"Mrs. Dumas, two is a wonderful age to capture a child's personality. This is the age when children become aware of their individuality and are more challenging to photograph, but Jo Alice is marvelous with children. She entertains them while Tom captures their expressions on film. Tell me, how will you use the portraits?"

"I'll probably hang one on the wall and give some to her grandparents."

"Where do you plan to hang the wall portrait?"

"Either above the fireplace or in the hall."

"May I suggest you visit our gallery here at the studio so you can see how various sizes fit in different areas? A mantel calls for a larger portrait than a hallway does, and we have all sizes on display here. How do you plan to light the portrait?"

"Well, I really haven't thought about that."

"When you come to the studio we can show you several ways to light a wall portrait: wall-wash ceiling fixtures, track lights, picture lights fixed to the back of the frame, or projection spotlights that can be focused to illuminate just the portrait, not the entire wall. Have you seen our work before?"

"Yes, I saw your gallery at the mall."

"I'm glad to hear that. When you come to the studio, we can show you not only different picture sizes but also many of the portrait finishes available, as well as our display of imported and domestic frames in all sizes. Which day would be best for you to visit us?"

"Well, I take Elizabeth to day care on Thursdays, so that's always a good day to run errands."

"Excellent. Would morning or afternoon be better for you?"

"I think morning while I'm still fresh."

"Fine. I have an opening this Thursday at 10:30. Is that convenient for you?"

"Yes, that's perfect."

"Now may I get the spelling of your name, with your address and phone number, so we can put you on our mailing list?"

The telephone conversation started with a question about price, probably because that is all Laura knew to ask. Maria's response showed that she was genuinely interested in getting to know Elizabeth and learning about Laura's needs. Maria created a desire for Laura to come to the studio so she could make intelligent decisions about her future purchase. Then Maria gave Laura a series of choices about the appointment time, none of them phrased to elicit "yes" or "no" answers. Maria wrote down the customers' names immediately so she could converse more personally with Laura. The mirror on Maria's desk reminded her to smile because a caller can perceive her attitude through the tone of her voice.

This young man came to the studio with a leather flight jacket, so I gathered up some air history magazines and a B-17 bomber model to help tell the story of his interest in flying. Hasselblad 150mm lens, *f*/11 at 1/60 sec., Fujicolor Portrait NPS 160 Professional

The day before an appointment, whether it is for a shooting session or a sales conference, one of my associates places a reminder call to the client. If the customer cancels, my staff member has time to contact other people on a waiting list for session times. And if a client is late or fails to show up for an appointment, a staff member makes a call that maintains goodwill, so the client doesn't feel guilty. This conversation might begin with the following remark:

"Laura, this is Maria at McDonald Photography. I must have made a mistake. I had you scheduled for an appointment today at 10:30. Can you please check to see what time you have us on your schedule?"

THE CONSULTATION

When customers come to the studio for a consultation, my associate's attitude and command of the situation establish the tone of the entire interview. The staff member must remember several important elements. Smile, be friendly, and show enthusiasm for and genuine interest in the clients and their portrait needs. Our staff member must also prepare for the interview by gathering all the sales aids needed, such as sample albums, price lists, clothing-suggestion brochures, and pre-portrait videos. Brochures showing examples of both good and bad wardrobe choices are available from Marathon Press (see the Resources section on page 189).

You can also help your clients visualize how their final portrait will look on the wall by showing them a display with

a range of picture sizes. This grouping might include, for example, a 20 x 24 and three 16 x 20 prints in the projection room, a 24 x 30 and a 30 x 40 in the frame room, a 30 x 40 in the foyer, and a hallway gallery consisting of several 16 x 20, 10 x 20, and 20 x 24 prints. Be sure that all the portraits are framed and have signs that identify the subject, size, and finish. For example, a label might read "24 x 30 Mantel-Size Portrait." And keep in mind that since the correct viewing distance for a 30 x 40 is 15 feet, the salesroom must be large enough for proper perspective. If possible, you should also arrange to show your client your own family-group portrait, preferably framed as a wall decoration.

You should remind your staff members that empathy is absolutely vital to a salesperson's success. Until you can see through the eyes and hearts of your clients, you aren't in any position to serve their needs. As noted California photographer David Peters says, "The consultation is a time to find the client's deep needs; the portrait is only a representation of that need." Asking some revealing questions will enable you and your associates to understand your customers better. Use the following suggestions as a jumping-off place. After you delve into your client's motivations, you should thank them for sharing their feelings with you.

✦ What do you think the perfect portrait looks like?
✦ Where would you put your ideal portrait?
✦ Did you have your portrait taken growing up?
✦ What do you remember about your mother and father when they were your age?
✦ What would you like your children to remember about you? And vice versa?
✦ What kind of parent is your spouse?

———— ✤ ————

THE SALES INTERVIEW

In Sweden, photographers call proof projectors "money machines" because they are so effective in increasing sales. Many clients who come to the studio thinking in terms of an 8 x 10 or 11 x 14 leave with a 20 x 24 print after seeing their proofs projected to 30 x 40. And photographers who can project 96 x 120-inch images find they sell more 40 x 60 portraits. It seems that the bigger you project images, the bigger you sell.

Unfortunately, many studios try temporary projector setups in the camera room or other areas not designed for projection, and they miss sales opportunities. If the projectors are permanently installed in a room that you can properly darken, you'll be able to persuade clients to attend a viewing session. Sales personnel also will be more inclined to show proofs on a projector if it is already set up. Intelligent people tend to do what is easiest and fastest, so it is up to the studio manager to make proof projection an enjoyable event.

No matter how proofs are projected, sales seem to increase. Some photographers prefer to use slide proofs with two projectors, dissolving from one to the other while playing evocative music. Slide proofs provide the sharpest large images of all the systems available; this feature is especially important for group portraits, in which the heads are small.

Probably the most popular system involves the use of a digital projector that enlarges images from a compact disc. The photographer sends the film to the lab, which puts them on a CD. Most photographers edit the images with software such as Kodak ProShots, Apple i-Movie, Kai's Power Tools, or Club Photo (See Resources section on page 189). These systems enable them to put numbers on the proofs and add music to the show. Then they can print proofs on an inkjet printer or copy the images onto a VHS tape using a Focus Enhancements TView Gold attachment on their computer.

The advantage of a VHS tape is that most clients have VCRs, but prints copied from the tape are so poor that they are not likely to hurt sales of finished portraits. I don't recommend letting clients take home the CD because it's easy for them to make prints on their home computers, severely injuring sales. Some photographers use cathode-ray tube (CRT) television sets to show proofs, but in my opinion, their picture quality isn't as good as digital projectors.

Photographers who like to deliver paper proofs use opaque projectors, such as the Beseler, Astrascope, EnnaScop, or Braun Paxiscope-XL. Our studio still uses paper proofs because our trade area extends 70 to 100 miles, making it difficult for our clients to return for a projection showing. These paper proofs provide excellent advertising for us when our clients show them to their friends and relatives. The danger of paper proofs being copied or scanned is reduced by the textured finish applied by the lab.

Once the preparations are complete, your staff member can proceed with the sales interview. When Laura arrives at the studio, Maria greets her enthusiastically in the lobby: "We have some exciting poses to show you." Maria invites Laura to sit next to her at a round table in the projection room. (Far superior to a counter or desk, a round table removes a physical barrier between my associates and the client.)

Two wall switches next to Maria make it easy for her to turn on the projector and turn off the room lights without having to walk in front of the client. Next, Maria turns on the projector to show the proofs, and, using PowerPoint, the computer dissolves from one image to another on a 24 x 30-inch movie screen. Soft, emotional music (for which copyright has been cleared) adds another dimension to the client's sensory perception. Our favorite song is "I Have You" by Connie Kaldor and Carmen Campagne, which places the love of a child above the love of material things. Other sources

for copyright-cleared music are listed in the Resources section on page 190. Maria gets Laura's reaction to the show, then narrows the selections to Laura's favorite poses. This presentation makes quite a contrast to a photographer handing a manila envelope to the customer over a glass counter.

After Maria has edited the pose selected by her client, she projects it to 30 x 40 inches on white mat-board in a frame. The wall-sized image is breathtaking in glorious color. The conversation might go something like this:

"Notice how much more clearly you can see expressions at this size, even from across the room," Maria points out. "In this full-length pose, Elizabeth's face is about the same size as it would be in an 8 x 10 close-up.

"What size is this?" asks Laura.

"30 x 40, which we call 'Life Size,'" Maria answers.

"How would it look in a smaller size, such as a 16 x 20?" asks Laura.

When Maria holds a 16 x 20 frame inside the 30 x 40 board, it looks like a postage stamp.

"I didn't realize it was so small," Laura exclaims.

When Laura expresses interest in seeing a smaller size, Maria shows her the image at 20 x 24, which she buys. Projecting proofs usually will result in an increase of at least one size from what the client planned to buy. For instance, if she had planned to buy a 16 x 20, she almost always will purchase a 20 x 24 or perhaps a 24 x 30.

"May I show you our finishes once again to refresh your memory?" Maria asks. She points out the differences between the three finishes and comments, "Of course, there's nothing wrong with the least expensive finish, but notice the painstaking work the artist did on the better finishes."

After Laura selects the middle-range finish, Maria fills out an invoice form, asking her to sign and approve the purchase.

"We require a first payment of 50 percent. Would you like to pay by check or charge card?" (Note that my associate uses the word *payment* instead of *deposit*; this is because this money isn't refundable.) Once a client has committed to buying a portrait, I'll have to pay the lab for it. Instead of giving Laura an opportunity to say yes or no, Maria closes the sale with a minor decision about method of payment.

This entire sales interview lasted thirty minutes, which is typical of studios doing a medium volume of sessions. Sales appointments are always scheduled for when two staff members will be present so that one can answer the telephone and handle drop-in clients. If clients need an appointment during the lunch hour, my staff members and I shift our schedules to accommodate them.

Serving our clients continues until they drive away with the order, and beyond. If I see a client leaving the studio after picking up an order or after a session, I walk the customer to the car and offer to help with the children and packages. I've instructed my staff to do the same. On occasion, my associates or I even go to a customer's home to help hang the portrait and suggest ways to light it. Service never ends.

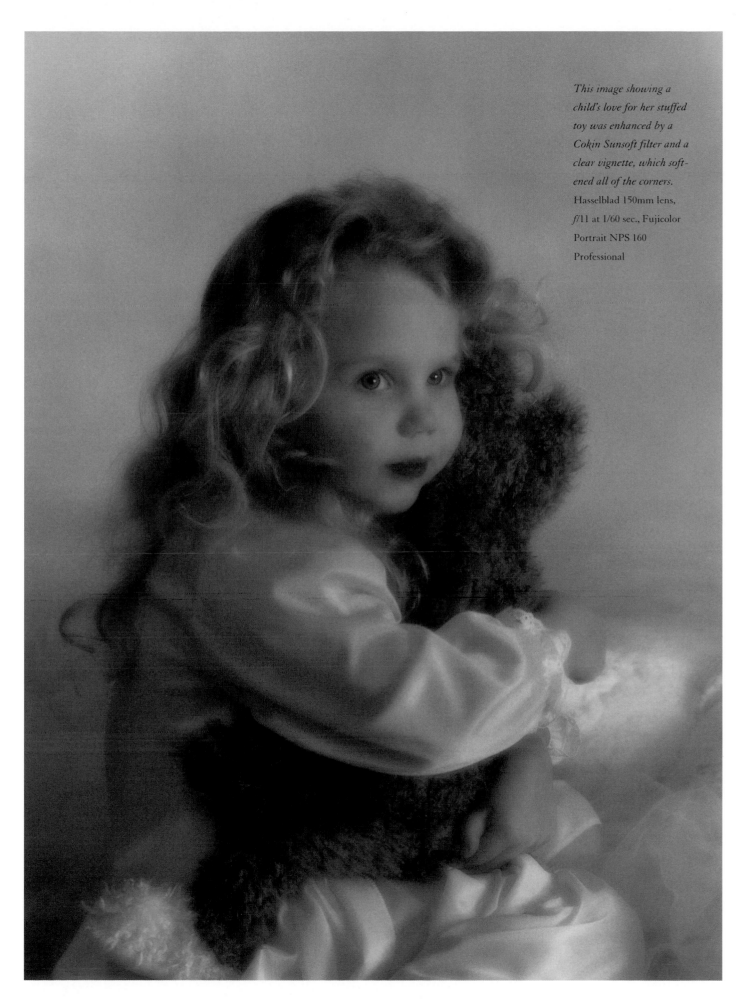

This image showing a child's love for her stuffed toy was enhanced by a Cokin Sunsoft filter and a clear vignette, which softened all of the corners. Hasselblad 150mm lens, f/11 at 1/60 sec., Fujicolor Portrait NPS 160 Professional

PROTECTING YOUR WORK

I T'S ALMOST IMPOSSIBLE TO EARN a profit in photography unless you protect your work from illegal copying. My view is that most people are honest, but are ignorant of copyright laws. Therefore, our first job is to educate them about copyright laws.

This education process starts when the client arrives for the session. We ask them to sign a document, called a *copyright caveat,* which outlines what they can and cannot do with the images we produce. (Used frequently by lawyers, caveat is the Latin word for "warning.") An example of this form is printed on page 113. After the client signs, one copy of the document is placed in the negative envelope for permanent filing and another copy is enclosed with the order when it leaves the studio.

Other steps in the education process include a note on our price lists which states that "images created by McDonald Photography, Inc., are protected by copyright laws of the U.S." When orders leave the studio, a form designed by the Professional Photographers of America that advises clients about their responsibilities in regard to copyright is enclosed.

COPYRIGHT IMPRINT

To discourage others from copying our prints, we imprint all images with our name and a copyright symbol (©). All prints 4 x 5 inches or larger are stamped with gold foil using machines made by T.J. Edwards or Veach, which heat up a specially made dye with our name and copyright seal. The die is imprinted onto the photograph in gold foil. I sign all canvas-mounted prints with a gel rollerball pen that comes in several colors including gold and silver. Billfold-sized (2 $\frac{1}{2}$ x 3 $\frac{1}{2}$ inches) prints are imprinted by our professional laboratory, with a masking negative or digitally inserted signal. Our lab also prints a copyright notice on the back of each print. However, this is covered up when the print is mounted, so it's necessary to imprint the front of larger prints.

Professionals on duty at a photo-finishing service or business copy center normally will not copy prints that have a copyright mark on them. The Professional Photographers of America, Inc., along with Olan Mills, Inc., and others, has won court judgements from some large photo finishers who copied work protected by professional copyright. This has discouraged local retailers from accepting prints that are protected by copyright seals.

ADDITIONAL PROTECTIVE STEPS

To make it even more difficult to copy prints, we ask the lab to texture them, breaking up the surface of the print by pressing them with a metal plate that leaves a pattern. Some of the patterns available include etching, pebble, and our favorite, linen, which looks like fine canvas. The texture diffuses the copied image, especially in the dark areas, making the copy image extremely poor.

When images are released electronically, many photographers and their vendors protect them by inserting a word such as "proof" next to the subject's face. If clients attempt to copy an image from the Internet or from a compact disk, they will have to do hours of work to remove the word "proof" from the image. With sufficient safeguards, clients will order from their professional photographer rather than taking the time and effort to copy their work.

Some photographers send out tiny thumbnail images from their computer printers for clients who feel they need to take home proofs. The quality of these images is too poor to copy.

Others copy their work on videotape, which can be played, sometimes with music, by clients at home. With current technology, prints from videotape have such poor quality that they are not a copyright threat.

FEES AND MINIMUMS

For most photographers, the sale of extra prints is important to their profit picture. A few photographers overcome the copyright problem by collecting a large fee in advance of the session, usually amounting to their average sale. For instance, if portrait sessions averaged $500 in the previous

year, the photographer would collect that amount at the start of the session in the form of a session fee or minimum order. If they collect a large session fee, then they are able to sell prints at a much lower price, thus making it more practical for the client to order from the photographer than go to a copy station.

With a minimum order requirement, the client must buy a certain dollar amount so that the session fee is lowered but the print costs are kept relatively high. For instance, the session fee may be $100 with a $400 minimum order in prints. The entire $500 is collected at the time of the session.

Most photographers can't command a big fee up front. The clients usually have a "wait-and-see" attitude, which means the photographer must show a beautiful set of proofs before the clients will pay a large sum of money for portraits. Some photographers are skillful in marketing plans which have the perception of a low front-end price but wind up with a large order.

Most of us would be surprised to discover the size of the average order produced by studios operated by big photography corporations who generate millions of dollars in sales each year. Almost all of them advertise a low price to attract sessions, then increase the order by using time-proven sales methods. For instance, they may print a speculative $200 package from the best pose in the session, while printing the package offered in the advertisement from the worst pose in the session. Often the client will accept the $200 package rather than a poor pose from the advertised $9.95 package.

I understand that images made at McDonald Photography are copyrighted under U.S. laws, and I must order additional copies from McDonald Photography, Inc. I understand that it is unlawful for me to copy their images in any form or have copies of their images made elsewhere.

McDonald Photography grants you the right to have your images printed in newspapers, magazines, business cards, computer web-sites or school yearbooks. Reproduction permission is specifically denied for use at copy stations, copy machines and scanning by you or anyone else.

(Signed)

(Date)

2915 Browns Lane, Post Office Box 1385
Jonesboro, AR 72403-1385
(870) 935-4522
FAX (870) 935-4550

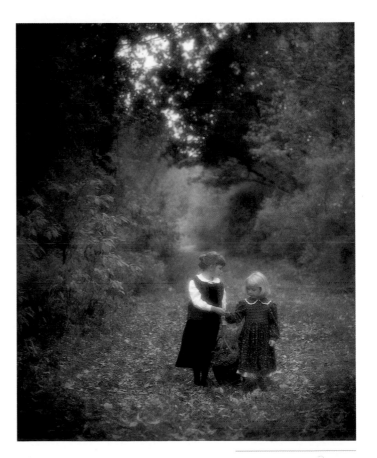

Two girls examine a leaf while on a walk through autumn woods. I used a Tallyn number 3 Softfuser to create the look of an Impressionist painting. Hasselblad 150mm lens, f/8 at 1/125 sec., Fujicolor Portrait NPZ 800 Professional

Sample copyright caveat.

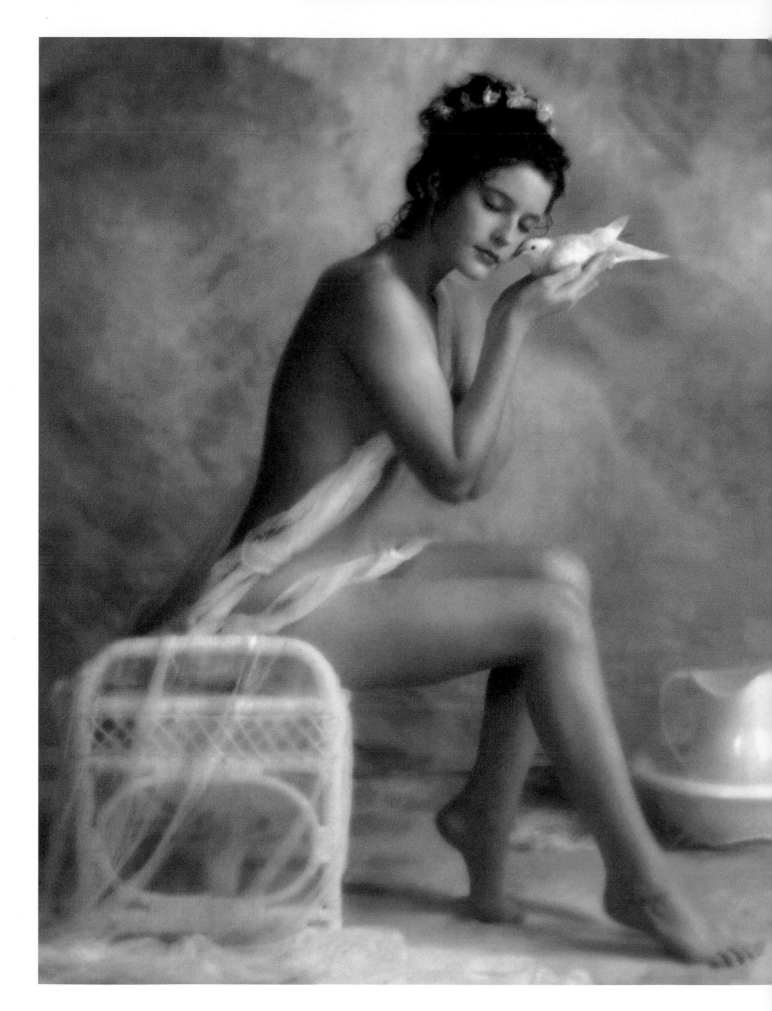

PROFILES

YUMIKO ARIGA

MANAGING *an eighty-six-year-old business requires constant market research and a willingness to change styles as people change. In recent years, Japanese young people have been influenced by television and magazines from all over the world, so they are better educated in art and photography than they used to be. High quality is the key to success in the future, just as it has been since my grandfather founded our company in 1915.*

PHOTO. KUNST-ATELIER ARIGA aims to be an all-around studio, history-wise, art-wise, and technique-wise. My father and grandfather had lives full of ups and downs, so our methods have come from the lessons of survival through wars, earthquakes, and economic hardships. After classical photographic training in Berlin prior to World War I, my grandfather had to escape from Germany before returning to Japan to establish our company.

In 1923, our studio building was completely destroyed by a fire resulting from the Great Kanto earthquake, which had a magnitude of 7. We lost most of the exposed dry plates and original prints. Ten years later, my grandfather built a five-story concrete building a few blocks away from the original building in Ginza. During World War II, it was bombed by B-29s, but fortunately we lost just the upper part of the building.

My grandfather became ill after the war, so my father supported the family by developing film and prints for the American soldiers. Since my father had a degree in dye chemistry from the Tokyo Institute of Technology, he became very interested in color photography. He researched it extensively, matching color negatives and paper with strobe lighting. My father taught photo science at Chiba University for almost thirty years, in addition to lecturing to photographic associations and institutions. He showed an interest in almost all kinds of visual media, such as VTR, holography, and ceramic photography. My father's extensive collection of old cameras, tintypes, and daguerreotypes are in a showcase in our reception room so the public can admire this memorabilia.

I've been interested in art and photography since I was a child, but I never had my own camera until I went to the United States as a high school exchange student and decided to make a journal with pictures. I decided to become a photographer and studied at the Rochester Institute of Technology (RIT) for four years, receiving a Bachelor of Fine Arts degree in 1986. Photo critique was emphasized at RIT. Teachers gave us exercises, and each of us solved the problems in our own way. Seeing how everyone else solved the problems enabled us to learn from each other.

My father died in 1985 while I was at RIT, so my grandfather encouraged and advised me until he died in 1993 at the age of 104. Since my father and grandfather passed away, my mother and I have participated in the business. My mother, Masumi Ariga, does office work and accounting, while I handle marketing and photography.

Operating five studios requires careful quality controls. We have studios in four hotels in the Tokyo area, plus the main studio in the Ginza District of downtown Tokyo, which has a population of about eighteen million people. Some of our photographers have worked with us for more than twenty-five years, so we leave them in charge of our hotel studios. We have about twenty employees in the Ginza studio, eight at the Keio Plaza Hotel in the Shinjuku District in Tokyo, seven at the Royal Park Hotel in the Nihonbashi District in Tokyo, five in the Keio Plaza Hotel in the Hachioji District in Tokyo, and ten at the Keio Plaza Hotel in Sapporo, Hokkaido.

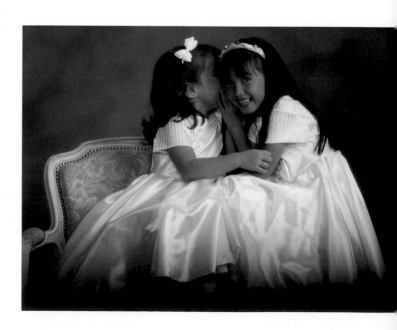

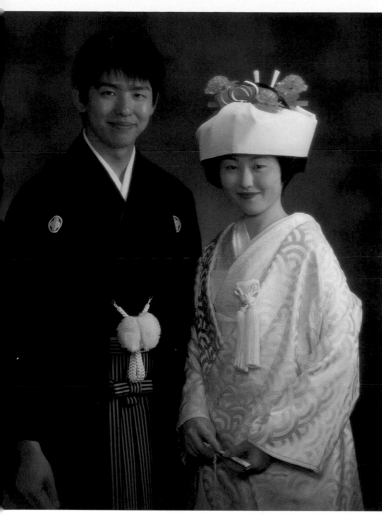

prior to such occasions as Coming of Age Day, 7-5-3 Day, Decoration Day, and the wedding season. For example, January 15 is Coming of Age Day, a national holiday when twenty-year-old people get dressed in kimonos and have their pictures taken at portrait studios. Then they go to pray for their health and future.

Coming of Age Day is one of the busiest times of the year for portrait studios in Japan. We promote Coming of Age Day with advertisements in a national newspaper in December and on New Year's Day. Two years after clients have had their portraits taken on Coming of Age Day, we send them direct-mail advertising for graduation photos. We continually market ourselves to the public.

Although we are not using digital cameras as yet, we have purchased a Fuji Kaleida GP24 inkjet printer, enabling us to make large posters, prints for window display, and photo album covers. Since the quality of digital prints has improved so much in the last few years, we sometimes make wedding albums with a mixture of traditional and digital prints.

Most of our staff members study with us for about five years, then return home and work in their fathers' studios. We try to give them as much experience as possible while they are here, so they rotate from position to position. The different tasks include acting as photo assistant, developing negatives (black and white or color), retouching negatives, printing (black and white or color), retouching prints, and mounting.

Members of the Imperial family, prime ministers, ambassadors, financiers, doctors, artists, and musicians are among our clients. Portraiture makes up 80 percent of sales in the Ginza studio, with the other 20 percent coming from weddings and commercial accounts. However, weddings account for 90 percent of the work in our four hotel studios since most Japanese couples are married in hotels.

When a client first comes to the studio, we show examples of our work in 8 x 10 prints. Proofing is done on 4 x 5 silk paper, and we allow our clients to take proofs home for selection. (However, we make "void" holes in them.) The proofs are numbered, so it is easy for clients to call us and place an order.

About ten times a year, we advertise in the newspaper

KEVIN AUYONG

PLEASANTON, CALIFORNIA

OVER A FOUR-YEAR SPAN *I accumulated nearly $130,000 worth of debt spread out over several credit cards. It wasn't easy to change careers from UPS employee to professional photographer. In just seven years, however, I developed a profitable portrait business in the San Francisco area. I guess what I should have done was to file for bankruptcy, but for some strange reason I always felt that I could turn the business around, pay off this huge debt, and make a lot of money.*

BY WORKING SEVENTY to one hundred hours a week, I was able to establish a viable business in four years. When I look back on how I started my business, I really wonder how I managed to get where I am today. It is definitely not the way I would recommend to anybody. Sometimes ignorance is a blessing, for if I'd had any sense at all I would have quit when I got so far in debt.

Initially, I planned to become a fashion photographer, but the work of David Peters (see page 156) and Lisa Evans (see page 132) showed me that portraiture could satisfy my need for a creative outlet and provide a handsome income, as well. About this time, I received a phone call from a person who had seen my work and wanted me to do portraits of her and her children. I explained to her that I was not a portrait photographer, but she said the reason she called me was because she wanted portraits that were not traditional. I wound up making $400 from that session, which was more than I had ever made from doing model portfolios.

I quickly learned that I needed to eliminate product lines such as weddings and model portfolios to concentrate on portraiture. Client referral led me to a session with two young brothers. The younger one kept crying and falling off a log he was sitting on. As I edited the preview slides, my worst fears came true. I wasn't happy with any of the images I had taken. But as I learned later in my career, photographers are overly critical of themselves, and we should let our clients be the judges. Mustering up as much confidence as I could and applying all the sales techniques I had learned from others, I produced a $2,500 sale! I was in shock. It was then that I decided to become an environmental portrait photographer.

Believing that it's not how much you gross, but how much you keep, I advise newcomers to start small with little equipment, working alone until the money starts coming in. I know some

photographers who started working out of their homes part-time, using only 35mm cameras and no lights, but within a year were earning a full-time living. Their start-up costs were not very high because they didn't spend much on equipment.

When you're starting out, it is really hard because you have doubts every single day. You wonder why you're not doing more portrait sessions. You wonder why your sales aren't higher. You begin thinking that maybe your photography is not good enough to sell. All these things eat at you and erode your confidence. It becomes a vicious downward cycle that has to be overcome on a daily basis. Every day you are not busy gives you a lot of time to reflect on these negative thoughts.

A burning desire to succeed kept me going. I was obsessed with it. I lived and breathed portrait photography seven days a week, 365 days a year. That hunger was one big reason I stuck with it. The next most important thing was the support of fellow photographers I met through our local association.

Their constant encouragement and friendship was vital. I found that we all had common problems, so I didn't feel like I was alone.

After completing college with degrees in business and photography, I thought I knew everything there was to know about photography. The truth was I didn't know anything at all. In college, they teach you photography techniques, but not how to make a living at it.

Aspiring photographers should join a local Professional Photographers of America–sponsored group and attend all of their educational opportunities. Then I suggest trying to become an apprentice for a photographer who has a successful business even if he or she isn't a great image-maker.

Making a session a pleasant experience probably is as important as the portraits themselves, because people are willing to pay more for a better buying experience. I want clients to know that when they come to my studio, it is a special place with special art. I think if you meet with clients ahead of time and listen to what they have to say you can virtually eliminate many problems that arise because of a lack of communication.

Price objection is one of the biggest problems in my business. Many of these objections stem from mass production studios having "brainwashed" the public. Everyone thinks the normal pricing for portraits is $9.95 for 104 photos, making it difficult to educate prospective clients.

I decided to specialize in children's and family portraits since they would fit into the pictorial style I wanted to do, which could be shown better in larger-sized portraits. I also decided I would pursue non-contract high school seniors. There was next to nothing for competition to capitalize on because I offered something they couldn't. I also considered doing boudoir and model portfolios, but when I ran the numbers there just weren't enough profits in there to make me happy.

Many photographers are jumping into digital imaging without making proper business decisions. Most studios will find that an analysis of their business workflow will reveal

they will make less money, not more, with digital. As much as I want to jump into digital, I can't figure out a way for it to make me more money.

Through my lab, I use digital retouching on almost all of my work. I'm capable of doing it myself, but the lab can do it cheaper. One of the unfortunate byproducts of digital retouching is that some photographers approach it as the Magic Fix and become careless. They think that digital wizardry will save them each time and turn garbage into salable masterpieces. There is a saying in the computer world: "garbage in, garbage out."

Except for high school seniors, I do not allow proofs to go out of the studio. Instead, I use a computer projector to show clients mural-sized images. At one time, I showed images on slides, but I have switched to a 60-inch TV and a Tamron Fotovix, cutting my lab bill substantially. In six months' time

I saved enough on lab bills to pay for the Fotovix. When you send a client home with proofs, you are not able to control the sale, which is important because they need our expertise as artists to guide them through the purchase of an adequately sized portrait.

Because of the time needed to make sales presentations for high school seniors, I sell them their proofs before they leave the studio. Clients sign an agreement that if they bring them back in one week, I will buy them back or apply the amount to their order. The proofs are numbered with a Sharpie pen with part of the number touching the face of the subject—not enough to block decisions on which pose to choose, but sufficient to discourage copying. If the proofs don't come back, they have bought the set. No one wants to keep the marked proofs as I charge a hefty amount for them. Since I instituted this policy, I have had prompt returns and fewer copying problems.

GEORGE BALTHAZAR

*A*S THE FIRST AFRICAN *American Certified Master Photographer in the State of Texas, I'm aware that there aren't many minority (especially African-American) photographers who are members of professional associations. In fact, there are only five African-American Masters of Photography in the Professional Photographers of America.*

THE THING I LIKE ABOUT PPA print competition is that prints are judged on each photograph's merits. The print monitors don't say, "The next print is by a black photographer"—they just call out the title of the print. There was once a time when minorities did not have access to educational opportunities like they do today. Now, a great many more minority photographers exist than one might imagine.

Creativity comes naturally to some photographers, while others have to work twice as hard. I had to work much harder to become a photographer and to achieve a certain level of photographic proficiency because I was self-taught and lacked God-given artistic talent.

Hard work and teamwork are the chief reasons for our success. Our support team consists of my wife, Debbie, who is the brains and creative force behind our business, along with our three lovely daughters, Toni, Annie, and Angee. They are my "indispensable employees." My daughters were the subject of one of my portraits, *Tres Hermanas,* which scored 98 and won "Best of Show" at the 1995 Southwestern Photographers Association convention.

At Phillis Wheatley High School in Houston, I was good enough in football to win a scholarship to Tennessee State University, where I received a Bachelor of Science degree, majoring in business administration. In 1963, I returned to the Houston Independent School District, where I taught and coached for the next twenty-four years.

With some friends I opened a photographic studio on a trial basis. Eventually, the Gallery Balthazar, Photographers, was created and I opted for a full-time career change. Although my primary photographic skills were self-taught, I have attended many schools and seminars sponsored by the Texas Professional Photographers Association and the PPA.

I wanted to become more than just a picture-taker. I wanted to be a good portrait photographer. To make my

dream happen, I entered prints in various categories with different types of subject matter, such as brides, children, seniors, and families. My goal was to be a well-rounded competitive photographer rather than one who specializes in a particular type of photography. I didn't want my competition images to be identified with just one style of lighting, posing, setting, or subject matter.

In 1998, I traveled to New Orleans to accept the Master of Photography degree at the PPA convention. In October of the same year, I became a Certified Professional Photographer, fulfilling a life-long dream of mine. I feel humbled by the honors bestowed on me by my peers, including prints in the PPA Loan Collection, Walt Disney World's Epcot gallery, the

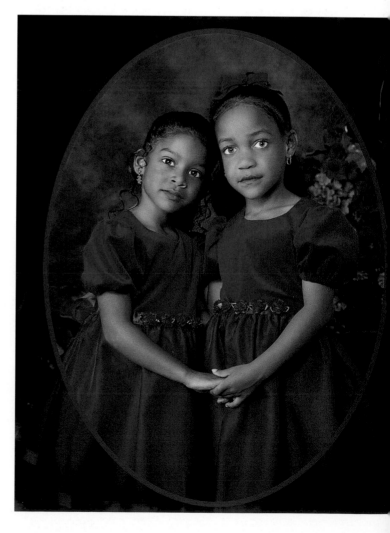

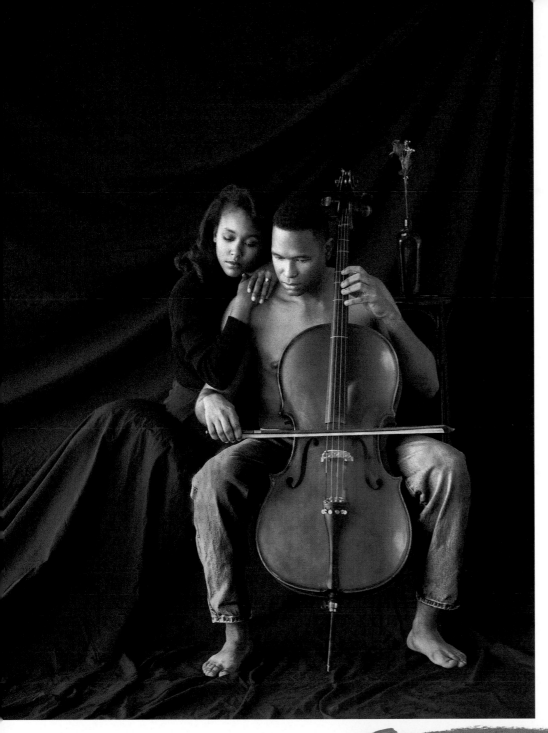

American Society of Photographers Traveling 100 Loan Collection, and the Photography Hall of Fame. In 1999, the Professional Photographers Guild of Houston named me "Master Photographer of the Year."

My inventory of studio equipment is quite simple. For more than twelve years, I've used nothing but Novatron lighting for everything in the studio. For weddings, I use Vivitar 285s with photoelectric slaves for double lighting. The Mamiya RB is my studio camera of choice, backed up with a Mamiya 645, my workhorse. I paint the majority of my own backgrounds on muslin. It has worked well for me.

THE BARCKHOLTZ FAMILY

SAGINAW, MICHIGAN

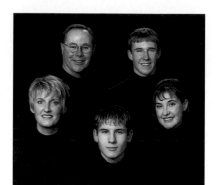

WHEN THE STILL OF night *silently arrives and the body lies with eyelids closed to rest, the visions appear, many times very detailed, at other times only moments of light. Sometimes they contain line, shape, color, and depth so great the heart-beat quickens with delight.*

Delight is followed by panic as I anxiously wonder if I will remember the image. Do I have the ability to capture the vision? Through this feeling of anxiety comes the possibility of failure or the thrill of accomplishment. This extreme emotion within dares us to take the chance. Fighting for our independence and facing our own insecurities is the ultimate struggle within.

Never content just to keep the pace, we always want to pull ahead. Wanting to be the driver of our destiny—not the passenger, content to go wherever the vehicle takes us.

Again the burning question, will I take the chance to try, to take from within? The answer must be yes! Give yourself and you gain even more in return: ultimately, growth from within!

WITH OUR ENTIRE FAMILY INVOLVED in our profession, we can offer art not available at volume businesses, such things as superior black-and-white portraiture, impressionist wall décor, and non-film digital creations. Some discriminating clients want hard-crafted art that cannot be cranked out by a machine in dozen lots. We do our own black-and-white printing and each piece is carefully composed, sometimes after hours of work.

There is a definite resurgence of the black-and-white image. Ads for everything from perfume to jeans are done in black and white. Sometimes they start with black and white, then add spot colors just to use the strength of the basic image. Black-and-white images are on the cutting edge of creativity. Strong black-and-white prints always have been accepted as art, while very few color images are ever accepted in the world's most prestigious art galleries.

My wife, Vicky, creates sensitive pastels that are more like impressionist paintings than photographs. Realism, or whatever you want to call an imitation of the way things look, is not the goal. Stylistic in their design, her images capture emotion and feeling, rather than "reality," becoming a personal expression of the subject and the scene, a moment in time captured forever in a work of art. The subjects become a part of the life around them, whether it's wildflowers or a quaint cottage. Pastel colors, rather than the brightness of primary hues, usually dominate each work.

The Saginaw Museum of Art featured my work in a one-artist show that attracted audiences from throughout Michigan. Some of Vicky's images were displayed at Northwood Gallery in Midland, Michigan.

Our daughter, Marti, has won many awards in the Michigan Professional Photographers Association, including "Best of Show" several times. She brings a youthful vigor to our presentations, with an eye for composition and color that is different from the older generations. As a result, her work is eminently accepted by our clients and highly rewarded by print jurors.

Our son, Ben, creates fantastic images on his computer, one of which was the talk of the 2001 MPAA convention. He expresses his creativity not only in computer images, but also in writing, so only time will tell where his imagination will take him as he completes college work.

Capturing the experiences of the senses is the focus of our entire family in whatever media we work. Sensitivity to the powers of light and texture, line and form infuse our work with additional meaning. Combining light, texture, and mood creates powerful images. We can capture what a woman feels, the essence of what a person is. We love to go on location with children to give them something to do. The end result is a portrait where the child is involved in an activity that interests him or her.

Portrait by Martha Barckholtz.

Portrait by Vicky Barckholtz.

Portrait by Benjamin Barckholtz.

I seem to have been driven to be a photographer, but that is not to say that the road has always been smooth and straight. I have only a couple of basic photography courses to my credit, no long list of schools or degrees. Instead I have picked away at my education through seminars and conventions.

In the beginning, it took my life savings to purchase my first medium-format camera, and a good-faith loan to bring strobe lights to my studio, housed in what was once our garage. It never seemed as pathetic at the start as it probably really was. A drive deep inside told me that I could succeed. My goal always has been to keep learning. This goal has been the key to my success.

I feel that I have found my niche in this world and it is in portraiture, especially black-and-white portraiture. My success would not have been possible if it were not for all the photographic organizations, big and small, that work so hard to help educate photographers. The Mid-Michigan Professional Photographers Association is the group that was most instrumental in my education. I told white lies to become a member in 1982, as I was making most of my very meager income through construction work. (The Association required members to receive most of their income from photography.) I knew in my heart that I was working toward a career in portraiture, not construction.

My big break came in 1984 when I won the title of Michigan Photographer of the Year for the first of six times. This instant recognition gave me confidence in myself and the confidence of my clients. In 1986, I added the Craftsmen degree to my Master of Photography degree, and I had the pleasure of presenting Vicky with her Masters degree that

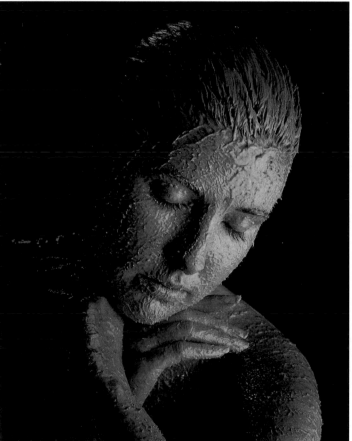

Portrait by Gregory Barckholtz.

year. This special evening has brought us closer than ever.

Since then one of my black-and-white images has appeared on the cover of *Kodak Times* magazine as well as the cover of Cameracraftsmaen of America's 2000 book. In 1992, Vicky and I lectured and judged in New Zealand, where we experienced photography in a different part of the world.

GREGORY & LESA DANIEL

TITUSVILLE, FLORIDA

Y LIFE SWITCHED *into high gear at age twenty-one, when I met my wife, Lesa. She sparked energy into my life and career.*

WHEN IT WAS JUST the two of us, Lesa handled the sales, public relations, and telephone responsibilities, while I did the photography and took out the garbage. This left a lot of production work that neither of us enjoyed, so we invested in our first employee to pick up the production end. This proved to be money wisely spent because it enabled us to concentrate on the areas where we excelled, increasing our production and quality.

In the beginning, most of our income was derived from weddings, and we needed to focus on increasing other product lines. To accomplish this, we began photographing dance studio recitals, where we found zillions of children, giving us a gold mine of a mailing list.

Every three months, these families received a direct-mail piece from us, offering promotion specials and—most of all—keeping our name fresh in their minds. In no time at all, weddings began to take a secondary role in our income. This diversification helped our cash flow, too, because when one product line seemed to be slipping, another took up the slack.

Both before and after opening our studio, Lesa and I have emphasized education as paramount to growth. Early on, Lesa encouraged me to attend Professional Photographers of America schools in different states. Fortunately, my first course was in business; it led to our development of short- and long-term marketing plans. This class marked a turning point in our career because we were able to put past experiences into perspective and begin to build a profitable business.

When we moved our business out of our home and into a storefront studio in 1987, we were fortunate enough to win several print competition awards. These not only attracted the attention of our portrait clients, but also the network of bridal consultants in the Orlando area, leading us to several high-end weddings.

Then came the responsibility to always produce the highest quality and service for each client. The sales environment and presentation had to suggest superior workmanship. It became apparent that we needed to solidify the objectives and goals we wanted to achieve. With Lesa and our staff, I brainstormed our philosophy and created a two-part plan to help us remember and implement our thoughts.

First, build a business where the employees would feel

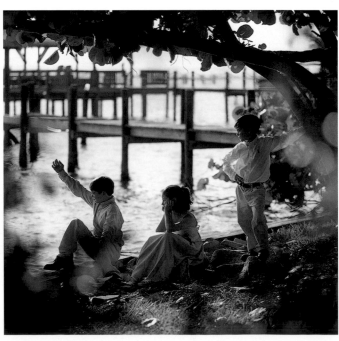

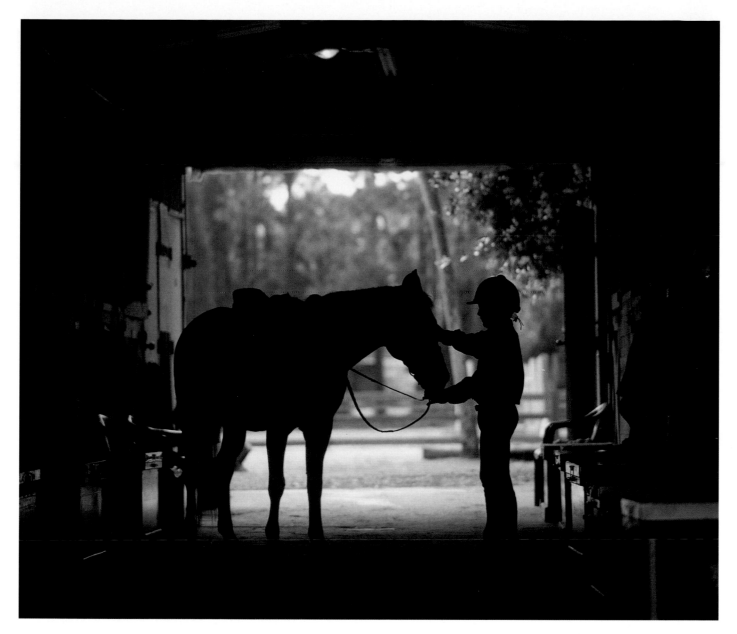

they were part of the whole operation. We outlined each person's tasks (including our own) and empowered everyone with the ability to make decisions and change the process. This gave everyone ownership of their processes, thereby encouraging change and improvements.

Next, make our clients feel like part of our family, so a mutual commitment would be established for a lifetime. We vowed to nurture a relationship with everyone who called or walked through the door. If we became their friends, we would understand better how to satisfy their needs, how to "seek first to understand, then to be understood," something I read in Dr. Stephen R. Covey's book *The 7 Habits of Highly Effective People.*

A few years ago, Lesa and I realized that growth in the twenty-first century would depend on elevating our image from a general-purpose mom-and-pop studio to the level of fine art. As a result, we changed the name of our business from "Daniel's Studio of Photography" to "Gregory Daniel, Photographic Artist."

This involved a process called "branding."

What makes a brand successful? First, the product must be so distinctive that it is easily recognized. Second, it must evoke such strong emotions that viewers wish they had one like it. But as important as both of these elements are, they are secondary to one main overarching element: *public perception* of your product.

If the public perceives it, then it is so. If they are confused about who you are and what you stand for, they will not buy. Public perception is an incredibly powerful tool in your arsenal of marketing weapons. Now the only thing you have to do is understand how to put this powerful tool to work for you.

The following four steps will help you develop a brand of your own. We will use restaurants to develop our analogy.

First, identify your target market and ensure you have a

group with which to market your product. For example, you may not think a fine French restaurant would be successful in a small town comprised of blue-collar workers.

Second, develop a survey to find out who they think you are. For example, you may believe you are a fine French restaurant but the public may think you are a cross between a McDonald's and an Olive Garden.

Third, focus on the results and develop a business plan that helps you to be who you want to be. Focus on what you love to do and what you do best. For example, if you want to be a fine French restaurant, then you must serve quality food with spectacular service, rich surroundings, and outrageous prices. Avoid sending out a mixed message to the public. Be extremely clear and leave no room for doubt as to who you are.

Fourth, renew the process by asking, asking, asking the public who you are. Take the results and adjust/refine by repeating steps one through three. Never assume you have completed the process!

Our goal is to have the market be able to identify a Gregory Daniel portrait and what it represents without seeing one. Just the name should evoke a consistent response from the public. I believe that developing goals and sound business principles will prove to be a worthwhile investment on your part. Branding is just one of the principles we have used to help us focus on who we are and where we want to take our business.

Review how the public sees you and develop plans to improve your image within the marketplace. The renewal process can act as a catalyst to pump life into your business and streamline your marketing approach.

Starting our business in a small Florida town closely tied to rocket launches from nearby Cape Canaveral, we realized we would have to expand our market in order to grow. As a result, we have rented display space at a mall in nearby Melbourne (a much larger city) and continue to develop business in nearby Orlando, where residents include prosperous executives serving its vast tourist industry.

Throughout the area, a Gregory Daniel portrait is easy to identify because of branding. When Florida residents see a painterly portrait with exquisite artistic quality, usually square and usually in a square gold frame, they immediately identify it as a Gregory Daniel piece.

Digital imaging will affect all aspects of photography,

including production management. The digital revolution is exciting and will create endless benefits to both studio owners and consumers. However, change may introduce risks in the workflow process that could alter a process to the point of catastrophic failure. Before you can think about changing a process, you need to know where you are today. Identifying your *current state* is a way to create a baseline from which changes can be made. Simply list the major operational processes you use to run your business. These typically include marketing, planning photographic sessions, doing sessions, sales presentation, and ordering/production.

Next, identify the tools and type of personnel needed to support each activity. For instance, you may use slide projectors and a skilled salesperson for the sales presentation and a light box for the ordering/production. Before adopting new technology, consider the changes by formulating a *future state* model. This is a fantastic way to brainstorm new ways of performing tasks differently in the future. Take a current process and try to see what it would look like in the future. For example, you may be excited about the new digital projectors that are on the market today. Map out a model and address the affected process, new task description, changed characteristics, and support system changes.

After the future state model has been developed, a risk assessment can be studied to address the likelihood of success, consequences if the new process fails, and possible labor/financial cost impacts. Contingency planning may ensure that the change you are about to make will not drive your business or product into the ground.

Next, it's important to set up ways to measure the process you are about to change, such as cycle time and customer surveys. Finally, an implementation plan will help identify problems that were not uncovered in the planning stages. This will help in the transition, outlining the steps to be taken and the timeline of when they will be taken.

Change should be embraced because it can shoot your business into the stars if managed in a thought-out way. It also can be the destruction of a company, no matter how big or small. Change should be respected and understood before it is implemented.pleasure of presenting Vicky with her Masters degree that year. This special evening has brought us closer then ever.

Since then one of my black-and-white images has appeared on the cover of *Kodak Times* magazine as well as the cover of the Cameracraftsmen of America's 2000 book. In 1992, Vicky and I lectured and judged in New Zealand, where we experienced photography in a different part of the world.

DON EMMERICH

DENVER, COLORADO
www.emmerichphoto.com

WITH DIGITAL IMAGING, the photographer can now capture what the mind sees, not just what the lens sees. I once thought the more I learned about photography the easier it would get. The reality has been quite the contrary. The practice of photography is a continual effort because you are only as good as your last photo. Perhaps one's knowledge is like a sphere: The more it expands, the greater is the area of contact with the unknown.

A PHOTOGRAPHIC STYLE is just as personal and unique as one's own handwriting, and just as resistant to forgery. My own personal style eventually evolved from much experimenting. I believe photography can be the most personally rewarding of all professions. For a career I simply fell into, photography is now something I cannot imagine living without.

Photography is the only profession wherein a vacation consists of doing exactly the same thing as we do every day on the job: taking pictures. You know you have made the right career choice when your work is the same as what you do for fun. The profession defines who you are; it is in your blood.

A technological tidal wave is sweeping through the world of photography: electronic digital imaging. The familiar tradition of silver and photo-chemistry is being challenged by the new domain of silicon and electromagnetism. For my business, digital has meant an acceleration of the creative process whereby photography is transmuted into an art that has both striking visual impact and bankable commercial value.

The investment need not be immense. There are a number of service bureaus offering services and equipment to photographers who want to retouch images on a computer or output photographs from their computer to a print or transparency.

There are several ways to acquire digital files. First there are the digital cameras, which record an image on a computer disk. If you prefer to shoot traditional film, there are scanners that let you digitize photographs or transparencies into a computer or central processing unit (CPU), either Macintosh or IBM-compatible, for retouching or storage. Negatives or transparencies can be written onto a compact disk (CD), then imported into your computer.

For proofing, there are color thermal printers, cathode-ray tube (CRT) printers, and a variety of electrostatic and ink printers, all of which provide high-quality color prints straight from the computer. Many photographers welcome the chance to retouch their own photos, rather than sending them to an operator for image enhancement. Even if you never retouch your work, it is useful to store your photographs on CD for archiving purposes.

If you want to get into digital imaging you will need a reasonably high-powered Macintosh or IBM-compatible computer. Color digital files need plenty of hard-disk space. Adobe Photoshop (the image retouching program) requires a 500MB hard drive and plenty of RAM. Photographic images are so huge they slow down computers considerably, so the more RAM your computer has, the faster you will be able to work.

The Achilles' heel of digital imaging is picture resolution. A silver halide molecule used in film photography to register a pixel is smaller and cheaper than a charge-coupled device (CCD) used in a digital camera. That's why many professional photographers still use traditional film cameras in combination with computer imaging. But even with this powerful partnership, image resolution remains the chief limitation. When a film image is digitized using a high-resolution scanner, it loses resolution, but in most cases, the loss is an acceptable tradeoff for the advantages of digital retouching.

Calibration and image fidelity also pose problems for digital imaging. It requires patience and care for the finished print

to wind up looking like the image you see on the computer screen. Digital is not an Aladdin's lamp that will cure all defects. A quality digital process starts with a quality digital image. The golden rule of computing—garbage in, garbage out—applies not only to alphanumeric data but to photographic data as well. Digital imaging can make a good image better, but it cannot transform a poor image into a great one!

One would think that photographers are the logical heirs of digital imaging, and, therefore, should dominate the realm. This outcome is by no means assured. Computer hackers, techno-nerds, or some other group could populate the field and displace photographers if they fail to embrace the new technology as their own.

Professional photographers should not be intimidated by this inevitable technology. Those who have mastered traditional photography have the technical ability to comprehend the digital imaging basics and to apply these new photographic tools to their work. Combined with traditional studio photography, digital tools and techniques will multiply a professional's capabilities and increase productivity.

Don't worry that the principles of digital imaging you learn today will be made obsolete by some future advance in technology. Of course techniques will improve and equipment

will be refined, just as they have been throughout the history of traditional photography. The principles of digital imaging will survive the evolution just as the principles of photography did. Faster and cheaper computers, increased resolution, improved media, and other advances should be anticipated with eagerness, not dread.

To be successful in the twenty-first century, photographers must know both their photographic craft and computer technology, so as to create and control their professional images. Before making photographs and creating images, we had to learn some of the fundamentals and technical aspects of cameras, light, film, and processing. Before we exposed that first image, we had to learn how to load film, operate the f-stops, etc. Likewise, with digital, we will first need to have a basic understanding of the equipment before we get started down the digital highway.

LISA EVANS

*D*OING WHAT YOU LOVE *for a living—it's everyone's dream. Most of us who open a business in photography feel so lucky to be doing just this. Yet, so often I find that once photographers have hung that shingle over the studio door, they find themselves going down a different path than they originally expected. Now that you need to make a living, when someone wants to pay you to do photography, you respond to that person's need.*

IT'S THE PEOPLE CALLING you who end up dictating your days and your future. Unfortunately, many of the people who call a portrait studio are looking for business photos, passport photos, senior portraits, or wedding albums. Rarely will you start out in this business getting phone calls asking for a 30 x 40-inch portrait to put over the mantel. As I traveled around the world speaking, I found so many photographers who had burned out—no longer doing much of the kind of photography they originally loved. Instead they find themselves doing photography that pays the overhead but doesn't satisfy the soul.

I feel lucky that from the beginning I have been very directed about wanting solely to create wall portraits and have designed my business to accommodate just that. My desire started out to be and still remains creating portrait art for my clients' homes . . . something very personal and meaningful and yet appreciated by a wider audience as a beautiful piece of art. I have never strayed from my vision, putting all my focus and energy into becoming the best "portrait artist" I can be. I focus on perfecting my art and have made a mark on the industry that is quite different from what the public had come to know as the typical "record" portrait photography. Equally important, I cultivate the business techniques and marketing ideas that bring the clientele that appreciate what I have to offer. Not straying from my dream, I am able to create what I love and make a name as an artist in my specialized style.

When I started my business I was told that I could never make a living solely from making wall portraits. Fortunately I never listened, because nineteen years later I've made my entire living from designing and creating portraits as art for my clients. Put the style of work that you want to do out there for the public to see and you'll attract clients who appreciate your vision. If you follow your heart and trust your intuition, you'll always create your finest artwork. Take the time to think about what is really important in your photography, listen to your heart, and create your dreams.

I am convinced that each one of us has a gift to give the world, a unique message or contribution. If you are lucky enough to discover your true God-given talents, it is a privilege to be able to give back to the world. You will find that you will grow with your art. You will demand new things from yourself—new visions and new ways of seeing. This will keep you fresh.

My gift to this and future generations and to myself is my portrait art. A carefully designed and artistically created portrait, one that captures a feeling and tells a story, is a piece of art that will evoke emotions and enhance the life of the owner. It will become a treasured family heirloom that will be meaningful and grow even more valuable with time.

To achieve this, I must first sincerely care about my subjects. I must take the time to get to know them; otherwise I can merely record their faces and surface selves. I spend a lot of time with my clients, listening to what is important to them: loved ones, special interests, places they love, and the little things that matter to them. It is so important to build the skill of listening to inspire openness and trust, to truly care about your subject. You listen with your ears, but more importantly with your eyes and with your heart. Remember, the client has the answers; you just have to pose the right questions. So much

of your final success, in creating an image that truly touches your client, comes from the never-to-be-neglected design consultation. My clients provide me with the inspiration to create something unique and different each time.

Too often photographers rely on formulas that they have learned and mold their clients to fit preconceived ideas. This is why we see so many portraits in which the subjects are stiff- and unnatural-looking. How satisfying can this be for the photographer, the individual who has come to this profession to express his or her creativity? I try to keep my palette open and let the client take my thoughts in whole new directions. Seek to understand, rather than to be understood. This is my imperative, then, and my reward, to make their portrait their true reflection.

Being able to make a business out of something you love doing is one thing . . . truly controlling quality of life is another. We feel good that we have found our gift in life, that we are able to give it back to the world in the form of a special piece of art, and that, with a bit of work and commitment, we are being true to our vision and our energy. But are you managing your days and your weeks to make time for your family life? I know this has always been a challenge as well

as a top priority for me. If you don't have well-defined personal parameters when you run your business, your business will run you!

Because family and my loved ones are a top priority, one primary rule of my business is that I do not work on Saturday or Sunday. And, because I would not ask it of myself, I never ask my employees to give up their family time either. When I opened in 1982 I was told by "the industry" that I should work on Saturdays and take Mondays off instead. It's true, many people do ask if we work on Saturdays. Yet these same people go to doctors and lawyers without the expectation that they are available on a Saturday. When your clients respect your talents and value your time they find time to come in during the week. After being in the portrait business for over nineteen years, I can count on one hand the times I have had to work on a weekend.

From the beginning, I realized that if I didn't set limits, my business could easily control me and no longer be what I loved doing anymore. Many photographers are so happy to say they own their business and can make their own hours, but let's be real. No one would work so many hours for someone else and then take their business problems home with them, as do many small-business owners. How far away is burnout from the total commitment we make to our own business, especially when our business is our passion?

In my quest to gain better control of my time I have acquired a "storybook cottage" in the woods. It is right out of a fairytale and is helping to make my dreams come true. By

having acreage that is wonderfully shaded throughout the day, I am able to create portraits at times like 10:00 A.M., noon, and 2:00 P.M. I once thought this impossible. Now, I do not have to travel so frequently to various locations where the sun dictates when I can shoot. I am building various portrait settings—a stone wall and a European gatehouse—cultivating fabulous flower beds along my creek, and designing sets with wonderful light all day long. I can shoot inside and out.

Years ago when I stopped speaking and teaching, I joked about not coming back to the podium until I could share how to master creating beautiful portraits at high noon—in order to be home with the family at dinnertime. After spending many years photographing in the last two hours of the day to utilize the easiest and most beautiful light, I was ready to enhance my personal life by eliminating the necessity of shooting during the "golden hours." I now have mastered the noon sunlight, and my clients love it. It takes effort and planning to create the lighting that flatters my subjects and delivers the art that I promise each one. It's not as easy as walking out and letting God light the whole world as He does so impeccably by twilight, but that's when I want to be with my loved ones. So a new way of thinking and seeing, and the fortitude to find a way to make the sunlight into what I needed have given me the control I need to put my family first.

I am following the path of my passion as a photographer. My vision is what I give back to the world. Don't lose sight of what made you fall in love with photography. What we need for ourselves is a commitment to our vision, the discipline to stay true to the work we want to do, and the determination to continue to grow in our art.

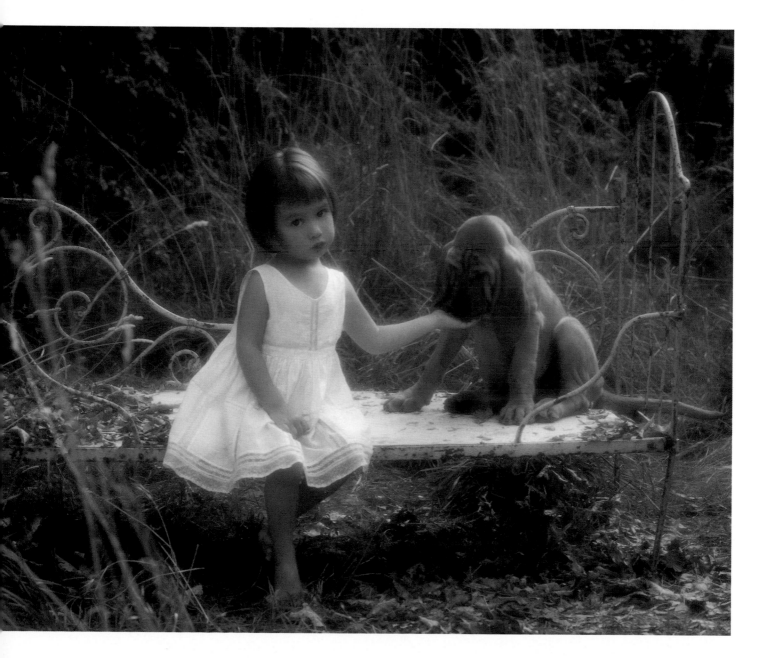

ALVIN GEE

HOUSTON, TEXAS
www.alvingee.com

MAKING THAT all-important, positive first impression on a client is the first step in creating a successful portrait experience. I have accomplished this by designing and building my "dream" studio. When my clients first walk in the door, they are met with an ambiance that says, "My photography is my art. Let me make you the center of it."

THOUGH MOVING into the new studio nearly doubled our overhead, I now have a splendid place to photograph large groups of up to fifty people. For the amount of time spent, groups are our most profitable specialty. We have reduced the number of weddings we photograph in order to make time to increase our family-group sessions. The camera room measures 25 x 26 feet with an 11-foot ceiling and a background painted by Lamar Williamson. My studio also houses a baby grand piano and winding staircase in the lobby that is great for groups and brides with cathedral-length trains.

Displaying portraits whenever and wherever I can is one of my most successful means of advertising. I utilize window spaces in various locations, such as hotel lobbies and mall storefronts, and display large portraits in sizes 20 x 24 and 30 x 40. The portraits are mounted on six boards measuring 4 x 8 feet and displayed to look like an 8-opening folio. Spotlighting each portrait makes them come alive.

I also take advantage of office buildings that desire to have various artists display work in their lobbies for a month to six weeks at a time. I simply ask the building manager to put our name on their list and notify us when a space becomes available. I display my best 16 x 20 to 30 x 40 portraits and use spotlights already in the space or clamp on 50-watt halogen spotlights with narrow beams that illuminate the portraits.

We buy display portraits from our lab when they offer specials just after the first of the year. Then we buy frame molding in 9-foot sticks and hire a craftsman to chop and join the corners. To make our portraits stand out, we use Larson-Juhl Italian frames, advertised in *Architectural Digest* and *Veranda* magazines, which you won't find in discount stores. A frame is like icing on a cake, and who can apply icing better than the baker?

Our staff is small: two sales specialists and me. One staff member speaks five languages, which really helps in a multi-cultural city with a population of more than two million people. Business is booming in the energy capital of the U.S., with many major companies building new high-rise office buildings, spurring a positive attitude in Houston.

My enthusiasm is the most important part of my selling strategy for two reasons. One is that I'm very excited about the images I've created and want the client to tune in to the beauty of the images I've captured for them. Secondly, I realize that my photography is my business and that I have the serious responsibilities of meeting my overhead expenses and supporting my family. People hire us to properly light, pose, and compose a portrait, but the single most important element that sells the portrait is expression. If clients have a good experience at a session, they will remember the good time they had every time they look at their portrait on the wall.

Since our business is a low-volume, high-priced studio, we avoid specials with Easter bunnies and Santa Claus. We do about three hundred sessions a year, averaging about $1,500 a session. To cultivate our wedding couples, we send a letter of congratulations on their wedding anniversary with a gift certificate for a 4 x 5 portrait, which is perfect for a newborn or mom-and-baby portrait.

Black and white is growing in popularity. We create a stunning portrait of children dressed in black turtlenecks and use their parents as "props" in the background. Photographing children wearing all black makes the faces stand out, creating a very dramatic look. We keep black turtleneck shirts in our studio for the convenience of our clients because they are virtually impossible to find in a hot, humid city like Houston.

Since all of our sessions are done on traditional negative film, I make my own slides, using a Nikon camera and a Besseler slide duplicator with Kodak Vericolor slide duplicating film, which I get processed in C-41 developer at a local one-hour lab.

Only a small percentage of our retouching is being done with digital, but I see it growing. I send Polaroid guides to our digital retouch artists to show them what I want, but we don't do many digital head swaps. I do traditional negative retouching myself and hire a local artist to retouch traditional prints. I'm more of a settler and not a pioneer, so

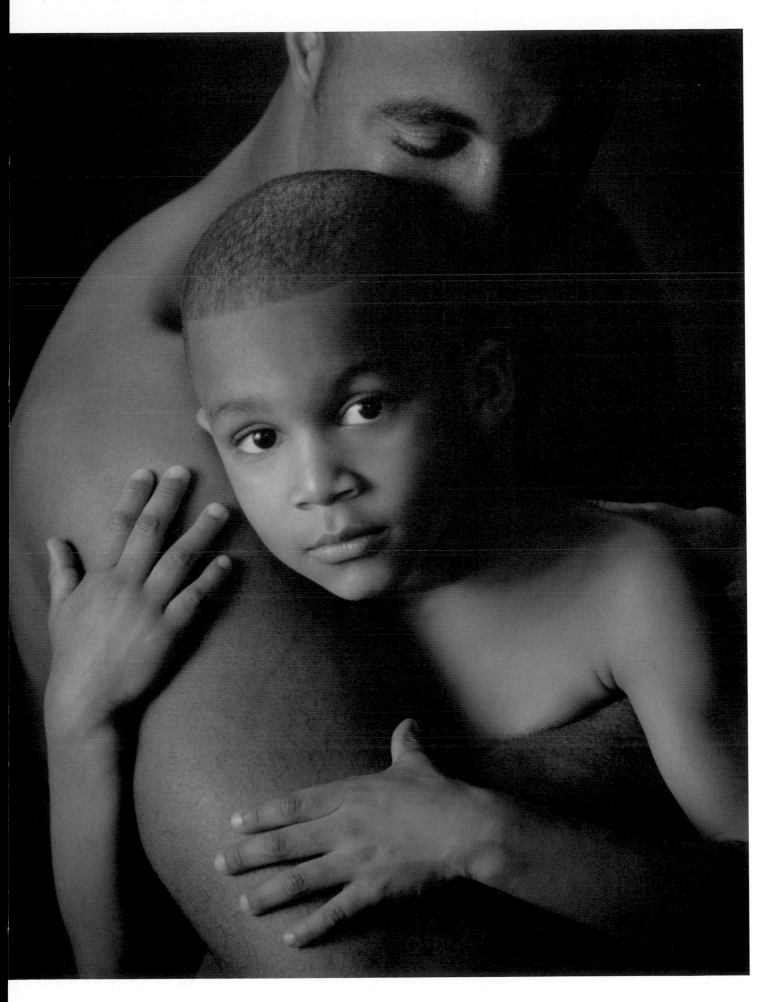

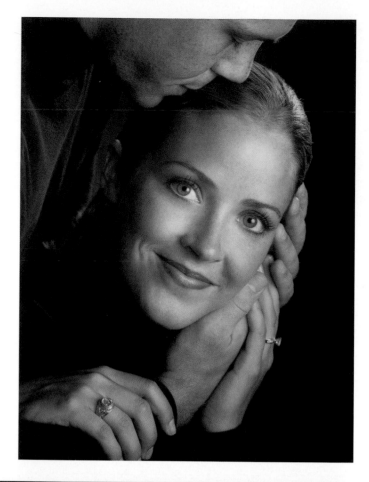

I'm not using a digital camera as yet. I want things that are tried and true.

No proofs leave the studio except for business portraits that are on contact sheets. We ask our clients to sign a document saying that our images are copyrighted, and the backs of the prints have a copyright seal. Right after a session, we ask our clients to do three things: sign the copyright document, pay for the session, and make an appointment for viewing the images in a slide show presentation. The slide show projection is done in a 12 x 16 room with two Kodak projectors capable of producing images from 16 x 20 to 40 x 50, using Schneider zoom lenses. The projector is on a cart that I can push toward the screen for smaller sizes.

One of the key questions we ask our clients is "Where do you plan to hang the portrait?" This gives us an idea of what size the client should purchase and what type of frame would be most suitable. Frames are sold from corners, with prices listed from 11 x 14 to 30 x 40. We sell Husar, Thanhardt-Burger, The Right Angle, and Larson-Juhl frames, all of which exquisitely enhance our canvas-mounted portraits.

For persons entering the portrait photography field, I recommend that those in their twenties go to college, but those in their forties attend one-week courses such as those taught at the Texas Professional Photography School. For young photography students, I highly recommend the Brooks Institute in Santa Barbara, California, for getting the best education in photography. Another avenue of training would be to study communications in any college to learn to relate to anyone from a child to a business executive. I would also recommend studying fine arts, language, and Dale Carnegie courses. In addition, I would work for a professional photographer for at least a year to learn the trade before going out on your own.

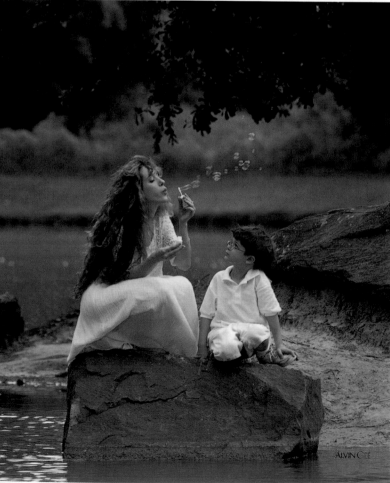

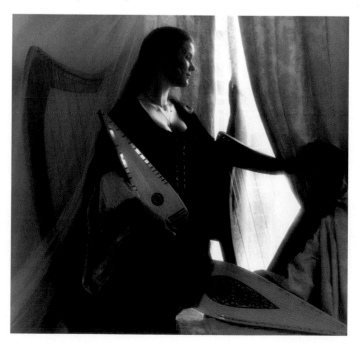

CHARLES GREEN

LONDON, ENGLAND
www.charlesgreen.com

GOING DIGITAL is very similar to going swimming. We put our toes into the water to see how cold it is and decide to try again later, as if by then the water will be warmer. The funny thing is that whenever we get into the water, it will still feel cold for the first thirty seconds, until our body becomes acclimatized to the new temperature. The best way to get in is to jump in and start swimming, which is what most people tend to do in the end.

THE PHOTOGRAPHER who waits for digital to get better, cheaper, or even to go away is missing out on the excitement and exhilaration of one of the greatest joys in creative photography today. Digital is the best thing to happen to photography since George Eastman invented film on a roll. Not only does it make taking pictures faster and easier, but it also opens up new avenues and possibilities after the image has been taken, for retouching, manipulation, and creative art.

The digital photographer is set free from decisions regarding film emulsions, types, and speeds and which filters to use and is now limited only by his or her imagination. The new breed of digital cameras is as good as, and in some respects better than, cameras with film.

I have given up my Hasselblads, Mamiya 67s, and a whole color lab taking hundreds of square feet. My current set-up consists of seven Fuji S1 cameras and a Fuji Pictography 4000 dye-sub printer, which produces in photographic quality one 12 x 16 image—or two 8 x 10s, or four 6 x 8s, or ten 4 x 5s—in just over one minute.

In addition I have an Epson 7500 inkjet printer which prints up to 24 x 30 onto a variety of papers, including matte, gloss, watercolor, fine art, and even directly onto canvas, at a speed of 3 x 24 inches per minute. Print permanence? The manufacturers quote at least 100 years!

New cameras and printers are regularly being unveiled, however, the quality, versatility, and speed of the equipment I now have will be sufficient for my own, and most other photographers' purposes, for the next three years. It will definitely pay for itself within one year, with savings in film, processing, previews, and lab costs, and by way of new applications in sales and services that could not have been possible with "old-fashioned" film.

Today's clientele also expects much more. Gone are the days when a client would willingly wait a week or two to see previews from a session and another few weeks, or even longer, to receive their finished print order. It was once considered more "exclusive" to have to wait. Today's customer expects everything to be faster, even instantaneous. The Internet has been totally responsible for that: Order online and expect delivery the following day. Anything longer is deemed to be inefficient and bad service.

A whole generation has grown up expert in the use of the computer, which is as natural to them as pen and paper is to us. We need to be able to appeal to their taste, cater to their requirements, and live up to their expectations.

The most common question of the past—"How much do you charge for an 8 x 10?"—has almost been replaced by "How soon can you provide us with the prints?"

It is now not only possible, but easy, to create the session, followed by the viewing with a digital projector, showing each portrait in a frame on a wall, and to have the portraits and enlargements printed, enhanced, and ready for collection the same day. Such excellent service shows our studio to be efficient, impressive, and worth the additional charge.

problem, I can make you lighter in Photoshop. . . ." By providing such service and possibilities the photographer is perceived to be much more of an artist than ever before.

There is, however, a tradeoff: Copyright is non-existent; reorders are dead. Most households own a computer, together with a scanner and a printer. Any image we give out will be copied. This is the new fact of life. Our charges must be worked out accordingly and should reflect this new situation.

This in itself can be turned to the photographer's advantage. A wedding photographer can show the whole wedding as a presentation at the reception, burn the CD and give it to the bride and groom to take away with them on honeymoon, for them to make their own prints later. The charge for this could be the same as that which would normally have includ-

ed albums and prints. The fee can be justified by the creativity of the photographer and the convenience of service—instead of in the time-consuming and costly task of producing albums with prints.

Digital photography is the future, which is here now. The water will never get better or dryer. So enjoy the swim!

Our finished product AD (after digital) is now not just as good as BD (before digital) but even better. The retouching of spots, imperfections in the skin, bags under eyes, untidy hair, reflections in glasses, mess in the background, etc., which would have taken much time to retouch conventionally, is now so fast and easy that we can now do it as a matter of course, which impresses the client and also encourages larger orders.

We now offer a whole new range of exciting finishes, from greetings printed onto the image to portraits turned into watercolor images and printed on fine art paper. Nothing is now impossible; the sky is not the limit. Hours of specialized work in the darkroom or by an experienced retoucher can now be achieved within minutes using Photoshop. Faces and expressions can be cloned from one image to another and look totally natural and undetectable. The comment "I look too heavy" can be countered by "No

LIZBETH GUERRINA & PAULINE TARICCO

POUGHKEEPSIE, NEW YORK

I*N 1972, I WANTED to have my children photographed. I took them to somebody and I wasn't pleased, so I decided to do it myself with a borrowed Rolleiflex. Eight months later, I had an exhibit, and that was it.*

AFTER WORKING ALONE for a short time, I was joined by Pauline Taricco, and together we developed our style of photography and our business philosophy. Those early years were so exhilarating! Every time we took a photograph, it was a joy to see the image we had captured. It was so exciting seeing those images we had in our minds develop on paper.

When we went into business, we never intended to do weddings, but people just expected it. Soon we had thirty bookings a year. We really enjoyed the actual portraiture and being with the bride, but we didn't like our lives committed so far in advance. Twelve years ago, we gave up weddings. It was a definite risk because we realized that weddings are the bread and butter for a lot of photographers. When we gave up weddings, we had enough portrait clientele built up so we couldn't fail. We don't need to do weddings anymore.

There is a lot more competition than there has ever been before. Every small town in America has a mall now, and almost every mall has two or three photography places. Now they're all doing what a general studio was doing five or six years ago—high key, low key, and all that. There will always be people who want fast service and quick turnaround.

Our advice to newcomers is to have extreme patience in the beginning. Don't compromise your style of photography. Fill your studio walls with portraits that you really love, even if you aren't attracting that type of clientele. Find people to pose for you and do what you really believe in.

There also is a clientele for the professional small studio, offering extra service and something special or something unique. You have to be smarter, but the future is there. You have to be able to market to the right people. There are people with good taste, and you have to show them your work.

We have portraits in beauty salons, restaurants, and real estate offices. We don't make any concessions for our displays; most people like them to decorate their walls. Of course, you have to change the displays regularly or the onlookers will get to where they don't notice the portraits.

In the beginning, we did more editorial-type advertising just to let people know we were there, but mostly we just tried to keep in touch with the people we had. We send out thank-you notes and a newsletter to remind clients we are here.

We have no employees, doing all of the studio work ourselves, so we need to do only about four sessions a week, yielding a $3,000 average. Black-and-white now comprises about 50 percent of our work, all processed at an outside lab. Along with watercolor prints, black-and-white gives us more product lines than ever before.

With a low-volume studio, we don't see the necessity of a digital camera because we like what we get from film. We see no need for the speed of showing proofs immediately after a session. The clients are exhausted from the sitting. I want the proof presentation to be special, so they have to wait for it. They come back in two weeks to see the proofs and then wait eight weeks for the finished portraits. It's like ordering a fine piece of furniture. We show our proofs on an Astrascope projector.

We use digital to improve one of our product lines, not for speed of delivery or the usual reasons voiced by most photographers. We enhance art manipulations with digital imaging to transfer a photograph into the softer light of a watercolor print, mostly ones of children.

John Singer Sargent discovered that when he traveled, he found freedom. I travel with six women photographers who challenge each other with an assignment. This allows me to come back to the studio with new enthusiasm.

My journey in life is always to search. Each time we experience something new we take something with us.

In our pre-portrait consultation, we show samples of traditional portraits and watercolor prints so our clients can make a choice. If they choose watercolor, we take the photograph with a watercolor in mind. Then I do a small image on my computer and send a sample to the lab so they can see the interpretation that I have in mind, how soft or how pale to make it. I feel that I need more artistic control for a computer print because it has no limits.

We take classes in digital imaging, then we go home to work with a computer on what we learned. I asked my mentor, Jim Chamberlain, to teach me just a few things at a time so I could practice before moving to another topic. He even gave me his phone number so he could talk me through a problem.

Those entering the professional photography field need to develop a style, because if you don't, you will just be run of the mill. If you want to make a living at photography, you have to produce something people really want. If you believe in what you do, there are people out there who will want it. From the very beginning, we had tremendous feedback from our clients, and that was inspiring.

Like painters seeking inspiration, we travel to scenic places such as Costa Rica and the Provence region of France.

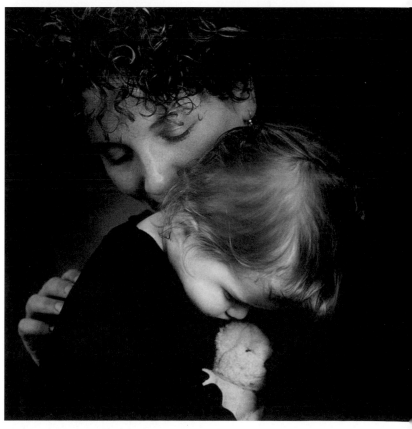

HECTOR H. HERRERA

MEXICO CITY, MEXICO
www.herrerafotografos.com

IN THE NEAR FUTURE, the artist-photographer will disappear if we don't charge more and more to compensate ourselves for our experience, time, investment, and ideas. We have to demonstrate to the public that our way of doing images is different, requiring the sensitivity of a master photographer to capture the real essence of a portrait, which is the emotion.

THE BUSINESS OF PORTRAIT photography has been changing in the last few years and we, the photographers, must rediscover the way of doing business. Digital photography has infinite possibilities in its ability to bring forth our thoughts, feelings, and delighted actions. Unfortunately, some customers think that digital photography must be less expensive, like fast food in a microwave oven. Just pop it in, and out comes the picture. On the contrary, digital photography is very complicated, more expensive, and requires greater investment in equipment and human resources.

Mexico City is one of the largest cities in the world, but like other big cosmopolitan urban areas such as New York, Paris, and Madrid, the portrait studios have disappeared. The reason why is a mystery, but most probably it's because people have no time for anything other than to just to go back and forth to their jobs, enjoy restaurants, and share some time with their families.

For the past three years, my studio at the Camino Real Hotel in Mexico City has been a totally digital studio. I go to the city once a week to attend my sittings there, for weddings or for something special. I have a manager at the studio, one photo assistant, and two technicians who digitize the work. When we have a sitting, we hire some people as assistants.

Recently, I started a new perspective in my photographic career, opening a new facility in a town called San Miguel de Allende, about 150 miles from Mexico City, a two and one-half hour drive. San Miguel is a quiet retreat beyond the reach of this world's commotion and bustle, a spot undoubtedly as placid and tranquil as the piece of heaven where the Lord's first Archangel (after whom it was named) makes his abode.

San Miguel is a place of indeterminate color. Its distinctive shades are present not only on roofs and walls, floors and arches, but also in the very air, floating in the atmosphere. Private courtyards are crammed with planters bursting with

fronds, while climbing shrubs and bougainvillea spill from the balconies. San Miguel is nothing but houses and shops, restaurants and shops, hotels and restaurants. It always has been this way, since the sixteenth century, when it was established as a commercial stopover.

It is hard to say whether San Miguel is a town or a village. There are no peasants here, no one trading in tools or livestock, no scent of earth or manure. Yet, it lacks the bustling air of places where people come and go to wrap up deals, the suffocating feel of places where people live, work, study, fall ill, or celebrate. San Miguel displays the uncertain color of the picturesque, while giving off the scent of well-tended tranquility, an aura of commissioned beauty.

At the local golf club, I began to work with the most prominent people, offering to create for them a President's Portrait Gallery in a special invitational program. We photographed fourteen people, giving the club a 16 x 20 canvas of

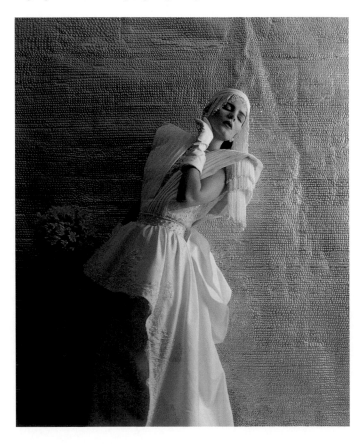

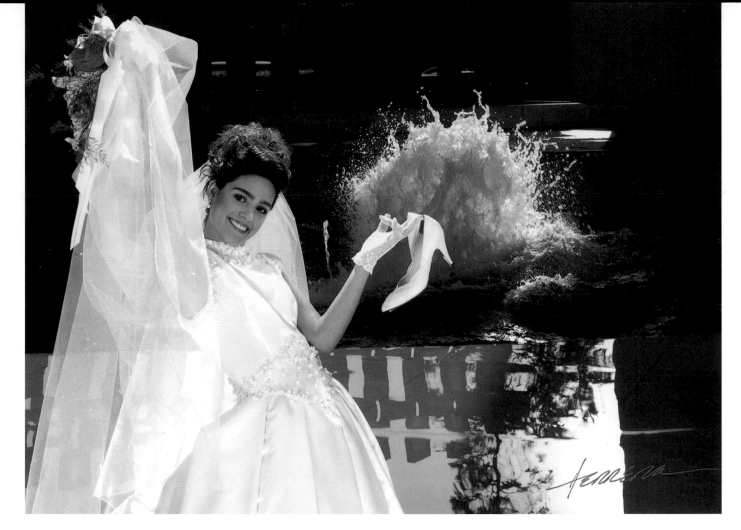

each of them, to create the Gallery. I captured these people in portraits taken in their own scenarios, capturing the essence of their personalities. Since none of these people had been photographed before, they all asked for a portrait of the same size for themselves. The result was good.

To begin the communication with the owners or directors of the finest hotels and restaurants, we organized a special section in the magazine *Bon Vivant,* which is edited in Mexico City. I suggested to the editor of the magazine to interview the fourteen people, which would encourage visitors to come to San Miguel to stay in some of those expensive hotels.

We put advertisements in various media outlets, including a full page in the newspaper called *Atención,* all in the English language because 50 percent of the population in San Miguel comes from abroad, mainly from the U.S. and Canada. We also sent two thousand letters announcing our services, and a telephone representative made calls to confirm the receipt of those letters.

These promotional activities have yielded excellent results in helping us get established in a new marketing area, which can be a challenge even for an experienced photographer who is well known in another city. I have seen some skilled portrait artists who failed to establish an adequate client base when they moved from one city to another, so I worked hard to make this move successful for me.

BRUCE HUDSON

RENTON, WASHINGTON
www.hudsonportraits.com; www.brucehudson.com

OUR GOAL IS TO create clients for life, to be considered a professional in our community on a par with the family doctor, dentist, lawyer, and accountant. This has been our goal since Day One, and we are accomplishing that in our community through service clubs, civic organizations, our local Chamber of Commerce, and our business behavior (professional, organized, and worth the price!). You must be willing to give back to your community, and if you do, it'll come back to you.

PERHAPS THE BIGGEST STEP to success is identifying client needs and wants through a consultation. Problems will be evident immediately and can be addressed in advance of the selling process. When client needs and wants are kept uppermost in our minds, three important things happen:

* You take the speculation and pressure out of the entire process for you and your clients.
* It relieves the pressure to sell, so you don't oversell through frustration.
* Most important, you can create clients for life by knowing what they want and giving it to them!

For handling client problems, offense is always better than defense. You *call* them first. *Admit* something is wrong. *Offer* a solution and *ask* their permission to take care of it for them. When you are on the offense, you can control the situation. When you are on defense (meaning you put it off until they call you first), you have to give something away in order to save face! That just cheapens your product. Learn the techniques of "recovery" by reading books and listening to tapes on customer relations. Making "Offense, not defense" your motto not only will save you money but will eliminate stress. In the long run, it will help you reach your goal of creating clients for life.

Our clients' lifestyle cycles fuel our business as we photograph their weddings, followed by their children, then senior portraits, and, eventually, another cycle of weddings. This lifestyle cycle gives us a never-ending source of business. Our studio's philosophy is based on creating an experience beyond expectation, keeping clients returning as we share each highlight in their lives.

In Seattle, we have been through good times and bad times, but my dream to succeed in photography continues unabated. It's still hard to believe I get paid for doing what I love to do.

The MPP marketing program offered by Marathon Press has been valuable for our year-round lifestyle advertising. We send them eighty images for use in postcards, a custom-made booklet, and a Web site. Marathon posts our current promotion on our Web site without any additional charge, and adds pre-produced pages such as "How to Decorate with Portraits" and "How to Dress for Portraits." The monthly fee gives us level billing for our advertising program, helping us avoid peaks in our advertising costs. It also includes a two-day marketing seminar.

Even in our high-tech studio, I still prefer slides for the proof presentation. With a $300 projector and a 40-cent slide, I can show a proof in the client's home and on the wall where they plan to put the portrait. I like to get them involved with the presentation by asking questions such as: "Do you have a ruler?" or "Do you have an extension cord?" Lower-key presentations work better for me than high-tech ones. In the studio, we present the slides in a dissolve show with music. I'm seeking emotion, not high-tech impressions. When I go to a restaurant, I don't care whether the food is cooked in a conventional or a microwave oven as long as it is good. We start with high-impact poses, put the lesser proofs in the middle of

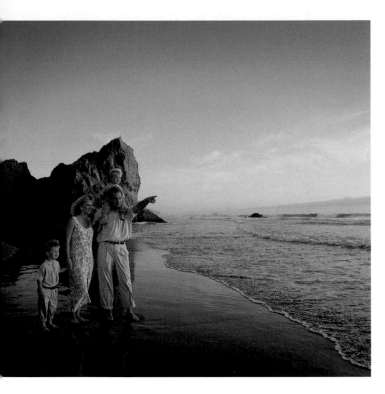

urge to do the easy things first, and do not interrupt a sale by answering the phone.

We've always been able to set goals, visualize them, and actualize them or take steps necessary to get them done. We reach our goals through persistence, not letting outside influences sidetrack our mission. We don't overanalyze situations. Many times key opportunities are missed by the time you've discussed it with too many people or thought about it for too long.

In a nutshell, our guiding principles are:

* Make customers for life.
* Overanalyze and be paralyzed.
* Dreams are nothing more than goals with a deadline.
* Imitation is limitation!

Consider yourself a businessperson first: photography just happens to be your product. Learn the ins and outs of business, time management, organization, bookkeeping, sales, and psycho-graphics. Pretty pictures are just the bonus. When the other things are in place, selling your work will be the easy (and fun) part!

the presentation, and conclude with a heart-stopper. The only time we use paper proofs is for high school seniors, and we only let them stay out of the studio for three days.

We keep our staff lean, with two full-time employees and two part-timers. Part-time people are wonderful because they aren't burned out by Friday! We have fresh faces and they work because they want to and not because they have to. That makes a big difference in attitude and we enjoy being together!

Making a conscious choice to stay lower volume (higher in price), we decided to do all of the photography ourselves. Hiring other photographers didn't fit that vision. We believe in letting professionals do what they do best: processing, retouching, and artwork, all of which are done for us by H&H Lab. We hire a small crew to do housekeeping on Sundays when we are closed. We would rather spend our evenings at home with the kids than printing in our own lab, vacuuming the studio, and cleaning the bathroom!

Mary Kay Ash (the guru behind Mary Kay Cosmetics) taught us a time-management technique we call "The Power of Six": At the end of the day, list six things that you want to accomplish the next day. Remember, just six things—any more than that and you will be overwhelmed and won't accomplish anything! We strive to do the hard things first, when we are fresh at the beginning of the day. Another goal is to get these six things done by shortly after lunch so the afternoon becomes "bonus time!" We like to think of it as beating Father Time at his own game.

Also consider opening one hour earlier, saving a specific time during the day (perhaps the half-hour after lunch) to return calls, and using voice mail so you can concentrate on and finish what you start. If you touch it, finish it. Fight the

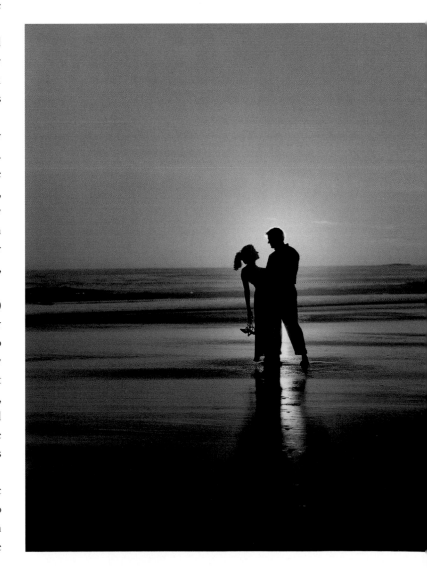

INDRA LEONARDI

JAKARTA, INDONESIA
www.kingfoto.com

UNTIL A FEW YEARS AGO, photography was still considered a medium of record rather than an art form. After graduating from Brooks Institute in 1987, I wanted to work to elevate portrait photography to an art form and to become recognized as an artist. I believe that within each of us, there is a yearning to appear beautiful and feel good about ourselves. We are all aware that none of us is born perfect; however, we still search for perfection.

"IT'S ALL IN THE GENES!" is a comment often associated with specific physical attributes that distinguish an individual, but seldom is it used to describe a profession. However, I see the comment as an apt description of my family, as I am the seventh photographer in our family tree. Naturally, genes alone do not transform a person into a professional photographer, as it entails hard work, perseverance, and constant learning.

It all started when my father entered the field of photography at the tender age of fourteen. Raised by an illiterate, widowed mother who supported her family by washing clothes for other people in their neighborhood, my father took up photography because it was a way to generate income for his family. His example of dedication and perseverance has taught me to work hard and be serious in whatever I undertake in life.

I grew up in my father's photo studio. Every time I went in or out of the family home, I passed through the reception area of the studio. As a teenager, I never imagined myself following after my father and becoming a photographer. Like many of my peers, I dreamed of becoming a successful businessman and making lots of money. However, I have always been intrigued by photography, and I took pictures in high school to earn pocket money.

After graduating from Brooks, I was determined to learn from those who had mastered the art and achieved a respected professional reputation. My first significant experience was as an assistant to Mr. Merrett Smith (see page 170). During this time, I gained knowledge of how he dealt with public figures. I shall forever remember his advice, that no matter what one's profession was, whether a celebrity or a statesman, everyone was essentially the same. The experience with him helped me to recognize my own desire to photograph people of great importance, people in the public eye, in order to record their images for posterity.

I also realized that another effective way to learn was by joining a professional photography association. In Asia, the photography industry is not well developed and lacks regular occasions to view the work of other photographers. Here in Indonesia, photography is still in its infancy and has not yet achieved the status of a true profession.

I became a PPA member immediately upon graduating from Brooks. Several months later, in 1988, I had my first experience at a National Convention, this one in Orlando, Florida. Although my parents' English was fairly limited, the three of us never missed a single class during the convention. We would start our days with the early-bird seminars and finish off with a night-owl keynote speech or late night classes. Everything we heard was like music to our ears and every image we laid our eyes on seemed to dance in our minds. To me at least, the experience was akin to being a little kid in a toy store. In the evenings, we would discuss that day's lectures in our motel room, often talking until the early hours of the morning.

Since 1988, I have never missed a National Convention, even though it meant travelling thousands of miles and spending at least twenty hours en route to the U.S.A. from Indonesia. Nothing has deterred me from attending these conventions, as I know the benefits far outweigh the distance, time, and cost. The mere idea of being in one room

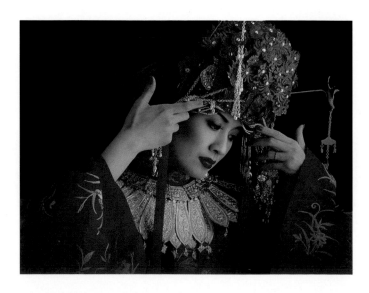

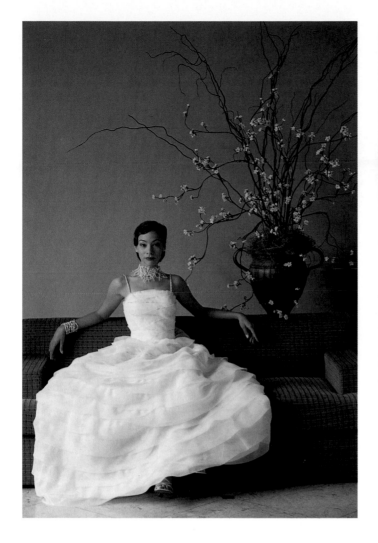

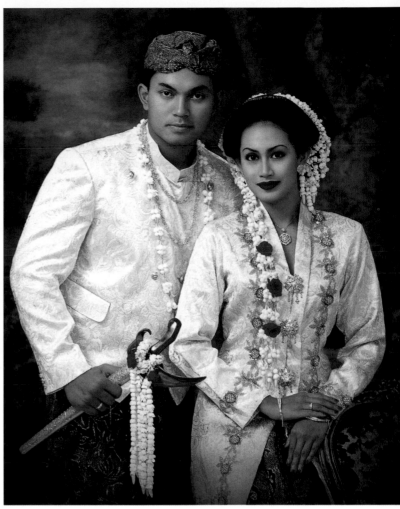

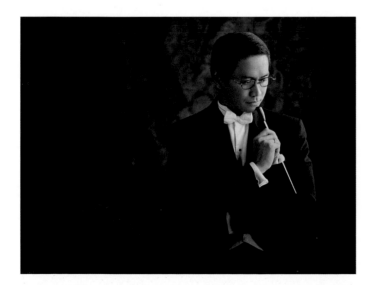

with so many other people who share a common passion for photography always excites me in a way that is difficult to describe. I have found that each photographer has a unique life story and I always have much to learn from each one's life experiences.

My favorite pastime is reading any kind of publication that contains a lot of pictures, such as art books, interior design magazines, and fashion magazines. Museums and art galleries are two places that provide me with the greatest inspiration. The paintings that adorn their walls portray great beauty, elegance, and breadth of individualism, all encapsulated in a moment of time. Viewing them triggers an inner need to create the same sort of images, to capture the essence of beauty and elegance in the one moment that will last well into the future.

One must remember that a client always wants to be treated as a king or a queen. I always try to understand what my clients want by talking with them before the sitting session, by advising them on their attire for the sitting, and by matching their personalities with the portraits. For example, if they are young, they normally want more vibrant and modern-style portraiture. If they are very conservative, they want a more conservative portrait.

We show proofs of postcard size, marked with a "proof" stamp, and we allow them to leave the studio. Recently, some clients have wanted to see their images through the Internet. These are mainly clients with a very tight schedule who live outside Jakarta. I believe the future of photography will be going digital, but on the other side, real art in photography will become more rare and more expensive.

CHARLIE LIM

SINGAPORE

www.charlielim.com

My APPROACH to photography is like cooking. The ingredients are my materials and props. The fire is light and aperture. My aim is to mix all the ingredients together to make one dish I can call my own.

FIRST AND FOREMOST, I was trained in oil painting, studying under the renowned American light painter Aaron Jones, from whom I acquired my skill of "painting" subjects with a light painter that looks and acts like a touch light. Many of my signature pieces involve this technique as well as Polaroid transfer and back projection. The combination of the three techniques makes my work stand out. I believe in the basics: *If you get it right from the beginning, it will form the powerful platform from which true success can be achieved.*

I believe this multifaceted background has helped me to appreciate the composition, color, and philosophy behind a photograph. Because of my art base, I am quite versatile. I have experiences in all areas, from people to product. After twenty years in this business, I've seen trends come and go,

but we continued to grow because of my understanding of business as well as the art of design.

In the face of increasingly intense competition, I believe there is a need to invest in digital equipment. Otherwise, we will lose out to the competition. However, you must realize that now every advertising agency and publishing company has workstations. Every art director can do it. If I hire a new graduate from an art school or polytechnic, I hire a computer expert.

So you ask yourself, should I join in the fray? I believe you have to, but I also think that there is still enough life in traditional methods, and that's where the photographer comes in. For no matter how clever a computer is, you discover things in the darkroom you wouldn't find in the computer. After all, a computer is a machine, while hands-on experiments are a different creative process.

I still enjoy the hands-on experiments of traditional photography because there is more soul in traditional methods. A few years back when light painting was the thing to do if you wanted to call yourself a professional photographer, I couldn't get enough of it. Now I use the technique sparingly, selectively, as an extra in my creative endeavors. A newly discovered "recipe" is my technique of crossover images. They're not multiple exposures because I keep the camera open while I replace the scene. You might call it "continuous exposures." The resulting collage of images merge and overlap delicately, which for certain purposes works extremely well. Sometimes, I use cross-processing, meaning a positive film is processed in C-41 print film chemicals.

There is a Chinese saying, "if small fortune doesn't go out, big fortune will come in." I started with only $1,200 in my bank account, surviving in the early years by doing a lot of freelance jobs in advertising and being thrifty in everything I did. In those early years, I had a constant fear of slow payment by clients because I needed more and more money to buy camera and lighting equipment.

Actually, I studied photography in the early '70s not to become a photographer, but to become a better art director. I felt that to become a better art director, I had to be able to direct a photographer. Before I knew it, more and more clients were asking me to do photo shoots.

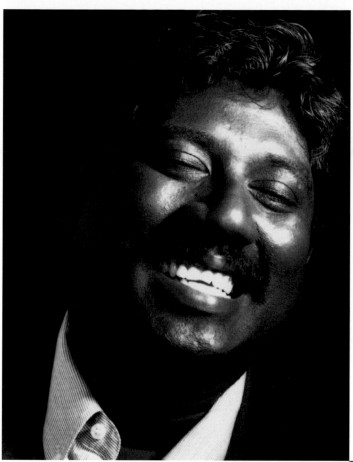

the hardware and software on file to help people customize their layout using my Stations 1 to 6.

This idea has prompted me to want to become an image-customizing specialist. I want to introduce the concept of a one-stop shop in Singapore, saving clients time and money. Everything can be done in one day under one roof, whereas presently, it would take three to five days for an art director to achieve what we can do in one day.

With a one-stop shop it would be easier to discuss copyright because there would be only one person to deal with. I think in a couple of years we will be more mature, and there will be less misunderstanding between clients and agencies or even photographers. I feel that all photographers should have some simple and important terms and conditions on the front of their quotation or invoices so the client understands copyright policies. These are very essential in establishing a good relationship down the road.

I try to strike a balance between material and spiritual assets, between creativity and technique. People who see my black Mercedes, Patek Philippe watch, and Montblanc pen may not see my knuckles, which have been hardened from practicing martial arts. I seek control of the mind and body, in yin and yang, the harmony of extremes.

Charlie Lim Photography is eighteen years old. I started off with photography representing only 10 percent of the business, but three years ago I cut off art design totally, going 100 percent photography. It was a gradual increase. The client base has broadened so much that I am able to concentrate on photography full time now. It is less stressful.

It is important to go out and do your own public relations. You can't expect people to know you when you lock yourself into your studio.

Now I'm focusing my efforts into providing a one-stop photography studio for my clients, from Station 1 to Station 6. Station 1 refers to props. Station 2 refers to talent, models, etc. Station 3 refers to our image library, i.e., photos of people in a swimming pool, people playing golf, etc. I have pictures stored from 1970 until the present—thousands of pictures. I have traveled overseas, accumulating pictures of many countries. Anytime a client asks for a calendar and needs to depict twelve countries, there's no problem.

Station 4 refers to the photo shoot itself. Station 5 refers to digital imaging. My next step, Station 6, is digital printing. My idea is not to compete with any individual company, such as a modeling agency or picture library, but to have other companies support my efforts. If art directors for an agency want to do a product shot for advertising, they could come to Charlie Lim Photography, spend a day, and walk out with the printed copy in hand. This is because I have all

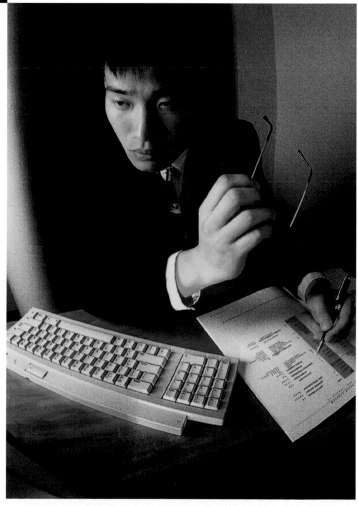

JEFF LUBIN

McLean, Virginia
www.jefflubin.com

*I*F YOU HAVE BEEN WAITING *for digital technology to arrive, wait no more. It's here and it's fantastic. Until 1999, I had little interest in digital capture. Then, as now, I was dealing with some of the most demanding clients anywhere and wouldn't have dreamed of using anything other than film. I just wasn't impressed by the final output of a digitally captured image enlarged to 30 inches or more.*

AS FOR CAMERAS, I had a fortune invested in world-class medium-format lenses, filters, backs, and vignettes, with no intention of giving them up. The digital cameras I tested seemed strange to me, and I didn't like all that large equipment between my subjects and me.

The Phase One instantaneous capture LightPhase digital camera back for Hasselblad and Mamiya medium-format cameras changed my thinking on digital photography. At first sight, I was struck by the similarity in appearance between the LightPhase back and my 220-film back. When I looked at the images captured with this non-scanning digital back, I couldn't believe my eyes—the fine detail was stunning. The highlight-to-shadow ratio was breathtaking.

What excited me the most about the LightPhase was being able to use it with all of the equipment I already owned, so the transition to digital was literally seamless. I was able to take light readings and set the *f*-stops and shutter speeds as I always had, with the extra bonus of seeing my images appear quickly on the computer screen in digital form. Without having to switch back and forth between Polaroid and film backs, I could make immediate adjustments to my lighting and composition.

My clients were also excited to be able see their portraits instantly. More and more of them have their own consumer digital cameras now, giving them a great interest and trust in the new technology.

As a wall-portrait specialist, I project large print previews into frames so clients can choose a size appropriate for their walls at home. When I made film portraits, I projected the Colorview slides that Burrell Professional Labs returned with my processed film. The clients made their selections and ordered prints, and I matched the negative with slide, masked it, and sent it to Burrell for negative retouching, artwork, and printing.

When I entered the world of digital, I needed a similar method of moving my work through the studio into Burrell's hands. With digital capture, the first real difference has been to see my work instantly as I create it. As thrilling as this immediacy is, it's even more appealing that my clients can view the portrait as I make it. They provide enthusiastic feedback on the spot about their likes or dislikes. If there's a hair out of place or clothing that's not just right, we fix it then and there, which increases the clients' confidence in the portrait session.

If I want to eliminate the extra sales appointment, I can immediately select the images I want to show my clients, then project them for the client's selection using my computer and an Epson PowerLight 5350 video projector. If the client needs a printout of the order selections, I can output low-resolution proof sheets on my Epson Stylus Color 3000 inkjet printer. If the client requires an electronic image for publication or Web use, he or she can leave the studio with a

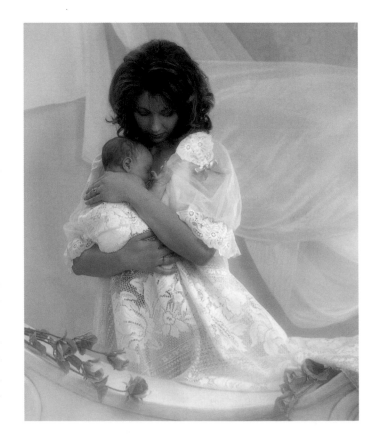

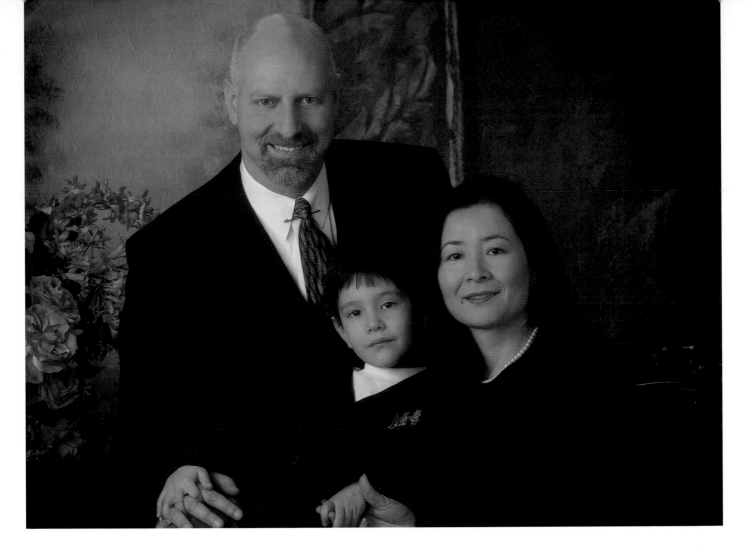

retouched JPEG or TIFF image file on a CD-R that I burn on my Yamaha CD-RW recorder.

I use Portrait Solution from PhaseOne—a remarkable sales tool. The presentation goes like this: I invite my clients into the sales room, offering refreshments, then introduce the show. I prefer doing this as a follow-up to the first visit so the clients have a break after the long portrait session. The software gives you a slide dissolve presentation and does the ordering right on the screen. The software gives me a light-table view that allows me to page through the images. This is essentially my final editing prior to presentation. I have "hidden" the images I do not want the client to see.

In the sales room, I present the images as a slide show with the click of a button. I prefer to display two images at a time so as not to confuse the client. I ask the client to pick one of the two until all of the images have been viewed and selected.

With selection completed, I move into the order procedure. This is as neat and easy as dragging an item from the product list onto the desired cropped image. The software automatically creates an order form and prepares an invoice. Now I can print out an invoice listing the items that have been ordered, with thumbnail images of each selected pose. I collect my deposit, hand the client a copy of the form and let them know when their order will be ready.

Preparing the order for the lab is a breeze. Using the LightPhase software, I select the chosen images and make TIFF files by running the images through the LightPhase processor. I can draw a crop box on the image with my mouse to alter any of the four sides. I import the digital image files to Photoshop on my computer and perform the necessary retouching. Then I burn the images on a CD-R that I send to the Burrell labs to be printed.

Digital control of the final image means being paid more for my talent than ever before. Now that I'm into digital capture, my creative abilities have increased in ways I couldn't imagine previously. Best of all, my enthusiasm for making a living in photography has been renewed. The real winners are my clients, who will be rewarded with my best work.

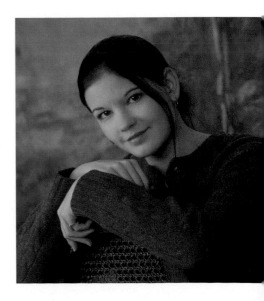

DON MacGREGOR

VANCOUVER, BRITISH COLUMBIA, CANADA
www.macgregorstudios.com

SUCCESS IN PHOTOGRAPHY today is a balancing act between two things. First and foremost is a true passion for what we do. The most successful photographers are passionate about image-making; they are passionate about creating portraits that have powerful emotional symbolism as compared to photographers who "just take pictures." The second foundation for success is a keen respect for business, and that is critical. We must focus on selling and marketing skills, realizing that what we produce is worth far more than the paper it is printed on.

ONE OF MY FORTUNATE RESPONSIBILITIES today is talking with aspiring photographers from local colleges and seminars. Giving them advice is not easy. Many are looking for a quick and easy rise to the top, and it just doesn't happen that way. I encourage people to embrace the passion of image-making and business skills. The most important advice I can offer is to analyze images. Look at the leaders in the industry and critically look at all aspects of their images, from lighting and posing to composition. Take them apart step by step. If you constantly analyze images at conventions, conferences, and local association meetings, you soon will start to incorporate those skills in your images without even realizing you are doing it.

Lastly, I would encourage aspiring photographers to become active in professional associations. Certainly there are headaches associated with organizations, but if they identify (and associate with) the leaders—the eagles that soar above—they will soon find their own wings and fly.

I firmly believe that portraiture has a bright future, but it will take on two distinct roles. First, there always will be a market for fine portraits and wall portraits. This is fine portraiture that is founded on art principles and passion for emotional symbolism. It is the kind of photography that incorporates outstanding lighting and compositional skills. For this style of work the market will be prepared to invest far more than the price of the paper it is printed on.

The other area will be the "volume" photographers who take "pictures." Their market will grow in size compared to

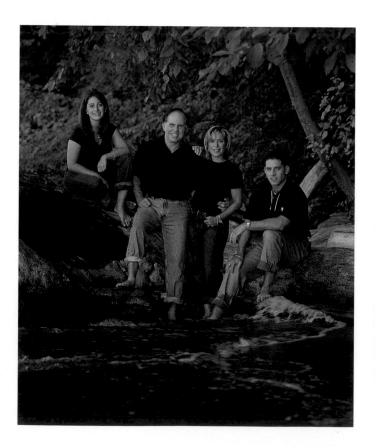

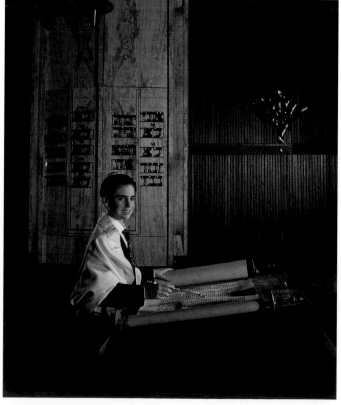

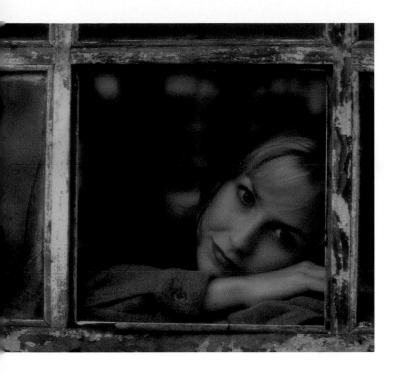

Currently, we are using a Canon D30 for capture, anxiously awaiting the release of a high-end Canon system. If we were Nikon-based, we would quickly invest in the Fuji S1 since the image quality is extremely good.

To archive digital files, we burn all original capture files to a permanent compact disk, then burn the final retouched files to the same disk.

I do all my own digital retouching work in-house using a Mac, although we have a full-time retouch artist who handles most of the studio's normal workload. However, I have advised the artist that she must learn Adobe Photoshop in order to keep pace with the growth of digital enhancement.

Unfortunately, 80 percent of digital output looks "digital." The key to quality is resolution and, more important, color management. However, the high-end digital laser output systems like the Cymbolic Sciences Light Jet printer, Kodak's laser printer, and the Lambda printers can produce outstanding results if given quality file information. The biggest reason that digital quality fails is that photographers try to cut corners by doing their own color management with limited training. If scans (or capture) are handled by well-trained professionals who understand monitors, color, and highlight and shadow detail, the results can be terrific! Of course, they must understand the relationship between these things and their output devices.

To date, we have had no success with trying to sell over the Internet. When we have tried to close a sale by sending the "proofs" over the Internet, we have had minimal sales. We have set a clear policy of refusing to sell portraits by the Internet, especially family or the more lucrative lifestyle sessions. Our Web site is visited often, but the inquiries are mostly from people who are bargain hunting.

the '80s and '90s. This market also will become primarily digital. Things like school pictures, baby pictures, church directory pictures, etc., will become the greater percentage of image-making for these photographers.

At present, we show our portraits to clients by the "transproof" projection. We make our own slide proofs (in house) and use 35mm projectors to present the originals. Recently, we have evolved into doing all of our family presentation in the clients' homes. While it is more work and involves more time, the sales are noticeably higher.

The viewing of children's sessions, engagements, etc., are done in the studio. We do not see presenting our more lucrative sittings digitally in the near future. I am a firm believer that the first impression is a lasting impression, and digital presentations from sessions that are designed as wall décor just don't have the impact (for expression and detail) that we see in slide proofs. We still print paper previews for weddings, allowing them to leave the studio after all fees have been paid. Our next step is to present weddings digitally.

Copyright is a tough issue. We certainly make every effort to educate our clients about copyright, and all of our images (including previews) have the required symbols on them. Slide proofs help a lot. It is not as easy for clients to copy them because they are numbered. Realistically, the copyright efforts keep honest people honest.

To date, digital capture is limited to business portraits and children's "theme" sessions. To put it simply, our concern is image quality. Having said that, I see our studio investing in one of the highest quality digital camera backs within a year or so. Quality of output (if color management is controlled) is growing by leaps and bounds, rivaling traditional photography in many areas.

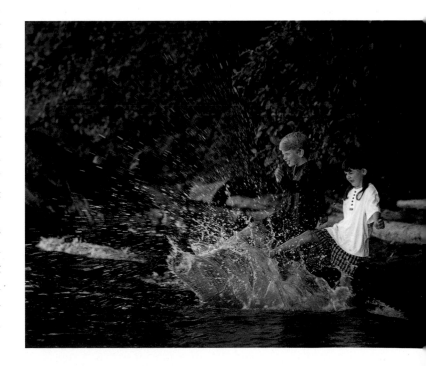

DAVID PETERS

SAN RAFAEL, CALIFORNIA

PHOTOGRAPHY IS to me very much a process of search and discovery. We direct the search by pointing our camera and choosing the moment to record. We discover what the moment means by viewing the image and feeling its impact. In portraiture, these chosen moments become infinitely valuable when they bring an understanding of who we humans are or perhaps could be. I believe the Creator has woven a thread that ties us all together. Maybe by observing the ways in which we are all alike we can better learn to "love one another."

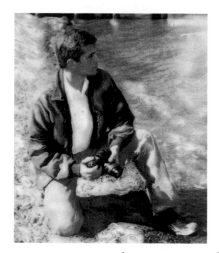

TO ELEVATE THE ORDINARY to the spectacular requires a fascination and appreciation for the gift of life. It is difficult to glorify what you cannot appreciate. Inspiration abounds. Sometimes inspiration comes from the creations of others: photographers, painters, sculptors, architects, poets, musicians, writers, dancers—anyone who has received a gift of vision and has acted upon it.

Sometimes inspiration comes from the simple observation of everyday life, beautiful meaningful gestures, expressions, and interactions that we take time to see and appreciate. I have learned that you need not fly a thousand miles for a spectacular image. You often need only to care enough to see.

Everything that we choose to include in the frame of our photographs means something. Everything must be scrutinized. Color, shape, and symbol affect not only the conscious, but the subconscious, too. Choosing elements that elicit the desired subconscious reaction can create powerful responses to our images.

A successful portrait requires communication and planning to properly set the stage with the appropriate lighting, colors, angles, and backgrounds. Then, camera ready, we watch, wait, coax, encourage, entertain, befriend, interact, or become forgotten until that tiny window appears that lets us see inside to our subject's real self. To arrive at that stage with a subject is an honor and a privilege.

I like total simplicity in a portrait, without any props except maybe the curve of a chair. I like to let the subjects move naturally, then capture a moment—like lifting a freeze frame from a movie. Currently, I am shooting more in the studio because of the time involved, perhaps only forty-five minutes for a session. I am working only four days a week, with about two hundred sessions a year.

It's just me and two other people to make client contacts, frame portraits, and so forth. Most of our sessions come from repeat business and charity auctions. We give 8 x 10 certificates to certain charitable organizations who sell them to their patrons for perhaps $100 each. This gives us target marketing with a qualified audience. From those, we average about $7,000 per session.

We like to have a consultation appointment with the clients somewhere between two weeks and a month before the session. We walk around the gallery and I tell a lot of stories about what these people mean to me. My goal is to change their perception of what a portrait is. Frequently, they say, "I had no idea it could be like this."

Often, people are emotionally touched by a portrait on the wall, not realizing that they're responding to the feeling, not caring whether or not it is crisp in detail. I ask them if they like detail in their portraits. If they say they don't know, I ask what kind of books they read. If they answer, "history," I shoot it sharp. If they say "romance," I shoot it soft.

What is important is that after three minutes, people know you are unique, and you can meet their needs. You're offering a very professional product that doesn't necessarily need to come from having a studio.

It takes considerable time for our prices to be justified in the clients' minds, time for them to get over the shock factor. At the presentation showing of images from the session, we try to give the feeling of having a pleasant experience as if our clients were enjoying a movie. We show the images on slides with one dissolving into another accompanied by music. The smell and taste of fresh popcorn add another dimension to the sensory perception of the occasion.

There is an art to making sure clients are pleased with their decisions. But this becomes difficult if the client perceives it as a sales process. It takes a very skilled person or a lot of time to train someone to do sales because speaking the right word at the right time could mean a difference of $1,000. My goal is to have two hearts rub up against each other, but sometimes in a sales consultation it just doesn't happen. Two great facilitators are television and movie clips; they are powerful tools because they open up the communication process immediately.

Someone starting a career today should focus not so much on the tools and gadgets of photography, but should place the biggest emphasis on how to reach people. In other words, the best way to start is to learn the art of creating a perception in people's minds. That is much more important.

Communication is what I would study. One thing that has made all the difference in the world to me is to be able to see the world through the clients' eyes. Once you can do that, it is the basis for all marketing, all sales, and all advertising. Then, when you create that beautiful product, you won't be frustrated because your clients aren't able to understand what you're trying to say.

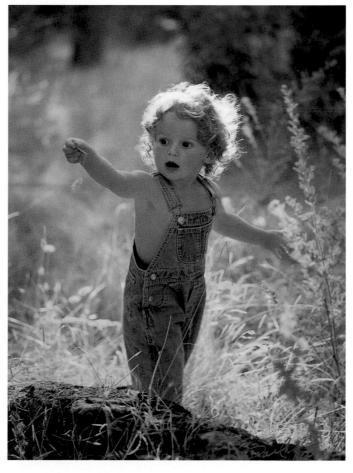

I am very grateful for the peace, hope, and joy the Lord has put in my life. I hope it shows in my work. That would be my proudest accomplishment.

RALPH ROMAGUERA

NEW ORLEANS, LOUISIANA
www.romaguera.com

BECAUSE OF OUR ABILITY to change to digital, we have quadrupled our sales in a five-year period, thanks to the youth and enthusiasm of my sons. We have grown because we understand our future lies in chips, not in cameras. We use a Kodak 560 in the studio, Kodak 520s and 620s at most events, and D30s at weddings.

AT WEDDINGS, we once backed up our digital cameras with traditional film, but I decided that was a waste of time, so we don't do that anymore. We've learned to use the appropriate chip for the appropriate job. For instance, using a 560 would give us too much information at a prom dance, so we use a 520 or a 620. The 560 is the appropriate camera for studio work.

Immediately after a portrait session, our clients see their images on a 20-inch monitor. Since we're using Photoshop, we can zoom in on a face to see detail even on a large-group portrait. With high school seniors, we get a credit-card number when they book the session. Just like the QVC channel, we ask on which credit card they would like to put the charges.

When we show their images on the monitor, they select the proofs they want to buy right then. The only proofs they take home are the ones they have bought. If they order within ten days, they can apply 50 percent of their proof cost toward the package. That means ten days, no exceptions, not for anyone and not for any reason. The more excited clients are about their portrait proofs, the better the order. Excitement dies down with time and the order shrinks.

Our family has three studios: one in LaPlace, Louisiana, run by my son, Ralph, Jr., one in Gretna, across the river from New Orleans, run by my son, Ryan, and one in Metairie, in the New Orleans Airport area, run by Mary Ann Brink. She's been with me since high school and knows our operation from start to finish, including camera work.

Processing is done in Metairie on a Kodak LED printer that can handle up to 20 x 30. We plan to buy an Epson printer that can handle 44-inch paper. Our lab has four full-time and five part-time employees, while each of the other studios has a photographer, a salesperson, a digital technician, and two part-timers. We hire two high school students for each studio with the understanding they will work from July to May, then their job ends and we hire the next year's crew.

If I were starting a photographic career today, I would look up someone I respect and try to train under them, even if I had to work for free. I don't think photographic colleges will teach you as much as an apprentice-type program of study. To succeed in this business you have got to have a lot of enthusiasm and work hard.

I began my career at the age of eighteen in the U.S. Naval Reserve, then went to work part-time for United Press International. Later I became a photojournalist for

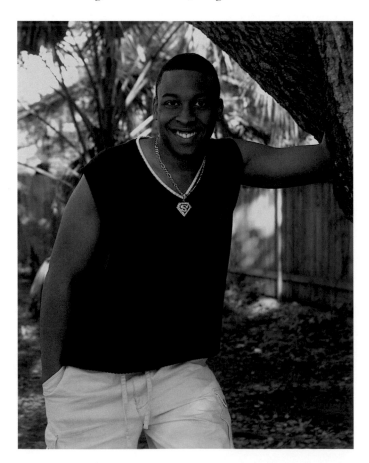

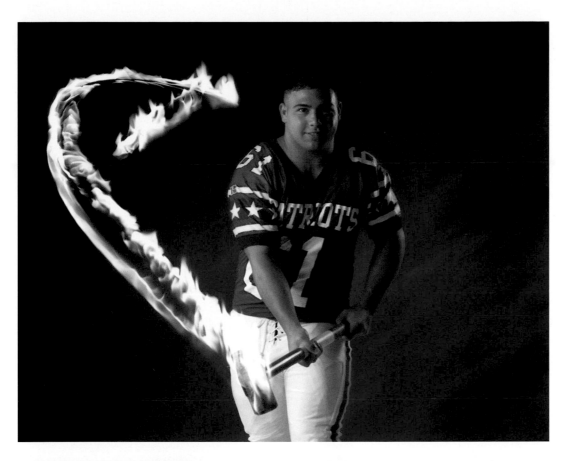

the *Times-Picayune* Publishing Corporation in New Orleans.

I started doing weddings on weekends, then in 1971, opened my first portrait studio in New Orleans. The highlight of my career was appearing on NBC's *Today* show celebrating 150 years of professional photography.

My recipe for success in the new millennium is simple: a pot full of digital capture and some tips on posing and lighting simmered with marketing and advertising ideas. *Don't forget the Tabasco.*

DUANE SAURO

*T*HESE ARE EXCITING *and unusual times. There has been more technological change that affects our industry in the last few years than perhaps in the entire past history of photography. The change is much more than camera, films, and darkroom improvements. Digital imaging is a fundamental change in the way that individual elements of an image are recorded, potentially altered, and then reassembled in the form of a print or other derivation.*

ARTISTRY HAS ALWAYS BEEN my priority. In addition to practicing camera techniques, I once invested many hours in the darkroom to create unique images. Local diffusion, elongating part of an image, texture screens, and exposing multiple images on one print were a few routine techniques I utilized. After the printing, I often would further alter the presentation of the portrait with various levels of oil-paint enhancements. I used paints both to increase the longevity of the print and to provide more unusual portrait presentations than photography alone could offer. My photography images were very evocative. I enjoyed what I was doing and my clients both appreciated and paid for my efforts.

Digital imaging advances creativity. I have largely replaced the traditional darkroom and print-enhancement techniques with a stylus and tablet. What I am most impressed with is the level of control these tools afford. The control is surgical in its precision. We can affect even the smallest areas of an image in a multitude of ways. On the simplest of applications we can enhance an image by correcting exposure problems, removing unwanted background objects, or even replacing and adding people using figures from different images. More magically, it offers an artist the ability to reinterpret and process an image in so many directions. Mood and symbolism can more easily dramatize a portrait statement or shift the image from the literal to the illustrative or even surreal.

Digital imaging is efficient. A virtual playground for creative digital imaging offers the added benefit of saving and reusing many elements of an image. This is a huge asset to us. Specialized backgrounds, flowing fabrics, and fantasy creatures are a few elements that can be reused again and again in various combinations as components for future creative projects. The resulting efficiency allows a much greater variety that we can offer our customer and a substantial reduction in our production costs.

However, it is only the tools that have changed. Despite this industry Renaissance, my customer, aesthetic, and business goals remain the same. Customers still want emotion, quality, and uniqueness. I still wish to continue to grow artistically and to enjoy what I do for a living. I still wish to focus my business efforts and increase profits. Although the customer and business advantages of digital imaging are indisputable, I must selfishly admit that it is the opportunity for creativity and self-expression that excites me the most and renews my enthusiasm in photography as an art medium. Life is good.

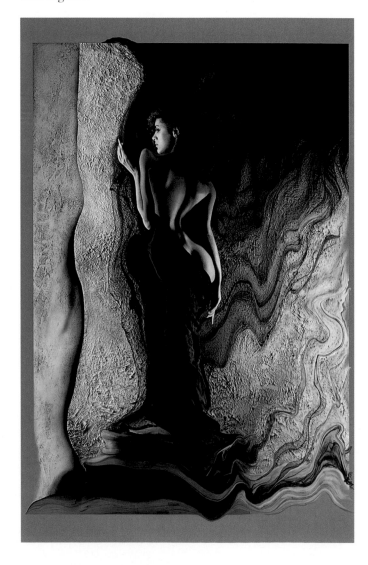

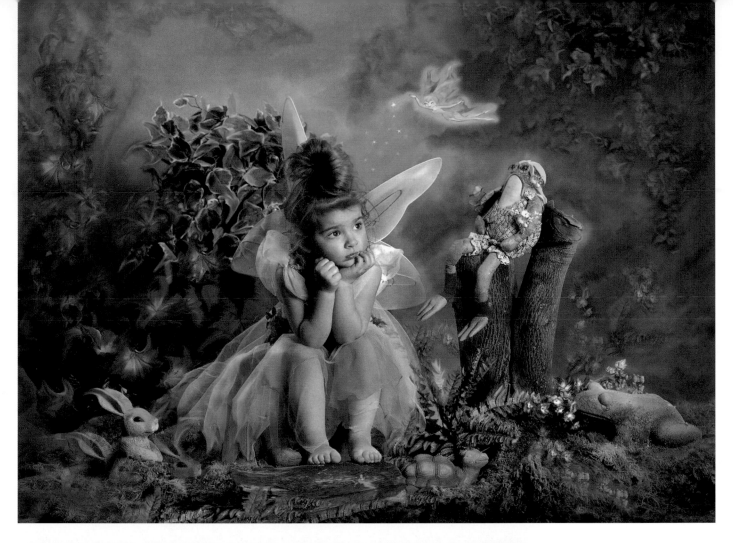

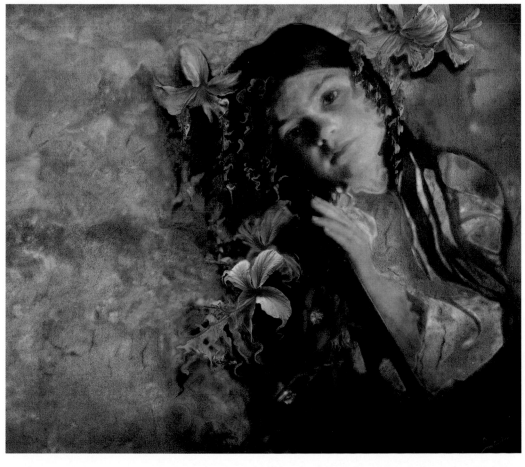

BURGHARD SCHMACHTENBERG

SOLINGEN, GERMANY

PRINCIPLES FOR SUCCESS *include fair dealing, honesty, generosity and flexibility. Photographers never should be intrusive or presumptuous, nor should they try to deceive or cheat any customer! In summary, the manager of a photography studio should be a first-class photographer, full of new ideas, a good buyer and seller, a psychologist, a public-relations specialist, a stimulating conversationalist, and a fascinating entertainer, especially with children.*

THE CUSTOMERS' FIRST IMPRESSION while entering your studio is psychologically important. You should give them the feeling of being among friends who don't intend to deceive them. I believe in the German saying, "The customer is king." Your customers should always leave the studio with the feeling that they've received the best possible product at a reasonable price, so they'll enjoy coming back and recommend you to their friends.

Employees must be trained to make the customers feel welcome and must exhibit excellent knowledge of the subject. Staff members must be able to sell our products with assurance and firm conviction. This high objective can be reached by careful selection of employees, their regular training, and an attractive team-bound system. Employees always are expected to be polite, good-tempered, and amiable, concentrating on the subject and the customer at the same time.

An excellent window display, which should be changed twelve times a year, attracts 67 percent of our customers. We ask our customers for permission to show their portraits in the window. If their answer is yes, they should ask us questions such as "How big will it be?" and "Can I buy it afterwards?," followed by "How much will the frame cost?" If they don't ask those questions, I don't put their picture in the window.

Customers will judge photographers not only by their knowledge of the subject but also by their appearance. Their warm personality and capacity to share the feelings of others puts their customers at ease. Being a good photographer isn't enough to be successful in business because you also have to be good at sales, window décor, psychology, body language, bank finances, and even bathroom cleaning.

My career began in 1965 with "Lehre," which in the strict German system means you have to learn from a master-class photographer. Once a week for the first three years, you have to attend a special photography school run by the government.

This is followed by an examination. Then you can have the title "professional photographer," but you aren't permitted to open your own studio. Still working as an apprentice for at least five more years, you also have to attend evening school for two years to be trained for the master-class examination. After passing that hurdle, you're allowed to open your own business.

I started my own studio in 1972, buying my father's small camera shop by paying him monthly. Also, I rented a small shop beside the camera shop and opened a portrait studio. Most German portrait studios include a camera shop selling to amateurs, who also represent potential clients for the studio. In 1990, I opened a new business that combines fashion and portraiture. We sell and rent bridal costumes and menswear and provide all that is needed for a wedding: rental cars, wedding invitation printing, children's clothing, etc.

The more fashion clients we have, the more clients we get in the studio. With this combination, we've tripled our studio wedding sales. In the beginning we had three people on our staff, but now it totals fifteen, with specialists in photography, bridal gowns, and menswear.

Slowly, I am entering digital photography, combining a Fuji S1 digital camera with my Mamiya RB67 and Hasselblad cameras. Only 5 percent of our retouching is done with digital, but it is all done in house by our staff. We transmit digital images to the lab via the Internet, but so far we have not used

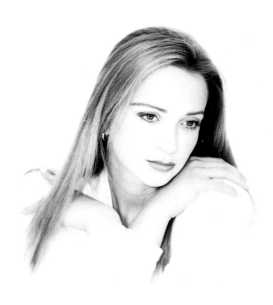

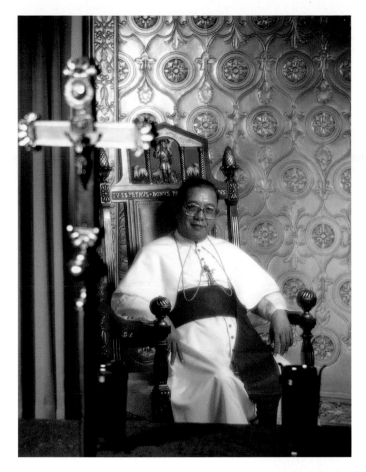

it for customer sales. Digital files are saved and stored on compact disks.

We use a Tamron Fotofix and digital monitor for the initial presentation to customers, but we do not allow proofs to go out of the studio.

Until now, portrait photographers have had a latent underdeveloped market. If every living room has a television, a videocassette player, a compact disk player, and a stereo system, it should also have a professional wall portrait. This means the photographer must continually have new ideas, better quality, and better sales methods.

Instead of competing in terms of price, photographers should compete for ideas. At the beginning of my career, my price system was based on high volume, like other photographers in the area. As my quality increased, surpassing other studios, I was able to raise prices and reduce sales volume.

Photography has given me a wonderful life, with speaking appearances in Japan, China, Korea, Indonesia, Singapore, Hong Kong, Malaysia, Ireland, and the United States. Most of all, however, I am thankful for my wife, Betty, my son, Benjamin, and my daughter, Jenniffer.

JOSEPH & LOUISE SIMONE

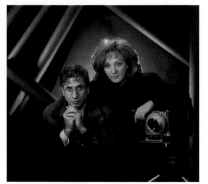

PHOTOGRAPHY IS THE REASON for our existence as we discover together the beauty of creation. Little by little, the chains that have bound us gradually loosen. This metamorphosis took place over the years as we moved from birth to a higher existence. Many of the questions about the purpose of our existence find their answers in photography.

WHEN WE ARE CREATING a photographic work of art, an overwhelming sense of goodness invades me. We never truly see unless we discover ourselves through others. We must agree with our subjects through our hearts.

To stimulate this creativity, I take long walks to let my mind fly with no expectations. Louise paints and draws to exercise the right part of the brain. This leaves the left side of the brain sleeping.

God helps us focus on what really matters. The main purpose of our lives on this planet is not just to eat and sleep, but to share the adventure of life. As we matured, our vision of purpose changed often, so today we want to touch people's souls, to look inside of them to achieve timeless portraits.

Born in Italy, I moved to France at the age of fourteen, where I stayed for ten years before migrating to Canada. I began my career working for a studio specializing in high school seniors and children.

Louise was a sixteen-year-old student when we met, and we got married three years later. She wanted to study art, but her father insisted that she study applied science. Instead, she started assisting me at weddings, and we opened our studio in 1975. The first year we did ninety-six ethnic weddings, sometimes starting at 12:00 in the afternoon and finishing the next morning. I thought I was a photographer until I went to the Canadian National Convention in Toronto. I cried when I saw the work there!

In 1976, I started taking courses under instructors such as Don Blair, Frank Cricchio, Tony Cilento, and Joyce Wilson.

In 1981 we decided to take fewer weddings and focus more on portraits. We gradually eliminated our staff of five employees. Now Louise and I do everything ourselves, limiting our work to only three or four sessions a week. When we are on assignment or teaching out of the city, we rely on voice-mail for client contact.

Marketing is mostly word of mouth, but we also have four window cases in Montreal hotels: the Sheraton Laval, the Hotel le Président, Place Victoria, and Château Vauoreuil Hotel, usually showing three 30 x 40 portraits in each location. (Although Montreal uses the metric system, inches are still used for sizes.)

We sell from 4 x 5 prints placed in folders with oval or rectangular openings, and we have not needed to project the images since all of the portraits on our walls are 30 x 40. Clients don't take proof prints out of the studio mostly because of the time factor in delaying their order. We can advise them about size, finish, and pose selection when orders are placed in the studio. This is not possible if the proofs go out. Only long-established clients are allowed to take proofs out of the studio.

Most of sessions are done in the studio because our clients are looking for a low-key Rembrandt style portrait, but we go on location for about 25 percent of our work. We do some outdoor portraits, but the short summer season in Montreal restricts that type of work.

For anyone wanting to enter the photographic profession, Louise's advice is to follow your intuition to become yourself—always with an open mind—and follow your strengths. Progress is more difficult without a college education, especially courses in psychology, art, composition, accounting, marketing, management, and computers. However, I think one-week development courses such as those sponsored by Canadian and American professional associations are the best way to evolve after college.

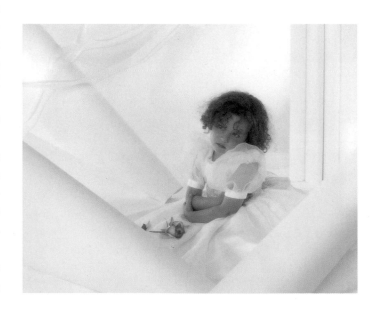

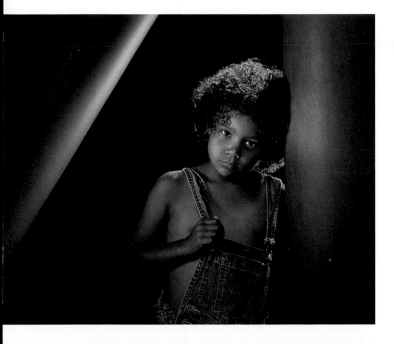

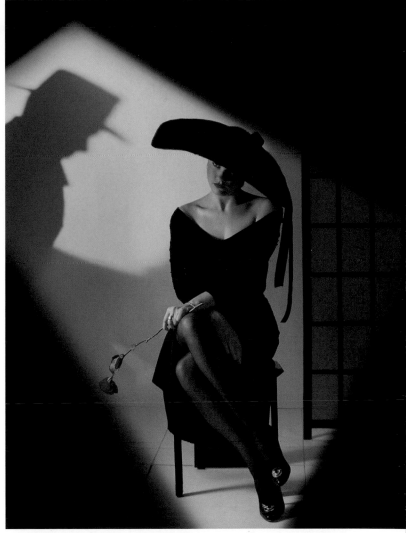

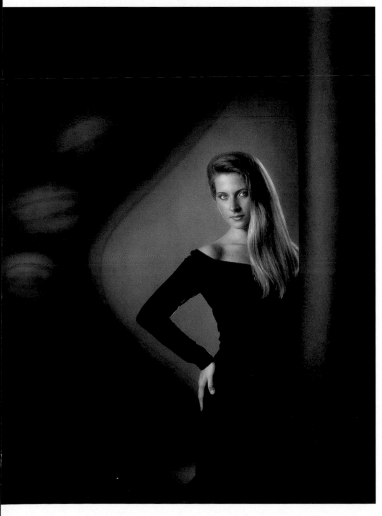

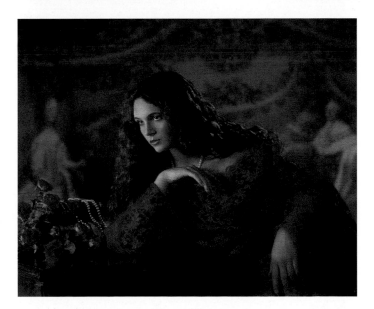

DAVID SMITH

STONE MOUNTAIN, GEORGIA
www.smith-studio.com

To SERVE THE GROWING *Atlanta market, my wife Linda and I saw the need to open a second studio in Gwinnett County, about twenty-five miles from our original studio in Stone Mountain and near the huge Mall of Georgia. We remodeled a 100-year-old house for the new studio, and we own real estate at both locations.*

STONE MOUNTAIN is a tourist area, while Gwinnett County is a shopping area. Lynn Brown is the primary photographer at the new studio, and our son, Jason, is the full-time photographer at Stone Mountain. Both of them have Master of Photography degrees from the Professional Photographers of America. I spend two days at each location. Each studio has its own set of client accounts, with separate operating statements.

To market the new studio, we bought a mailing list from a national company, listing prospects by zip code. Then we went into nearby neighborhoods and wrote down the addresses of 1,500 homes. Surprisingly, we got a 10 percent return!

For years, we have sent out a newsletter containing information about our studio and seasonal specials to past clients. It has been a tremendous way for us to advertise because it gets directly into our customers' homes.

In addition to the 2,000 names on our mailing list, we also put the newsletters in different shops and malls. Publishing a newsletter is easy for me because I got my start as a graphic designer working for a printing firm.

Like most long-established photographers, we are entering the digital age a little at a time doing limited digital shooting and retouching. We do our own digital retouching but also use an outside lab for many services. Digital photography has reached higher standards in relation to sharpness, color balance, and overall appearance, and new technology will no doubt bring even more pleasing results.

Digital imaging provides instant gratification, but I think people are trying to put all of this together too hurriedly. With a $20,000 piece of equipment, I have to ask myself, how am I going to get my money back? What I like about the traditional silver image is that it won't change.

We use a lower-end digital camera for business portraits and for promotional advertising pieces. I shoot the image on digital and then send it to the lab for printing. It appears to me the biggest advantage of digital photography is the elimination of proofs and having the ability to show images immediately after a session. We don't have to let proofs go out of the studio.

Presently, we still use paper proofs, allowing them to leave the studio after a deposit has been paid, but we require clients to sign a copyright release. We show proofs on an Astrascope projector, with plans for putting the images on a compact disk and showing them on a digital projector. We show digitally captured images on contact sheets.

Both studios are open from 9:00 to 5:00, Monday through Friday, with Saturday sessions available on a pre-payment basis only. Clients must pay their session fee in advance to secure a Saturday appointment, when both studios normally are closed.

If I were seeking an education to prepare me for a portrait career, I would check first to see what local schools had to offer in the way of business, some courses that would give me knowledge about what it takes to get a studio up and running. Given a choice, a photography school would be great, but most liberal arts schools have photography courses. Regardless of where I went, I would combine art

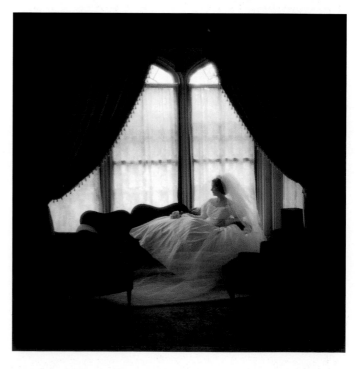

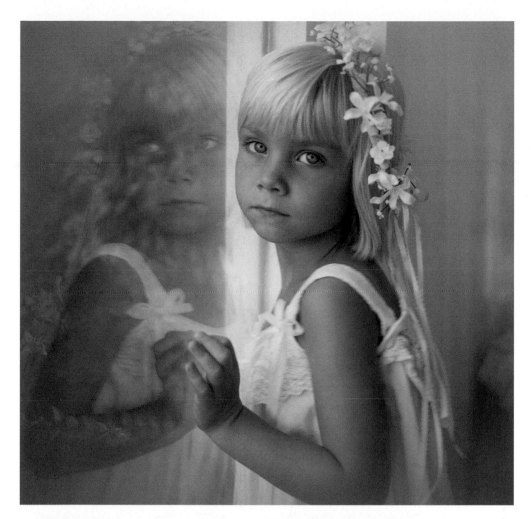

with business. If I could go back in time and study all over again, marketing and advertising would be high on my priority list.

Second, I would be cautious about borrowing too much money and running the risk of not being able to pay it back. This may not sound like a principle of education, but it is a very important lesson to learn in forming a business. Third, I would look at professional organizations because there is a lot of information there. When clients try to decide which photographer to choose, they look at your credentials. Try to apprentice with a successful photographer. You can learn more in two years of apprenticeship than in four years of college.

Whatever success we have had over the past thirty years comes from our love for God and His creation. Man doesn't create, he only rearranges and reworks what God has already created. Nothing is possible without His light.

KENT & SARAH SMITH

PICKERINGTON, OHIO
www.kentsmith.com

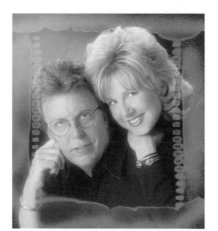

I N THE WHIRLWIND *of technological changes, we believe our primary focus should be people skills, because they never change. Not equipment, but how to make your subjects look good ranks number one in our studio. I think many photographers try to do everything with equipment, but it's so much more important to learn the fine points of portraiture.*

THERE IS NO END TO EDUCATION. The moment you think you have learned enough, you need to go back to school. Consumers may not know why they like a portrait, but they know what they want. We see black-and-white portraiture coming into vogue as never before because simplicity is always in style.

Like the Energizer Bunny, traditional film cameras just keep going. Once I used a Hasselblad older than my age, so it had paid for itself many times over. My fear in changing to digital cameras is the obsolescence factor.

However, it's not a question of whether we will go digital, but when. First we're trying to get our infrastructure in place. That means setting up sales stations and presentation systems as well as a management system for digital images.

We are using Fuji S1 and Kodak 760 cameras, plus the Fuji Pictrography printer. Things we once turned away we can now do instantly. We can do a few images and within a half hour the clients are leaving with a finished portrait. The public perception is that portraits done quickly don't have value, but the exciting part of digital is the ability to do art enhancement that once was very hard to do. With customers, we try not to use the word digital. Knowing what and how much to retouch is important. Over-retouching can hurt a fine portrait.

Customer service is the key to our management style. A lot of photographers think we have a silver bullet that creates success, but that's not it. It's the way clients are treated. We have a staff meeting each morning at 8:30 and alert everyone about the clients who are expected that day because everything is done by appointment.

We greet clients by name in the parking lot, helping them into the studio. On a rainy day, an umbrella can be your best greeting. For sessions, the client's name appears on a star on the dressing room door. Gift-wrapped cookies are placed on the counter inscribed with the message "I hope your experiences

are sweet." In the consultation session, we probe the clients' likes and dislikes so we can pre-plan the shooting session.

The vocabulary and proper attire of our staff promote our image. Some words are never used, and other words are encouraged in our staff meetings. Also, our enthusiasm is our best asset. Many clients express their appreciation for our care and concern.

One client confessed she had previously made an appointment at another studio. However she changed her appointment to our studio because a friend of hers recommended us highly. She said the difference between studios was unmistakable from the first telephone call. We got her thinking about aspects that had never occurred to her. And the day before the session, we called to see if she had any last-minute questions or needs. When the family arrived, we called everyone by name and made them feel comfortable. She said she felt we really cared about her and her family.

There is one really fabulous thing about all of the attention to detail that we use in our studio. It is absolutely free! Our passion is our craft and customer satisfaction is our goal, with less concern for the bottom line. The customer is always right; we treat clients that way. Our motto is "Good enough isn't good enough."

Educating the client is indeed the key to greater sales, and the general public definitely needs an education on what beautiful portraiture can be. We need to get excited about our

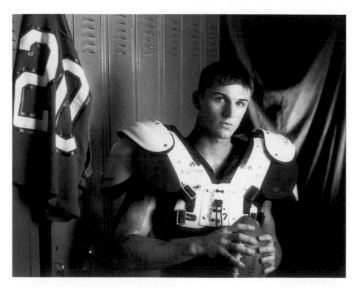

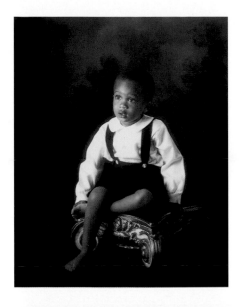

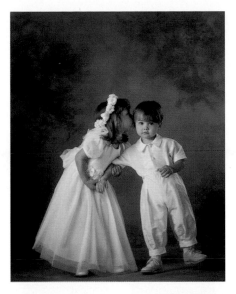

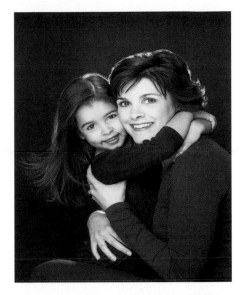

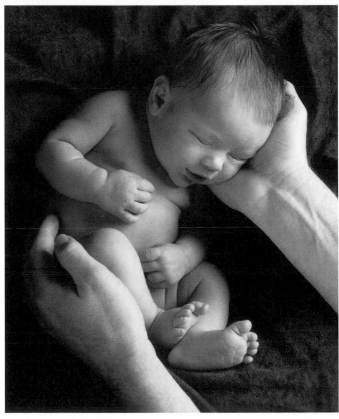

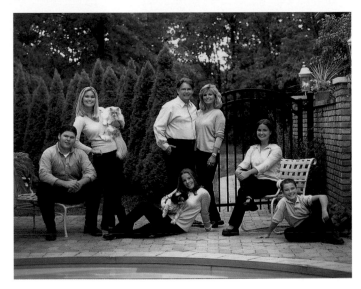

product and create a desire for it. We promote ourselves by the way we display portraits in the studio. We upscale by uncluttering. Our walls don't need to show every image we ever took. We've carefully designed each wall space to plant a particular seed, presenting each product as we would have our clients display it in their homes.

Fine merchandisers can teach us a lot. When you walk into a well-merchandised store, you know exactly what they are selling. For example, we sell two types of images. The first choice is large wall portraits on canvas for open rooms. These portraits are to be enjoyed from the middle of the room. The second choice is gallery-style portraits that are smaller in scale

for hallways where the vewing distance is short. We try to simplify these concepts for our clients. Confusion kills sales, and clutter leads to confusion. What are you really selling?

Image control helps us protect ourselves from copyright infringement. For years, low session fees have been a loss leader, but now we are trying to get our session fees up to cover costs, so print prices don't have to carry the burden. We as portrait photographers need to learn from commercial photographers who charge high day rates so more of us can survive.

Senior proofs are the only ones allowed out of the studio, but these have a number on the face of the print. If we sell proofs later, the number is removed.

We encourage photographers to look for inspiration outside professional photography organizations. Beware of the inbred cousin syndrome; so many photographers follow the other guy and charge a little less.

Success depends on good business practices first, photography second. If you have a good sense of business, you can hone your skills in photography. You need to understand the costs of doing business—don't give your work away!

MERRETT T. SMITH

ORKING WITH celebrities requires a relaxed style on the part of the photographer, yet an efficient system that doesn't waste any time. I always have the camera room and lights set up when they arrive. I know what they want, and I don't have to experiment, so it only takes an hour or less. I try to find common ground with them, to talk about something I'm familiar with so I can carry on a conversation while I'm doing my work.

SOME PEOPLE YOU CAN JOKE WITH, and some you can't. As a rule, I'm quite a happy person, and that makes it easier to work with celebrities. I keep my equipment and lighting set-up simple so I can spend my sitting time working on expression, posing, and creativity.

While in the Navy, I was making a portrait of a superior officer who sensed my nervous anticipation, and he calmly told me, "Just remember *you're* the one in command of this session. Whenever you photograph an important person, look at them as equals and don't let them control your creativity. If they shove you around, you'll lose control of the situation and won't do a good job for them." Since that night, I have remained in control, seeking to create a lasting work of art. I have dedicated myself to studying the art and science of photography to prepare myself for that moment when I am behind the camera.

Women like quite a bit of time in a portrait session, and, of course, I allow them that. Men, however, usually are in a hurry, and I try not to hold them up. I have always felt that customer relations are extremely important, and I try to remember that the customer is always right. No matter how great my portrait is, if the customer doesn't like it, I have failed.

Our profession takes an endless amount of ambition and tenacity. We know no forty-hour weeks. There have been many times when I have had to work through the night getting out Christmas or wedding portraits. The phrase "think you can, think you can" has been an inspiration that has kept me climbing. I never permitted the word "can't" in my vocabulary. I knew I wasn't the smarter or swifter man, but I knew I would win because of my "I can" motto.

I love my profession. Every morning I look forward to going to work. I know I shall never retire. A person who truly loves his work is indeed fortunate. Fire fueled by my love of

photography has seen me through a long, hard journey with countless hours of trial and error, personal preparation and, oh yes, a whole lot of luck.

My dream began at the age of six when the postman delivered a small package to a humble home in American Fork, Utah. Inside the package was a Kodak Brownie camera ordered from a Montgomery Ward catalog. One look into the viewfinder and I was totally fascinated. From that day on, I knew I was going to be photographer. I earned money for a developing tank, chemicals, and a small printer, turning my bedroom into a darkroom.

Few people ever saw me without my camera, and every good-looking girl in school became my model—anyone willing to stand still and smile for me. By the time I got to high school, I had to take responsibility for all the yearbook pictures because all the professional photographers in our town had gone to military service in World War II. After graduation from high school, I enlisted in the U.S. Navy, where I was assigned to the photo lab. While in the Navy, I married my childhood sweetheart, Gail, and we joined forces to take portraits of shipmates, friends, and relatives. I did the negative retouching, using lead on black-and-white and then dyes on color film. Gail finished the portraits with oil coloring.

Three years in the Navy passed quickly. Then the real challenge began: coming face to face with the reality of making a living in photography. We bought a studio in Provo, Utah, and worked twelve- to fifteen-hour days to pay the bills. With one child, and another on the way, we had to pay not only for the studio, but also for a house and furniture.

Things gradually improved, so we decided to sell the Provo studio and move to Ogden, Utah, where I became a partner in a studio and photo-supply enterprise. The years in Ogden were a time for real growth and learning. I took business classes at the local university and attended professional seminars, conventions, and workshops. I sat in the front row, took notes, asked questions, and volunteered to do anything that would help in my quest for knowledge. Over the years I have been privileged to be associated with many of the greatest photographers in the world. They have taught me, inspired me, criticized me, put me down, and picked me up again. I have tried to take the knowledge and ideas of those

photographers and create my own style, not wanting to be a carbon copy of anyone.

While at Ogden, I discovered that partnerships are sometimes difficult, so again we moved, purchasing the leading portrait studio in Salt Lake City. After settling into this new studio, good things began to happen. The Mormon Church asked me to photograph their president, David O. McKay. This led to an opportunity to do portraits of Richard Nixon, Ronald Reagan, Michigan Governor George Romney, and the governor of Utah and his family.

When a new Theater in the Round opened in Salt Lake City, Gail and I showed some of our portraits to the manager, suggesting that we install a gallery of 20 x 24 oil portraits in matching gold frames, featuring stars who would appear at the theater. We did the sessions during dress rehearsal, then spent a lot of sleepless nights to have a beautiful gallery of 140 portraits ready for opening night. Some patrons remarked that they enjoyed the gallery as much as the shows.

The theater gallery led to work with some movie stars in Hollywood, who encouraged me to move to Los Angeles, so I opened a studio in Century City Shopping Center, adjacent to Beverly Hills. For the first couple of years, business was dreadfully slow, but I got a break by landing the contract for the Beverly Hills High School yearbook. This led to a clientele of future brides, weddings, family groups, and debutante balls.

Then foreign visitors began to visit the Century City Shopping Center in large groups. Seeing my displays in the studio windows, Arab princes and princesses came in for portraits of themselves, as well as their entire families. They ordered a tremendous number of prints and frames. Later, Donny and Marie Osmond asked me to photograph the guest stars for their television shows.

In 1980, I went with the Osmonds to Washington, D.C., for President Reagan's inauguration program. This led to an invitation to make portraits of President and Mrs. Reagan, as well as his entire cabinet. My session with President Reagan was one of the most difficult of my career. I had a 1:00 P.M. appointment, but I was running a little behind. I'd just finished photographing Elizabeth Dole, then the Secretary of Transportation, in her office, and she arranged for all of my equipment to be taken over to the White House because of a heavy rainfall.

The security dogs were unable to sniff through all the equipment, and it had to be checked by hand. We were held at the gate in the downpour with no cover, so when I entered the Oval Office I was dripping wet from head to toe. Hurriedly, I set up as I heard the President's voice down the hall. He came in, took one look at my assistant and me, and decided to give us more time. Nancy came in toward the end of the session, so I photographed them together, producing one of the best portraits I've done of the two of them.

I photographed all of President Reagan's cabinet for years. I was completely set up when they got there. I always made Polaroid tests, so it took only about fifteen minutes to do forty exposures. I work with a Mamiya RZ67, using a 70mm back so I can finish an entire session without reloading.

Later, I was invited to make portraits of the forty-first President of the United States, George H.W. Bush, and his wife, Barbara, as well as many movie stars. I have achieved a degree of success, so I feel it is my turn to pay my dues. One way I have tried to help all the young photographers who are struggling as I once did was by writing a book, *Shooting for the Stars* (Hines Pro Guide Publishing, 1994).* My desire is to give ideas about posing, lighting, expression, and background. Don't sit back and wait for things to happen, but jump in feet first and make them happen. Then your dreams, too, will become a reality.

For information, please contact Merrett Smith, 2016 Kerwood Avenue, Los Angeles, CA 90025. Fax: (616) 233-0632.

JOS SPRANGERS

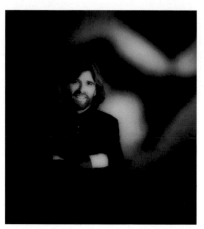

*N*OWADAYS *PEOPLE are spending fortunes to have "feel-good" experiences. They do not cut down on holidays, outings, or restaurants. If we can combine our own positive feelings with the personal emotions of the subjects of our photographs, it will make these photographs all the more valuable as this will create the positive atmosphere we are aiming for.*

MY PHOTOGRAPHY AND LIFESTYLE go hand in hand. Both are positive and relaxed, and this is how all my subjects are approached. My style has let me change from a village photographer to someone with a nationwide audience, also changing my business from a retail photography shop to a portrait studio.

Because it's not common to retouch images in countries like The Netherlands, Belgium, Germany, and France, digital portraiture has not swept Europe like it has the U.S. Our clients are afraid that images are becoming more unrealistic and too fantasy-like. It has everything to do with photography style. The pictorial style uses retouching, whereas the journalistic style hardly ever does.

My photography style is pictorial with strong journalistic influences; that's why I use conventional retouching in a subtle way, but only with images on canvas. In our countries it is a habit to retouch reproductions only, preferably reproductions of photographs of those who died recently.

The quality of digital prints is amazing, but the flexibility in working methods, costs, and sustainability is still a problem.

Although it's customary in my country to get part of the expenses and profits out of reprints, I try to get all my expenses and profits with the first order. Because I have more personality and flair in my photography nowadays than in former times, it's not a very big problem for me to have a much higher price for the first order.

Although I tried many alternative methods, I have found proofing with slides is the most effective for me. The possibility of projecting my images in frames, for instance 100 x 100cm (40 x 40 inches), spurs the client to make a quick decision about buying large wall portraits. In The Netherlands it is quite difficult to sell large wall portraits because it's not a national habit to hang photos on the wall. I do not allow proofs to leave the studio because I sell only *finished* products, not *half-finished*!

I have to guide people to look at proofs in a proper way. If the proofs cannot be viewed under my supervision, then there is a big chance that my clients will make a wrong choice. That would cost me money in the end as well as lower my quality, because they might not see the need for things that need to be done to enhance the portrait unless I guide them. Because I manipulate in the darkroom, I have to tell my clients, with some examples, how the manipulated images will look as finished products. There sometimes is a big difference between the slide proofs and the finished images.

During the slide-proof session I try to persuade my clients not only to buy the first order but also to order the reprints. They then don't have to take the trouble to come back a second time. Their presents for friends and relatives are ready very quickly. During this session the decision to order has been made easy for my clients because the reprint price is much cheaper. To choose one image out of ten slides with almost the same quality is very difficult.

To make it easier, we make a sort of bargain overture by offering to place them in a special box where they can put the images (mounted on a special art-board) that they didn't choose for the first order, but which are nice enough to take as reprints. Clients are afraid they will regret it if they don't take them.

The emotional mood of the proof session is vitally important, but the reason for the portraits is that most of my clients or their children are celebrating something so they are already have a warm feeling about the occasion.

Even if you place a copyright sticker on the reverse side of the photograph, as I do, it is difficult to protect the image from being copied by some clever relative or friend of the client. That's why I get my fee first before the images leave the studio.

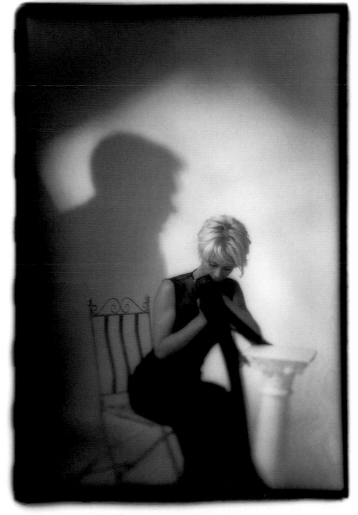

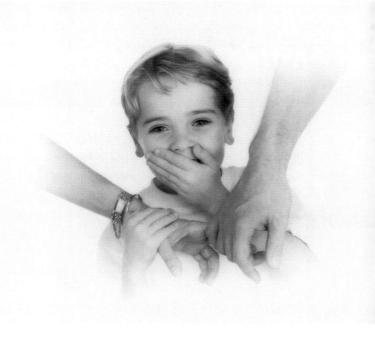

MICHAEL TAYLOR

PASADENA, CALIFORNIA

RELAXED ELEGANCE *is a good way to describe the main thrust of my portraiture. I love to bring people together in a natural way that reflects their ease with each other. I still want to use corrective posing, corrective lighting, and the like, but not to the point that people get stiff. The little things that go unfixed reflect a sense of naturalness in a portrait. It was very common for a portrait painter several hundred years ago to leave a button undone or a wisp of hair askew so that life remained in the painting.*

THE MOST IMPORTANT ASPECT of any sitting is the development of a relationship with my subject. I could be in the most wonderful location with the greatest-looking family, all perfectly coordinated, but if I do not have rapport with my subjects, my portrait will mean nothing. I'm very sympathetic to people and strongly desire to make them look good to bring the best emotionally out of them. I hope that, especially with children, there's a sense of personality and pride.

The home environment is especially great with children. I like the sense of history we capture when they're growing up. If we can capture something representational, with some emotion and history all in one image, that's really wonderful. That's what I'm after. I start with formal images, then encourage them to change clothes for something more informal.

Black-and-white sittings, exposed on Kodak T-Max 100 Professional film, are growing in number. But I'm careful not to mix black and white with color in a single sitting. I've found that if we start mixing films, we have a harder time selling. People tend to gravitate toward either the color or the black and white, and then they only have half as many images to choose from. So we decide at the outset to shoot either color or black and white, then stick to that decision.

For location work, I will spend an hour or so at a client's home. I bring three ProPhoto compact monolights, a Mamiya RZ camera, and increasingly use a Mamiya 645 AF camera. The auto-focus and light weight of the Mamiya 645 AF system help me be more interactive with the subject. I can spend more time relating to them. That helps me capture more story-telling images.

The foundation of great portraiture is proper lighting of the face. If I can get good lighting on the face, I can work in virtually any location. I want directional lighting falling across the face, and I can get it in three ways: available directional light, artificial directional light with strobes or tungsten lights, or a combination of artificial and available light.

In my lighting setup, essentially I make a wall of light, one that I can place anywhere. It is like being able to make a "north light window" and placing it anywhere I want. Think about that concept: my umbrella, soft box, and halo are essentially a portable window. Doesn't that take some of the mystery of portrait lighting out of the equation?

When I travel, I build my wall of light—my window— with three ProFoto ComPact Plus Special 600-watt-second lights (one is primarily a backup). I prefer these self-contained mono-lights to studio-style systems with power packs and tethers because they give me more freedom of movement and finer control over the power output.

On location, the first light I set up is the fill light, a ProFoto ComPact light just off the key light side of the camera. This is the base for the overall exposure, the nondirectional foundation light onto which I will build all other lights. If there's a bright ambient light, I can use it as a fill light, since it will provide a base overall exposure. When I can, I bounce the fill light off a wall in the environment, which will more closely resemble the natural look of the room in the photograph. Occasionally, I use an umbrella if the color of the wall casts an unpleasant color onto the subject's skin. Ideally, the

wall will be a warm color so that the fill light will provide a warm foundation. This helps with the warmer cast of the shadowy areas under the chin and nose.

I take an exposure reading using a Sekonic light meter with the fill light on, then I keep it on as I adjust the exposure, so that the combined exposure from the key light and the fill light will be about 1 stop more than the fill light by itself. For example, if I start with the fill light at $f/5.6$ and turn on the key light, the combined reading would be $f/8$.

For the key light, I usually use a bare bulb in a Westcott Halo light modifier—the essence of an easy-to-use, on-location soft box. I point the bare bulb at the translucent fabric of the soft box and directly toward the subject. Then I feather the key light from the subject toward the camera. This uses the full width of the light modifier. In the best of all possible worlds, the key light would have a glass dome or plate over the flash tube to diffuse it further. This lighting technique is just like using the entire window if an actual window were my light source.

Even though I carry umbrellas and soft boxes in my lighting kit, I am not forced to use them in every circumstance. As I look around the space, I realize that I can bounce the light off almost any surface. Sometimes I use the third ProFoto ComPact as a background light, bouncing it off the wall behind the subjects on the same side as the key light. For example, if the key light is camera left, I will place the background light also camera left, behind the subjects, pointed toward the wall to the left of the subjects. This provides a very natural look, like having illumination from a large north-light window extending behind my clients.

Sometimes I use a Photogenic MiniSpot 200-watt tungsten lamp—a continuous light source—for an edge light, hair light, or background light, or to warm up areas behind the subjects where there's a cool, blue shadow. The light is very clean if you keep it from falling on the mask of the face. You do not want to mix the color temperatures of the light falling across the face; keep it one temperature and as clean as possible. The MiniSpot also works wonderfully as a separation light, giving a portrait great warmth.

These lights are tools for enhancing my portraiture, not

limiting it. I don't let tools define me. Rather, I define how I want the tools to work for me.

Successful portrait photographers should embrace the lighting conditions they find, rather than trying to emulate the exact conditions that have worked before. The biggest mistake they can make on location is looking for the background first. I look for areas with back lighting. I look for reflected light. I look for ways to manipulate the existing light. I look to discover areas that can make a portrait work. I look at unique situations. Most importantly, I look for a fresh way to use light.

When I spot a possible location, I run through a quick mental checklist: Is the lighting on the subjects good? What would make a good background? What lighting will make the subjects and background look more three-dimensional? Does the spot have visual interest? Is there enough room to put up my lights? Can I arrange the people and the scene to get a sense of depth and dimension? Is there pleasing color harmony between the people and the environment?

As with all things, creating a successful location portrait requires give and take. It's a balancing act to make the different elements come together. Rarely are the answers clearly defined, but if I have these factors in mind and I prioritize them—like good directional light, rapport with the subject, and unique lighting situations—my chances of producing a beautiful portrait increase dramatically.

MICHAEL THOMPSON

NASHVILLE, TENNESSEE
www.micaelrenee.com

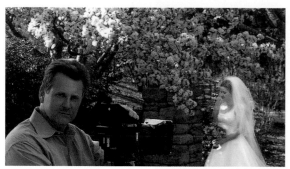

WORKING WITH *international music stars in a city that's considered the home of country music caused us to reevaluate our business. We downsized in recent years, moving from a mall location and reducing our staff. I didn't like staying open seven days a week at the mall location, where a staff of eight people was required. After a few years I realized the mall had ceased to generate any additional business. My wife Reneé and I moved into a rental space and scaled back to three part-time employees.*

MALLS WITH COMMUNITY AWARENESS THEMES such as the symphony, ballet, and baby animals with children provide some of our best advertising. When we moved from Memphis to Nashville ten years ago, we displayed in doctors' offices and empty store spaces, paying the owner for electricity to illuminate the portraits. We consider large portraits hanging in client homes as our best form of advertising, although we also do television spots.

We are making the move into digital because we believe that photographers who don't make the move will be left behind. That is what happened to photographers who failed to change to color film forty years ago. About 80 percent of our work now is done with digital capture, using a Mega Vision back on my Mamiya RZ67 for portraits and a Kodak 520 for weddings. However, I still use film for photographing large wedding groups. I will continue this procedure until I feel comfortable with digital. I expect to go 100 percent digital when I get things worked out.

One of the problems I have encountered with digital is the need for in-camera masking since the digital image is too wide for 8 x 10 and similar formats. I placed an acetate mask on the ground glass to help view the image like an 8 x 10.

Also, I don't like the lens problem with digital that makes all lenses appear longer than the film for which they were designed. This is especially troublesome with wide-angle lenses because you lose about half of the field of view. I must work farther from the subjects than with film and the 180mm lens normally used for portraits. This situation creates a communications problem. After years of working at less than 10 feet from a subject, it takes a lot of adjustment to carry on a conversation from 20 feet. Also, the RZ67 is difficult to focus with a digital back.

Much of our portraiture is done on location, oftentimes outside of Nashville. We show images shortly after this type of session, using Kai's Power Show with music composed by a local friend. We are able to make a sales presentation about forty minutes after a session, saving the time and expense of returning to the site.

However, sessions done in Nashville are shown about a week later. I would rather take my time for the proof presentation because of the need to edit, and perhaps crop, images. I use a Box Light projector that projects digital images as well as slides, projecting onto a wall. I start with a 40 x 50 image and then come down, often showing 20 x 30 slim-lines.

We rarely let proofs go out of the studio but do use contact sheets for business portraits. Eventually we plan to burn images onto compact disks for weddings so couples can send images to friends and relatives.

If I were starting today, I would stay small and work entirely on location, renting an 800-square-foot gallery for a showroom. All sales would be done on location too, just as sales are currently conducted. This type of selling helps overcome the client excuse of not having space for a large portrait.

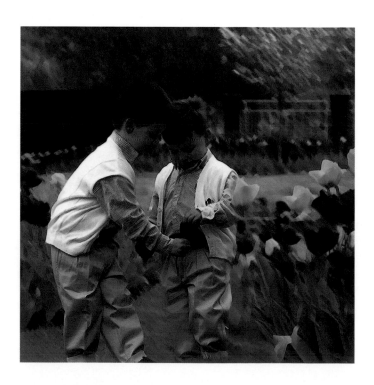

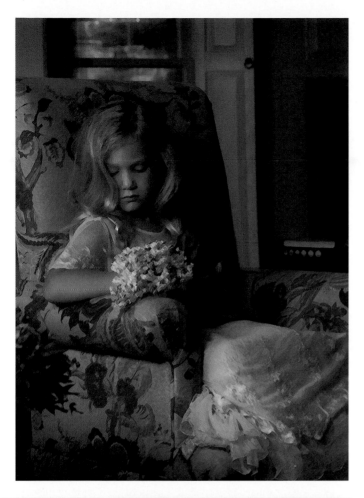

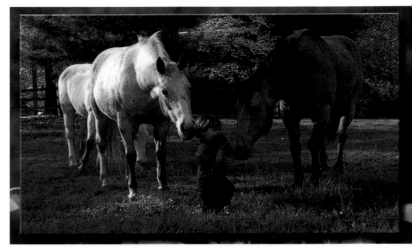

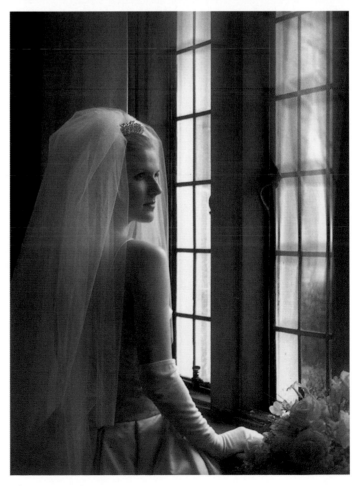

Those wanting to get into portraiture should take business courses. The biggest problem for creative people is that of not having a concept of how to stay in business. Also, I advise taking courses in psychology, art, and computers. I would rather have a good photographer with a great personality than a great photographer with a lousy personality.

DARREN TILNAK

MELBOURNE, AUSTRALIA
www.tilnakcollections.com.au

PORTRAITURE *is an emotional medium. It's so much more than simply picturing somebody's physical appearance. It's about conveying the extra dimension that is their personality or character. Any photographer can capture the "cardboard cutout," but I would like to always capture the heart and feelings of the subjects who are in front of my lens. What I want to do with my pictures is to tell a story and to create emotion. Everything else is secondary to the creation of real feelings.*

OUR CLIENTS THINK we are unique in the way we can conceptualize imagery in such a way that they become the ideas of the person. If a client has a problem, first we find out what it is and second, we act on it immediately. We have a 48-hour turnaround policy in place at the studio, which works out very well. All queries or complaints are directed to Alison, our customer service complaint officer, to ensure the appropriate action is taken immediately.

Problems, causing us to have to redo portraits, come from miscommunication or expectations from the client that are unorthodox or unreasonable. Having said that, we take every action to satisfy the customer every time, knowing full well that the customer is not always right.

Time efficiency improves when we can group tasks: return several phone calls at one time, write letters at one time, conduct photo shoots at one time, and take care of sales appointments at one time. This guarantees an optimum and efficient, organized way of working so we don't become overwhelmed.

Once you attain a reasonable level of photographic skill, you need to concentrate on the other aspects of running a portrait studio. These include communication skills, marketing, the game of sales, managing a staff, negotiation skills, investments, and personal development. To succeed as a photographer requires energy flow and creating high self worth, which orchestrates a belief structure in oneself.

I recently formed a company called Pathway Enterprises, which literally deals with and delves into all of the other important aspects of becoming a professional photographer. To be truly successful requires total integration of all these talents at a high level.

There is no question that the future of photography lies in digital capture; I am among the 5 percent of Australia's portrait photographers who are using digital capture at a higher level. However, only the image-maker who has worked to achieve the other skills outlined will excel in the business of portrait photography.

We use digital capture for 100 percent of our work, currently with Nikon D1 and D1x cameras, with all retouching done in Photoshop. Film is a thing of the past for me. Digital prints are as good, if not better, up to 20 inches. After that, you have to interpolate the images using software.

Digital capture is much more profitable for us because it eliminates the cost of film, processing, and proofing. In past years that averaged about $100 per session. Now it is zip. Also, reprints are a lot more cost-effective. We save our files on CDs in the JPEG format.

Sales sessions immediately follow the shoot, saving the digital captures to the hard drive, then showing images via our Sony data projector, combined with emotion-stimulating music. Once an order is placed and paid in full, a client may

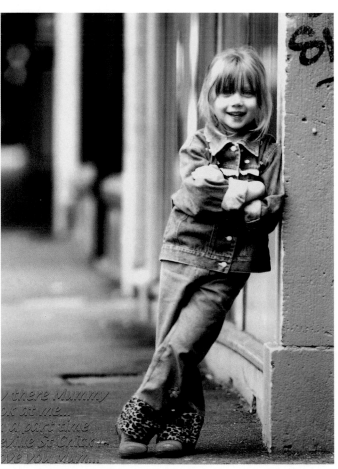

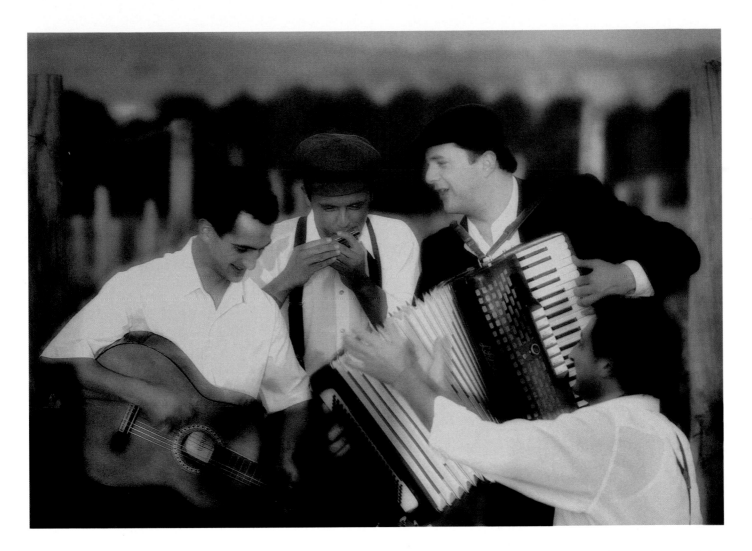

purchase a CD of all images, which is an extra sale. As part of the CD sale, we sign copyright over to the client, but no paper proofs are shown or offered for sale. In the future, we are keen to run our business in a pure e-commerce fashion, using the Internet to show images to clients.

When I started, I chose not to do a degree, instead taking short and very intense courses in photography, psychology, human behavior, people skills, visualization, and dance. I suggest newcomers to the field look closely at human behavior and improving their people skills, understanding the arts, marketing, and communication.

Once you find out what the people are all about, then you have something to say. I think the problem with photography schools is that they focus too heavily on science, although science has become more important with the advent of digital technology.

From the beginning, I seemed to have a flair for photography and learned to believe in myself to achieve a position in the photographic industry. I created a portfolio of work, then went door-to-door calling on up-market studios in Melbourne. Essentially, I am a "people person" and my studies in psychology help me as a portrait photographer.

We had to educate the public on what excellent portraiture

should be worth. I analyzed our break-even costs, plus margins, to calculate that I am worth "x" amount of dollars per shoot. I made a conscious effort to widen the gap between the average dollar sale and the cost associated with each session. Lack of capital and ignorance about business are the causes of most photographic failures.

By producing imagery that was unique, innovative, and original, I won national awards, then sent out press releases to all the major magazines, radio stations, and television channels. This had an awesome impact on my positioning in the marketplace.

TIM & BEVERLY WALDEN

LEXINGTON, KENTUCKY
www.waldensphotography.com

THE THING WE LIKE and dislike about this business is that you never master it; there's always room for improvement. Just when you think everything is under control and you know everything, something always comes along that is a new challenge. Also, we have always dreamed of being just the "artist," but the business demands that we wear many hats: businessperson, marketing specialist, salesperson, boss, and administrator.

HOWEVER, WE FEEL our clients think of us as artists. Their perception is that we are unique and creative, in addition to being a very service-oriented business. Whether they love the product or not, they are assured they will walk out happy. Clients are aware that they will spend some money for our services, but because they know that it has a value, they consider it an investment.

After reading the book *E-Myth,* by Michael Gerber, which talks about what makes a business succeed, we realized that the thing that sells a business is perception, not reality. We became what we are today because of the way we were perceived when clients came into our studio. We began investing in those things that would create a perception of success for the business. We used the services of an accountant, lawyer, banker, financial advisor, and computer expert, as well as decorators and graphic designers, to make us look like we were already a success long before we were successful.

We quickly learned that just because you think you're good, that doesn't guarantee that customers will be seeking your services. We had to learn how to market the business. The thing that caused the greatest growing pains in the beginning was our lack of an effective marketing strategy. Realizing that we didn't know enough in this area, we had to bring our knowledge to a new and greater level through both study and experimenting with different marketing strategies.

First and foremost, we established our position in the marketplace by defining a recognizable style that was distinctively ours, without concern about who liked or disliked it. This enabled real growth because the people who really like the style identified with it quickly and invested in our services. Our low volume not only provides us time to express our art, but also enables us to have the time to develop excellent customer-service practices. Spending time with our clients developed customer loyalty, which ultimately brought us the more financially successful people in our area.

In order to create the level of art that we desire for our clients, it must be a custom art piece, using the best and finest supporting artists and materials, thereby establishing us as a high-priced business. Our goal was to produce the finest product, which is a slow and expensive process. To lower costs would compromise the quality of the product. This we will not do. We believe that no matter what we charge for a product, we give people what they came for and a little more, making it as much an experience as a purchase. In doing this, we have created loyalty, made friends, and generated the best word-of-mouth advertising.

Our images are copyright-protected in a twofold manner. First, we distribute printed literature that explains that these are copyrighted items. Because we work in a high-end market that attracts people who are investing in an art piece, they don't want a copy, they want the *original*!

For every session, we actually create sales suggestion brochures telling the client what they should purchase. Images are shown on a computer for color images and on a Fotovix for black-and-white images. We do not allow proofs or previews to leave the studio.

When it became evident that we could no longer get the work done on our own, with our backs against the wall, we began hiring our first employees. We called them "reactive employees" because they were hired to come in and help due to an existing workload. Desperation birthed this move because we were at a point where we just didn't have much of a choice; we could not handle any more work ourselves without sacrificing our family time.

Although we started with one marketing person, we now have two marketing people, one who works locally and another who is generally on the road. We also have a full-time office manager who also does sales, a full-time computer operator who does the designing and graphic applications, a part-time framer, and a part-time lab technician. There are times when jobs will create a need for outside contractors—when it is just too costly to hire regular staff for those few times when that service may be needed.

Because our product is so personal, the best method for

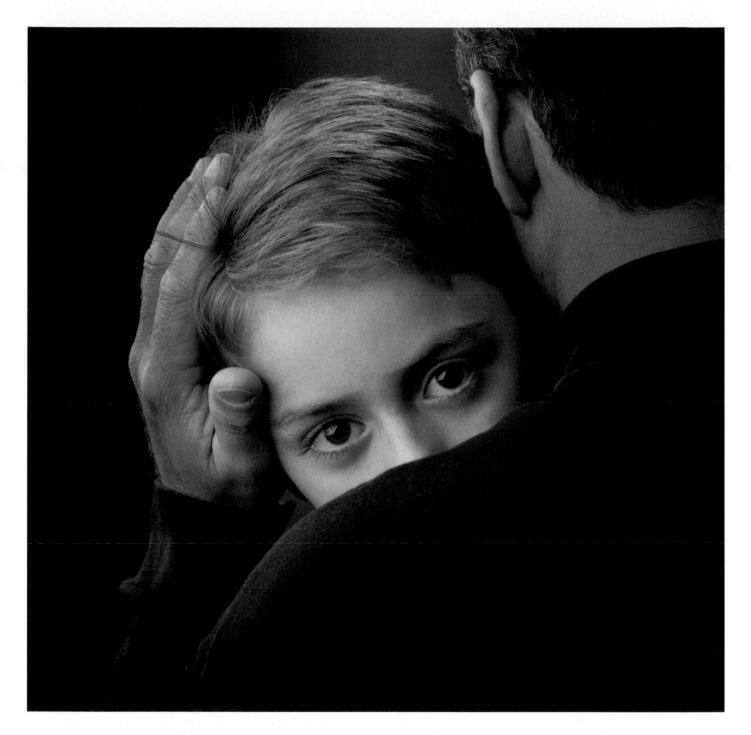

identifying client needs or problems is through investing time in the client on an *appointment-only* basis. The best method of dealing with client problems is face to face. We are always prepared to listen and willing to ask clients what they would like us to do to make the situation better. If the request is reasonable, we do it, remembering that our reputation could be destroyed in no time at all.

Our staff is trained on how to communicate with clients and to know exactly what questions to ask. Because everything is done on a one-on-one basis, our strategy meetings allow us to identify those things that are working well for us and the areas where we are doing something wrong, as well as devise plans to become better.

Each morning, we conduct a ten-minute time-management meeting in which we block our calendars so that we can best utilize the time in each day. Employees have a master task list on their computer screens, which is accessible by everyone so that the staff can communicate throughout the day. We invest time in managing time through training classes and seminars. The key is to put importance on it and lay a plan for what we wish to accomplish.

About 15 percent of sales are spent on advertising and self-promotion, with operating costs running about 60 percent of sales.

My advice for newcomers would be first to realize that your photographic talent has less to do with your level of

success than you think. The important things in being successful in the business lie in becoming a well-rounded individual who knows the value of his art, knowing how to run the business, and having the ability to market it effectively. It's vitally important to create a niche.

Through all of the changes that are taking place, my vision for photography is to see the art remain intact. I am reminded that ultimately what we are selling is what hangs on the wall, and the method of how we get to that point is not that important. I do not want to see photographers lose sight of the fact that art—aesthetics, composition, lighting, and emotion—is the driving force behind photography. The other things are just tools of the trade, making it easier to get to the piece of art.

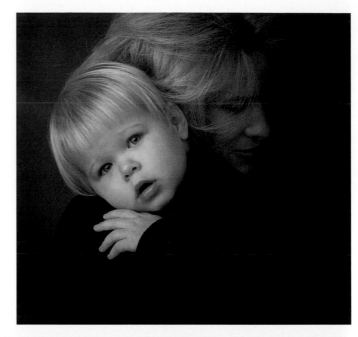

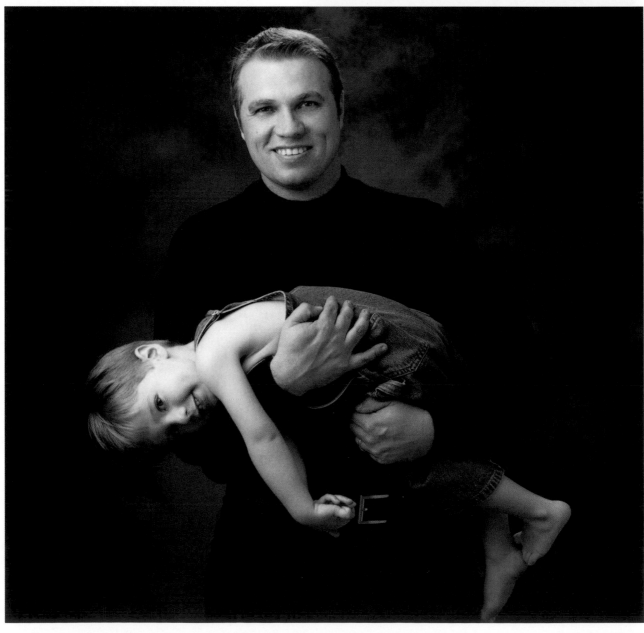

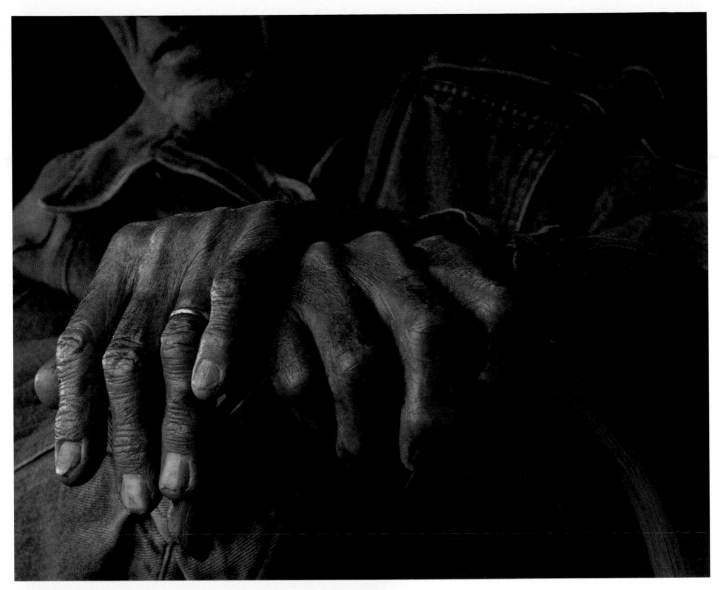

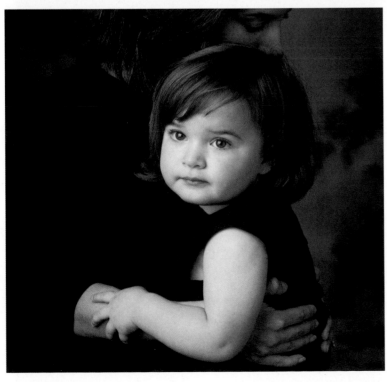

DAVID A. ZISER

Cincinnati, Ohio
www.ziser.com

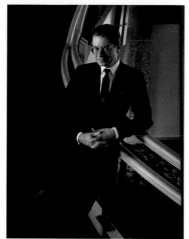

*I*N MY HEART AND SOUL *is a passion for photography that gives me the energy to produce visual photographic interpretation for my clients. I believe that a client chooses me for a particular assignment because of the difference between my work and the alternatives. This belief gives me the motivation for what I do. I feel that I am there to do more than just capture the people, places, and events of the day. It is my responsibility to capture the warm feelings among family and friends.*

TO DO THAT EFFECTIVELY, I must, on every assignment, make the very best possible use of my creative ability and technical expertise, without compromise. When making photographs for our clients we are not just using the hardware tools of cameras, lenses, film, and digital capture. We must use our compositional tools of light, color, detail, form, shape, depth, balance, and perspective as well. We constantly need to be squeezing that thing we call our brain to get those creative juices flowing.

Knowing that every time we are behind the camera we will be giving 110 percent helps keep our minds fresh, sharp, and alive, keeping our creativity fresh and exhilarating. Just as we exercise our bodies to keep them in shape, we need to exercise our minds to keep them operating at peak performance as well.

We can never tell ourselves that we know it all, that there is nothing else to learn. There are a million hallways that we can walk down, and a million doorways that we can open. We must constantly strive to improve our photography, to take it just a step further and try to push the limit. All of us need to be pushing the boundaries together.

There is a constant need to share with our fellow professionals, giving them the insights that we have gained in our own professional experience and letting them continue to pass these new ideas—with their own improvements—on to others. There can be no secrets. There is no greater joy in the world that to give something to someone else, then have that person give it back to you in a new and improved version. Then we can pass it on to another to have it change and improve again. This cycle can do nothing but improve our photography and our profession. That needs to be the goal of everyone.

Starting in 1979, I attended every seminar, workshop, and convention that I could. I would listen to the best photographers in the field, study what they were teaching, and learn what they were doing. I relentlessly pursued this course of action and methodically monitored my results.

There was one pitfall to this strategy, though. Copying the masters only makes you a master copier. This is not what I wanted at all; I wanted a blending of their styles and techniques with my own creativity in order to produce a style entirely my own. I wasn't looking for the recipe to make their soup. I was looking at their ingredient list, maybe varying some of the amounts, and adding a few of my own spices. The final broth would be my own.

The whole thought process and action helped me distill one of my basic tenets about this profession which, simply stated, is this: It's the difference that makes the difference! I wanted my work to be different from the work of other photographers in my area as well as those with whom I had the wonderful opportunity to study. I didn't want to be a copy of my teachers any more than I wanted to copy what everyone was doing locally. I wanted this difference to be the reason my potential clients called me. I wanted my clients to know what this difference was. I wanted this difference to be the reason for my anticipated photographic success.

Think about this for just a moment. Sameness is boring, stagnant, not growing. Sameness breeds frustration, mediocrity, and eventually contempt for what one is doing. Look at how many photographers don't photograph weddings any more and proudly proclaim it. Such a proclamation is simply

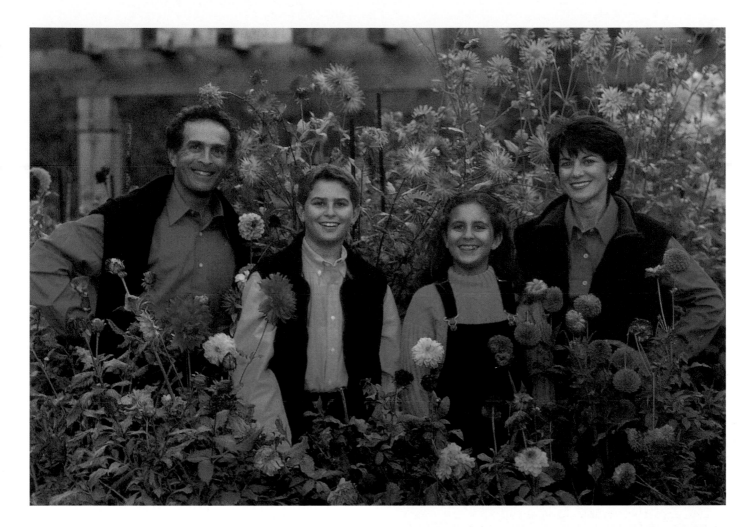

an admission that they were failing to grow in their wedding photography. Sameness kills enthusiasm!

There are two losers when this happens. One, of course, is our self; the other, the client.

There is no greater personal or professional injustice than to compromise the client because we don't like what we are doing due to a loss of enthusiasm. It is a disservice to our profession as well to have a client call a photographer for a particular service and for the photographer to take the assignment and then give only a 50-percent effort.

Photographers not committed to their clients are also not committed to this profession, and should change jobs. But, in all fairness to some of these photographers, hopefully they recognize the problem and will select a different hallway of possibilities to rekindle their enthusiasm. I certainly hope so.

The advent of digital photography may rekindle enthusiasm in some photographers. At this time, I am capturing some of my images digitally and some from film. The lab keeps the film and sends me a compact disk (CD) because of the high quality it produces. With film or digital capture, I run everything through the ProShots system for presentation to the clients, allowing me to edit the images with title slides.

Although some photographers see a time when all images will be shown to clients on the Internet, I think it's

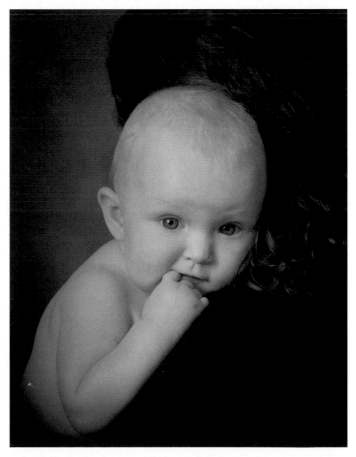

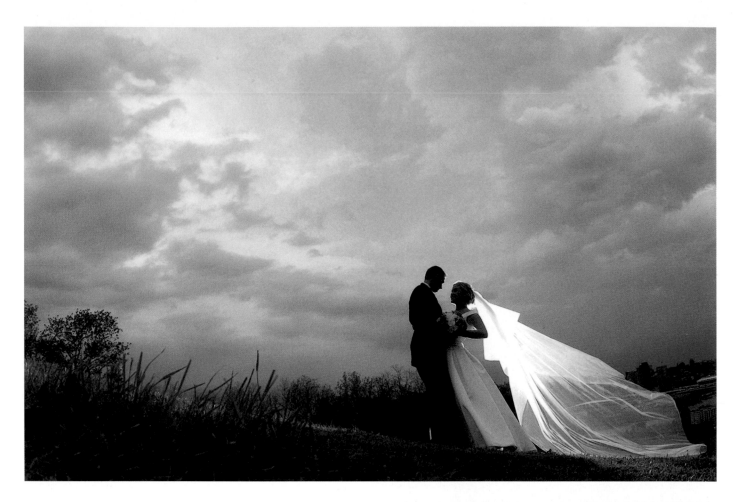

vitally important for the photographer to be proactively involved with the initial showing of images. When we do sessions in clients' homes, we make digital images of wall spaces that would be ideal for portraiture. With Pro-Shots, we can show the clients images in a frame on a wall in their own home! You can imagine the emotional impact of this presentation, especially accompanied by royalty-free music. When the presentation is complete, I merely turn down the volume. It's not brain surgery! After the client makes a selection, I make an inkjet print so I can send it to the lab with art and color instructions.

The Internet gives us add-on sales for those potential clients who are not able to attend the presentation showing. Of course, I never let clients take proofs out of the studio, and those images on the Internet are protected from downloading by a watermark on the face of the print.

If our photography can capture the real feelings between our clients, our clients will experience these emotions again when they view our portraits. Then we have captured something very special, lasting, and important to them!

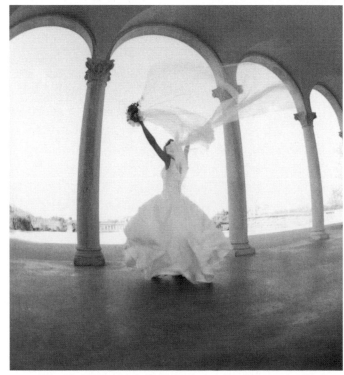

RESOURCES

Suppliers and Businesses

Adobe Systems Incorporated
345 Park Avenue
San Jose, California 95110
Phone: (800) 833-6687
Fax: (408) 537-6000
Web site: www.adobe.com
Software, including Photoshop

American Photographic
Resources, Inc.
6718 Baker Boulevard
Fort Worth, Texas 76118
Phone: (800) 657-5213
Fax: (817) 431-0434
E-mail: aprnow@aprprops.com
Web site: www.aprprops.com
*Bubble Bears, squeakers, acrylic
plastic cubes, gold vinyl, furniture,
and props*

B&H Photo
420 Ninth Avenue
New York, NY 10001
Phone: (800) 606-6969
Fax: (800) 947-7008
E-mail:
photo@bhphotovideo.com
Web site:
www.bhphotovideo.com
*Photographic and digital
equipment*

Barton Manufacturing
and Master Frame Builders
P.O. Drawer M
Calhoun City, Mississippi 38916
Phone: (800) 856-5461
Web site: www.barton-mfg.com
Frames

Bill S. Weaks
508 S. Broadway
Plainview, Texas 79072
Phone: (806) 296-0828
Fax: (806) 296-0828
E-mail: weakscamera@o-c-s.com
Used cameras and equipment

Bruce Hudson
16627 Benson Road South
Renton, Washington 98055
Phone: (425) 271-9709
Fax: (206) 226-4363
Web site: www.brucehudson.com
Photography training videos

Burns Picture Frame Co.
109B East Baley
Nash, Texas 75569
Phone: (800) 933-9047
Fax: (903) 831-5461
Frames

Calumet Photographic
890 Supreme Drive
Bensenville, Illinois 60106
Phone: (800) CALUMET
Fax: (800) 577-3686
Web site:
www.calumetphoto.com
*Photography equipment
and supplies*

Camera World
of North Carolina
P.O. Box 9426
1809 Commonwealth Avenue
Charlotte, North Carolina 28299
Phone: (800) 346-3114
Fax: (704) 376-1826
E-mail: CameraWrld@aol.com
Web site:
www.cameraworldnc.com
*Sailwind Leon Pro II
vignette kit (see Chapter 6)*

Club Photo
650 Saratoga Ave.
San Jose, California 95129
Phone: (408) 557-6743
Fax: (408) 557-6799
E-mail:
sales@event.clubphoto.com
Web site:
www.event.clubphoto.com
*On-line photo proofing for
photographers*

Color by Michael
10525 FM 1585
Wollfforth, Texas 79382
Phone: (806) 866-0373
Fax: (806) 866-0374
E-mail: Clrbymich@door.net
T-shirts

Concord EFS National Bank
5763 Summer Trees Drive
Memphis, Tennessee 38134
Phone: (800) 238-7675
Web Site: www.concordefs.com,
Credit card merchant accounts

Decorative Crafts
50 Chestnut Street
Greenwich, Connecticut 06830
Phone: (800) 431-4455
Fax: (203) 531-1590
E-mail:
info@decorativecrafts.com
Web site:
www.decorativecrafts.com
Furniture

The Denny Manufacturing
Company, Inc.
P.O. Box 7200
Mobile, Alabama 36670
Phone: (800) 844-5616
Fax: (334) 452-4630
Web site: www.dennymfg.com
*Background lifts and mirror
Plexiglas*

Discover Business Services
Phone: (800) 374-2000
Credit card merchant accounts

Double Dog Design
(Marybeth Wydock)
3375 Ridgerock Way
Snellville, Georgia 30078
Phone: (770) 736-3420
Fax: (509) 753-2963
E-mail:
dogdesign@mindspring.com
Graphic design

Eastman Kodak Company
343 State Street
Rochester, New York 14650
Phone: (800) 242-2424
(traditional products)
(800) 235-6325 (digital and
applied imaging products)
Web site: www.kodak.com

Edmund Scientific Co.
60 Pearce Avenue
Tonawanda, New York 14150
Phone: (800) 728-6999
Web site:
www.scientificsonline.com
Levels (bubble or spirit)

Epoch Arts
2727 W. Airport Freeway
Irving, Texas 76062
Phone: (888) 376-8627
Fax: (888) 376-8628
Web site: www.epocharts.com
Easel frames

Franklin-Covey Co.
Store locations throughout the
country.
Phone: (800) 819-1812
Web site:
www.franklincovey.com
*Audiotapes and CDs of The 7
Habits of Highly Effective
People by Stephen R. Covey and
time management products*

Fuji Photo Film USA
P.O. Box 7828
Edison, New Jersey 08818
Phone: (800) 880-3854
Fax: (732) 857-3487
Web site:www.fujifilm.com
*Cameras, film, paper,
and processors*

Granite Bear Development
P.O. Box 1489
Columbia Falls,
Montana 55912-1489
Phone: (888) 428-2824
Fax: (303) 265-9235
Web site: www.granitebear.com
Software for photographers

Gross Medick-Barrows
1345 Export Place
El Paso, Texas 79912
Phone: (800) 777-1565
Fax: (800) 456-4107
Web site: www.g-m-b.com
*Boxes, proof albums,
and photo folders*

Harrison & Harrison Optical
Engineers
1835 Thunderbolt Drive Unit E,
Porterville, California 93257
Phone: (559) 782-0121
Fax: (559) 782-0824
E-mail: Harrisonop@aol.com
Viewing screens and filters

HP Marketing Corp.
16 Chapin Road
Pine Brook, New Jersey 07058
Phone: (800) 735-4373
Fax: (800) 282-9010
E-mail:
info@hpmarketingcorp.com
www.hpmarketingcorp.com
*Braun Photo Technik Paxiscope-
XL proof projector (replaces
EnnaScop and Astrascope)*

infoUSA, Inc.
5711 S. 86th Circle
P.O. Box 27347
Omaha, Nebraska 68127
Phone: (800) 321-0869
E-mail: help@infousa.com
Web site: www.listbazaar.com
Sales leads and mailing lists

JFM Enterprises, Inc.
4476 Park Drive
Norcross, Georgia 30093
Phone: (800) 462-3449
Fax: (770) 409-1013
E-mail: info@jfmenterprises.net
Web site: www.jfmenterprises.net
Frames

KEH Camera Brokers
Phone: (404) 892-5522
Fax: (404) 892-1251
Web site: www.keh.com
Used cameras and equipment

Kendall-Hartcraft
P.O. Box 270465
Hartford, Wisconsin 53027
Phone: (800) 558-7834
Fax: (800) 298-3121
Email: Comments@kmaf.com
Web site: www.kmaf.com
Frames

Kent Watkins
Mid-South Photographic
Specialties
2502 Glenwood Drive
Jonesboro, Arkansas 72401
Phone: (870) 932-4454
Lab services (black and white)

Larson Enterprises
P.O. Box 2150
Orem, Utah 84058
Phone: (800) 351-2158
Fax: (801) 225-8097
E-mail: sales@larson-ent.com
Web site: www.larson-ent.com
Reflectors and soft boxes

Leonard Levy
21 Ober Street
Beverly, Massachusetts 01915
Phone: (978) 922-1990
E-mail: mrlevy@gis.net
*Used cameras and equipment; NPC
Polaroid backs*

The Levin Company
1111 West Walnut Street
Compton, California 90220
Phone: (800) 345-4999
Fax: (310) 608-7418
Web site: www.Levinframes.com
Frames

The Lighter Side
4514 19th Street Court East
P.O. Box 25600, Dept L9704
Bradenton, Florida 34206-5600
Phone: (941) 747-2356
Fax: (941) 746-7896
Bandit Box #5644

Lindahl Specialties
Photo Control
Corporation/Lindahl Products
4800 Quebec Avenue North
New Hope, Minnesota 55428
Phone: (800) 787-8078
Fax: (763) 537-2852
E-mail: info@lslindahl.com
Web site: www.lslindahl.com
Lens shades

Lyle Teague Moulding Co.
410B West Main Street
Henderson, Tennessee 37075
Phone: (615) 824-8669
Fax: (615) 824-8054
Frames

Lyons Engraving & Framing
(Don Bailey)
2606 E. Nettleton Ave.
Jonesboro, Arkansas 72401
Phone: (800) 643-0104
International phone:
(870) 935-9462
Name-holders for frames

Marathon Press
1500 Square Turn Blvd.
Norfolk, Nebraska 68702
Phone: (800) 228-0629
Fax: (402) 371-9382
Web site:
www.marathonpress.com
*Advertising, postcards, gift certifi-
cates, and window envelopes*

The McGraw-Hill Companies
P.O. Box 182604
Columbus, Ohio 43272
Phone: (800) 228-6898
Fax: (614) 759-3759
E-mail:
customer.service@mcgraw-
hill.com
Web site: www.mcgraw-hill.com
Coloring books

Micro Warehouse
3512 State Route 73 South
Wilmington, Ohio 45177
Phone: (800) 367-6808
Fax: (732) 370-2432
Web site: www.Warehouse.com
*Focus Enhancements TView Gold
adapter*

Mind's Eye Graphics
1019 Commerce Drive
Decatur, Indiana 46733
Phone: (800) 942-9518
Fax: (260) 724-4004
Web site: mindseyeg.com
E-mail: customerservice@
mindseyeg.com
T-shirts for graduating seniors

Music for Little People
P.O. Box 1460
Redway, California 95560
Phone: (800) 409-2457
Fax: (707) 923-3241
E-mail: melody@mflp.com
Web site: www.mflp.com
*Children's music, including
Lullaby Berceuse, featuring
"I Have You" by Connie Kaldor
and Carmen Campagne*

Petals
155 White Plains Road, Suite 100
Tarrytown, New York 10591
Phone: (800) 920-6000
Fax: (800) 628-0143
Web site: www.petals.com
Silk flowers and arrangements

Photogenic Professional Lighting
525 McClurg Road
Youngstown, Ohio 44512
Phone: (800) 682-7668
Fax: (330) 758-3667
Web site:
www.photogenicpro.com
Lights

Photographer's Warehouse
525 McClurg Road
Youngstown, Ohio 44512
Phone: (800) 521-4311
Fax: (330) 758-8010
Web site:
www.photographerswarehouse.com
*Light stands and economy
electronic lights*

ProShots
4162 Dye Road
Swartz Creek, Michigan 48473
Phone: (810) 733-6191
Fax: (810) 733-6519
E-mail: info@proshots.com
Web site: www.proshots.com
*Digital proofing and ordering
system*

Quantum Instruments, Inc.
1075 Stewart Avenue
Garden City, New York 11530
Phone: (516) 222-6000
Fax: (516) 222-0569
E-mail: QuantRep@qtm.com
Web site: www.qtm.com
*Quantum Radio Slave 4i
and Qflash*

Quill Corporation
P.O. Box 94080
Palatine, Illinois 60094
Phone: (800) 789-1331
Fax: (800) 789-8955
Web site: www.quillcorp.com
*Fellowes Staxonsteel drawers
(for filing negatives)*

Regal/Arkay Photo Products
2769 South 34th Street
Milwaukee, Wisconsin 53215
Phone: (800) 695-2055
Fax: (414) 645-9515
6-foot camera stand

Ritz Camera
6711 Ritz Way
Beltsville, Maryland 20705
(locations throughout
the United States)
Phone: (877) 690-0099
Fax: (301) 419-2098
Web site: www.ritzcamera.com
*Photographic and digital
equipment*

River City Sound
(Bob Pierce)
P.O. Box 750786
Memphis, Tennessee 38175
Phone (800) 755-8279
Fax: (901) 274-8494
Web site:
www.Rivercitysound.com
Royalty-paid music

Ross-Simons
9 Ross-Simons Drive
Cranston, Rhode Island 02920
Phone: (800) 835-1343
E-mail: customerservice@
ross-simons.com
Web site: www.ross-simons.com
Tea set for children

Royalty Free Music
(Gary Lamb)
7051 Highway 70-S #278
Nashville, Tennessee 37221
Phone: (800) 772-7701
Web site: www.royaltyfree.com
Royalty-paid music

Sekonic Professional Division
Mamiya America Corporation
8 Westchester Plaza, Elmsford,
NY 10523
Phone: (914) 347-3300
Fax: (914) 347-3309
E-mail: info@sekonic.com
Web site: www.sekonic.com
Sekonic light meters

SuccessWare Inc.
3976 Chain Bridge Road
Fairfax, Virginia 22030
Phone: (800) 593-3767
Fax: (703) 352-0537.
Web site: www.SuccessWare.net
Studio management software

T.J. Edwards Co.
33 Dover Street
Brockton, Massachusetts 02401
Phone: (508) 583-9300
Fax: (508) 583-6155
E-mail: tjedwards3@aol.com
Web site: www.tjedwardsco.com
Wyman Super Regal or TC-900
hot stamping machines

Tallyn Photo Supply
Phone: (800) 433-8685
Fax: (309) 692-8346
Web site: www.tallyns.com
Softfusers, polyester mirror for
floor, diffusers, gels, spot patterns,
and photographic equipment

Thanhardt-Burger Corporation
1105 Washington Street
LaPorte, Indiana 46350
Phone: (800) 826-4375
Fax: (219) 325-0665
E-mail: wtburger@wtburger.com
Web site: www.wtburger.com
Frames

United Manufacturers Supplies
80 Gordon Drive
Syosset, New York 11791
Phone: (800) 645-7260
Fax: (516) 496-7968
E-mail: customerservice@
unitedmfrs.com
Web site: www.unitedmfrs.com
Frame hardware

The Veach Company
37007 S Oak Street
Kennewick, Washington 99337
Phone: (800) 523-9944
Fax: (509) 586-7774
Web site: www.veachco.com
Hot-foil stamping machines

Wicker by Design
2705 Newquay Street
Durham, North Carolina 27705
Phone: (800) 731-6666
Fax: (919) 309-0500
Web site:
www.wickerbydesign.com
Wicker furniture and props

Zuga
Web site: www.zuga.net
Portrait galleries and information

Organizations

American Society
of Photographers
P.O. Box 316
Willimantic, Connecticut 06226
E-mail: ppanerl@aol.com
Roland Laramie, executive
director
Organization for PPA
degree-holders

Professional Photographers
of America
229 Peachtree Street NE,
Suite 2200
International Tower
Atlanta, Georgia 30303
Phone: (800) 786-6277
Fax: (404) 614-6406
Web site: www.ppa.com

Professional Photographers
of California
P.O. Box 187
Fairfield, California 94533
Phone: (707) 422-0111
E-mail: PPC@castles.com
Web site: www.ppconline.com

Pro Photographers Society
of New York
P.O. Box 56
Limestone, New York
14753-0056
Phone: (814) 368-9115
E-mail:
headquarters@PPSNY.com
Web site: www.ppsny.com

Texas Professional
Photographers Association
P.O. Box 1120
Caldwell, Texas 77836
Phone: (979) 272-5200
Fax: (979) 272-5201
E-mail: dougbox@aol.com
Web site: www.tppa.org

Wedding & Portrait
Photographers International
1312 Lincoln Blvd.
P.O. Box 2003
Santa Monica, California 90406
Fax: (310) 395-9058
Web site: www.wppinow.com

SELECTED BIBLIOGRAPHY

...on, Richard. *Portraits.* New York: Farrar,
...aus and Giroux, Noonday Press, 1976.
...n, Richard. *Words That Sell.* Chicago:
...ontemporary Books, 1984.
...ker, Robert W. *Best of Show.* Miami:
...Anran Publishers, 1982.

Blair, Don. *Body Parts.* Norfolk, NE:
Marathon Press, 2000.

Blanchard, Kenneth, and Spencer Johnson.
The One-Minute Manager. New York:
Penguin-Putnam, Berkley Publishing
Group, 1983.

Butler, Stephen. *Gainsborough.* London:
Studio Editions, 1992.

Covey, Stephen R. *The 7 Habits of Highly*
Effective People. New York: Simon &
Schuster, Fireside, 1989.

Dwyer, Michael. *Preparing for the Digital*
Revolution. Norfolk, NE: Marathon Press,
2000.

Fairbrother, Trevor. *John Singer Sargent.*
New York: Harry N. Abrams, 1994.

Falk, Edwin A., Sr., and Charles Abel.
Practical Portrait Photography for Home and
Studio. New York: American Photographic
Book Publishing Co., 1959.

Fassbender, Adolf. *The Pictorial Artistry of*
Adolf Fassbender. Nutley, NJ: The
Fassbender Foundation, 1994.

Gilbert, Albert. *Gilbert: A Portfolio.* Toronto:
Hines Pro Guide Publishing, 1994.

Holme, Charles. *Art in Photography.* London:
The Studio, 1905.

Hough, Thomas. *The Portrait.* Rochester, NY:
Eastman Kodak Company, 1993.

Karsh, Yousuf. *Karsh: A Fifty-Year Retro-*
spective. Boston: Little, Brown & Co., 1983.

Levinson, Jay Conrad. *Guerrilla Marketing.*
Boston: Houghton Mifflin, 1993.

May, Rollo. *The Courage to Create.* New York:
W.W. Norton & Company, 1975.

McIntosh, William S. *Location Portraiture.*
Rochester: Saunders Group, Silver Pixel
Press, 1996.

Monteith, Ann K. *The Professional*
Photographers Marketing Handbook.
Norfolk, NE: Marathon Press, 1995.

Morgan, Jim. *Management for the Small Design*
Firm. New York: Watson-Guptill
Publications, 1997.

Ness, Paul. *Professional Portrait Techniques.*
Rochester, NY: Eastman Kodak Company,
1980.

Newhall, Beaumont. *The History of*
Photography. Boston: Little, Brown & Co.,
1982.

Peters, Thomas J., and Robert H. Waterman,
Jr. *In Search of Excellence.* New York:
Harper & Row, 1982.

Scavullo, Francesco. *Scavullo Women.*
New York: Harper & Row, 1982.

Sinsheimer, Karen. *Watkins to Weston:*
101 Years of California Photography. Santa
Barbara: Roberts Rinehart and Santa
Barbara Museum of Art, 1992.

Smith, Merrett. *Shooting for the Stars.* Los
Angeles: Hines Pro Guide Publishing, 1994.

Solkin, David H. *Painting for Money.*
New Haven: Yale University Press, 1992.

Steward, James Christen. *The New Child.*
Berkeley: University Art Museum and
Pacific Film Archive, University
of California, 1995.

Swindoll, Charles R. *Strengthening Your Grip.*
Dallas: Word Publishing, 1982.

Wendorf, Richard. *Sir Joshua Reynolds.*
Cambridge, Massachusetts:
Harvard University Press, 1996.

Wildi, Ernst. *The Hasselblad Manual.*
London: Focal Press, 1986.

Yergin, Daniel. *The Prize.* New York:
Simon & Schuster, 1992.

INDEX